The Beauty of the Cross

The Beauty of the Cross

The Passion of Christ in Theology and the Arts, from the Catacombs to the Eve of the Renaissance

RICHARD VILADESAU

OXFORD
UNIVERSITY PRESS

OXFORD
UNIVERSITY PRESS

Oxford University Press, Inc., publishes works that further
Oxford University's objective of excellence
in research, scholarship, and education.

Oxford New York
Auckland Cape Town Dar es Salaam Hong Kong Karachi
Kuala Lumpur Madrid Melbourne Mexico City Nairobi
New Delhi Shanghai Taipei Toronto

With offices in
Argentina Austria Brazil Chile Czech Republic France Greece
Guatemala Hungary Italy Japan Poland Portugal Singapore
South Korea Switzerland Thailand Turkey Ukraine Vietnam

Published by Oxford University Press, Inc.
198 Madison Avenue, New York, New York 10016

www.oup.com

First issued as an Oxford University Press paperback, 2008

Oxford is a registered trademark of Oxford University Press

Library of Congress Cataloging-in-Publication Data

Viladesau, Richard.
The beauty of the cross: the passion of Christ in theology and the arts,
from the catacombs to the eve of the Renaissance / Richard Viladesau.
 p. cm.
Includes index.
ISBN 978-0-19-518811-0; 978-0-19-536711-9 (pbk.)
1. Crosses. 2. Crosses in art. 3. Christian art and symbolism.
4. Jesus Christ—Passion. I. Title.
BV160.V55 2005
246'.558—dc22 2005008224

9 8 7 6 5 4 3 2 1

Printed in the United States of America
on acid-free paper

To the new generation of my family

Jack Alden Truett
Julia Christine and Caroline Rose Lowe
Michael Ivan and Dominic Marino
Griffin Walsh
Vivienne and Grant Geyerhahn

Preface

This volume represents the first part of a study of the concept and the symbol of the cross in Christian theology and imagination. Each of the chapters will examine the theology of the cross in both its conceptual and aesthetic mediations within a specific historical context, from the early church to the eve of the Renaissance.

The first chapter is methodological. After explaining the notion of aesthetic theology and its relationship to theoretical, conceptual theology, it sets forth the specific problem to be examined here: the Christian perception of "the cross"—that is, the suffering and death of Jesus—as a salvific event. Finally, it deals with the ideas of paradigms, styles, and classics that will guide the progress of the book's exposition.

The following chapters attempt to correlate theological paradigms of interpretation of the cross—that is, a particular aspect of Christian soteriology—with artistic styles that were more or less contemporaneous with the theological ideas of each paradigm, or that illustrate a parallel theological attitude.

Each chapter begins with a representation of the crucifix that in some way exemplifies the focus of the chapter. There follows an examination of themes from representative theological writings on soteriology and a consideration of artistic developments that are to some extent parallel, or that can be seen to embody similar themes and reactions to the cross. The general method, then, is one of correlation between two kinds of interpretation of the Christian tradition and of human experience: between theology as explicit systematic thought and as affective and communicative images. The justifica-

tion and general principles of a method that takes the aesthetic realm as a theological locus have been expressed in my previous works,[1] and here will only be briefly summarized.

Within the aesthetic realm, this volume will emphasize especially visual and poetic art, both liturgical and nonliturgical. Poetry (including especially the texts of hymns) often provides a clear but also imaginative and affective expression of theological ideas. Visual images of the passion can also be correlated to general theological themes; but, as we shall see, their connection to more particular theories of salvation is often ambiguous. The illustrations will allow us to look closely at several classical works that are representative of larger movements in art. Other visual artworks referred to in the text unfortunately cannot be reproduced here; but in an appendix I refer the reader to various Web sites where they may be viewed.

This book is intended for a general audience: educated lay people, students, artists who wonder about theology, theologians who have little knowledge of the arts. But I hope it may also to be of use to scholars who wish to pursue the topic further. Hence I have included footnotes not only to indicate my sources and occasionally to suggest further lines of thought but also to provide a number of significant theological quotations in their original language.

Finally, it should be noted that my ultimate project is one of systematic theology. This book is not intended as a text in historical theology, per se, nor, a fortiori, as art history. It is rather an exploration of historical themes, ideas, and images that are the necessary background to a contemporary theology of the cross. I have therefore not pursued in detail many questions of dating, influence, and context that would be important to the historian. On such topics, this book needs the complement of more detailed studies by specialists. On the other hand, this volume remains within the realm of exposition of historical data, and within a limited period. A projected future volume will extend this study from the Renaissance to the contemporary era, and will undertake the further task of correlation of these historical data with contemporary intepretations of Christian experience.

I wish to express my gratitude to those who made this book possible: especially to Andrew Jacobs, who provided invaluable aid in the preparation of the final text, and to Cynthia Read of Oxford University Press, who guided it to publication.

Contents

The Beauty of the Cross

I

The Beauty and the Scandal
of the Cross

The Notion of Aesthetic Theology

In one episode in his popular series of naval-historical novels, Pat-
rick O'Brian portrays his hero Dr. Maturin at a concert, where he
suddenly becomes aware of the scent of the perfume worn by the
woman he loves. He reflects to himself:

> "A foolish German had said that man thought in words. It
> was totally false; a pernicious doctrine; the thought flashed
> into being in a hundred simultaneous forms, with a thou-
> sand associations, and the speaking mind selected one,
> forming it grossly into the inadequate symbols of words, in-
> adequate because common to disparate situations—admit-
> ted to be inadequate for vast regions of expression, since for
> them there were the parallel languages of music and paint-
> ing. Words were not called for in many or indeed most
> forms of thought: Mozart certainly thought in terms of mu-
> sic. He himself at this moment was thinking in terms of
> scent."[1]

Contemporary neurological studies confirm Maturin's insight:
thought takes place in many symbolic forms besides the verbal/con-
ceptual; and even within the latter, imagination and feeling have a
much stronger place than a purely "rationalist" epistemology could
fathom.[2]

In line with this insight, contemporary scholarship recognizes
that art and music are themselves ways of thinking and communi-

cating, with a complex relationship to verbal/conceptual thought. At one extreme, they may be independent, and convey their own kind of message, one that is untranslatable into words (as O'Brian recognizes via his character). On the other hand, they may serve a complementary role to words and concepts: expressing ideas, illustrating them, extending their reach into the realm of affect and desire, sometimes adding to ideas another meaning that has an ambiguous relationship with their purely conceptual content.[3] It is this ambiguous relationship that gives shape to the present volume. It is my purpose to explore the realms of both theoretical/conceptual theology and what I call "aesthetic theology" in order to explore the various relations that they have to each other, to the gospel message, and to existential faith.

The role of artistic expression has always been especially great in Christianity. Alongside its Scriptures and its conceptual theology, Christianity has always had an "aesthetic" theology: an understanding of faith that is reflective, but whose reflection is embodied in artistic modes of thinking and communicating. This mode of theology is exercised first of all in liturgy and preaching. There its relationship to word and to concept is fairly straightforward. Liturgy uses symbolic acts, gestures, and language that are the subject of explicit reflection and commentary in the conceptual discipline of sacramental theology. Preaching uses the art of rhetoric to produce appreciation and appropriation of the Christian message in both its Scriptural and its doctrinal embodiments, including conceptual theology. But aesthetic theology is exercised also in architecture, art, poetry, and music; and in these areas, the relation to message and to conceptual thinking is much more complex and varied. Moreover, for the average Christian these forms of aesthetic theology are arguably the most common medium for receiving the faith, for understanding it, and for reflecting on it, for contemplating its content, and for appropriating it on a personal level.

Perhaps surprisingly—or perhaps not, since we frequently fail to reflect on things that we most take for granted—in Western theology before the modern period the place of art and the arts in faith has been comparatively little commented on. Even in Eastern Christianity, where the iconoclast controversy provided a certain amount of reflection on the theological idea of "image," there was little theological reflection on the actual practice of religious pictorial art precisely as art. The Byzantine theological approach to the icon was quasi-sacramental; only with medieval developments (which we shall consider later) did art as such become significant. In the West, the function of sacred representative art was conceived primarily as narrative: art provides a pictorial transmission of words for those who could not read.

In the Western Middle Ages we do find some indications of an understanding of the arts as distinct modes of understanding, communication, and reflection. For example, Aquinas quotes Augustine's statement that "all the affections of our soul, by their own diversity, have their proper measures [modos]

in voice and song, and are stimulated by I know not what secret correspon-
dence" (*Confessions*, bk. 10). He goes beyond Augustine in opining that singing
has a valid place in worship even when the words cannot be understood (as
was beginning to be the case with the polyphony of the Notre Dame school
during his time), because music can embody an "intention" toward God apart
from the words (*S.T.* 2 2, q. 91, art. 2, ad 5; see also 2 2, q. 83, a. 13, c.).

While music was considered one of the liberal arts (because of its math-
ematical nature) and was thought to be an earthly echo of the intelligible "mu-
sic of the spheres," the pictorial arts were relegated to the status of servile
crafts. Even in the West, their usefulness or appropriateness in the church was
sometimes challenged, although never with the vehemence of the Eastern icon-
oclasts. But despite the near ubiquity of sculpture and painting in the Western
church, and despite the significant theology of beauty that we find in the Scho-
lastics, there is little that would qualify as a "theological aesthetics" dealing
with the pictorial arts.

Nevertheless, we find some comments on their importance. One of the
most significant comes from the quill of William (Guillaume or Guglielmus)
Durand (Durandus or Durantis), nicknamed in Latin "Speculator" ("reflector,"
from his book *Speculum Judiciale*, the "mirror of law"). Born in about 1230,
William survived nearly to the end of the century (1296) and lived an adven-
turous and productive life as a canon lawyer, advisor to several popes, bishop,
administrator of the Papal States, and (in this last capacity) warrior. He also
found time to write, and his *Rationale Divinorum Officium* is one of our two
major sources for information on the Western liturgy of the Middle Ages. It is
in this work that William gives the rationale for the use of art in the church.
He begins by repeating the standard Western defense of the use of images,
current since the time of the iconoclast controversy, and repeated ever since
then: "Pictures and ornaments in churches are the lessons and the scriptures
of the laity." He then quotes Gregory the Great, the authority for this idea: "For
what writing supplies to the person who can read, that does a picture supply
to the one who is unlearned, and can only look. Because they who are unin-
structed thus can see what they ought to follow: and *things* are read though
letters are unknown." But even while appealing to the authority of Gregory,
Durand actually goes far beyond him in what follows:

> The Agathensian Creed forbids pictures in churches: and also that
> that which is worshipped and adored should be painted on the
> walls. But Gregory says that pictures are not to be done away with
> because they are not to be worshipped: for paintings appear to move
> the mind more than descriptions; for deeds are placed before the
> eyes in paintings, and so appear to be actually going on. But in
> description, the deed is done as it were by hearsay: which affects
> the mind less when recalled to memory. Hence also it is that in

churches we pay less reverence to books than to images and pictures.[4]

Note that Durand himself was a literate and educated person, not one of the illiterates for whom Gregory thought pictures were intended. His rationale for pictures actually goes far beyond Gregory's, as Aquinas goes beyond Augustine on music. Both medieval authors quote the great Fathers as authorities, but then go on to imply a theory of art that in some ways contrasts with that of the Patristic era.

Durand tells us that pictures are *more effective* at presenting the message than verbal descriptions are, precisely because they are pictures. It is notable that he stresses the practical educative function of paintings: the message is not merely to be proclaimed but imitated, and pictures give a better example to imitate than words can do. It is perhaps not too much of a stretch to say that his position anticipates the arguments of "virtue ethics" on the need for examples of virtue rather than mere conceptual formulations. As we shall see, in the later Middle Ages a similar attitude inspired spiritual writers to provide explicit instruction on the use of images—both mental and physical—for meditation and contemplation—although still generally without much reflection on the nature of images or of art.

Despite this lack of reflection, the actual place of the arts in the life of faith seems to have been enormous. Philosopher and novelist Iris Murdoch goes so far as to remark that some of the great Christian doctrines "have become so celebrated and beautified in great pictures that it almost seems as if the painters were the final authorities on the matter, as Plato said that the poets seemed to be about the Greek gods."[5]

Theoretical and Aesthetic Mediations of Theology

Contemporary academic theology has begun increasingly to recognize the importance of this more primary aesthetic theology both as a source of the faith tradition and as a parallel reflection on it: one that is most frequently formed by the church's dogmatic theology, but that is sometimes in tension with it.[6] Hence in each period of the history of the church, we may speak of its theology existing in both conceptual/theoretical and aesthetic "mediations."

A technical epistemological note is needed here. By using the term "mediations" I do not mean to imply that either concepts or artistic symbols are simply the means of representing some prior message that exists apart from them—although they may sometimes also have this function, for example with regard to scripture or dogma. One might indeed speak, in contemporary language, of theoretical and aesthetic "constructs." Equally, one might refer to these as different "languages" or "language games," in the sense that Wittgen-

stein gave to that term. What is "mediated" primarily by such constructs is meaning: specifically, meaning deriving from the immediacy of God's self-revelation. Hence this is not a mediation of something "else" that preexists it, but precisely of the act of insight. I am using the term "mediation," therefore, in the sense of a "mediated immediacy": the symbolic embodiment of human encounter with reality. Specifically, in the theological context, what is mediated is our relationship to God and to the world, the self, and others in the perspective of God. I have discussed the theoretical basis for this notion elsewhere,[7] and it must here be presupposed. On the other hand, I believe that the contents of this study stand independent of the epistemology and theology of revelation that I espouse. If the reader prefers to think simply of the theoretical and the aesthetic "modes" of theology, the argument of this book is unaffected.

It will be my purpose to exemplify such aesthetic theology with regard to a central object of Christian faith: the passion of Jesus, symbolized and epitomized by his death on the cross. I will attempt to show how various artistic portrayals of the passion and reflections on it embody distinct theological perspectives on its meaning for salvation, and evoke different responses. At the same time, I will present the parallel story of the development of the conceptual theology of the cross: that is, the question of soteriology, specifically as it relates to Jesus' self-offering. We will examine how the classic theology of the church explained the place of Jesus' suffering in human redemption. And we will ask whether, to what extent, and how the artistic portrayals of the cross relate to the conceptual theology.

The Scandal of the Cross

There are several reasons why this theme is particularly suitable for the study of aesthetic theology and its relationship to living religion and to conceptual theology. From its earliest times, Christianity was distinguished as being *religio crucis*—the religion of the cross.[8] The cross has always been its most obvious and universal symbol; and in the contemporary world, we are once again reminded that it is the cross and its meaning that set Christianity apart from other world religions.

St. Paul speaks of Christ crucified as "a stumbling block to the Jews, and foolishness to the Gentiles" (1 Cor. 1:23). In the contemporary situation of encounter of the world religions, the cross, having become familiar and comforting to Christians, is once again revealed in its scandalous and shocking nature. In my freshman class, Christian students were surprised to learn of the reverence with which Muslims think of Jesus; and even more surprised that most Muslims teach that Jesus was not crucified. I asked a Muslim student to explain this to the class. She replied immediately: it is inconceivable that

God should allow His prophet and Messiah to suffer such a death; rather, God took Jesus to Himself (See Qur'an 4, 157–158).[9] Another Muslim student commented that while he was very affected by the portrayal of human suffering in Mel Gibson's film on the passion, he obviously could not believe that any of this had happened to the Christ: it had happened to someone else, or it was an illusion produced by God.

The cross also scandalizes Hindus and Buddhists. The Zen master and author D. T. Suzuki wrote:

> Christian symbolism has much to do with the suffering of man. The crucifixion is the climax of all suffering. Buddhists also speak much about suffering, and its climax is the Buddha serenely sitting under the Boddhi tree by the river Naranja. Christ carries his suffering to the end of his earthly life, whereas Buddha puts an end to it while living and afterward goes on preaching the gospel of enlightenment until he quietly passes away under the twin Sala trees. . . . Christ hangs helpless, full of sadness on the vertically erected cross. To the oriental mind, the sight is almost unbearable. . . . The crucified Christ is a terrible sight.[10]

As a symbol of salvation, the cross has not lost its offensive character to those outside the Christian tradition. Indeed, the broken figure of Christ to many represents the opposite of salvation. Indian saints are seated on the ground, in connection with Mother Earth, in control of the physical and spiritual worlds, having conquered pain and illusion.[11] For Sunni Muslims, God's prophets are blessed and triumphant: they have achieved God's peace (*salaam*) in their total submission (*Islam*) to God.[12] For many Jews, the cross is the offensive symbol of a history of persecution, based on the accusation of deicide. And for many post-Christians in our secular culture, the cross symbolizes above all the burden of guilt-feelings and the masochism that Christianity has sometimes imposed on people. (See for example the 1996 crucifixion collage by contemporary artist Tammy Anderson. On a brown background covered with Scriptural passages stands a black cross. At the intersection of the arms is the face of an agonized crying boy. Surrounding it on four sides is the snarling face of a figure in a clerical collar, holding a Bible. The artist describes the work: "Overwhelmed with guilt and fear, a mind-numbing repetition of screaming angry faces and Biblical verses echo before the young boy and flood the canvas . . . religion as seen through the eyes of a child.")

It would seem that it is once more important for Christians to reflect theologically on this symbol and what it represents. How is the passion of Christ salvific? How does it reflect the "wisdom and power of God"(1 Cor. 1:24)?

The Beauty of the Cross

Such questions become all the more pressing and intriguing when we look at them in the light of aesthetic theology. In one of its meanings, aesthetics concerns beauty. The arts as means of communication do not always serve this end. But in fact, the crucifixion frequently has been portrayed in a beautiful manner; the cross is frequently a beautiful object. What is the meaning of such portrayals? Christians more or less take for granted the idea that gives the title to this book: the beauty of the cross. But should they do so? How can the cross be beautiful? Is suffering beautiful? Is a representation of suffering beautiful?

Obviously, such questions bring us to a central issue of "theological aesthetics." What do we mean by "beauty"? How is it related to the good, to God, to ultimacy?

Clearly, when we speak of the "beauty" of the cross, we are speaking in a purposely paradoxical way. The basis of the paradox is already enunciated in the New Testament. St. Paul famously summarizes and expands on the paradox of the cross in the celebrated verse from 1 Corinthians cited in part earlier:

> But we preach Christ crucified: to the Jews, a stumbling block, and
> to the Gentiles, foolishness; but to those called, Jews and Greeks,
> Christ is God's power (δύναμιν) and God's wisdom (σοφίαν); for
> God's foolishness (το μωρὸν) is wiser than humans, and God's
> weakness (το ἀσθενὲς) is stronger than humans. (1 Cor. 1:23).[13]

And, by extension, presumably God's ugliness is more beautiful than human beauty.

To speak of the beauty of the cross, then, is to speak of a "converted" sense of beauty. The cross challenges us to rethink and to expand our notion of the beauty of God, and indeed of "beauty" itself. Barth and Balthasar both insist strongly on this point. The Christian notion of beauty—and specifically of the divine beauty—must be able to include even the cross, "and everything else which a worldly aesthetics . . . discards as no longer bearable."[14] The cross gives a new sense to Rilke's phrase in the first Duino elegy, "beauty is nothing but the beginning of terror."[15]

From its earliest era, the church has applied to Christ in his passion the words of the fourth "Song of the Suffering Servant" from the book of Isaiah (Isa. 52:13–53:12)—thinking of them, indeed, as a direct prophecy of the passion.[16] Here we read that "there was no beauty in him to make us look at him, nor appearance that would attract us to him" (Isa. 53:2–3). As Barth says, "Jesus Christ does present this aspect of Himself, and He always presents this aspect first. It is not self-evident that even—and precisely—under this aspect he has form and comeliness, that the beauty of God shines especially under this as-

pect. . . . We cannot know this of ourselves. It can only be given to us."[17] Yet to Christian faith, it *is* given that Christ is—precisely in the cross—the supreme revelation of God's being, God's "form," "glory," and "beauty." The transcendent "beauty" and "light" of God, then, must embrace also "the abysmal darkness into which the Crucified plunges."[18] This implies that the meaning of God's "beauty" is only finally known by God's self-revelation. For Balthasar, it would be a misunderstanding of the "analogy" of beauty to make it the simple projection onto God of our "worldly" experience of the beautiful and desirable. In speaking of God's being,

> we must be careful not to start from any preconceived ideas, especially in this case a preconceived idea of the beautiful. Augustine was quite right when he said of the beautiful: *Non ideo pulchra sunt, quia delectant, sed ideo delectant, quia pulchra sunt* ["Thing are not beautiful because they give pleasure: but they give such pleasure because they are beautiful"] (*De vera rel.*, 32, 59). What is beautiful produces pleasure. *Pulchra sunt, quae visa placent* ["The beautiful is that which, when perceived, gives pleasure"] (Thomas Aquinas, *S. T.* 1, q. 5, art. 4, ad 1). Yet it is not beautiful because it arouses pleasure. Because it is beautiful, it arouses pleasure. In our context Augustine's statement is to be expanded into: *Non ideo Deus Deus, quia pulcher est, sed ideo pulcher, quia Deus est* ["God is not God, because God is beautiful; rather, God is beautiful because God is God"]. God is not beautiful in the sense that He shares in an idea of beauty superior to Him, so that to know it is to know Him as God. On the contrary, it is as He is God that He is also beautiful, so that He is the basis and standard of everything that is beautiful and all ideas of the beautiful. . . . [The Divine being] as such is beautiful. We have to learn from it what beauty is. Our creaturely conceptions of the beautiful, formed from what has been created, may rediscover or fail to rediscover themselves in it. If they do rediscover themselves in it, it will be with an absolutely unique application, to the extent that now, subsequently as it were, they have also to describe His being.[19]

It is in exactly this "converted" sense that the Fathers—especially Augustine—speak of the beauty of the cross, in full consciousness of its ugliness. They frequently contrast quotations from the Old Testament that they took to be direct prophecies of Christ: on the one hand the passage from Isaiah— "there was in him no beauty or comeliness" (in the Latin of the Vulgate, *non erat ei species neque decor*) (Isa. 53:2)—and on the other the verse from Psalm 44, in which David (as they thought) refers to Christ as "beautiful beyond all the sons of men" (*speciosus pre filiis hominum*), sometimes in conjunction with the verse from the *Song of Songs*, "behold, you are beautiful, my beloved" (*ecce tu pulcher es dilecte mi*) (*Song of Songs*, 1).[20]

Augustine, for example, comments: "to us who can discern he is every-
where beautiful: beautiful in the hands of his parents, beautiful in his miracles,
beautiful in his flagellation, beautiful giving up his spirit, beautiful carrying
the cross [pulcher in patibulo], beautiful on the cross [pulcher in ligno], beautiful
in heaven."[21] Crucial, of course, is the phrase "to us who can discern" (nobis
cernentibus): Christ's beauty is not apparent except to those who know how to
discern spiritual beauty. That beauty consists above all in goodness or justice,
which we are called to imitate, and thus become similarly beautiful. Augustine
is very explicit in his commentary on 1 John:

> Our soul, my brethren, is ugly because of sin: by loving God, it be-
> comes beautiful. What kind of love is it that make the lover beauti-
> ful? God is always beautiful, never deformed, never changeable.
> God, who is ever beautiful, loved us first; and how did God love us,
> if not as ugly and deformed? Not in order to send us away because
> we were ugly, but rather in order to transform us, to make us beau-
> tiful out of our deformity. How shall we be beautiful? By loving the
> One who is always beautiful. The more love grows in you, the more
> beauty grows: for love itself is the beauty of the soul. . . . And how
> do we find Jesus beautiful? 'Beautiful in form beyond the sons of
> men, grace has been poured out upon your lips (Ps. 44:3)' . . . By
> taking flesh, he took on your ugliness, as it were: that is, your mor-
> tality, so that he might adapt himself to you, be like you, and incite
> you to the love of interior beauty. Then how do we find Jesus ugly
> and deformed, since we find him beautiful and lovely beyond the
> sons of men? Ask Isaiah: "And we saw him, and there was no
> beauty or comeliness in him" (Isai. 53:2). These are like two flutes
> playing different melodies; but it is one breath [spiritus] that blows
> both flutes. . . . Both flutes are played by the same spirit: they are not
> dissonant. . . . Let us ask Paul the Apostle, and he will explain to us
> the harmony of the two flutes. The music plays, "Beautiful in form
> beyond the sons of men: he who, since he was in the form of God,
> did not think it robbery to be equal to God." There is "beautiful in
> form beyond the sons of men." But the music also plays, "We saw
> him, and he had no beauty or comeliness: He emptied himself, tak-
> ing on the form of a slave, coming to be in human likeness, and
> behaving as a human" (Phil. 2, 6, 7). "He had no beauty or comeli-
> ness," so that he might give you beauty and comeliness. What
> beauty? What comeliness? The love of charity: so that caring you
> might love, and loving you might care. You are already beautiful: but
> do not depend on yourself, lest you lose what you have received; de-
> pend upon the one who made you beautiful. . . . "Let us love one an-
> other, because God loved us first."[22]

Augustine stresses inner beauty, what we might call the "moral beauty" of Christ, the beauty of God's incarnation for human salvation, a beauty that shines out even—and indeed, especially—in the cross. St. Jerome puts it succinctly: "What could be more beautiful than that the form of a slave should become the form of God?"[23] The beauty is that of the divine love abasing itself to raise up humanity, and the cross is its ultimate (but not unique) expression. This allows us to make a distinction and a contrast: the crucifixion as murder was ugly; as martyrdom it was beautiful. Physically it was ugly; spiritually—in its meaning, self-sacrifice for others—it was beautiful. What happened to Christ was ugly and horrid; his willingness to undergo it was beautiful. The emphasis is on the divine compassion, and on Jesus' free acceptance of his death.

But there are theologies of the cross that go farther: not only Jesus' self-sacrifice was beautiful, but the fact of its happening was beautiful, because necessary. Even the evil of the crucifixion is in some way taken up into the beauty of the divine plan. We shall see that this idea is taken up in theology in a number of ways, including St. Anselm's famous "satisfaction theory" of salvation. The examination of the place of the cross in various models of soteriology will be the primary concern of the theoretical/conceptual theologies examined in this book.

The second and parallel concern deals with theology as expressed in art: in aesthetics as another way of thinking. Some of that art is verbal. It can express the paradox of the cross by directly evoking mental images, associations, and thoughts about a transcendent message. Words have the peculiar power of being able to negate the limits of their own finite form. But we will also be concerned with visual art. How does one *show* this paradox? Augustine and others have given us a verbal theology of the cross and of the beauty of the cross. But how does one *portray* it? How does one visually show the beauty of what is apparently ugly and horrid? Can visual art portray and even evoke the conversion of feeling demanded by the cross? How is visual message connected with theoretical theological message?

Paradigms, Styles, and Classics in Theology

As will become apparent in this study, religious art and theological concept are partially parallel and partially incommensurable languages: they sometimes intersect and influence and translate each other, they sometimes develop independently, and they sometimes have different concerns altogether. The relationship is complex, both historically and theoretically. As Alain Besançon remarks, it is not easy to analyze the relation between great thinkers and art.

> One might imagine that they concentrate the spirit of their times in themselves . . . or that they give us a key to understand what was go-

ing on around them; or, on the other hand, that their thought influ-
ences artists indirectly, through the mediation of more or less infe-
rior and distant disciples.[24]

One might say the same about the influence of artists on thought. It would
be nice if things fit systematically: St. Anselm "invents" the satisfaction theory,
and artists start portraying the suffering Christ on the cross. But in fact it was
not so simple: the humanistic and suffering portrayal of the crucifixion pre-
dates Anselm—whose theory in any case was neither completely original nor
universally accepted for a long time. Similarly with the influence of St. Francis
and Franciscans: as we shall see, here there was a very definite influence on
art. But it was not exclusive or inventive: there was an inheritance from By-
zantium that was partially absorbed and partially transformed.

Moreover, we must remember that even religious art has nearly always
served other goals than simply being a medium for a message or serving re-
ligious devotion. Art may convey a message, or it may strive for beauty, or it
may be decorative—or all of these. Furthermore, religious art and the varia-
tions in its styles depend on factors other than its content. The arts have their
separate lives, in which patrons, consumers, locations, talent (or the lack of it),
tradition, materials, techniques, and so on, all play an important role, quite
apart from the message that religious art, at least ostensibly, serves. (Indeed,
it is possible—and has until recently been quite common—to study the history
of religious art with virtually no attention to its religious content.)

We will be dealing, then, with two distinct but overlapping forms or me-
diations of theology. Within each, there are further complexities. There are
different kinds of verbal language: imaginative, transcendent, abstract; and
each of these can play a part within the kind of theology that I am characterizing
as "conceptual." There are different arts, and each art has its own relationships
to the different realms of words.

To deal with this subject adequately and in detail would require many
volumes of careful studies of individual theologians and artworks. That is ob-
viously beyond the scope of this small book. My purpose is more modest. I
hope to compare various "paradigms" of soteriology with each other and with
various styles of artistic presentation of the cross, appealing to "classic" pres-
entations in conceptual and aesthetic theology.

I have dealt elsewhere with the notions of theological paradigms and the
partially parallel movements of artistic styles through Western history.[25] A brief
summary must suffice here to clarify the presuppositions of my method.

I use the notion of "paradigms" in the sense that the term has been adapted
to theology by various theologians from its original use in Thomas Kuhn's
celebrated thesis on scientific revolutions.[26] Hans Küng, for example, adopts
Kuhn's definition of a paradigm as "an entire constellation of beliefs, values,
techniques, and so on shared by members of a given community."[27] A para-

digm in this sense designates fundamental ways of thinking that are common within an era, despite differences of theory on particular subjects. As C. S. Lewis remarks in his essay "On the Reading of Old Books":

> Every age has its own outlook. . . . Nothing strikes me more when I read the controversies of past ages than the fact that both sides were usually assuming without question a good deal which we should now absolutely deny. They thought that they were as completely opposed as two sides could be, but in fact they were all the time secretly united—united *with* each other and *against* earlier and later ages—by a great mass of common assumptions.[28]

So, for example, St. Thomas and St. Bonaventure both exemplify the high Scholastic medieval paradigm in theology, although each was the founder of a different "school" of thinking. They were nevertheless united in many presuppositions, methods, and questions that differed from those of the apocalyptic paradigm of the early church or the Hellenistic paradigm of the early Fathers, and from those of their successors and disciples in later ages. At the same time, within each large paradigm there are subparadigms, or "microparadigms," as Küng calls them, consisting of different schools of thought, language groupings, and so on. And there will be individuals and groups who do not "fit" within the reigning paradigm.

As the title of Thomas Kuhn's book indicates, he believed that paradigm changes in science were revolutionary, not the product of a process of growth. In other areas, however, the relationship between an older paradigm and its successor may not necessarily be so simple. In some cases, a new model may simply replace the old, as Kuhn's thesis holds. But even in this case, as Küng suggests, there is frequently more continuity than might immediately be apparent. On the other hand, in areas other than the positive sciences, the new paradigm may not always been seen as superior. It may sometimes be absorbed into the old, or in some way combined with it.[29] Or the new model may be resisted, and the problems that call for its adoption may be "shelved" for the moment.[30] At the limit, the new paradigm may be persecuted and destroyed. And, while in science it is normal for the new paradigm to replace the old (after the acceptance of Copernicus, a serious scientist could no longer espouse the Ptolemaic system), in other areas of culture, different paradigms may coexist in societies and even within individuals (Martin Marty said of the Roman Catholic church that it is papal in theory, episcopal in organization, and presbyterian in practice). Hence in theology we find that paradigms overlap and sometimes coexist with each other within the same period—just as artistic styles sometimes do.

Küng names six great Christian theological paradigms, of which three are relevant to this work.[31] (1) The first century was dominated by an apocalyptic paradigm inherited by Jewish Christianity from the worldview of late Judaism.

The reigning theological framework was the imminent arrival of the eschaton: the "last times," to be brought about by divine intervention, with the coming of Christ as judge of the world. (2) With the delay of the eschaton and the entry of the Gentiles into the church, apocalypticism quickly gave way to the Hellenistic paradigm of the early Greek and Latin Fathers. Greek philosophy—especially Stoicism and Platonism—provided a model for theological thinking. This Patristic paradigm provides the primary theoretical basis for Orthodox thought. (3) Through the mediation of Augustine, by the eleventh century there emerged in the West the medieval Catholic paradigm, centered on Scholasticism and the papal organization of the church.

Of course, as has already been said, each of these paradigms can be subdivided. There are differences in the Patristic period between Latin and Greek writers, between city and countryside. There are minority voices like the Syrians and Armenians. There are theological differences on what constitutes orthodox doctrine. Within the Western medieval paradigm there are significant differences between the "high" and the "late" Middle Ages, between monastic and university theology, between Thomists and Scotists, between academic and pastoral genres of writing. And, of course, as Wittgenstein stressed in his early writings, there is an inevitable and irreducible difference between a "language" or cultural system conceived in the abstract and its actual reception and use by any particular community or individual.[32] Nevertheless, we may recognize there are large patterns of similar theoretical, technical, and cultural-linguistic formation: the intellectual and spiritual "environment," which, like the physical environment, can be more or less constant for a time, and can change from era to era.

It has long been noted that the arts also have undergone something like "paradigm shifts." Indeed, the study of "periods" and "movements" is commonplace in art history, alongside the study of individual artists and their schools. The parallels between these shifts in style and changes in other aspects of culture have also been the subject of reflection and comment. In Hegel's lectures on aesthetics, art is seen (along with religion and philosophy) as one of the three major forms of the self-development of Spirit, and the primary example of the history of changing worldviews.[33] Without Hegel's idealistic framework, but following a similar insight, twentieth-century philosopher José Ortega y Gasset analyzed the stylistic changes in Western art as progressive shifts in "point of view," and noted a series of parallel shifts in Western philosophy.[34] Paul Tillich, while not explicitly pursuing the question of shifts in style, made explicit connections between certain modes of representing the sacred and certain "types" of religion.[35]

In this study, I will present the aesthetic mediation of theology within the framework of "styles" of art that arose and flourished during periods that can be seen as roughly chronologically parallel to corresponding paradigms in conceptual theology. In a very general way, and not surprisingly, the arts and con-

ceptual theology followed similar paths: academic theology moved from the Patristic to the monastic to the university context; Christian art moved from house churches and cemeteries to monasteries, to cathedrals, aristocratic and royal courts, friaries, and cities.

This volume deals with the conceptual theology and the arts in Christianity up to the eve of the Reformation and the Renaissance. We are dealing with the arts, then, as Hans Belting puts it, before the age of "art": that is, before art existed "for its own sake."[36] Religious pictorial art in particular was seen as a means of reflection and narration; but above all, it was mediation of divine presence. In the Eastern theology of the icon, this was explicit: the icon is a "window" to the transcendent world; it has a quasi-sacramental function, both within and outside the liturgy. The West emphasized the narrative function of pictures. But here also they mediate presence, albeit more indirectly. In both cases, a theological message is explicitly or implicitly present. In Western art, the stylized conventions that controlled sacred art and defined its purpose in the Byzantine icon were sooner or later abandoned in favor of indigenous styles, and finally in favor of naturalism. In the West, then, the artistic function of mediation both of the sacred itself and of the theological reflection on the sacred must be placed in the context of other conditioning factors. Nevertheless, even these "extrinsic" factors may still be the means of conveying a theological message, even if it is implicit and beyond the intent of the artist.

For example: the smile of the Gothic Christ, the Virgin, and the saints reflects the stereotyped emotions and expressions of courtly manner, as does the graceful "Gothic curve" in posture. Sometimes, in particular works of art, it may "mean" no more than the following of a style, the unconscious acceptance of a period's standards of beauty. Yet this does not exclude but rather necessitates the further question of what it is in this style or manner that lent itself to a religious treatment. What "theology" is implicit in the courtly smile of the Virgin, in the gracious pose, particularly when they are explicitly combined, as they frequently are, with allusions to the passion? Even incongruity would be significant; but if there is a congruence, it is even more meaningful.

I will not be concerned here with the mechanisms of the developments or the changes in style, nor with the many national and local differences within the general styles of particular periods—these are subjects for the art historian whose competence far exceeds mine. Nor is my purpose a history of theology, per se. My interest here is in the correspondences and differences between the conceptual and aesthetic mediations of theology. These are exemplified by systems of thought, ideas, and intentionalities, as they are variously embodied in concepts, words, and images. The primary focus is on types or paradigms and styles, rather than on the close examination of either individual thinkers and artists or their historical periods.

Obviously, even an examination of general paradigms involves a good deal of historical contextualization. But much more could be said about the social/

economic/political/psychological conditioning and situation of both the arts and theology than is undertaken here. Hence this work makes no pretense at giving a complete picture from either a historical or an aesthetic point of view. On the contrary, its theological interest cries out for more detailed study of the historical and aesthetic issues that it touches on. This is perhaps especially true regarding the history of visual art. My brief expositions call out for more detailed examination not only of individual works but also of the variations in development in the various media (miniatures, painted crosses, sculpture, fresco) and of the differences between and within national and local styles. But reasons of space and competence restrict this volume to a particular and limited kind of theological aesthetics.

For this reason, the focus will be on certain "classics" of the Western theological tradition: works of written theology and of art that, in David Tracy's words, "involve a claim to truth as the event of a disclosure-concealment of the whole of reality *by the power of the whole*—as, in some sense, a radical and finally gracious mystery" and that have proven themselves to have a lasting power to challenge people to encounter the truth they disclose.[37]

Following Frank Burch Brown, I have expanded the notion of a "classic" to apply not only to specific works but also to the larger ways of thinking and feeling that they represent. Hence not every theological text that I will refer to is itself a great work; it is the schools of thinking that they represent that are Christian classics. Likewise, in the field of art, although I will begin each chapter with the consideration of a particular artwork that is in some way illustrative of its period, the primary classics I will consider are *styles*. The Romanesque and the Gothic and other general forms of art were invented in a Christian context and for the sake of expressing spiritual ideas and feelings. "Thus in a sense the Gothic style itself is as much a classic as is Rheims or Chartres or York Minster; for these Gothic churches are far more similar than they are different in artistic and religious meaning and effect."[38] It is the styles themselves that are the "classics."

Obviously, a certain engagement of subjectivity is demanded by this notion of the "classic": it is not just what is written but how it is understood; not merely what is painted but also what the viewer brings to the painting that allows it to disclose reality. Presentation and reception together form a kind of exemplar of a paradigm: a way of looking at things, a "classic" of lived Christian theology. At the same time, such classic styles are embodied in individual works, which may themselves also be artistic classics in their own right, and even apart from their theological significance. But it is the latter that will primarily engage our attention in the examples that follow.

Each of the following chapters of this study will examine the theology of the cross in both its conceptual and aesthetic mediations. The individual chapters attempt to correlate theological paradigms with artistic styles that were more or less contemporaneous or that were consciously derived from the the-

ological ideas of each paradigm. I have permitted a certain chronological lati-
tude in the choice of examples, even though the chapters correspond to suc-
cessive historical periods. The history of religious art, as has already been
noted, does not always neatly correspond with the history of ideas. Moreover,
as Küng observes, a paradigm in theology—or a style in art—is not necessarily
simply replaced when a new period opens; frequently it remains and expands
or deepens alongside the later development. Therefore, for example, I have
taken the Byzantine liturgy as an example of the Patristic paradigm. For even
though that liturgy developed over centuries, it remained—and remains—true
to its Patristic sources and inspiration.

2

The Cross in the New Testament and the Patristic Paradigm

The Graffito of Alexamenos

In an unfrequented corner of the Palatine museum in Rome there is a collection of ancient graffiti. Most visitors give them no more than a glance before passing on to the more attractive statues and artifacts. Roughly etched on slabs of marble, these inscriptions once defaced the walls of the imperial palaces that stood on the spot. Among them is one from the residence of the imperial pages called the graffito of Alexamenos.[1] It consists of a very roughly drawn image and a few words of Greek. In style and appearance it has nothing to distinguish it from the many other similar pieces of graffiti that abound in Roman museums; but for the Christian it has a particular significance. The rough incision shows a crucified man with the head of an ass. Next to him is a smaller figure with an arm extended in his direction. Nearby are the crudely carved words ΑΛΕΞΑΜΕΝΟC CEBETE ΘΕΟΝ, "Alexamenos worships [his] God." It is the earliest known pictorial representation of the crucifixion of Christ and of his adoration as divine. In a city so full of the triumphant monuments of Christianity, there is something strangely moving in finding this first visual testimony to the Christian faith amidst the fragments of daily life of pagan Rome; and even more so in finding it in this rude sketch, probably drawn by a palace page with cruel schoolboy humor to mock the faith of a fellow slave.

The graffito reminds us of how Christianity must have appeared to the sophisticated ancient pagan world: a strange minority religion from a small backwater of the civilized world: a religion that was

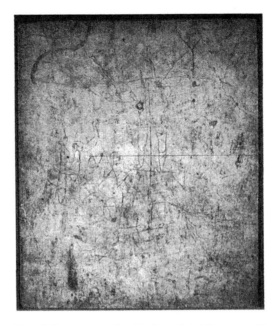

The graffito of Alexamenos. Credit: Scala / Art Resource, New York.

centered on a man punished as a criminal with the most humiliating form of execution, and a faith practiced mostly by slaves and people of the lower classes. It reflects the Roman belief that the Jews worshipped a god with the head of an ass—a notion that was apparently also carried over to Christians.[2] It also shows graphically the scandal of the cross to which St. Paul refers. For sophisticated Hellenistic society, the notion of a suffering god was ridiculous: an obviously mythological conception. For the adherents of popular religion, Jewish or gentile, the notion of a savior who was himself defeated by the powers of evil was equally absurd.

How did the cross, the symbol of degradation, an occasion for mockery, become the primary symbol of Christian faith?

The Historical Event of the Passion

Before looking at the theology of the cross, as formulated in theories of redemption and expressed in art and poetry, it would be well to have a sense of the nature of the historical events of the passion, as far as contemporary scholarship can reconstruct them.

"The passion of Christ" generally refers to the events of Jesus' last days, from the agony in the garden to the entombment. It is impossible to reconstruct a detailed historical account of all these events, especially those preceding

the crucifixion, by attempting to harmonize the accounts in the gospels. (For example: were there one or two trials before the high priests?) But there are sufficient ancient sources on the use of crucifixion as a form of capital punishment to fill out and concretize this part of the gospel narrative—even if we must be cautious, since we do not have much direct evidence on exactly how procedures were locally adapted in the varied lands under Roman rule.[3]

An undergraduate once asked me in class whether Jesus was the only person crucified by the Romans. The question itself betrays how far we are from the context of ancient world that is presumed by the gospels. The use of crucifixion as a punishment was in fact widespread. It seems to have been adopted by the Romans from the Carthaginians. The Romanized Jewish historian Flavius Josephus tells of several mass crucifixions carried out by the Romans in Judaea, one in 4 B.C. and others during the Jewish Wars that led to the destruction of Jerusalem.[4] Even the Jewish King Alexander Jannaeus (104–78 B.C.) is said to have used crucifixion as a punishment of eight hundred fellow Jews who had sided with his enemy, the King of Syria.[5]

Crucifixion was regarded as a most terrible and ignominious death. The Romans generally did not inflict it on citizens; it was a punishment for the lower classes, slaves, violent criminals, and rebels. Its cruelty was meant to serve as a deterrent. It constituted the utmost humiliation and degradation. This was true in a special way for the Jews, for according to the Law, "God's curse rests on him who hangs on a tree" (Deut. 21:23).

The hanging on the cross itself was the last part of the process of execution. It was generally preceded by torture: normally, scourging with a whip. This scourging could itself be severe enough to bring about death (note that in Luke [23:16,22] and John [19:1] Pilate intends the scourging of Jesus to substitute for his crucifixion; while in Matthew [27:26] and Mark [15:15] the scourging is performed after the sentence, as part of the execution). The crossbeam (*patibulum*) was then laid on the victim's shoulders and fastened to his arms, and he was driven, naked and again under the whip, to the place of execution. The upright beams of the crosses (*stipes*) were usually already standing at the place of execution. (We must recall, once again, that crucifixion was a fairly common punishment. It would have involved a great deal of needless work for the executioners to set the entire cross into place each time, especially if the victim was affixed to it on the ground, as is so frequently portrayed in Christian art.) The crossbeam, with the condemned already attached, was set into a groove at the top or a notch on the side of the upright beam, creating the shape either of a T or of a Latin cross.[6] The footrest (*suppedaneum*) that we so frequently see in crucifixes is not mentioned by ancient descriptions of crucifixion—but it seems possible that one is shown in the graffito of Alexamenos.[7] On the other hand, there was sometimes a peg driven into the upright as a seat (*sedile*) that the victim straddled or sat upon sidewise. This served to keep the condemned from sagging under his own weight and suffocating quickly. If the

sedile was used, the victim's feet could be left hanging, or could be nailed or bound. Crucifixion was intended to be a lengthy and painful death. Expiration finally came about from a number of causes: loss of blood, starvation, exposure, heat stroke, the predations of animals at night, as well as eventual asphyxiation. When a quicker death was desired (although this was not the usual purpose of crucifixion), the *sedile* or seat was eliminated, and the legs of the crucified could be broken to hasten death.

The gospel accounts of the crucifixion of Jesus indicate several concessions that the Romans apparently made in order not to offend local sensitivities. Among the Jews, a body could not be left on the cross overnight because of the text from Deuteronomy referred to earlier (Deut. 21:22: "and if a man has committed a crime punishable by death and he is put to death, and you hang him on a tree, his body shall not remain all night upon the tree, but you shall bury him the same day, for a hanged man is accursed by God; you shall not defile your land which the Lord your God gives you for an inheritance"). Therefore there would have been no seat on the cross, and the legs of those executed with Jesus were broken to bring about their death. Because of Jewish sensibilities, the victims were probably not totally naked as they were driven to the place of execution. We are told that Jesus was reclothed after the scourg-ing; at Golgotha, he was again stripped, possibly leaving a loincloth.[8] The use of a stupefying drink was sometimes permitted as an act of mercy to the con-demned. Because he was clothed on the way to Golgotha, Jesus would not have been nailed to the crossbeam until his arrival there. The nails would have been placed through his wrists (not through the middle of the hand, as in many paintings; an attachment through the palm would not support the weight of the body). From the need to use a reed to give him a sponge to drink from, we may surmise that Jesus' cross was higher than some. The fact that the inscrip-tion bearing the reason for execution was placed "over his head" might seem to indicate that the crossbeam was placed into the side of the upright, resulting in a Latin shaped cross; but placement of the crossbeam on top, giving a T-shaped cross, is also possible: the sagging of the body would leave room above the head for the inscription.

Theologies of the Cross in the New Testament: Theological-Aesthetic Mediation

As Gerard Sloyan points out, "Christ's suffering and death were early trans-posed into the theological key of *mythos*."[9] The gospels' accounts of the passion are already a form of "aesthetic" theology: that is, they are dramatic narratives,[10] structured to bring out theological perspectives and interpretations of the his-torical fact of Jesus' suffering. They give us not a plain description but a the-ological rereading of the facts that fills in details by reference to the fulfillment

of Old Testament prophecies (this is especially true of John's gospel) and places the events in the light of their ultimate salvific meaning.

Not surprisingly, we find different—and sometimes contrasting—theologies of the passion at work both in the gospels themselves and in the other writings of the New Testament. A dramatic example of such a contrast is found in the Roman Catholic liturgical readings for the fifth Sunday of Lent (year B in the liturgical calendar). In the gospel reading, taken from John (12:20–33), we hear that Jesus feels "troubled" in spirit; yet he will not pray to be saved from his "hour." The passion for John is the hour of Jesus' "glory": it is seen already from the perspective of the resurrection, the new life that comes from death, and Jesus enters into it knowingly and willingly. Significantly, there is no account of an "agony in the garden" in John's gospel. On the contrary, the Johannine Jesus asserts that he himself freely gives up his life, and no one takes it from him (John 10:18).

But in the second reading, from the Letter to the Hebrews (5:7–9), we are told that Jesus "offered prayers and supplications with loud cries and tears to God" (bringing to mind the Synoptic accounts of the "agony in the garden"); and that, "son though he was, he learned obedience from what he suffered." Perhaps most surprisingly, the letter continues: "when *perfected*, he became the source of eternal salvation." Hebrews not only emphasizes the negative, fearful aspect of Christ's passion but also sees it as part of a necessary process that Jesus had to undergo in order to attain perfection.

We might say that these two texts correspond to two images of Jesus—one stressing his divinity, the other his real humanity (although in their totality, both John and Hebrews contain both perspectives). They also correspond to two complementary but different theological perspectives on the cross that are found already in the New Testament. In John's gospel, as in the theology of Paul, the cross is seen above all as the expression of the salvific will of God, which Jesus freely accepts and accomplishes (as we say in eucharistic prayer: "before he was put to death, a death he freely accepted").[11] On the other hand, the reading from Hebrews evokes an earlier theology of the cross. While recognizing its salvific import, this theology emphasizes the negative character of the cross, which was felt by Jesus as suffering. This early theology is preserved in the speeches of Peter in the Acts of the Apostles: "He was delivered up by the set purpose and plan of God; you even made use of pagans to crucify and kill him. But God freed him from death's bitter pangs, and raised him up" (Acts 2:23–24); "You put to death the Author of life. But God raised him from the dead" (Acts 3:15). Here the cross is indeed a part of God's plan of salvation; yet there is a contrast. Jesus' death on the cross is the work of sinful humanity, opposing God's will; but God nevertheless triumphs, by raising Jesus. The cross is the evil work of humanity; the resurrection is God's triumphant response of victory over evil. The whole is the realization of God's "plan"; but its elements are different in relation to God.

We have here not contradictory theologies but different perspectives on the same reality. The cross and the suffering of Christ are evil, the expression and result of sin; they are not to be glorified in themselves; they are not God's will. Yet they fit into God's plan of salvation: God saves not by miraculously taking evil out of the world, or by sparing his beloved from it, but by using it. God makes good come from evil, life from death. In this sense, God is the author of the event of the cross; and in this sense (and only in this sense) the cross can be willingly accepted, and can be the symbol of salvation—even while being rejected as the symbol of sin and alienation.

The New Testament clearly conveys to us the faith assertion that salvation takes place through Jesus, and is in some way connected to his death and resurrection. However, its theology remains for the most part on what I have called the "aesthetic" level: that is, it gives us multiple images of salvation, but not a coherent explanatory theory of how salvation takes place.[12] Theologian Edward Schillebeeckx has compiled the major images. Most of these are metaphors drawn from the Jewish religion and/or from secular experience. Thus, "salvation" (itself a metaphor) is accomplished thorough divine adoption or filiation; by a re-creation or restarting of the world; by our receiving of God's Holy Spirit; by our formation in the image of the risen Christ; by entry into God's kingdom; by rescue, or our being freed from servitude and slavery; by the payment of a ransom or price (without any specification of its recipient); by reconciliation of hostile parties after a dispute; by legal "satisfaction"; by expiation, through sin-offering, as in the sacrifices of the Law; by the "bearing" or "taking away" of our sin; by legal aid before the court of God's justice; by victory over demonic powers. Other New Testament passages are descriptive of the existential experience referred to in these metaphors: salvation is achieved through our sanctification and justification; through our being formed into a new community, based on brotherly love; through the reception of a new way of experiencing; through forgiveness of sins and the freeing of our freedom; through inner renewal and the granting of (new) life.[13]

Of particular importance for its later influence was the metaphor of Christ's death as a ritual "sacrifice," like those of the Old Testament, through which the world is "redeemed" or ransomed, and our sins canceled out. This image is found especially from the letters of St. Paul and is developed by the much later Letter to the Hebrews. Christ can be seen as both the sacrificial victim and the high priest of the offering, which consists above all in his voluntary and total obedience to God. The shedding of his blood is the sign of that total obedience.[14] It is noteworthy, however, that the New Testament does not explain the "mechanics" of this means of salvation: it simply presumes the unsystematic notion of sacrifice common to the Old Testament and other ancient religions.[15] It must also be remembered that the forgiveness of (past) sins is only one aspect of the New Testament idea of salvation. It must be complemented by the even more central idea of Christ's lordship, established by his

resurrection, which makes possible our entry into the new age over which Christ presides.[16]

Theology of the Cross in the Patristic Period: Theoretical Mediation

The theology of the Patristic period elaborates on the New Testament images and expands them. The sacrifice/high priest theme is prominent: following the Letter to the Hebrews, the Fathers take for granted the idea that a pure sacrifice is needed for the forgiveness of sins, and that the animal sacrifices of the Old Testament were the foreshadowing of the final and perfect sacrifice offered by Jesus. But this notion is by no means exclusive: it is combined with many other images of Christ's work as savior.

Athanasius of Alexandria and the Eastern Tradition

A major early classic that incorporates nearly all the Patristic themes on redemption is the treatise *On the Incarnation of the Word* by St. Athanasius, bishop of Alexandria (c. 297–373). Written before the year 319, it was addressed to a convert from paganism, with the explicit intent of refuting the pagan and Jewish objections to the Christian notion of the divinity of Christ, or, from another point of view, of the enfleshment of God. Anticipating a theme that would become central to Christian soteriology, Athanasius argues that the incarnation of the Word was necessary for the salvation of humanity, because only the death of the incarnate Word could suffice to overcome humanity's subjection to death, incurred by its primal disobedience to God.

This apologia occupies a large part of Athanasius's treatise, and its exposition is (as he acknowledges) lengthy and repetitious. But the outline of the argument is easily synthesized. The premise, taken for granted by Athanasius, is the Genesis account of humanity's primal sin and condemnation by God. Through this sin, humanity rejected the contemplation of God for which it was destined. As a result, it received the condemnation of death: "death had the mastery over them as king." Notably, for Athanasius death meant the turning of humanity back to its "natural" state: that is, to the nothingness from which God had brought us into being (*On the Incarnation*, 4). This meant that humanity was in danger of perishing, and the rational image of God would disappear from existence. God could not rescind humanity's condemnation: God's word must stand. But, on the other hand, Athanasius argues, it would have been unfitting for the creation that had partaken of God's Logos to be completely ruined. It would be unworthy of God's goodness to allow God's creature to perish because of the deceit of the devil. Indeed, it would be a kind of "neglect" on God's part were this to happen (6).

Humanity's repentance was obviously necessary; but in itself it would not suffice to save us. God had to be true to God's own "law." Repentance could not avert humanity's just condemnation, nor repair our fallen nature. Only the Logos, the Word that had created all things, could re-create humanity, offer itself on behalf of humanity, and be our "ambassador" to the Father (7).

Hence the incarnation took place for humanity's salvation: the Word, while continuing to fill all things (8), took on a body in order to be able to die for our sake:

> For the Word, perceiving that not otherwise could the corruption of men be undone save by death as a necessary condition, while it was impossible for the Word to suffer death, being immortal, and Son of the Father; to this end He takes to Himself a body capable of death, that it, by partaking of the Word Who is above all, might be worthy to die in the stead of all, and might, because of the Word which was come to dwell in it, remain incorruptible, and that thenceforth corruption might be stayed from all by the Grace of the Resurrection. Whence, by offering unto death the body He Himself had taken, as an offering and sacrifice free from any stain, straightway He put away death from all His peers by the offering of an equivalent. For being over all, the Word of God naturally by offering His own temple and corporeal instrument for the life of all satisfied the debt by His death. And thus He, the incorruptible Son of God, being conjoined with all by a like nature, naturally clothed all with incorruption, by the promise of the resurrection. For the actual corruption in death has no longer holding-ground against men, by reason of the Word, which by His one body has come to dwell among them (9).
>
> And thus taking from our bodies one of like nature, because all were under penalty of the corruption of death He gave it over to death in the stead of all, and offered it to the Father—doing this, moreover, of His loving-kindness, to the end that, firstly, all being held to have died in Him, the law involving the ruin of men might be undone (inasmuch as its power was fully spent in the Lord's body, and had no longer holding-ground against men, his peers), and that, secondly, whereas men had turned toward corruption, He might turn them again toward incorruption, and quicken them from death by the appropriation of His body and by the grace of the Resurrection, banishing death from them like straw from the fire (4).

We can see clearly in Athanasius's treatise an adumbration of the themes of substitution and "satisfaction" that would play such a major role in the entire history of the theory of atonement. All humanity was under penalty of death, and Christ gave his body over to death in place of all. God's condemnatory

word had to be fulfilled: Christ paid this "debt" to God's judgment. Athanasius takes for granted that this death is an offering or "sacrifice" to God. But this theme of the necessity of a death on humanity's behalf is not the exclusive mode of understanding Christ's work. Athanasius adds several other significant ideas. Of major importance is the idea of the restoration of God's image, which had been lost through sin. Only the Word could effect this restoration, since an image, once erased, can only be restored through the original (14). In this sense, Christ's work can also be seen as a kind of "healing" (in line with the idea of Christ as "physician" or "healer" so prominent in the early church). Death is a "plague" from which Christ rescues us; God's word, by being united with human nature, associates us with the Word's natural immortality, and thus restores to us the immortality for which we were destined. Because of the union of the divine word with our nature, Christ is also humanity's "ambassador" to God. Moreover, the revelation of the Word in human form is the means of effecting humanity's repentance and return to the contemplation of God. Christ's human form attracts humanity's senses and intellect, allowing him to teach the way of salvation and give example to us. All of this constitutes Christ's defeat of the devil, by which he takes humanity from the latter's power.

Of particular interest is Athanasius's treatment of the cross. The "price" or "ransom" that had to be paid for humanity was simply death. The penalty decreed for humanity's sin was the loss of the divine gift of immortality, and the consequent necessity of a natural end to bodily existence. Every form of death fulfills that penalty. Why, then, Athanasius asks, did Christ choose to undergo the ignominious death of the cross? In order more fully to reveal the union of humanity with the Word's divine nature through the resurrection. If he had died of sickness or age, it would have been thought that his death was merely due to natural human weakness, whereas in fact union with the Word strengthened Christ's body. He who was the healer could not fittingly be subject to death by disease. On the other hand, his death was needful: it was the purpose of his incarnation. Without it, there could not be a resurrection and a restoration of humanity. Therefore, Christ gave himself to suffer death at the hands of others: "He did not Himself take, but received at others' hands, the occasion of perfecting His sacrifice" (22).

Moreover, Athanasius continues, a public death was necessary for the sake of revealing the resurrection. Had Christ not died openly, his resurrection would not have been believed.

> How were His disciples to have boldness in speaking of the Resurrection, were they not able to say that He first died? Or how could they be believed, saying that death had first taken place and then the Resurrection, had they not had as witnesses of His death the men before whom they spoke with boldness? (23)

Furthermore, Christ allowed death to be imposed on him, rather than choosing his own manner of death, so that he might prove his power over every form of death (23).

Athanasius gives several further reasons for the suitability of the cross as the instrument of Christ's death. He argues that in order to bear the curse laid upon us, Christ had to receive the death set for a curse, that is, the cross: for "cursed is he who hangs on a tree" (Lev.18:5, Gal. 3:13). Moreover, the spreading out of his arms on the cross symbolizes Christ's gathering all peoples, Gentiles and Jews, to himself: "When I am lifted up, I shall draw all people to myself" (John 12:32). Since the lower atmosphere was the place where the devil wandered since his expulsion from heaven, it was suitable for him to be defeated in his own territory, through Christ's being lifted into the air on the cross (25). Furthermore, unlike other forms of execution, like beheading, crucifixion left the body of Christ undivided, as was suitable to the symbol of the unity of the church (24).

Athanasius mentions that the Word suffers through its union with humanity. But despite the affirmation of the necessity of Christ's death as a sacrifice and ransom, notably absent from Athanasius's treatment of redemption is any stress on the suffering itself. On the other hand, Athanasius stresses the humility of the Word in undertaking such a union and in undergoing a disgraceful form of death.

We find here not only an anticipation of nearly all the major themes of Christian soteriology but almost a compendium of Patristic thought on the matter. Athanasius's ideas are repeated, with varying emphases, by many other early thinkers. Christ is teacher and example for humanity's reform. As Logos, he is the divine philosopher who reveals the illuminating and saving knowledge of God (Athanasius, Clement of Alexandria, and others; the theme of "Christ the philosopher" is also seen in early Christian art).[17] Christ is also the victorious hero who battles against and triumphs over the devil and his forces of evil (Irenaeus, Hippolytus of Rome, and many others). Frequently the means of this triumph is seen to be the obedience of Christ to the Father, which is contrasted with the disobedience of Adam.[18] A subtheme to the idea of victory over the powers of evil is the idea of Christ the "physician," for example in Ignatius of Antioch.

A number of the Fathers go farther than Athanasius in developing the New Testament metaphor of Christ as our "ransom." Several (Origen, Basil the Great, Gregory of Nyssa, Augustine) think of the ransom price as being paid to "death" or to the devil, who has some kind of "right" over humanity because of our sins. But the devil's seizure of Christ in lieu of humanity proves to be his own undoing, since the divine Life could not be held by death, and the bonds of hell are broken by the rising Lord.[19] Gregory of Nazianzus, on the other hand, rejects the idea that God would pay a ransom to the devil, even with the purpose of defeating him. The "ransom price" is paid rather to God:

not because God holds us captive, but because only by the union of humanity with divinity in the Son could the human race be sanctified and the devil overcome.[20]

Frequently, however, the Scriptural ideas of sacrifice, propitiation, ransom, and so on, are simply repeated, with no attempt to explain the "mechanics" of what took place, as though the meaning of these notions were self-evident. So, for example, Cyril of Jerusalem (315–386) writes in his famous *Catechesis*:

> 1. Every deed of Christ is a cause of glorying to the Catholic Church, but her greatest of all glorying is in the Cross; and knowing this, Paul says, *But God forbid that I should glory, save in the Cross of Christ.* For wondrous indeed it was, that one who was blind from his birth should receive sight in Siloam; but what is this compared with the blind of the whole world? A great thing it was, and passing nature, for Lazarus to rise again on the fourth day; but the grace extended to him alone, and what was it compared with the dead in sins throughout the world? Marvelous it was, that five loaves should pour forth food for the five thousand; but what is that to those who are famishing in ignorance through all the world? It was marvelous that she should have been loosed who had been bound by Satan eighteen years: yet what is this to all of us, who were fast bound in the chains of our sins?
>
> 2. And wonder not that the whole world was ransomed; for it was no mere man, but the only-begotten Son of God, who died on its behalf. Moreover one man's sin, even Adam's, had power to bring death to the world; but *if by the trespass of the one death reigned* over the world, how shall not life much rather reign *by the righteousness of the One?* And if because of the tree of food they were then cast out of paradise, shall not believers now more easily enter into paradise because of the Tree of Jesus? If the first man formed out of the earth brought in universal death, shall not He who formed him out of the earth bring in eternal life, being Himself the Life? If Phinees, when he waxed zealous and slew the evil-doer, stayed the wrath of God, shall not Jesus, who slew not another, but *gave up Himself for a ransom*, put away the wrath which is against mankind?
>
> 3. Let us then not be ashamed of the Cross of our Savior, but rather glory in it. *For the word of the Cross is unto Jews a stumbling-block, and unto Gentiles foolishness,* but to us salvation: and *to them that are perishing it is foolishness, but unto us which are being saved it is the power of God.* For it was not a mere man who died for us, as I said before, but the Son of God, God made man. Further; if the lamb under Moses drove the destroyer far away, did not much rather the *Lamb of God, which taketh away the sin of the world,* deliver us

from our sins? The blood of a silly sheep gave salvation; and shall not the Blood of the Only-begotten much rather save?[21]

But Cyril also anticipates the systematic theological argument that the cross was in some way needed to satisfy God's justice:

These things the Savior endured, *and made peace through the Blood of His Cross, for things in heaven, and things in earth.* For we were enemies of God through sin, and God had appointed the sinner to die. There must needs therefore have happened one of two things; either that God, in His truth, should destroy all men, or that in His loving-kindness He should cancel the sentence. But behold the wisdom of God; He preserved both the truth of His sentence, and the exercise of His loving-kindness. Christ took our sins in *His body on the tree, that we by His death might die to sin, and live unto righteousness.* Of no small account was He who died for us; He was not a literal sheep; He was not a mere man; He was more than an Angel; He was God made man. The transgression of sinners was not so great as the righteousness of Him who died for them; the sin which we committed was not so great as the righteousness which He wrought who laid down His life for us—who laid it down when He pleased, and took it again when He pleased.[22]

The closest the Fathers come to an overarching systematic theological explanation of salvation is in their notion of the incarnation. On the basis of a Platonic way of thinking, the Fathers teach that by the incarnation the divine Logos "assumes" the whole of human nature and both heals and "divinizes" it through union with his divinity (Irenaeus, Athanasius, Gregory, Cyril, Gregory of Nyssa, Gregory Nazianzen, and others).[23] John of Damascus, at the end of the Patristic period, defends the orthodox understanding of the hypostatic union precisely on the basis of its soteriological significance. The incarnation of the divine Word in a true human nature exalts all human nature—not as though all the individual hypostases of human beings had been exalted but because our entire nature has been exalted in the hypostasis of Christ. This idea is almost universally present in the Eastern Fathers, and subsumes all the other images of salvation that they use. Christ's suffering on the cross is placed in this more fundamental incarnational context. It is the consequence of his voluntary acceptance of the whole human condition. He unites fallen human nature with his divinity, so that it may now conquer sin and death. John of Damascus explains the meaning of Christ's assumption of the "blameless passions" that made it possible for him to suffer:

We confess that he assumed all the natural and blameless passions of man, for he took on humanity completely and all that was belongs to him, except sin. . . . The natural and blameless passions are

those that do not depend upon us but have entered human life as punishment for our transgression: hunger, thirst, fatigue, pain, tears, corruption, fear of death, anguish and its bloody sweat, the angels' aid in our natural weakness, and so on; all exist in human nature. Christ assumed all so that all may be healed. He attempted and conquered to prepare the victory for us and to give to nature the power to overcome the adversary, so that the nature that had been conquered would, by means of the very same tests, conquer the one who had formerly conquered it.[24]

In line with the Johannine picture of Christ, who lays down his own life and takes it up again, the Fathers emphasize that Christ's suffering and death are voluntary: in his divine power, he wills to assume them. John Damascene's words are a good example: "One never sees anything compulsory in him; rather, all is voluntary. It was by willing it that he became hungry, willing it that he knew fear, and willing it that he died."[25]

Augustine of Hippo and the Western Tradition

In St. Augustine, the greatest inspiration of Western theology, we find many of the same ideas as in the Eastern Fathers, but with a somewhat different emphasis. Augustine also presumes that by assuming human nature, Christ becomes one with all humanity. However, his stress on "original sin" and its inheritance leads him to give particular emphasis to Christ's sacrifice as a needed purification from sin, both original and personal. In his famous book on the Trinity we find one of his major statements of the themes that were to be so influential in subsequent Western thought:

> The truth is, men were more inclined to avoid the death of the flesh which they could not avoid, than the death of the spirit; that is, they shrank more from the punishment than from what deserved the punishment. . . . So then, in order that *as by one man came death so by one man there might come the resurrection of the dead* (1 Cor. 15:21), the mediator of life came to show us how little we should really fear death, which in our human condition cannot now be avoided anyway, and how we should rather fear ungodliness which can be warded off by faith. And to do this he came to meet us and the end to which we had come, but not by the way we had come. We came to death by sin, he came by justice; and so while our death is the punishment of sin, his death became a sacrifice for sin.[26]

It is notable that Augustine begins with the idea of Christ as an example for us, and then connects it with the notion of sacrifice for sin. Like so many of the Fathers, he is particularly insistent on Christ's freedom in embracing his death:

the spirit of the mediator demonstrated how he did not come to the
death of the flesh as any punishment for sin by precisely not forsak-
ing [that flesh] against his will, but because he wanted to and at the
time he wanted to and in the way he wanted to. In virtue of his be-
ing compounded into one being with the Word of God, he said, *I
have authority to lay down my life and I have authority to take it up
again. No one takes it away from me, but I lay it down and I take it up
again* (John 10:18). . . .

For it came about that the chains of many sins in many deaths
were broken by the one death of one man which no sin had pre-
ceded. For our sakes the Lord paid this one death which he did not
owe in order that the death we do owe might do us no harm. He
was not stripped of the flesh by right of any alien authority; he alone
stripped himself (Col. 2:15) of it. And he was able not to die if he did
not wish to, it follows since he did die that it was because he wished
to; and thus *He made an example of the principalities and powers, con-
fidently triumphing over them in himself* (Col. 2:15).

The death of Christ was also his triumph over the devil and the powers of
evil. It was a sacrifice to God, a payment of the debt owed by humanity, and a
freeing from the powers of evil, which had some kind of rights over humanity
because of original sin. Expanding on St. Paul's metaphor, Augustine presents
Christ's defeat of the devil as a kind of legal overturning of the latter's rights,
on the basis of Christ's sacrifice:

By his death he offered for us the one truest possible sacrifice, and
thereby purged, abolished, and destroyed whatever there was of
guilt, for which the principalities and powers had a right to hold us
bound to payment of the penalty; and by his resurrection he called
to new life us who were predestined, justified us who were called,
glorified us who were justified.

So by a death of the flesh the devil lost man, who had yielded to
his seduction, and whom he had thus as it were acquired full prop-
erty rights over. . . . Thus the Son of God did not disdain to become
our friend in the companionship of death. . . . Yet in being slain in
his innocence by the wicked one, who was acting against us as it
were with just rights, he won the case against him with the justest
of all rights, and thus *led captive the captivity* (Eph. 4:8, Ps. 68:19)
that was instituted for sin, and delivered us from the captivity we
justly endured for sin, and by his just blood unjustly shed *cancelled
the I.O.U.* (Col. 2:14) of death, and justified and redeemed sinners.[27]

Augustine can also refer to Christ's sacrifice as "the great price with which
Christ bought us"—without explicitly specifying to whom the "price" is paid,

but insinuating that it is to God's justice. Like the Fathers in general, Augustine takes for granted the idea that "sacrifice" is a means of purification from sin. But the sacrifice must be offered by one of those whom it will benefit; hence the need for Christ's humanity, which Augustine presumes makes us one with him. At the same time, the sacrifice could only be perfectly acceptable if offered by a "high priest" without sin; hence the need for Christ's divinity:

> true sacrifice can only be correctly offered by a holy and just priest, and only if what is offered is received from those for whom it is offered, and only if it is without fault so that it can be offered for the purification of men with many faults. This is certainly what everyone desires who wants sacrifice offered for him to God.
>
> What priest then could there be as just and holy as the only Son of God, who was not one who needed to purge his own sins by sacrifice, whether original sin or ones added in the course of human life? And what could be so suitably taken from men to be offered for them as human flesh? And what could be so apt for this immolation as mortal flesh? And what could be so pure for purging the faults of mortal men as flesh born in and from a virgin's womb without any infection of earthly lust? And what could be so acceptably offered and received as the body of our priest which has been made into the flesh of our sacrifice? Now there are four things to be considered in every sacrifice: whom it is offered to, whom it is offered by, what it is that is offered, and whom it is offered for. And this one true mediator, in reconciling us to God by his sacrifice of peace, would remain one with him to whom he offered it, and make one in himself those for whom he offered it, and be himself who offered it one and the same as what he offered.[28]

The Theology of the Cross in Art, Music, and Liturgy: The Aesthetic Mediation

The Cross as the Instrument of God's Triumph

As we have seen, for the Greek Fathers the passion of Christ was seen as a moment within the larger framework of the salvific incarnation of the Logos. This perspective remains strongly present even today in the prayers and hymns of the Byzantine rite of the church. The divinity and majesty of Christ are never forgotten, even in the consideration of his passion. He is above all "One of the Trinity." A prayer referring to the events of Christ's death, recited by the deacon during the incensation at the start of the eucharistic liturgy, repeats an idea we have already seen in Athanasius, and gives a good summary sense of the Byzantine theological perspective: "When your body was in the tomb, and Your

soul in hell, when You were in paradise with the thief, You were at the same
time—O Christ, as God, upon Your throne with the Father and the Spirit—
infinite and filling all things."[29]

The Celebration of the Passion in the Byzantine Liturgy

The Byzantine liturgy of the passion, although it developed significantly
through the centuries, provides even in its present form an excellent example
of the Patristic theological "paradigm" of soteriology. The hymns of Matins for
Great (Good) Friday, called "The Office of the Holy and Redeeming Sufferings
of Our Lord Jesus Christ," provide a good example of the application of this
perspective specifically to the cross. Here we find a detailed meditation on the
events of the passion, and an explicit affirmation of their redemptive value. Yet
the incarnation is seen as the ultimate source of salvation;[30] the overall context
is one of adoration of Christ's divinity; and the inevitability of the resurrection
is never forgotten. In one of the hymns "at the Praises," after the ninth gospel,
we hear an explicit enumeration of Jesus' sufferings:

> O Savior, every member of your holy body endured humiliation for
> our sake; the head with thorns, the face with spit, the cheeks with
> blows, Your mouth with vinegar and gall, the ears with blasphemies
> from the unfaithful, the back with scourges, the hand with the reed,
> the whole body with the weight of the cross, Your hands and feet
> with nails, the side with a spear. All this You suffered to deliver us
> from suffering.[31]

But the ending line of the hymn is an explicit reference to the incarnation as
the source of salvation: "Through love of mankind You came down to raise us.
O Almighty Savior, have mercy on us."

Similarly, the hymns for the "Vespers for Holy and Great Friday," con-
scious of the divinity of the one suffering, place the crucifixion in a cosmic
context:

> All creation was transformed with fear, when it beheld you hanging
> on the cross, O Christ. The sun was darkened and the foundations
> of the earth trembled. All creation suffered with the One who created
> all things. O Lord, who willingly suffered for us, glory be to You!

> Why do evil and iniquitous people concern themselves with what is
> in vain? Why have they condemned to death the Life of All? O what a
> great wonder! the Creator of the world is handed over to the lawless
> ones, and He who loves mankind is raised up on the cross, that He
> might free the enslaved of the Abyss who are crying out, "O long-
> suffering Lord, glory be to You!"

The all pure Virgin, seeing you, O Word, lifted upon the cross today, lamented as a mother, her heart bursting with sorrow and moaning from the depths of her soul, her countenance deeply scarred with grief, she cried out so mournfully: "O divine Child, how great is my sorrow. O light of the World, O lamb of God, why have you passed from my sight?" Beholding all this, the heavenly hosts were struck with fear, and they cried out, "O incomprehensible Lord, glory be to you!"

As she beheld you hanging upon the tree, O Christ our God, she, who gave birth to You, the creator and God of all, cried out in such great sorrow: "Where has the beauty of your countenance gone, O my son? I cannot endure this sight of unjust crucifixion. Hasten and arise so that I may also see your resurrection from the dead on the third day."

Today the master of creation stands before Pilate and the Creator of all is condemned to the cross. As a lamb he is willingly led and fastened with nails. His side is pierced, and he who rained manna on the earth is given drink from a sponge. The savior of the world is struck on the cheek, and the creator of all is mocked by his own servants. For those who crucify him, he entreats his Father, saying, "Father, forgive them this sin because the lawless ones know not what injustice they do." O what a supreme love for mankind.

O, how could the lawless council condemn to death the King of Creation without being ashamed at the thought of his good works which he recounted to them saying, "O my people what have I done to you? Have I not filled Judea with miracles? Have I not raised the dead with a word? Have I not cured infirmities and sufferings? So now, what do you give me in return? Why have you not remembered me? For the healing you have wounded me, for life you gave me death; you hang me, your benefactor, on a tree as a criminal. You treat me, the Lawgiver, as a law breaker. You condemn the King of all." O long suffering Lord, glory be to you.

An awesome and glorious mystery occurs today: the one who cannot be contained is now restrained. He who freed Adam from the curse, is bound. The searcher of hearts and souls is questioned unjustly. He who confined the deep, is now confined to prison. In front of Pilate now stands the one before whom the heavenly powers tremble. The creator is struck by the hand of a creature. The judge of the living and the dead is condemned to the cross. He who conquered hell is sealed in a tomb. O innocent Lord who graciously suffered all things and saved all mankind from the curse, glory be to You.[32]

And the hymns "at the Praises," after the gospel, continue in the same strain:

> When the Arimathean lifted you, lifeless from the cross, O lord of
> life, he anointed you, O Christ, with myrrh, and wrapped you in a
> shroud, and he was moved by heartfelt love to kiss your body not
> subject to decay; but was restrained by fear, and rejoicing, he cried
> out to You: "Glory to your condescension, O lover of humankind!"
>
> O Savior of all, when you placed yourself for all humankind in a
> new tomb, the Abyss, which ever mocked, was terrified when it saw
> you; the bonds were shattered, the gates were broken, and the
> graves opened and the dead arose. Adam joyfully called out to you:
> "Glory to your condescension, O lover of humankind!"
>
> When you, by divine nature indescribable and infinite, were
> willingly enclosed in the tomb, you ended the mysteries of death, O
> Christ, and annihilated the kingdom of Hades, favoring the sabbath
> day with your blessing, glory, and light.
>
> When the heavenly powers saw you, O Christ, calumniated by
> lawless men, they were amazed at your long-suffering which our
> words cannot express. And when they beheld the stone of your tomb
> being sealed by the hands that pierced your incorruptible side, they
> still rejoiced at our salvation and cried out to you, "Glory to your
> condescension, O Christ."[33]

Several Scriptural images of salvation are present in these hymns: notably, sacrifice, the freeing of the enslaved, the conquest of death and the devil. But the underlying soteriological theme is the incarnation: it is *God* who undertakes our salvation in the passion. There is a constant sense of sacred irony: it is the creator and judge, the loving giver of life, eternal Life itself, who is unjustly judged and condemned to death. In the light of God's majesty, what is emphasized about the events of the passion is the aspect of humiliation more than that of physical pain. Indeed, any sense of tragedy is attenuated, since it is presumed that the nature, the purpose, and the triumphant outcome of the divine drama are known not only to us, the present faithful, but also to its major participants: to Jesus himself, to Mary, and to the disciples; and also to its cosmic witnesses: the angels, the souls in hell awaiting deliverance, the creation itself. In its present form, the service includes a dramatic ritual "lamentation" over Jesus at his death and burial,[34] and describes the heart-rending sorrow of the Virgin. These elements, which imply a certain appeal to the emotions of the participants, were added in the early Middle Ages. (This "humanistic" development will be discussed in more detail later in this chapter and again in chapter 3). But the overall context is doctrinal and theological rather than affective: what is primarily evoked is a sense of wonder, awe, and joy at the incomprehensible mystery of God's long-suffering patience and love for humanity. This awe-inspiring love is seen in the infinite God's condescend-

ing to be united with our nature. The supreme expression of this condescension is that One of the Trinity—the impassible, all-powerful, and ever-blissful God—can be humiliated, suffer, and die at the hands of creatures.[35]

In the light of the incarnation, the cross is the event and the sign not of suffering or defeat, but of God's triumphant glory. This view was informed especially by the Patristic reading of the passion in the light of John's gospel, in which Jesus himself not only foretells his impending death but also explicates its theological meaning. Thus St. Cyril of Jerusalem (ca. 313–386) comments:

> He did not die involuntarily, nor was his death merely the result of violence; he offered himself of his own free will. Listen to what he himself said: "and as I have power to lay it down so I have power to take it up again" (John 10:18). Thus he proceeded of his own free will towards his passion, happy to undertake a work so sublime, filled with joy over the fruit that his act would produce, namely, the salvation of humanity. He was not ashamed of the cross because it procured the redemption of the world. Yet it was not just any nondescript man who suffered thus: it was God made man, and, as a man, he was fully intent on obtaining the victory through obedience.[36]

Centuries later, but manifesting the continuity of the tradition, the Byzantine bishop Andrew of Crete (died ca. 720) writes in a homily for Palm Sunday:

> What is the "glory of the Lord"? It is the cross, on which Christ was glorified; that splendor, I say, of the glory of the Father, as Christ himself said when he was confronted with his passion: "Now the Son of Man is glorified, and God is glorified in him, and will glorify him yet more" [John 13:31–32]. Christ, in this passage, calls his exaltation on the cross "glory." The cross of Christ is his glory and his exaltation. He himself said: "And I, when I am lifted up from the earth, will draw all to myself" [John 12:32].[37]

The Theme of Triumph in the Roman Liturgy of Good Friday

The celebration of the cross as the symbol of God's triumphant work is also found in the Latin liturgy for Holy Week, especially in two hymns by the sixth-century Merovingian court poet and bishop of Poitiers, Venantius Fortunatus. The *Vexilla Regis* ("The Standard of the King") was sung at Vespers from Palm Sunday to Holy Thursday, and *Pange Lingua* ("Sing, my tongue") at the Solemn Afternoon Liturgy of Good Friday.[38] Both hymns were composed for a solemn procession (November 19, 569) to welcome a fragment of the true cross. The

cross of Jesus was supposedly discovered in Jerusalem by Helen, the mother of the emperor Constantine, and it quickly became an important object of devotion. Relics of the cross were particularly valued because of the desire for material mediations of salvation and supernatural power.[39] A fragment of the "true cross" was sent by Emperor Justin II and Empress Sophia to Queen Radegunda, who had retired to a convent (named Sainte Croix, "Holy Cross") near Poitiers.

The *Vexilla Regis* celebrates the cross as the instrument of redemption, using a number of familiar images:[40]

(1) Vexilla Regis prodeunt;
fulget Crucis mysterium,
quo carne carnis conditor
suspensus est patibulo.

(1) They bring forth the standards of the
 King:
the mystery of the cross shines forth,
by which the creator of flesh
is hanged by flesh on the cross.

(2) Confixa clavis viscera
tendens manus, vestigia,
redemptionis gratia
hic immolata est hostia.

(2) The body [is] fixed by nails,
extending the hands [and] the feet.
For the sake of redemption,
here was immolated the [sacrificial] victim.

(3) Quo vulneratus insuper
mucrone diro lanceae,
ut nos lavaret crimine,
manavit unda et sanguine.

(3) From whom, on high,
wounded by the sharp point of a lance,
there flowed water and blood,
that he might wash us from sin.

(4) Impleta sunt quae concinit
David fideli carmine,
dicendo nationibus:
regnavit a ligno Deus.

(4) Those things are fulfilled
that David sang in faithful song,
saying to the nations,
God has reigned from a tree [lit. "wood"].

(5) Arbor decora et fulgida,
ornata Regis purpura,
electa digno stipite
tam sancta membra tangere.

(5) O beautiful and glorious tree,
beautified with the purple of the king
chosen of a noble heritage
to touch such sacred limbs.

(6) Beata, cuius brachiis
pretium pependit saeculi:
statera facta corporis,
praedam tulitque tartari.

(6) Blessed [tree] from whose branches
hung the price of the world:
[you were] made into the balance [scales] of
 the body
and took away the prey of the underworld.

(7) Fundis aroma cortice,
vincis sapore nectare,
iucunda fructu fertili
plaudis triumpho nobili.

(7) From your bark you pour out a sweet
 smell,
more delicious than the taste of nectar;
joyous, by your fertile fruit
you praise the noble triumph.

(8) Salve, ara, salve, victima,
de passionis gloria,
qua vita mortem pertulit
et morte vitam reddidit.

(8) Hail altar, hail victim
of the passion's glory,
by which life brought death to an end,
and by death, gave life again.

The hymn *Pange Lingua* similarly praises the cross for its special place in the working of our salvation:[41]

(1) Pange, lingua, gloriosi praelium certaminis,
Et super crucis tropaeo dic trium-
phum nobilem,
Qualiter Redemptor orbis immolatus
vicerit.

(1) Sing, my tongue, of the battle of the glorious struggle, and over the trophy of the cross proclaim the noble triumph by which the sacrificed redeemer of the world conquered.

(2) De parentis protoplasti fraude facta condolens,
Quando pomi noxialis morsu in mor-
tem corruit,
Ipse lignum tum notavit, damna ligni
ut solveret.

(2) Pitying the crime of our first parent, when he sank to death through the bite of the forbidden fruit, the Creator chose this tree then to repair the injury of the [forbidden] tree.

(3) Hoc opus nostrae salutis ordo deposcerat,
Multiformis proditoris arte ut artem falleret,
Et medellam ferret inde, hostis unde laeserat.

(3) [God's] order appointed this work of our salvation, so that cunning might cheat the cunning of the multiform betrayer, and might bring a remedy from the very place where the enemy had wounded [us].

(4) Quando venit ergo sacri plenitudo temporis,
Missus est ab arce Patris natus orbis conditor,
Atque ventre virginali carne factus prodiit.

(4) Therefore when the fullness of sacred time arrived, the Son, the creator of the world, was sent from the Father's heavenly throne, and appeared, having been made flesh in the virgin's womb.

(5) Vagit infans, inter arcta conditus praesepia,
Membra pannis involuta virgo mater alligat,
Et pedes, manusque, crura stricta cin-
git fascia.

(5) The infant hidden within a lowly manger cries; the Virgin mother wraps his body with cloth and closely binds his hands, feet, and legs.

(6) Lustra sex qui jam peracta, tempus implens corporis,
Se volente, natus ad hoc, passioni deditus,
Agnus, in crucis levatur immolandus stipite.

(6) When thirty years had passed, coming to full stature, the sacrificial Lamb, by his own will, having been born for this, is surrendered to the passion, and is raised on the tree of the cross.

(7) Hic acetum, fel, arundo, sputa, clavi, lancea,
Mite corpus perforatur, sanguis, unda, profluit.
Terra, pontus, astra, mundus quo lavantur flumine

(7) Behold the vinegar, the gall, the reed, the spit, the nails, the lance: the tender body is pierced, blood and water flow out, a river in which the earth, the sea, the stars, the world are washed!

(8) Crux fidelis, inter omnes arbor una nobilis,
Nulla talem silva profert, flore, fronde, germine.
Dulce lignum, dulces clavos, dulce pondus sustinens.

(8) Faithful cross, among all, the one and only noble tree; no forest produces the like in flower, leaf, or blossom. Sweet wood, bearing a sweet weight on sweet nails!

(9) Flecte ramos arbor alta, tensa laxa viscera,
Et rigor lentescat ille, quem dedit nativitas,
Ut superni membra regis miti tendas stipite.

(9) Bend your branches, high tree, relieve the stretched-out body, and let that rigidity given you in birth become pliant, so that you may extend the members of the heavenly King on soft wood.

(10) Sola digna tu fuisti ferre pretium saeculi
Atque portum praeparare nauta mundo naufrago,
Quem sacer cruor perunxit, fusus agni corpore.

(10) You alone were worthy to bear the price of the world, and as an ark to prepare a haven for the drowning world, you who were anointed with the sacred blood poured out from the Lamb.

Together, these two hymns provide us with a rich medley of Patristic images of *salvation*. There are some very general notions, such as "salvation" (*Pange Lingua*, 3) or the repairing of harm (*Pange Lingua*, 2). Salvation is also portrayed as the healing of a wound inflicted by the enemy (the devil) (*Pange Lingua*, 3); it is accomplished by God's use of "art" or cunning to counter the devil's evil scheme (*Pange Lingua*, 3)—a possible reference to the theme of the "deceit" of the devil by the substitution of the immortal, sinless Christ for sinful humanity; it is the washing of the world by Christ's blood (*Pange Lingua*, 7; *Vexilla Regis*, 3). Special prominence is given to the metaphor of "redemption," the paying of a price for our salvation (*Pange Lingua*, 1, 10; *Vexilla Regis* 2, 6). In the same context, the cross is likened to the scales of justice, by which the prey of hell

is taken away (*Vexilla Regis* 6). There is also an emphasis on the idea of sac-
rifice, in which Christ is the self-willed victim or Lamb (*Pange Lingua*, 1, 6, 10)
on the altar of the cross (*Vexilla Regis*, 8).

Unlike the Byzantine hymns quoted earlier, Fortunatus makes no mention
of the salvific value of the incarnation as such, nor of the idea of divinization
so dear to Eastern thought. Rather, like most Western theology after Augustine,
Fortunatus places emphasis on redemption as the remedy for the fall. While
Eastern theology tended to place the cross within the context of the entire life
of Jesus, as the incarnation of the Word, Fortunatus seems to anticipate An-
selm's idea that the incarnation was for the sake of Jesus' death: he was "born
for this," that is, for the passion (*Pange Lingua*, 6). We also see here indications
of an affective relation to Jesus: his body is called a "sweet" weight, and even
the cross and nails are "sweet" by association with him (*Pange Lingua*, 8).
Although Jesus' sufferings as such are not dwelt on, a consciousness of them
is implied in the plea to the cross to be softened (*Pange Lingua*, 9). Some degree
of interest in Jesus' humanity seems to be indicated by the stanzas that speak
of his birth and infancy (*Pange Lingua*, 4, 5)—although the Virgin's swaddling
of the infant is possibly meant to prefigure Christ's binding in the passion.
There is no mention of Jesus' teaching, or of Christian imitation. On the other
hand, the cross itself is presented as bearing fruit (*Pange Lingua*, 8; *Vexilla
Regis*, 7)—presumably in the engraced lives of the followers of Christ.

As in the Byzantine hymns, the cross is a "mystery" because by it the
Creator suffers at the hands of creatures (*Vexilla Regis*, 1). But despite their
comparative emphasis on the theme of sacrificial death, Fortunatus's poems
are essentially triumphal. They are written in the meter of a Roman military
hymn.[42] The cross is God's means of glorious victory in battle (*Pange Lingua*,
1; *Vexilla Regis*, 7); Christ/God reigns as King from the cross (*Pange Lingua*, 9;
Vexilla Regis, 4);[43] his blood is compared with the imperial purple (*Vexilla Regis*,
5). The cross is the trophy of Christ's victory (*trophaeum*, the Roman monument
of victory on which the defeated enemy's weapons and insignia were hung—
Pange Lingua, 1), the battle-standard of the King (*Vexilla Regis*, 1).

The Logos on the Cross: The Pictorial Representation of the Crucified in the Early Church

These ideas are frequently reflected in the pictorial symbolism of the ancient
and medieval church. The early church was not without a spirituality of the
cross, in the sense of sharing in Christ's sufferings[44]—as is evident from the
literature surrounding the cult of the martyrs. It also used the cross as a sym-
bol: first of all not in the form of an image, but as a gesture. The church Fathers
Tertullian and Origen both mention the custom of making the sign of the cross
on the forehead before beginning prayer or work.[45] Cyril of Jerusalem testifies
to the belief that the sign of the cross had power to ward off demons:

> If any disbelieve the power of the Crucified, let him ask the devils; if
> any believe not words, let him believe what he sees. Many have been
> crucified throughout the world, but by none of these are the devils
> scared; but when they see even the Sign of the Cross of Christ, who
> was crucified for us, they shudder.[46]

We may deduce from the symbol of the *orans* (praying figure, usually female,
representing the soul and the church) portrayed so frequently in the catacombs,
that the early Christians stood cruciform in prayer, with arms extended to the
side, rather than raised above the head, as was the pagan custom.

In the making of the sign of the cross, the symbol was used—as already
in St. Paul's writings[47]—to encapsulate the entire economy of salvation, and
the power of God that accomplishes it. Five times in the Synoptic gospels we
are presented with a saying of Jesus indicating that his followers must "take
up the cross" and follow him (Mark 8:34, Matt. 16:24, Luke 9:23, from the
Marcan tradition; Matt. 10:38 and Luke 14:27, from the "Q" source). The phrase
is rich in meaning. Most obviously, it presents the suffering and death of Jesus
as a model for his disciples, who, like him, reject the values of the world and
must expect to undergo the punishment that was reserved for rebels. But the
"taking up" of the cross may also be connected with the idea of taking Jesus'
"yoke" upon oneself (Matt. 11:29) in place of the "yoke of the Law." A further
symbolic dimension may be implied: every Roman soldier on campaign carried
a stake (*stauros*—the same Greek word used originally for the upright beam of
the cross of crucifixion). These were assembled together at night to form a
pallisade around an encampment. The general's stake was carried by his or-
derly. Matthew's and Mark's passion accounts see the carrying of Jesus' cross
(*stauros*) by Simon of Cyrene as a parody of this practice: the Roman soldiers
mockingly treat Jesus as a general whose pallisade stake is carried by an orderly
behind him.[48] In this perspective, the gospel's injunction to take up the cross
is an ironic reversal of the mockery: Jesus really is the leader whom we are
called to follow, and the cross is the bulwark behind which we find safety.

A similar meaning for the idea of "taking up the cross" attaches more
directly to the practice of signing oneself with it. The cross had the shape of
the Greek letter tau (T) and the ancient form of the Hebrew letter tav (written
either upright, +, or lying on its side, ×). Like the letter *X* in our alphabet,
these were used as a mark and could mean a "marking." In the vision of the
prophet Ezekiel (Ez. 9:4–6), those who are to be saved from the wrath of God
are marked with a cross (i.e., the letter tav) on their foreheads. There is some
evidence that eschatologically oriented Jewish groups, inspired by this text, had
taken up the practice of signing of themselves with the *tav*/cross by the time
of Jesus.[49] The early Christians connected the passage from Ezekiel with the
cross of Christ. In addition, of course, the cross on its side is also the Greek
letter chi (X), the initial letter of the name "Christ" (ΧΡΙΣΤΟΣ). Hence in mark-

ing themselves with the "sign of the cross" and with Christ's initial, Christian expanded on the Old Testament symbol of God's protection and possession. In baptism, the forehead of a new Christian was anointed with oil in the form of a cross, symbolizing both the sharing in the paschal mystery of Christ's death and resurrection and a "branding" of the person with the Lord's mark as the sign of belonging to Him and of being under His protection against the powers of the world.[50] Christians repeated the gesture—making the "sign of the cross" on their foreheads—as a reminder and evocation of the Spirit and power they received at baptism.[51]

The cross in this period was thus seen in the light of God's salvific power manifested in the resurrection, and was therefore a sign of hope for salvation. The art of the catacombs tended to portray scenes of deliverance: Daniel in the lions' den, Noah in the ark, the three young men in the fiery furnace, Susanna saved from the elders by Daniel's judgment (all of these appearing in the posture of the *orans*). Especially prominent is the figure of Jonah: his being thrown into the waters, swallowed by the fish, and restored to safety graphically symbolized salvation through the waters of baptism, dying, and rising with Christ.[52] The theme of sacrifice is present in the portrayal of Abraham and Isaac and in the figure of the Lamb. There are also portrayals of deliverance that are typologically connected to the cross: the staff of Moses parting the sea or striking the rock to draw forth water; Noah's ark.[53] But portrayals of the crucifixion itself are rare before the fifth century.[54] As we have seen, the earliest known representation is pagan, and was meant to ridicule Christian belief. In the catacombs and on sarcophagi, Christ is almost invariably shown as a youthful, beautiful, and majestic figure.[55] His miracles dominate the scenes showing his earthly life.

From the time of Constantine, the cross (without corpus) appears often: but it is the symbol of triumph, not of defeat or of suffering. Legend states that the emperor-to-be Constantine, while still a pagan, had a vision of the cross (apparently in the form of the chi-rho monogram of Christ), with the words "in this [sign] you will conquer."[56] He subsequently made the cross literally into his battle standard, creating a new imperial banner called the *labarum* that eventually replaced the old individual legionary standards (*vexilla*) with their representation of a dragon (or serpent). Eusebius gives a detailed account of its appearance:

> A description of the emblem in the form of a cross which the Romans call the *labarum*: It was like this: a long gilded spear with a transverse bar, like a cross. At the top of this same spear was affixed a wreath made of gold and precious stones. Within this was the sign of the saving name: that is, two letters signified the name "Christ" by means of its initial characters, with the *P* [the Greek letter *rho*] in the middle [of the *X*, the letter *chi*]. From this time the emperor also

used to wear these same two letters on his helmet. From the cross-bar of the spear, a cloth was suspended: it was purple, covered with precious stones joined together and interlaced with gold. . . . And this banner affixed to the crossbar was square in shape.[57]

Constantine also decorated the entrance to his imperial palace with an image of himself with the cross above his head and under his feet the dragon,[58] adorned the palace with jeweled crosses,[59] and in a prominent place in the center of Rome erected a statue of himself holding a cross, with the inscription "By this saving sign, which signifies true power, I have preserved your city from the yoke of tyrranical domination."[60]

Already during the reign of Constantine and his successor Licinius, coins were struck bearing the cross (in various forms) surrounded by a victor's garland.[61] In the fourth and fifth centuries, scenes from the passion of Christ became the object of artistic representation; but the crucifixion itself was omitted. In its place, we frequently find the *crux gemata*—a bejeweled cross, symbolically tying the instrument of death to the triumph of the resurrection.[62]

A mosaic in the Archiepiscopal chapel in Ravenna (early fifth century) shows a young, beardless Christ, dressed in Roman military uniform, with a jeweled cross in the halo behind his head, trampling on a lion and a serpent (see Ps. 90 [91], 13). He carries over his shoulder a long, slender cross that he grasps by its shaft like a standard—or perhaps a weapon.[63] In other contexts, the cross still appears as it did in Constantine's original *labarum*, in the form of the Greek letter *chi* (X) combined with the letter *rho* to form the monogram of Christ (XP being the first letters of "Christos" in Greek).[64] (See the famous Ravenna fresco of the emperor Justinian and his court, in which the soldiers' shields are decorated with the chi-rho).[65]

Even when the portrayal of the crucifixion became common,[66] the focus long remained on Christ's victory through the cross. In one of the earliest depictions, on a fifth-century ivory now in the British museum, Jesus is shown both carrying the cross and crucified.[67] The representation is theological and narrative (combining several moments of the story in a single scene) rather than "realistic." In both scenes, Christ is young, long-haired, and beardless: the Apollonic "beautiful Christ" favored by the period. In the first scene, he carries a thin cross over his shoulder, holding it by its shaft, as in the Ravenna mosaics. In the crucifixion scene, his head is surrounded by a nimbus of glory, and, despite the soldier piercing his side—an event that the gospels place after Jesus' death—he appears alive and triumphant. The ends of the cross are splayed, as in a stylized liturgical cross (this is most visible at the bottom of the upright beam, which is not inserted into the ground, but appears to rest on top of it). What is portrayed is the object of Christian devotion, not the mere historical instrument of execution. Once again, the cross is seen in the light of the incarnation and resurrection.

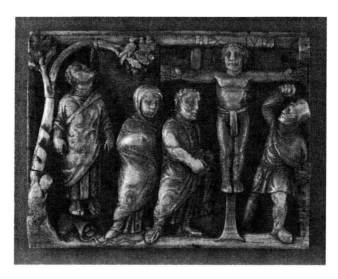

The crucified Christ, 5th or 6th century ivory relief. Credit: HIP / Scala / Art Resource, New York.

During the early centuries of Christian art, the sacrificial aspect of the passion was often evoked by portraying the paschal lamb, symbol of Christ, at the crossing of the lateral and horizontal beams of the cross. (The paschal lamb is at the same time, of course, the triumphant Lamb of the Apocalypse). Examples of such representations, Eastern in origin, are found at Ravenna and in St. Mark's in Venice. But the crucified Jesus was also occasionally depicted— as, for example, on a panel of the wooden doors of the basilica of Santa Sabina in Rome.[68] In this representation, probably dating from the early sixth century, Jesus is portrayed in the "Syrian" style, with long hair and beard, and is nude except for a loincloth-type undergarment. There is no halo or other mark of divinity. Yet the figure of Jesus is much larger than those of the two thieves crucified at his sides (so that these look like children next to him). Although nailed to the cross, Jesus appears to be standing upright, not sagging; his extended arms (and also those of the two thieves) are bent in a way reminiscent of the praying figures (*orantes*) of the catacombs; and he is alive. There is no attempt to portray suffering as such. Clearly the elements of historical "realism" here are subordinated to the theological narrative purpose of the panel: the cross is a moment in the drama of salvation history, leading to the triumph of the resurrection and seen in its light.[69]

The comparative starkness of the Santa Sabina depiction of the crucifixion is exceptional in early Western Christian art. There are other instances in which Christ is depicted nude on the cross,[70] but such images seem to have been so rare that, despite their faithfulness to the Scriptural account, their appearance could cause scandal to the faithful.[71] Much more typical, from the sixth century

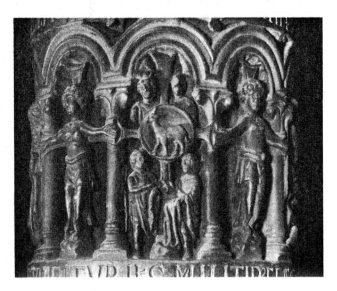

The Lamb on the cross. Byzantine, 6th century. San Marco, Venice. Credit: Erich Lessing / Art Resource, New York.

onward, is the representation in the Rabula gospel book (dating from the year 586),[72] where Christ is shown wearing a *colobium*, a long sleeveless tunic extending from the neck to the ankles, with regal and/or triumphal attributes: the purple color and broad bands of gold.[73] Similar in style is the representation found on the wall of the church of Santa Maria Antiqua in Rome (ca. 750). Here, as Hans Belting points out, the adoration of the crucified in heaven takes the place previously occupied by the image of the Lamb of God from the Apocalypse. The painting dates from shortly after the Council of Constantinople (692), which had mandated the portrayal of the human Christ in place of the "old manner" of symbolic representation by the Lamb. This representation of the crucifixion is paradigmatic for the era. It is "neither a historical Crucifixion nor the usual apocalyptic adoration of the Lamb in heaven. It combines the two themes in a new, synthetic presentation."[74] The eyes of Christ are open; he is clearly living and in triumph. He is robed, as in the Rabula codex. The image is not a portrayal of the passion and death of Christ; nor is it merely a reminder of the narrative. Rather, it presents that history in a synthetic theological view: in the light of its present, future, and eternal significance. We are presented, in Grillmeyer's phrase, with "the Logos on the cross." It is with this understanding that we must look at the majority of Western crucifixes until the later part of the Middle Ages.

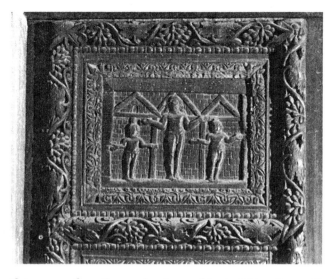

Crucifixion scene from the wooden doors of Santa Sabina, Rome. Credit:
Scala / Art Resource, New York.

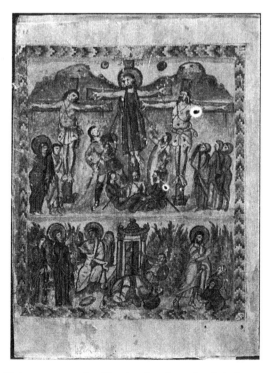

The crucifixion, manuscript illumination from the Rabula gospels (6th
century). Credit: Scala / Art Resource, New York.

Development of the Icon of the Crucifixion in Byzantium

It is difficult to give an accurate and complete account of the development of the Byzantine crucifixion icon from its beginnings through the Middle Ages. Highly competent scholars make different and sometimes conflicting statements. The reasons for the difficulty are readily apparent. In addition to the usual difficulties of dating artifacts, we are confronted with the conservatism and imitative character of religious art, which often means that later works are in a style that imitates an earlier. We can be sure that many Byzantine images have been lost. Often they were painted on the walls of churches or on highly perishable wood, and they were subject not only to the normal accidents and vicissitudes of history like fire and flood, but also to the depredations of warfare (especially in territories that from the eighth century on were under assault by militant Islam, which eventually conquered the entire empire). There is also the difficulty that arises from the pluralism within the Eastern Roman Empire, centered in Constantinople, but extending from Italy to Syria. But in the case of the Byzantine icon, there is also the special problem caused by the two hundred years of the iconoclast movement. During the reigns of iconoclast emperors, there was purposeful removal and destruction of pictorial representations, especially in the areas most directly under imperial control. Although most of the iconoclasts approved of the use of the cross as a symbol, they opposed the portrayal of Christ crucified. Hence there is a certain degree of speculation in the reconstruction of the history of this particular type of image, on the basis of remaining (often later) examples.

Nevertheless, even if we cannot be certain of dates, there seem to be several clear points of development of the crucifixion icon that represent theological concerns. As we have seen, in early Christian painting, East and West, Christ on the cross is portrayed alive and in triumph, with the eternal life of the Logos and the resurrected life of the body—even when the portrayal narratively includes the death of Christ. Meditation on the cross centers not on Christ's suffering as such, but on the idea of God's astonishing condescension. The cross is seen in the light of the doctrine of the incarnation, with a strong affirmation of the divinity of Christ, which not only permits but necessitates the resurrection.

Probably by the mid–ninth century, Byzantine fresco and mosaic art began normally to portray Christ dead (or dying) on the cross (although the earlier triumphant model can still be found, especially in ivory and enamel works intended for liturgical ornamentation). It is most likely that doctrinal considerations were at work in this move. To portray Christ dead on the cross was to affirm the reality of the incarnation, against the Docetism and Monophysitism that were thought to be implied in the positions of some of the iconoclasts. One group of these, the Paulicians, had in fact opposed the use not only of the crucifix but even of the cross, and precisely on the grounds that Christ was not

really crucified. Others were probably orthodox in their Christology and sote-
riology, but opposed icons because of fears of superstition and misuse. But
apologists among the iconodules tended to frame the issue (perhaps unfairly,
one feels, in many cases) in terms of the affirmation or denial of the reality of
the incarnation. Iconoclasm, it was claimed, by rejecting the possibility of pic-
turing Christ must implicitly reject the reality of the real, physical and thus
depictable humanity united with the Logos.[75] The representation of the death
of Christ was therefore a theological refutation of the real or supposed errors
of iconoclasts as well as other Docetistic heretics.

At the same time, Byzantine orthodoxy wished also to affirm—and sym-
bolically portray—the divinity of Christ, even in his death. This led to the effort
to portray the dead or dying Christ in such a way that his suffering body ap-
peared at the same time resplendent with inner life. Byzantine painting and
mosaic art attempted to portray a paradoxical "life in death." What it strove to
represent is stated succinctly in the inscription on a small crucifixion icon from
Sinai: "Who does not shake with fear to see you, my Savior, hanging from the
cross? You wear the garment of death, but you are also clothed in the robe of
the everlasting."[76]

Much of Eastern theology saw the symbol of this "life in death" in the
water flowing from the side of Christ after his piercing with a lance. Eastern
theology was preoccupied with the implications of the dual but united natures
in Christ. One question that arose was: in the light of the incarnation, what
was the status of the body of Christ after his death and before the resurrection,
while his departed soul was visiting hell to trample the devil and release his
prisoners?

The definition of the "hypostatic union" in the fifth century had made it
possible to hold that Christ's death was the separation of his human soul from
his body, but not the separation of the Logos from either.[77] Before this time,
some Fathers—including Athanasius, Epiphanius, Ambrose, Augustine, and
Hilary—had taught that death had meant the separation of the Logos from
Christ's body. For, as Ambrose argues, the Word of God is life itself; it would
be impossible for Christ to die, as long as the Word was united with his body.
Since Christ did in fact die, the Logos must have departed from the corpse.[78]
But the doctrine of the one "hypostasis" allowed one to affirm that the body of
Christ, even when really dead, was still the body "of" the Logos. Hence the
symbolic/theological representations we see in early crucifixion scenes (like
that of the Rabula manuscript) could show the triumphant Logos on the cross
while at the same time indicating the bodily death of Christ.[79]

A related topic was the question of the incorruptibility of Christ's body.
The Fathers took it for granted that the Psalms contained direct prophecies of
Christ's death and resurrection. This was true a fortiori of the verse in Psalm
15 (10), "you will not allow your holy one to see corruption," since it was already
used in the New Testament about Christ's resurrection (Acts 2:24–32). But

how is it that Christ's body did not see corruption? Was it simply that it was quickly raised from the dead, and therefore did not have time to deteriorate, as Augustine and some others held?[80] (This explanation was necessary for those who thought that Christ's death included the separation not only of the soul but also of the Logos from his body.) Or was the body of Christ inherently immune from corruption, precisely because of its union with the Logos?

The extreme form of the latter position was the heresy of Aphthartodocetism, deriving from the Monophysite theology of Julian of Halicarnasus. He held that the body of Christ, even before the resurrection, was divine and naturally incorruptible (*aphthartos*) and impassible (although he could freely choose to suffer). The death of Christ, therefore, was apparent rather than real, since his body, informed by the Logos, was naturally and inherently immortal. The emperor Justinian I proclaimed this doctrine in 564, and he would probably have imposed it on the whole Eastern church had he not died the following year. But one could also hold the incorruptibility of the body of Christ without going to this extreme, on the basis of the hypostatic union—as was taught, for example, by John Damascene.[81] The Logos remains united to the dead body of Christ, preserving it not from real physical death (i.e., separation from the human soul) but from corruption, until the reunion with Christ's human soul at the resurrection.

This theology seems to have exerted direct influence on the Byzantine icon of the crucifixion: the body of the dead Christ is still the abode of the eternal Logos, the principle of life. Hence it is portrayed as glorious and "living," even in the reality of death. Christ on the cross is "asleep"—a metaphor used both for his human death and for the "dormant" divine life in him. This metaphor is used in the Threnodes Kanon of the Good Friday service, and is found in many homilies on the passion. As we have seen, it was sometimes connected with the figure of the lion, which was supposed to sleep with its eyes open—hence the open-eyed Christ of early crucifixes. But it was also behind the new portrayal of the closed-eyed Christ "asleep" in death but still alive through the Logos.

The flow of blood and water from Christ's side began to be understood specifically as the visual expression of this paradox. The flow of blood and water from the dead body, a miracle related in John's gospel, was already portrayed as a part of the entire narrative evoked in the symbolic-style crucifixion scenes of early Christian art. As we have seen, its symbolic sense relating to baptism and the foundation of the church ("from the side of Christ") was already widely exploited. But now this event takes on a new Christological significance in Eastern theology, in the light of the "life-in-death" theology and iconography of the crucifixion. A sermon of George of Nicomedia (late ninth century) testifies to this understanding: the angels are terrified at the killing of the creator, while the effusion of blood and water "bears witness to the simultaneity of life and death, divinity and humanity."[82]

From the sixth century, the Byzantine Orthodox liturgy proclaimed faith in the incorruptibility of the body of Christ in the rite of the *zeon* (from the Greek word for "boiling"). After the consecration and before communion, the celebrant of the eucharist added warm water to the chalice. As we have seen, there was already a tendency to interpret the liturgy allegorically in terms of the death of Christ. The *zeon* rite was meant to signify that the water that flowed from Christ's side when he was pierced was *warm* water—that is, that the body of Christ, although dead, was still warm, as though alive. This accorded with and emphasized what was already a miraculous occurrence, namely the flowing of blood from a dead body. Origen had already called attention to this event, which was no doubt meant by the evangelist to be understood as both a symbol and a miracle. But Orthodox theology now drew a further conclusion: if blood *flowed* from Christ's side, with (warm) water, then the blood in the body was still circulating. The body of Christ, even in death, was incorruptible in the strongest sense: it was not subject to the laws of death because of the presence of the divinity.

In the eleventh century a monk of Studion, Niketas (or Nicetas) Stethatos, proposed a variant theory to justify the *zeon*. After his death, even though its connection with the Logos was weakened, Christ's body was still inhabited by the Spirit, which prevented its corruption by keeping the blood in circulation— so that when Christ was pierced the blood flowed, and the water that accompanied it was warm.[83] Hence "in the chalice we drink the blood very warm [because of the addition of the *zeon*], as it flowed from the Lord, for the blood and water flowed for us from the flesh of Christ that remained warm and living because of the Holy Spirit."[84]

Niketas's theory was widely accepted in the Orient (with the notable exception of the Armenian church), although it was rejected by the West.[85] Whether it had a direct influence on iconography—or served as an ideological explanation for iconographic developments that had already taken place—is a matter of speculation. But there is no doubt that the Byzantine portrayal of Christ crucified had undergone significant modifications just before this time, with elements that continued to be stressed in the period of Niketas. One of these was the emphasis on the flow of blood, represented not as merely flowing out from the spear wound but as a large curve arching forth from Christ's side or as a forceful straight band shooting forth. Examples are seen in manuscripts from Studios, frescos in Cappadocia and the Caucasus, an enamel in St. Mark's in Venice, and mosaics in the monasteries of Daphne and Hosios Lucas.[86] The notion of the "incorruptibility" of the flesh of Christ, whether attributed to the presence of the Logos or to vivification by the Spirit, seems to have been a major theological motive in the development of the classic icon of the "beautiful Christ": Christ's eyes are closed in death, but he remains beautiful, as though merely sleeping.

From the eleventh century, the Byzantine liturgy for Great (Good) Friday

began to undergo changes that both called for new icons (for example, the descent from the cross, the mourning over the dead Christ, the burial, and eventually the "man of sorrows") and encouraged developments in the treatment of traditional themes.[87] Correspondingly, in the late eleventh and early twelfth centuries, a new style of icon painting began to appear, evidencing a new stress on the reality of the passion as a historical human drama, inviting an affective response.

The tendency toward a more "naturalistic" presentation of the crucifixion was part of a general religious trend toward meditation on the passion. In the year 975, the Byzantine Emperor John I Tzemiskes transferred from Berytos to Constantinople an icon of the crucifixion that was attributed to the hand of Nicodemus, the member of the Sanhedrin who was a secret follower of Christ. Since he was presumably an eyewitness of the crucifixion, his image was supposed to present the crucifixion as it happened. Nicodemus was also involved in the burial of Christ, and it was at this same period (tenth century) that the mourning of the dead Christ became an element in the Great (Good) Friday liturgy, in connection with the third "station," the entombment. A major feature of this addition was the *threnos*, or lament of Mary, developed from the sermon of George of Nicomedia mentioned earlier. Although the first known examples of Byzantine representations of the descent from the cross are dated later than this time (twelfth century), the theme may well have been present earlier.[88] Slightly before the year 1204, a shroud from Palestine (possibly the same that was later known as the Shroud of Turin) was exhibited in Constantinople.[89] It was purported to be the burial shroud of Christ (although this claim is difficult to square with the biblical accounts of how Christ was buried). We have already noted the tendency to treat the eucharistic liturgy as an allegory of the death and resurrection of Christ. The practice of portraying the figure of the dead Christ lying on his burial sheet on the *aer*, the covering placed over the bread and wine during the great entrance, probably dates from about this same time—although the symbolic understanding, without the portrayal, is even earlier.[90]

A treatise on the icon of the crucifixion by the eleventh–century scholar and statesman Michael Psellus (1018–1078) shows that its contemporaries were aware of the development of this new, more "humanistic" and historical type of portrayal of the crucified Christ. Psellus claims that the prototype of the icon is not another icon (as was the case with traditional painting) but the event itself of the crucifixion.[91] He calls the new style "living painting": images that "speak" to us through the depiction of emotions and the call to response.[92] The icon in the new style is equated with poetry, which is capable of communicating. Through artistic depiction, it is able to institute a dialogue between past and present.

This applies in a special way to the crucifixion icon. In it, according to Psellus, the artist attempts to present the paradox of life-in-death in the closed

eyes but graceful form of the Christ on the cross: for "such is the body of our Lord . . . animated and yet dead."[93] The painting would "make Christ's life visible even in his death."[94] According to Psellus, in the new icons Christ is shown living

> at his last breath . . . at once living and lifeless. That [the artist] now shows him with exact empathy (*mimésis*) is possible because both [life and death] were united in that moment. As Christ was then living against the laws of nature and despite his pain was dead, so he now allows himself to be painted against the rules of art, because grace makes it possible for art. . . . Thus the dead man seems to be alive, yet one sees precisely what is dead—the body.[95]

As Belting summarizes Psellus's eloquent aesthetics:

> The painter aims at the all-but-impossible task of representing the Hero as both alive and lifeless (*empsychos* and *apsychos*), impossible in that the body, which is the only thing to be seen in the picture, was the dead part of Christ. He did his best by showing Jesus "living, at his last breath" and by giving him the beauty, the "appearance of life" (*empsychôn eidos*), befitting "living painting" (*empsychos graphé*). All the same, God had to guide his hand to achieve the miracle of showing Christ as much "against the rules of art" as he had once lived in death "against the laws of nature."[96]

Another factor in the development of the "humanistic" portrayal of the crucified was an emphasis on the dramatic moment of Christ's dialogue from the cross with his mother. The passage in the Scriptures is very brief, but it was expanded upon by pious meditation. We must recall that piety took it for granted that Mary knew the nature of the incarnation and its purpose from the moment of her consent to it. Nevertheless, she did not grasp the necessity of the cross, and had to be instructed in its necessity for human salvation. In the celebrated homily of George of Nicomedia referred to earlier, the preacher invites the hearers to imagine a (mental?) dialogue between Jesus and Mary at foot of the cross. He uses the words of the Scriptures, but interprets what they mean in the minds of the two. These meditations strongly influenced the development of the Great Friday liturgy of the passion, introducing into the hymns the reactions of Mary as she learns from Christ the meaning of the cross, and initiating in turn a spiritual dialogue of the congregation in sympathy with her. The celebrated poet Symeon Metaphrastes (last half of the tenth century) was author of the ritual liturgical lament. By the twelfth century, the monastic Byzantine liturgy for Good Friday included the Marian Kontakion (hymn) in which Jesus from the cross tells Mary not to mourn and instructs her about the necessity of the passion.[97] The icon of the crucifixion likewise regularly made reference to this dialogue, portraying Mary with the gesture of

the extended hand that indicates speech (and that also reflects the shape of the liturgical spoon used for giving communion).[98]

In general, emphasis on the suffering of Christ on the cross was combined with and mediated by sympathy with the suffering of Mary. The oldest known image of the dead Christ showing his wounds (the *imago pietatis,* frequently known in its Western form as the Man of Sorrows), for example, is an icon from Kastoria, from the twelfth century. Significantly, the facing panel shows Mary with the child Jesus. Because piety imagined that the mother of Christ was aware of from the beginning of his purpose in becoming human, in many icons, the sad-eyed Mary mourns her son's fate even as she embraces the child Jesus.[99] Icons of this "tenderness" genre that parallel the mourning icons were seen first in the twelfth century in Constantinople. They echo the hymns of the Holy Friday liturgy: the joy of motherhood is combined with sorrow at the anticipation of the cross. The common theological theme, the central one of the Patristic paradigm, is the notion of the incarnation of God.

The mosaic of the crucifixion in the church of the Dormition in Daphne, Greece, created about 1085, provides an excellent illustration of the new "humanistic" Byzantine crucifix that developed in the eleventh century. The dialogue of Christ with Mary is clearly indicated by her gesture toward her son. Christ is portrayed, however, after the moment of his death. His eyes are closed, or reduced to mere slits; his head is inclined toward Mary. The blood flows from the wound in his side in a great arch. The body appears not sagging like a dead weight, but erect, as though Christ were standing on the *suppedaneum.* The arms are raised to the level of the head, in a pose reminiscent of the attitude of prayer.

A similar crucifixion is seen in the fresco painting at Hosios Lucas, from slightly later—the first quarter of the twelfth century. Here the body of Christ is portrayed in the sagging S-shape that would become a convention in Gothic painting. The blood from the wounds in the hands and feet flows normally, while the blood from the lance wound spurts forth in a powerful straight jet. The dialogue with Mary is indicated not only by her gesture and by the inclination of Christ's head toward her but by the inclusion of the words "Behold your son . . . behold your mother." The continuity of this tradition can be seen by comparing the Daphne and Hosios Lucas crucifixes to the fresco in the Monastery of Studenica, Serbia, painted in 1209. Subsequent Byzantine iconography follows the same pattern, with little deviation.

The attempt to portray the life-in-death of Christ in pictures, with its new "humanistic" and more "naturalistic" corpus and its appeal to feelings, implies a step away from the older "iconic" model of graphic art. The visual begins to have more importance in relation to the conceptual, and the production of feeling augments the declaration of faith. The painting of the crucifixion becomes more a portrayal of an individual moment in the story of salvation, complemented by portrayals of other distinct moments, rather than a synthetic

theological statement of the whole meaning of the incarnation/resurrection/ apocalyptic return. Nevertheless, we are clearly still far from "naturalism" or physical realism, despite the presence of naturalistic elements. The "realism" of the icon is still of the Platonic kind. Even after its "humanistic" development, the Byzantine icon remains primarily a mediation of presence, not a portrayal of visual perceptions. On the level of content, it uses pictures to present ideas or knowledge (including, in the case of the cross, its transcendent dimension). It is true that portrayal is now more attached to the story, and spontaneously understood more in terms of what happened at specific moments of the narrative and what they "looked like." However, elements of the narrative that were separated in time (for example, Christ's dialogue with Mary and the flow of blood from his side) are still frequently presented in a single image; the context of the whole is the theological affirmation of Christ's lordship, so that even his suffering is seen in the light of glory; and the conception of the whole is dictated by theological and religious motifs, dictated by tradition, rather than by the aesthetic impulses of the artist or indeed of "art" itself. The kind of naturalism and realism that would eventually dominate Western portrayals of the crucifixion remain for the most part foreign to the Byzantine iconic tradition and even offensive to its theological suppositions.

As we shall see, the "humanistic" Byzantine crucifix had a profound influence on the development of Gothic art. However, before we consider that re-merging of the traditions, we must turn first to a period of separation, in which Western theology moved from the common Patristic paradigm into a specifically Western form of Augustinianism adapted to the newly converted Celtic and Germanic peoples. In art, this was the period of the development of the Romanesque—a Western continuation of the Roman heritage, in some ways more dependent on the spirit of ancient Rome than on the modifications that created the Byzantine style, but also modified in its turn by Celtic, Gothic, and Frankish influences. This will be our subject in the next chapter.

3

The Monastic Paradigm and the Romanesque Style

The Cross of Fernand and Sancha

On December 21 in the year 1063, the reigning monarchs of León and Castille, Fernand I ("el Magno") and Sancha, assisted at the consecration of the royal Basilica of San Isidoro in the kingdom of León. They also presented to the basilica an extraordinary gift: an ivory reliquary cross, containing a fragment of the cross of Christ.[1]

Fernand was the son of the king of Navarra. Sancha was the sister of the king of León. Their union permitted a confluence of two distinct cultural currents in Spanish Christianity. The kingdom of León (which Fernand took over after the death of Sancha's brother) encompassed northwestern Spain, including Asturias and Galicia. It was the refuge of the Visigothic monarchy after the invasion of the Moors. It represented political and religious traditionalism. Navarra, on the other hand, was a focal point of modernity. Its territory centered on the lands of the fiercely independent Basques, who had successfully resisted the Visigothic invasions and had only recently fully accepted Christianity. Under Fernand and Sancha, the united kingdom of León and Castille was opened up to theological, religious, and artistic ideas from France—especially the great monastic foundation at Cluny—filtered through the rich religious culture of Catalunya.[2] Some of these influences, combined with Visigothic elements, can be seen in the ivory cross that bears the monarchs' names.

The shape of the cross itself is Latin: it lacks the flared arms typical of earlier Spanish crosses. The figure of Christ stands straight, with the feet on a *suppedaneum,* or footrest. Above his head

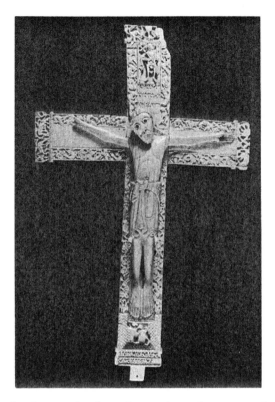

Ivory crucifix of Fernand and Sancha. Credit: Archivo Fotográfico, Museo
Arqueológico Nacional, Madrid.

is the inscription proclaiming him King of the Jews, in Latin, partially abbre-
viated. The hands are nailed through the palm, and the feet are placed next to
each other and attached separately, so that four nails are used in all (according
to the tradition of Cyprian, Gregory of Tours, and Benedict XII).[3] The ribs are
clearly portrayed on the torso, as are the pectoral muscles. The waist is girt
with an embroidered cloth, tied in front. The folds are reminiscent of the
stylized treatment of clothing in manuscript painting. The face is calm; the
lips are closed and slightly curved in a smile. The beard and hair are carefully
groomed, with plaits and curls symmetrically arranged. The head inclines
slightly downward and to the figure's right. Most striking are the eyes: insets
of black jade indicate that they are wide open.

Along the margins of the cross are small figures. Those on the vertical
beam are nude humans, emerging from tombs. Those on the bottom—below
the knees of the Christ figure—are intertwined and face in all directions. Above
this point, the figures tend upward, and become more distinct and individual as
one progresses to the top of the cross. On the crossbeams are nude figures in
grotesque positions, intertwined with animals who bite or grasp at them.

Again, we are reminded of the style of manuscript painting—both Mozarabic and Irish.[4]

At the bottom of the cross, under the feet of Christ, is a nude figure, walking bent over and looking upward: Adam. At the top, above the inscription, is a rectangle representing a doorway. Here we see another figure of Christ, his feet upon the bottom lintel, as though he has just entered. This Christ is apparently nude, but has a cloth draped through his arms in such a way as to cover his genitals. He has the wounds of the nails in his hands and feet. His face looks upward. His left arm is raised; his right carries a flared and jeweled cross on a jeweled staff. Behind his head is a halo, also with a flared cross. He is beardless, youthful. Above and to the sides of the doorway is a tiled roof. Above it is a great bird—the Holy Spirit—hovering over Christ. To its left and right are angels (one of them now lost), who appear to be assisting the ascent of the uppermost figures on the margins of the cross.

The reverse of the cross is also carved. At the juncture of the beams is the (partially broken) figure of the Lamb of God, its head surrounded by a halo with a cross with flared ends. Close to its head, which is facing backward, is another cross, with four equal arms and a circle in the center, superimposed on a floral motif. The cross is filled with intertwined vines, leaves, and flowers, circling around fantastic beasts and birds. There are also human figures engaged in a struggle with demons.

The iconography of the cross is complex but at the same time straightforward. The crucified Christ is the incarnate divine Lord, the risen savior, and the eschatological judge. The cross is therefore the tree of life and sign of hope for salvation from the powers of hell, which continue to attack the Christian.

The connection of the crucifixion with the dead coming forth from the tomb stems from Matthew 27:52–53: at the moment of Christ's death, "behold, the veil of the temple was rent in two from top to bottom, and the earth quaked, and the rocks were split, and graves were opened, and many bodies of the saints who were asleep arose and came out of the graves after his resurrection, and went into the holy city, and appeared to many." Hilary of Poitier's influential commentary on the passage (written about 350) explicitly relates it to Christ's "despoiling" of death[5]—which is in turn the meaning of his descent into hell to break its power, as symbolized here by the figure of Christ above the inscription. The order of the Mozarabic Liturgy attributed to St. Isidore, the patron of the basilica where the cross was housed, contains a reference to this event in the prayer following the "Sanctus":

Truly holy and truly son of God [is] Jesus: he ascended the cross so that death might lose all its power in his death. He descended into hell, so that as victor he might draw out humanity deceived by the old error and slave to sin, and might with a powerful hand break open the locks of the doors, and show the glory of his coming resurrection.[6]

And a sermon of Peter Chrysologus pictures Christ carrying his cross into hell as a kind of battering ram, with which he breaks down the strongly fortified doors—the very image seen here and in so many medieval portrayals of the "harrowing of hell."[7]

The message of the cross also has existential applications: we too shall rise one day (1 Thess. 4:14). Indeed, the iconography of the cross as a whole reflects the Visigothic liturgy for the deceased, leading to the speculation that the occasion for its creation was a funeral or memorial.[8] The figures engaged in struggle with animals recall a verse from Psalm 73:19, used in the Visigothic office for the dead: "do not cast to the beasts, Lord, the souls that recognize you; do not forget the souls of your poor ones." They may also represent the church, attacked by demons in the form of ferocious beasts, yet triumphing in the end because of God's spirit—an idea to be found later in the influential writings of the twelfth-century monk Rupert of Deutz (ca. 1075–1127).[9]

As we have noted earlier in our consideration of Byzantine art, it was a common belief that the lion slept with open eyes. Christ, the Lion of Judah (Rev. 5:5), even in the "sleep" of bodily death, remains the living Word of God, who "neither sleeps nor slumbers" (Ps. 121:4). It is in this sense that the second-century (?) *Physiologus* interprets the verse from the *Song of Songs*: "I was sleeping, but my heart was awake" (5:2).[10]

The Aesthetic Mediation: The Image of the Cross in the Early Middle Ages

Christ the Warrior Hero and the Tree of Life

A triumphal vision of the cross suited the militant character and heroic ideals of the barbarian peoples converted to Christianity in the centuries after the fall of Rome. Moreover, their very concrete mentality was favorably disposed to the cult of the cross as a relic and the gesture of the sign of the cross as a protection against evil. The Anglo-Saxon poet Cynewulf, in his great work, *The Dream of the Rood* (eighth century—before 750), portrays the cross itself meditating on the passion and its own role in it. Christ is portrayed as a divine hero, consciously enduring suffering for the sake of our redemption:

Ongyrede hine Þa geong hæleð,	Then the young hero prepared himself,
(Þæt wæs god ælmihtig),	that was Almighty God,
strang ond stiðmod.	Strong and firm of mood,
Gestah he on gealgan heanne,	he mounted the lofty cross
modig on manigra gesyhðe,	courageously in the sight of many,
Þa he wolde mancyn lysan.	when he willed to redeem mankind.

As in the hymns of Fortunatus, the cross itself is seen as fruitful: it is the tree of life, opposed to the tree that brought death to Adam and Eve. Visual examples of this theme are numerous. It will suffice to mention a few from different periods. In a painting of the crucifixion in the "coronation sacramentary," roughly contemporary with the *Dream of the Rood* (mid-ninth century), the ends of a tau-shaped cross extend into an interlace design that blossoms into a florid golden vegetation that fills the page.[11] (Although it is very common in the Romanesque period, the "tree of life" theme endures both in literature and in art well into the Gothic period and beyond. St. Bonaventure's celebrated meditations on the passion, which we shall consider in the next chapter, are called *The Tree of Life*. One of the most eloquent visual examples of the conception of the cross as the "tree of life" is seen in the so-called Cloisters cross [sometimes known as the Bury St. Edmund cross, from its probable place of origin].[12] And in the early Gothic period the theme is evidenced in the popularity of the so-called *Astkreuz*, or fork cross, in which a forked tree-trunk replaces the usual crossbeams of the crucifix.)

An even more radical case of "inculturation" of Christianity into Germanic culture is found in the ninth-century Old Saxon poem the *Heliand*.[13] Here, as in the *Dream of the Rood*, Christ is seen as a heroic warrior, overcoming the forces of Satan. He is called *drohtin*, the Saxon title for a warrior-chieftain. His disciples are his "thanes," or warrior-companions. The passion section is particularly revealing. In the garden of Gethsemane, Jesus not only finally accepts the "chalice" of suffering that the Father wishes him to drink but makes a thane's salute to the chieftain before drinking it: "I take this chalice in my hand and drink it to your honor, my Lord Chieftain, powerful Protector!"[14]

The arrest scene "depicts Christ and his disciples as an embattled warrior group making their last brave stand against a superior enemy force,"[15] much like the heroic Anglo-Saxons battling the Vikings in the later poem *The Battle of Maldon*. Far from abandoning Christ at his arrest, the disciples form a defensive perimeter around their chief, ready to give their lives for him:

> Christ's followers, wise men deeply distressed by this hostile action
> [of the warriors come to arrest him], held their position in front.
> They spoke to their Chieftain. "My Lord Chieftain," they said, "if it
> should now be Your will that we be impaled here on their spear-
> points, wounded by their weapons, then nothing would be as good
> to us as to die here, pale from mortal wounds, for our Chieftain."[16]

Simon Peter, a "noble swordsman" and a "very daring thane," cuts through the ear and cheek of Malchus, giving him a mortal wound. It is only at Christ's command that resistance ends. He explains that he must undergo the "workings of Fate"—for the ancient Saxons, the ultimate determinant of reality, but here a power subject to God's will. In stark contrast to Patristic theories of the

deceit of the devil, in the *Heliand* Satan works to *prevent* the crucifixion of Christ, for he knows that this event will mean his defeat and the destruction of his kingdom. It is Satan who sends Pilate's wife the dream that causes her to tell Pilate to "have nothing to do with this just man."

The cross itself is interpreted as a tree or gallows: "The Crucifixion is thus brought home to people accustomed to seeing prisoners of war, criminals, and even oxen, hanging from trees sacred to Woden as a religious sacrifice."[17] Moreover, there is a replacement of Woden himself by a new Lord: in the story of the crucifixion, "the listeners heard clear echoes of the hanging of Woden in the cosmic tree when he tried to learn the answer to the riddle of death, and discovered the mysterious runes."[18] The death of Jesus is accomplished through Fate (*wurd*), which is God's power. Throughout the *Heliand's* passion account, G. Ronald Murphy remarks, Jesus is portrayed as a captured prisoner of war—as many of the Saxons themselves had been under the conquests of Charlemagne. Murphy's analysis continues: "The death of Christ is brilliantly treated as an *escape* of a prisoner of war from his captors, and the resurrection as the return of the warrior leader to his own people. The enemy from whom Christ escapes is transformed from the Roman army to death itself."[19]

After the resurrection, Christ ascends to the right hand of God, where, like Woden, he is able to observe all that happens in the world. But, as Murphy observes, Christ in the *Heliand* has surpassed Woden. "Not only has he overcome fate's power over people, He has overcome His own fated death by His own strength, 'the power of the Chieftain.' He is therefore worthy of taking Woden's place and of being seated upon the throne, and thus of assuming the old god's final function of observing all that happens in the world."[20]

The *Heliand*, of course, is directed to the very specific situation of a particular group. Nevertheless, it can serve as an example—albeit an extreme one—of the mentality that met Roman Christianity during the early Middle Ages. Through the eyes of the Germanic warriors, the metaphor of the battle against the power of Satan takes on a new concreteness. It is through such eyes that we must look at the early medieval representations of Christ triumphant on the cross.

The Early Medieval Crucifix: Christ in Majesty

As we saw in the previous chapter, the earliest Western models of the crucifix stressed the divinity of Christ and the theology of the cross as the instrument of God's victory, rather than a naturalistic presentation of the event of the crucifixion. The types represented by the early ivories, the crucifixion scene in Santa Maria Antiqua, and the Rabbula gospel book were repeated, with local variations, throughout the early Middle Ages.

The violent iconoclast controversies in Eastern Christianity had little effect on the West. There was a certain mitigated "iconoclasm" during the ninth

century. Carolingian theologians had rejected an understanding of images as being some kind of locus of power, and rejected the superstitious adoration of images. ("Adoration," of course, in its original sense signified "praying to," *adoratio*). In the following years, there were instances of the prohibition of the use of images inside churches—for example, by St. Agobardus of Lyon. But even Agobardus, for all his suspicion of images, joined in the Western consensus that approved of their use for didactic purposes.

However, there was one celebrated instance of Western iconoclasm in the Ottonian period that had direct bearing on the portrayal of the crucifixion of Christ. A certain Claudius, a contemporary of Agobardus, was sent in 826 by the Emperor Louis the Pious to take charge of the diocese of Turin, in northern Italy. He found the churches full of images, and proceeded to get rid of them. In his defense of his actions, he concentrates primarily on the standard iconoclast arguments against the honoring of images in general. However, he includes a remarkable paragraph specifically directed against the depiction of the crucifixion:

> These practitioners of false religion and superstition [who defend the use of the cross] say: "It is for the sake of remembering our Savior that we accept and venerate and adore the cross painted and designed to honor him." But what pleases them about our Savior is nothing other than what pleased the nonbelievers [*impiis*]: that is, the disgrace of the passion and the degradation of death. They believe about Christ the same as nonbelievers, whether Jews or pagans, who deny his resurrection, and cannot think of him except as suffering and dead; and they believe in him and hold him in their hearts permanently undergoing his passion, and they do not attend to or understand what the Apostle [Paul] says: "Even if we once knew Christ according to the flesh, now we no longer know him this way."[21]

To such people Claudius says: "You recrucify the Son of God." Christ told his disciples to take up the cross, not to adore it.[22] (Interestingly, a similar line of reasoning would be adopted by later dissidents, including the Cathars. "If they hang your father, will you adore the rope they hanged him with?")[23]

A monk named Dungalus wrote a response to the "perverse" opinions of Claudius. He acknowledges that there is a conflict: some say that the cross is good and holy, the banner (*vexillum*) of Christ's triumph, and the sign of eternal salvation. Others, however, say that in the cross all that is shown and remembered is the disgrace of the passion and death of Christ. The same could be said for the relics of the martyrs who died for Christ. (This remark is particularly significant in its times, an age that had a passion for relics.) Dungalus's final argument does not address Claudius's specific complaints about the cross, but simply repeats the celebrated dictum of Gregory the Great about the di-

dactic value of art: it is one thing to adore a picture, and quite another to learn
through a history in pictures what is to be adored. "For what the Scriptures
present to those who can read is made present to the uneducated by looking
at pictures; in them the ignorant see what they should follow; in them those
who do not know letters are able to read."[24]

It is unclear from Claudius's text and Dungal's response whether they are
referring to painted crucifixes—that is, with the corpus of Christ—or to the
cross itself, even without a figure, or to both. The Eastern iconoclasts generally
rejected images of persons, but they permitted and even encouraged the use
of the cross (without corpus) as a symbol. But we know that in the Carolingian
West, there existed crucifixes as well as decorated crosses without a corpus.
On the former, the portrayal of a regal, triumphant Christ on the cross was the
norm. A great variety of styles is seen, mixing symbolic and historical ele-
ments.[25] In some cases, Jesus is still clothed in the antique manner, or, alter-
natively, in the *colobion* robe typical of the "Syrian" style; in others, he is nude
except for a linen cloth about his waist (a detail derived from the fourth-century
apocryphal *Gospel of Nicodemus*).[26] In the following Ottonian period, a more
"narrative" type of crucifix also appears, with Jesus dead on the cross. The
appearance of such crucifixes, found especially in Germany and England, was
perhaps a reflection of developing eucharistic doctrine.[27] Beginning in the late
tenth century, large wooden reliquary crucifixes often show Christ dead. These
crosses, of which the gift of the Archbishop Gero to the Cathedral of Köln
(Cologne) is the earliest extant example, were positioned behind a special "altar
of the cross" on a triumphal column. (Later they would be moved to the top of
the "rood screen" that separated the clergy in the sanctuary from the laity in
the body of the church.)[28]

In northern Europe, such portrayals coexisted with the older type from
about the mid-ninth century onward. But in most Western art of the Roman-
esque period, the triumphal theological element prevails over historical real-
ism: Jesus' head is usually surrounded by a halo; he sometimes wears a golden
crown; and most frequently, despite the fact that "narratively" he has died, he
is portrayed iconically, alive with the divine life that would be manifest in the
resurrection.[29]

The more "iconic" representations of the crucifixion do not attempt pri-
marily to present its historical appearance, but rather to mediate the presence
of the person of Christ. Unless they form part of a series of representations of
different moments, they tend to synthesize the theology of the entire passion/
resurrection narrative and to anticipate Christ's apocalyptic return as judge.
Thus the event of Christ's death (sometimes, but not always, explicitly repre-
sented by the flowing sacrificial blood)[30] is portrayed in the light of the union
of his humanity and divinity, and therefore in consciousness of his victory over
death and hell, and of his impending resurrection. The wide-open eyes of the
crucified symbolize Christ's divine life, even in death. We are not so much

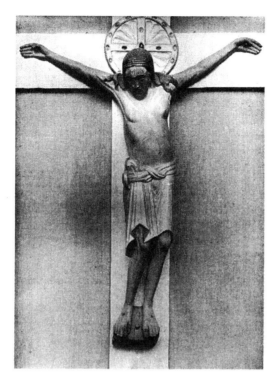

Crucifix of Archbishop Gero, Cologne. Credit: Foto Marburg / Art Resource, New York.

confronted with a narrative moment (although this is of course included in the memory) as with the presence of the Lord who is high priest, king, and coming judge. (See for example the twelfth-century Imerward crucifix, with its clothed, open-eyed, and stern-looking Christ).

In contrast to the Imerward cross, the lips of the crucified on the cross of Ferdinand and Sancha seem to show a slight smile. More striking to the modern viewer are portrayals of the crucified Jesus in which he is shown very openly smiling or even laughing on the cross. Probably the best known example of this type is the crucifix of San Damiano in Assisi, whose figure of Christ, according to legend, spoke to St. Francis, telling him to restore his church. This is a *croce dipinta*: a flat wooden cross, with a painted figure of Christ. There are also a number of crucifixes from northern Spain and Catalonia in the twelfth century with sculpted figures of Christ that clearly emphasize his smiling lips. In some of these, Christ is clothed in the *colobion*; in others, he wears only a loincloth. In many, but not all, he is crowned. In some, the marks of the passion—for example blood streaming down the forehead—are apparent. Yet the smiling face is serene, even joyous.

In this crucified yet smiling Christ we can discern several levels of "aes-

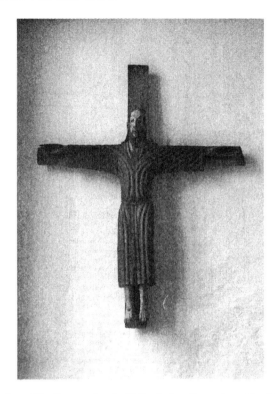

Imerward crucifix. Braunschweig Cathedral, 12th century. Credit: Erich
Lessing / Art Resource, New York.

thetic theology" at play. The Catalan and Spanish crucifixes are in the *genre* of
the *majestat* (Spanish *majestad*): they portray the lordship of Christ and his
"priesthood," as understood through the medieval interpretation of the Letter
to the Hebrews. They also refer, sometimes explicitly, to the coming Christ,
understood through the Apocalypse. (It was natural that this theme, which
appeared in the apses of early basilicas, should be transferred to the majestic
Christ on the cross.) They are primarily an "iconic" type of art: a means of
presence. However, the present and apocalyptic lordship and priesthood of
Christ are tied to the historical event of the cross. Hence the images portray
or at least evoke narrative elements: the cross itself, sometimes the signs of
suffering on Jesus' brow. But the event is seen in Johannine perspective: Christ
is the Logos in majesty on the cross. We see the truth of what happened in the
crucifixion, not its mere physical appearance.

The smile of Christ therefore reminds us that the One who suffered on
the cross is the incarnate Word, as the Council of Ephesus (431) taught: "If
anyone does not confess that the Word of God suffered in the flesh, and was
crucified in the flesh, and tasted death in the flesh, let that person be anathema"

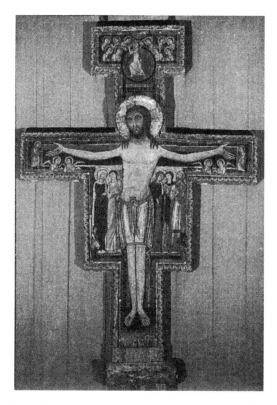

The cross that spoke to St. Francis, San Damiano. Current location: Santa Chiara, Assisi. Credit: Scala / Art Resource, New York.

(DS 263). Yet, despite the reality of his human suffering, in his divinity Christ remains impassible: he is inseparable from the eternal bliss of God. This is the doctrine of the Council of Chalcedon (451), which emphasized the impassibility of the divine nature of the Word, against those who "stupidly" claimed that there was in Christ a single nature that was both fleshly and divine, and who "astonishingly" affirmed that the divine nature of the Son was itself capable of suffering (DS 300).

The smile is also a sign of the Christus Victor theme that dominates Patristic soteriology. The cross is the means of Christ's triumph over sin and death: a triumph already manifested in the resurrection, and to be consummated at the Last Judgment. Frequently, as in the cross of Ferdinand and Sancha, there is explicit iconographic connection to the Apocalypse.

In this light, we may wonder whether the triumphant smile of Christ may imply not only the joy of triumph but also an element of derision of Christ's enemies. Medieval thought tended to read the psalms as prophecies of the passion,[31] and to interpret the passion in light of the psalms. In the Messianic

Psalm 2 we read: "The kings of the earth rise up, and the princes conspire together against the Lord and against his anointed. . . . He who is in heaven laughs, the Lord derides them." Already the Acts of the Apostles, quoting this verse, identifies those who "conspire against the Lord" with those who put Jesus to death: "Herod and Pontius Pilate in league with the Gentiles and the people of Israel" (Acts 4:24).[32] Since the first part of the verse refers to a conspiracy against the Lord's anointed (the Messiah, Christ), it was natural for Christian commentators to read the remainder of the verse as referring to the risen Christ (so Augustine, Remigius, and Cassiodorus, among others). An early (fifth century?) commentary says that Christ, "who rose from the dead, and reigning already dwells in heaven, when he comes for judgment will show them [namely those who conspired against him] to be worthy of laughter and derision."[33] The same commentary cites Proverbs 1:26, where Wisdom (equated exegetically with Christ, the Logos) says of those who rejected her counsel, "I in turn will laugh at your doom, I will deride you when terror overtakes you."[34]

We may probably presume that the medieval artists and viewers—or at least the clergy who directed the making of artworks—would be cognizant of this dimension of the symbolism of the smile or laughter of Christ. But if it is in the background, as one of the meanings of a polyvalent symbol, nevertheless in most cases the predominant message of the smile on the lips of the triumphant crucified seems to be positive. In one famous Catalan example, the smiling face is pointed upward: Christ seems clearly to be smiling in love toward his Father. Most frequently, the smile is directed to the viewer. In no portrayal is there any hint of a sneer, as the word "derision" might indicate (although this would in any case be unexpected: it would be inconsistent with the divine dignity of Christ.)[35] On the other hand, a similarly open and apparently joyous smile appears in the same period on Catalan statues of the Virgin and child. In these cases, the smile appears not merely to express an inner peace (as with the detached half-smile that we see so frequently on the face of sculpted Buddhas) but also to be outward directed. In combination with the wide-open eyes, it engages the viewer directly, in a person-to-person manner. Its primary meaning is iconic: it mediates the presence of Christ, smiling upon us with a regard of joyous benevolence. It gives us the message that we instinctively take when we see a smile on the face of someone engaging us: it says that he is happy to see us. For the believer, the triumph of Christ over death and sin is reason for joy.

Even where we encounter representations of Christ dead on the cross, the remembrance of the crucifixion takes place in a theological rather than a purely historical context. The purpose of its portrayal is not to show what the cross looked like at a particular moment but to evoke the whole story of the passion as a salvific event, in the light of faith in Jesus as the incarnate divine Logos, the conqueror of hell, the resurrected Lord. In this period, art is oriented to

the theological meaning of the cross, rather than its external appearance. Especially in Byzantium and in the Western art that came under its influence, "the crucifixion scene remained immersed in an atmosphere of great nobility, where the sentiments of sorrow always yielded first place to the contemplation of the mystery."[36] In this sense, while we may call such portrayals "narrative," they have at the same time an "iconic" function. Their purpose is not merely to inform the viewer but to evoke the saving presence of what the narrative recounts. The blood that is frequently portrayed flowing from the side of the victorious Christ is the purifying stream in which the world is washed, the blood of the paschal lamb that marks the faithful. Christ reigns from the cross.[37]

The Theoretical Mediation: The Theology of the Cross from Gregory the Great to Abelard

The Theory of Salvation in the Early Middle Ages: Gregory the Great

As we have seen, the cultural and spiritual mentality of the early Middle Ages was congenial to the image of Christ as victor on and through the cross. The victory of Christ included the defeat of the devil, of Death personified, and of all the forces of evil. We have also seen that there is abundant support, both in the New Testament and in the Fathers, for such a "militant" view of Christ's work. Nevertheless, on the theoretical theological level, the predominant paradigm for understanding the victory of the cross was Augustinian, in particular as the great Father's teachings were expanded and popularized by the sermons of Gregory the Great (540–604).

Gregory greatly stresses the Christus Victor theme. In his hymn for Palm Sunday, for example, he addresses Christ as "conqueror" (*Victor*) and King, speaks of his spirit as "powerful," and, like so many of the Eastern Fathers, contrasts the ignominy of the cross with the infinite (but hidden) majesty of the One who underwent it.[38] However, in his theological writings Gregory insists that the Lord defeated the devil by reason, not by force (*non virtute sed ratione*). As Augustine had said, the devil had some kind of rights over humanity: "he held humanity in his captivity as it were justly" (*quasi juste*). The reason for this is that humanity in Adam had freely placed itself under the devil's unjust sway, choosing to make itself a debtor to death. Again following Augustine, Gregory takes it as self-evident that only some kind of sacrifice to God could erase humanity's guilt. Animal sacrifice, however, would be inadequate; only a rational being could suffice as the offering for sin that took place in a rational being. But the sacrificial victim would have to be without sin himself. For this reason the Son of God became human by a Virgin birth, so

that he could receive human nature, but not inherit human guilt. By means of his sacrifice, then, we could justly be absolved of sin.[39]

The sacrificial theory seems to imply that it is God—or God's justice—that must be appeased in order for humanity to be absolved from sin. Nevertheless, Gregory affirms that the devil has some kind of rights. He does not explicitly explain how sacrifice to God undoes those rights. We may probably assume that he understood that the "rights" of the devil depended entirely on humanity's alienation from God. When this was overcome, those "rights" presumably disappeared. However, Gregory also repeats the earlier Patristic theory of God's "tricking" the devil out of his rights over humanity. Specifically, he likens the humanity of Christ to the "bait" that hides his divinity, on which the devil is "hooked" like a fish. When the devil unjustly wished to deliver Christ to death, he lost us, whom he held with some kind of right. (Interestingly, Gregory consistently modifies the notion of the justice of the devil's "rights" over us with a "quasi.") Here Gregory does not hesitate to appeal to the hidden power of Christ's divinity, which transfixes the devil and overcomes him.[40] Nevertheless, here also there is a "rational" form of redemption, rather than mere violent conquest: for the entire schema of the "deceit of the devil" depends on the supposition that the devil indeed had some kind of right over humanity that had to be overcome in order for us to be saved "justly."

Anselm and the Satisfaction Theory

In the period that was to serve as prelude to the scholastic era, St. Anselm of Canterbury (1033–1109) produced a theory of salvation that was to influence the language of theology for over half a millennium, and that remains influential today. Anselm's purpose in his book *Cur Deus Homo* (*Why God [Became] Human*, written between 1097–1100) is apologetic: like Athanasius, he wishes to show to nonbelievers (now Muslims and Jews, rather than pagans) that the incarnation is a reasonable doctrine.[41]

Prior to Anselm, Western theologians tended to repeat the soteriology of the Fathers, with particular emphasis on St. Augustine and Gregory. For example Bruno of Segni (1048–1123), Anselm's younger contemporary, does little more than reiterate essentially Augustinian ideas in explaining why God the Word became flesh. Bruno sees the motivation for our redemption in God's desire to restore the original order of creation, disturbed by the sin of the rebellious angels, and to do so by saving humanity from the devil's power through sacrifice:

> The omnipotent and merciful God, lest his works be rendered powerless or foolish, since God is truly powerful and perfectly wise,
> since He could not use a just humanity to reestablish the order of angels fallen through sin, determined to redeem that order through

unjust humanity, which was difficult. Therefore first God had to snatch humanity from the power of the devil, and thus God determined to restore the angelic nature itself; and this not without a sacrifice [*immolatio*].[42]

As we have seen, Augustine thought that the devil had "some kind" of rights over humanity. Bruno presumes the same: humanity must be "snatched" from the devil's power. Likewise, Augustine takes for granted that sacrifice is a means of worshipping God and of seeking the restitution of humanity. Bruno similarly accepts the idea without examination. He seeks the need for the incarnation in the nature of a *fitting* sacrifice for the sake of a rational creature: such a sacrifice must itself consist of a rational creature. But no human was worthy to be this sacrifice, since all are affected by original and personal sin. The angels were unsuitable for this task: they are incorporeal, while a sacrifice must be visible; they would not be disposed to become incarnate and die for unjust humanity; and if one did so, there would be a danger of idolatry toward this angelic savior. The only remaining possibility was for the Creator to save humanity through the assumption of a human nature that could offer fitting sacrifice for all humans. All of this is already contained in Augustine. But in explaining why it was the Son among the persons of the Trinity who undertook to be incarnate, Bruno refers not to the ideas of ransom or payment or conquest, but to the theme of deceiving the devil: "It was fitting only to Wisdom, that is, to the Son of God, to wisely deceive the devil."[43]

One of Anselm's principal motivations is to reject the idea that the devil has any rights over humanity, or needs in any way to be outwitted by God.[44] Instead, he centers his argument on the idea that only a being who is both human and divine could offer God appropriate "satisfaction" for sin's offense against God's "honor."[45] The notion of "satisfaction" had strong traditional roots. In content, it is not far removed from the ideas already common in the theology of redemption: the "propitiation" of God by right sacrifice, the fulfillment of God's just sentence, the substitution of Christ for humanity in "payment" or redemption. The word "satisfaction" itself was frequently used by the early Fathers (in particular Tertullian and Augustine) in the context of penance. Celsus had even applied the idea to Christ as our "satisfaction" and "appeasement" to God.[46] Anselm's near contemporary Radulfus Ardens had anticipated him in using the term for Christ's redemptive work—although he applies it to Christ's humility in being incarnated, rather than to his death.[47] Moreover, the early medieval penitentials had developed the patristic idea of satisfaction for sins through penance in terms of "redemption"—a concrete penance is a kind of price paid for one's sins. They use the words *redimere* (redeem, buy back) or *se redimere* (redeem oneself). The commercial analogy was strengthened by the fact that one could pay someone else to satisfy one's penitential obligation, or could in place of it pay to have a certain number of masses celebrated.[48]

It was Anselm, however, who made the notion of "satisfaction" the key to a theoretical system of soteriology. Moreover, he provided the major theological impetus for understanding "satisfaction" in the context of reparation for an offense against the "honor" of God. Again, the notion of God's "honor" was not new: it occurs in the Fathers and early theologians, frequently in conjunction with "glory." It names both an attribute of God's majesty and what is "owed" to God by humanity and "given" in worship.[49] Sacrifice was already seen as a means of honoring the deity; and so Christ's sacrifice could be understood as being a means of giving to God the honor owed by creatures.[50] It has been suggested that the notion of "honor" in Anselm's feudal society was influenced by the Germanic concept of êre, which was focused more on external splendor or standing than was the Latin honor, which was a more interior and moral quality (although it also involved external recognition).[51] Timothy Gorringe points out that there are sources for Anselm's thought in both the Latin and Anglo-Saxon legal traditions. "In Roman law, just being rediscovered in the schools of Pavia and Bologna, satisfactio referred to compensation to an injured person other than by direct payment."[52] And in Anglo-Saxon law there existed a system of fines in payment for criminal offenses, including homicide. This system, which Tacitus had admired among the Germanic tribes,[53] was intended to avoid blood feuds. The amount of the payment for a person's life—the wergild (from wer, man; gild, price, yield)—depended upon the social status of the offended person.[54]

Hence we can say that the positive content of Anselm's satisfaction theology was not really new. As the great historian of the atonement Jacques Rivière puts it, the "satisfaction" theory was really a restatement in "scientific" form of the old doctrine of redemption. But this was in itself significant of a new theological paradigm: Anselm represents one of the beginnings of the scholastic effort to understand faith in rational terms. Part of the context of his writings is the more cosmopolitan setting in which Christian intellectual life was beginning to live. As we have seen, Anselm had an apologetic goal in mind in writing his Cur Deus Homo: he wished to show the rationality of the doctrine of the incarnation in light of its rejection by Jews and Muslims. Debates—both real and literary—between representatives of these groups were taking place in England and elsewhere during Anselm's lifetime. (Jews of course were the primary intellectual opponents in the north of Europe; Muslims were involved in similar debates in Spain). Such debates, appealing to reason as well as the principles the religions had in common, were a significant step beyond the blind hostility and prejudice that often characterized popular and political relations between the groups. In the "Disputation of a Jew with a Christian concerning the Christian faith" (Disputatio Judaei cum Christiano de fide Christiana) written by Gilbert (Gislebertus) Crispinus, abbot of Westminster, and sent to Anselm for his approval, we note a typically eirenic tone. The Christian replies to the Jew's questions and objections concerning Christianity: "It is reasonable

enough for you to ask about all these things, and it is fitting to inquire concerning them; but in return, I will ask that you have patience with me."[55]

At the same time, we might consider Anselm's attempt to explain the ancient metaphor of redemption on the basis of the idea of a debt to "honor" as a kind of "inculturation" of Patristic theology into the emerging Franco-Germanic world of feudal chivalry, with its incipient "code of honor." And, finally, the satisfaction theory fit with and supported the already developing spirituality of personal affective relationship to Jesus.

Like Athanasius, Anselm argued that satisfaction must be accomplished by the freely accepted *death* of the God/man. Everything else in human existence is owed to God; but the death of a sinless person would be a gratuitous offering (presuming, with the traditional reading of Genesis, that death is the result of sin.)[56] And the death of a divine person alone would have the infinite value needed to satisfy God's honor.[57]

Anselm foresees and clearly states the obvious objection to this schema: "it is a strange thing if God so delights in, or requires, the blood of the innocent, that he neither chooses, nor is able, to spare the guilty without the sacrifice of the innocent."[58] But he nevertheless wishes to show that the death of God's Son is "reasonable and necessary" (1, 10). It would not be right or proper (*non decet, non convenit*) for God to cancel sin without compensation or punishment; otherwise, there would be no difference between the innocent and the guilty (1, 12), and this would be unsuitable for God. In his "Meditation on Human Redemption," Anselm acknowledges that all things are possible for God:

> Was it then another kind of necessity [than a debt to the devil] that
> made the highest humble himself so, and the mighty one labour so
> much to do this work? But all necessities and impossibilities are
> subject to his will. What he wills, must be; what he will not, cannot
> be. Therefore this was done by his will alone. And because his will
> is always good, he did this solely out of goodness.[59]

Nevertheless, Anselm's statement should not be read as an absolute voluntarism: the context of his thinking is still largely Platonic, and he presumes that concepts such as justice and beauty refer to realities because they are rooted in God's essential being. Hence God's liberty is not such that God could do anything against the divine dignity (*indecens*) or do anything improper (*inconveniens*) to the divine nature. It is not necessary for God to redeem humanity; the "need" is all on our side. But if humanity is to be redeemed, it must be in accord with the divine nature: God must be just (1, 12).

> God was not obliged to save mankind in this way, but human nature
> needed to make amends to God like this. God had no need to suffer
> so laboriously, but man needed to be reconciled thus. God did not
> need to humble himself, but man needed this, so that he might be

raised from the depths of hell. The divine nature did not need nor
was it able to be humiliated and to labour. It was for the sake of hu-
man nature that all these things needed to be done, so that it might
be restored to that for which it was made.[60]

Anselm has therefore added something to the notion of redemption as
conceived by Athanasius: he moves from the notion of substitution in punish-
ment to an attempt to explain the need for Christ's death on moral grounds.
Christ's death is not merely a matter of fulfilling a divine sentence of punish-
ment; it has to do with the intrinsic order of the universe and with God's very
nature as supreme goodness.

Anselm is quite explicit about this. God's "honor" is intrinsic to God. It is
not subject to injury or change. But the creature injures itself in not honoring
God. The sinner "disturbs the order and beauty of the universe, insofar as he
or she is a part of it, although the sinner cannot in any way injure or tarnish
the power and majesty [dignitas] of God." It is impossible for God to lose honor;
for either it is rendered, or God takes it by punishment of those who offend
against it (1, 14). Even sin must serve the order and beauty of the universe, in
God's infinite wisdom: either by reconciliation, or by punishment. "For when
it is understood that God brings good out of many forms of evil, then the
satisfaction for sin freely given, or if this be not given, the exaction of punish-
ment, hold their own place and orderly beauty in the same universe" (1, 15).
"For the free satisfaction for sin, or the exaction of punishment from the one
who does not satisfy (given that God brings good out of many-faceted evil),
have their place in the universe and their own beauty of order." Otherwise,
there would be deformity in the ordered beauty of the universe, and God would
be deficient in ordering, which is unthinkable. Indeed, a significant (although
secondary) theme of the Cur Deus Homo is that the creation and salvation of
humanity are a means of God's bringing good out of the fall of the angels,
whose number is to be made up by us.

At the same time, the "debt" that we owe God is nothing other than up-
rightness of will: and this means recognizing God as our end (1, 11). We cannot
achieve happiness except in this way. Concretely, this means that we cannot
achieve our goal of beatitude except by the remission of sin (1, 10). And re-
mission of sin cannot take place without a righting of the disorder that sin
causes to the order and beauty of the universe: "without voluntary payment of
the debt, God cannot let the sin go unpunished, nor can the sinner attain
happiness" (1, 19).

Anselm also incorporates the Christus Victor theme into his theology of
satisfaction. Honoring God is also the conquest of the devil. But through the
cross of Christ, humanity conquers in weakness and mortality, to make up for
sin committed in strength and vigor (1, 22).

In summary, then: by the incarnation, divine love provides the means of

satisfying divine justice. Ironically, however, Anselm's attempt to justify the traditional teaching on the incarnation ends up placing all soteriological value in the single moment of Christ's death. The incarnation itself is reduced to the necessary condition for the sacrifice; the resurrection is reduced to a consequence.

"Satisfaction" and Devotion to the Humanity of Christ

As we have seen, in St. Anselm's classic version of the "satisfaction" theory, human sin is an offense against God's honor that can only be fittingly remedied by the incarnation and passion of a divine Person. The death of Christ, therefore, became the central, if not exclusive, moment of salvation. It was seen as the reason for the incarnation itself.

Anselm himself saw the spiritual implications of his theory. Since *every* (mortal) sin is an infinite offense, and requires infinite satisfaction, *each* individual sinner may rightly regard the death of Christ as God's sign of personal love for him or her. *My* sins are sufficient reason for Christ's death. In a prayerful discourse attributed to Anselm we read: "The cause of your death was my iniquity; my sins produced your wounds."[61] But this means that I am also the "reason" for the incarnation, which takes place for the sake of the redemptive passion.[62] Anselm writes:

> For what can be thought of more merciful than this: that God the
> Father says to the sinner, condemned to eternal torment and not
> having the means of redeeming himself: "Take my only begotten
> and give him as your price." And the Son himself says: "Take me,
> and redeem yourself." For this is what they say, so to speak, when
> they call and draw us to Christian faith.[63]

In his grateful response to the redemption of humanity through the passion, Anselm also exemplifies another important development in medieval spirituality: the spread of the notion of prayer as dialogue with Christ. As we have seen, Anselm conceives the interior action of grace as God's "word" to those called to faith. This word, when it evokes a conscious response, constitutes a particular kind of prayer: not merely contemplation, or the thankful recollection of God's salvific deeds, but a kind of active dialogue between the eternal God and the temporally situated believer. Significantly, such dialogue can be carried on not only with God the Father but also with Christ. Since the time of the Council of Carthage (397), the church's liturgical prayer in general—and in particular, the eucharistic prayer—was addressed to the Father. Private prayer, however, continued to be addressed to Christ. This practice was developed further in the eleventh century, with particular emphasis on the humanity of Jesus and especially on his passion.[64]

From about the time of Anselm, in fact, we see the development of a new

sense of personal relationship in prayer to Christ, and a new affective appreciation of his humanity.[65] On a dogmatic level, the affirmation of the real humanity of Christ had been crucial to orthodox faith since the time of the Council of Chalcedon (451). And, as we shall see, this affirmation had important effects on Byzantine art, specifically in the portrayal of the crucifixion. One can also find anticipations of the later devotion to Christ in church Fathers like Clement of Rome, Ignatius of Antioch, Augustine, John Chrysostom, the Cappadocians, among others.[66] Nevertheless, as we saw earlier, it was the divine lordship of Christ, manifested in his resurrection/ascension, and anticipated in his expected return, that was the primary focus of attention during the first millennium of Christianity.

In the eleventh and twelfth centuries, the spirituality of Benedictine and Cistercian monks began to turn toward Christ's humanity. Important figures in the development were Peter Damian (1007–1072) and John of Fécamp (990–1078). But Anselm was among the most influential—to the point that the new movement has even been called the "Anselmian revolution."[67] Not only his theology but also his prayers were widely circulated, and their spirit was imitated by his disciples. This spirit of prayer included an intense personal relation to Christ, centered on gratitude for the salvation accomplished by his passion. His prayers and meditations, and those of his disciples, frequently explicitly reflect Anselm's theology of redemption.

In the "Discourse on the Passion of the Lord," addressed to "Lord Jesus Christ, good shepherd, who deigned to die for your flock," we read:

> none could satisfy for sin except a human, and none could absolve except God. He who for himself owed nothing, mercifully became human, and by dying for us paid our debt. . . . O good Jesus! O loving Jesus! What shall I give to you, what shall I undergo for you, who underwent so many things and so much for me? The proof of love is manifest in works. What then shall I do, who all unworthy have received so much? Receive what is your own, and do with your servant what pleases you.[68]

And slightly further on:

> Shall I rejoice in your death, or sorrow over it? I shall rightly do both: I will rejoice indeed in the grace of the one who gives it, and in the love of the one who dies. But first I shall sorrow over the cause of his death, that is, over my consciousness of sin, and I shall share the sorrow of the dying one. If I do not rejoice, I am ungrateful; if I do not sorrow, I am cruel. But since the time of sorrow comes before the time of rejoicing, I will walk sadly, with bowed head, and I will make your passion mine.[69]

A disciple of Anselm wrote a number of private prayers (long attributed to Anselm) intended for priests to say while celebrating the eucharist. They stress the real presence of Christ, and especially his passion. For example: "As the priest holds the body and blood of Christ in his hands, he should recall what sufferings Christ underwent for us on the cross."[70] The priest, while holding the host, should call to mind each element of passion, and should speak to the body in his hands: "speak to the sweetest body itself of the most sweet Lord, which you hold in your hands, and talk to him as though present." The mass is spoken of as the sacrifice of the cross itself: the saints in heaven regard "the price of their redemption celebrated on earth," and the celebrating priest should not doubt that the angels are present worshipping their creator "in that hour of the sacrifice of the body and blood of your Redeemer."[71] Before communion, the priest should address Christ: "we eat your body and drink your blood: that is, the price of our redemption."[72]

Another striking early example of intimate personal encounter with Jesus, mediated by the passion, is given in the writings of the monk Rupert of Deutz. Rupert describes a vision that he had in a dream (I have attempted in the translation to capture some of the rough quality of the Latin):

> I saw myself standing before the altar, and on it, in the middle, the cross of the Lord; and on the cross, the image of our Lord and Savior. When I looked more closely, I recognized that it was the Lord Jesus himself who was there, crucified and alive, with his eyes open and directed at me. When I saw this, immediately bowing my face, I say to him: "Blessed is he who comes in the name of the Lord (Matt. 23)." With what humility he received this salutation, with what a worshipful inclination of his head, is impossible to describe, except to say that the interior man, seeing this, could feel, to some extent, how truly he says of himself, "learn from me, for I am meek and humble of heart (Matt. 6)." This was not enough for me, unless I could grasp him with my hands, and, embracing him, kiss him. But what could I do? The altar itself was too high for me to reach him. But he himself also wished this thought or desire of mine. For I felt that he willed it, and at the prompting of his will the altar itself opened up in the middle, and received me hastening into it. When I had quickly entered, I grasped the one my soul loves, I held him, embraced him, and kissed him for a long time. I felt how much he accepted this gesture of love: while I was kissing him, he opened his mouth, that I might kiss him more deeply. Clearly in doing this, he was giving a meaning: to fulfill what the longing beloved says in Canticles: "Who shall give thee to me as my brother, sucking at my mother's breasts, that I might find thee outside, and might kiss thee, and none would despise me. I would grasp thee, and lead thee

into the house of my mother, where thou wouldst teach me, and I shall give thee a drink of spiced wine, and the juice of my pomegranates (*Song of Songs*, 8)."[73]

Rupert goes on to give a symbolic interpretation to the encounter: it was meant to invite him more deeply into the sacraments. Shortly after this vision, he presented himself for ordination, which he had hitherto postponed.

The fact that in his dream Rupert at first takes the living Jesus for an image seems to presuppose a crucifix of the Romanesque type that was discussed earlier in this chapter: the Christ that Rupert sees is alive and triumphant on the cross. This vision, therefore, does not seem to imply an affective association with Jesus' human sufferings. It fits more with the older tradition of mystical union with Christ as God. Rupert in fact interprets the vision spiritually and symbolically, in terms of the traditional mystical reading of the *Song of Songs*. Nevertheless, it is significant that it is precisely in the image of the crucifixion that Rupert encounters Christ; and his intensely emotional and even physical encounter with the crucified anticipates the highly affective spirituality of the new age—which, however, finds a new center for its devotion, not in the Godhead of Christ, but in his human suffering.

Rupert's vision has as its background the monastic practice of the *lectio divina* (literally "divine [or sacred] reading"—a meditative rumination on the Scriptures). Monastic life had always encouraged prolonged contemplation of the events narrated in the Scriptures. Such prayer easily led to the association of texts with each other, and to their use in new contexts—on the principle of the unity of God's message in the Scriptures. It also led to a personalizing of the meaning of passages. In the eleventh and twelfth centuries, this practice of meditation was expanded in three major ways: first, it was systematized into a method; second, the use of imagination, rather than intellectual contemplation, came to be central to its exercise; and third, the events of Christ's earthly life became the primary focus of attention. But among these, the passion was supreme. As a disciple of Anselm notes, the thief crucified with him knew Christ better hanging on the cross than in his teaching in the temple or performing miracles.[74]

The emergence of this new method of meditation had important consequences for Christian spirituality:

> By activating the imagination, it drew the Christian into the events, even assigning him a role as an actor in the drama. Once inside the event, he responded to the scene with a variety of human emotions. This led to identification with Christ and a desire to imitate his virtues, especially humility and poverty, along with a willingness and even a longing to suffer with Christ in his passion.[75]

Throughout eleventh-century Europe there was a flourishing of poetry about the cross (Fulbert of Chartres, Hermann von Reichenau, Peter Damian).[76] As

we have seen, the cross had already become a strong focus of devotion, especially through the wide diffusion of relics of the "true cross." The use of an imaginative form of meditation made possible a kind of mental pilgrimage even for those who could not visit Jerusalem, Rome, or one of the many other sites where such relics were revered.

More important, by praying before a crucifix one effectively placed oneself in the presence of the crucified at the moment of the passion. Among numerous prayers attributed to Anselm of Canterbury (but probably written by his disciples) are many to be said before the cross. The prayer addresses Jesus in the present tense, as though the event of the crucifixion were actually taking place: "I humbly entreat you, loving majesty and great love, who are hanging on the cross . . ." "I beg you, Jesus, who hear the prayers of your family, by all the love that you have for humanity as you hang upon the cross . . ."[77] For medieval spirituality, this was not merely an exercise in imagination: theology taught that Jesus on the cross had present to his mind all those for whom he made his sacrifice. Hence we—although temporally in the future—actually were "present" to him. By our mentally placing ourselves at the event, the presence becomes mutual.

Abelard and His Opponents: Scholastic and Monastic Theologies in Conflict

THE ERA OF THE ANSELMIAN REVOLUTION. Anselm's theory of "satisfaction" provided a model for Western soteriological thinking until the beginnings of the modern period. However, it was neither unchallenged nor unchanged by subsequent thinkers, and its most significant features—the rejection of the idea of the rights of the devil and the notion of "satisfaction" of a debt to God's honor—were not universally accepted. Even among some of Anselm's own disciples, the notions of debt to the devil and/or of Christ's violent snatching of humanity from the grasp of hell were slow to be replaced.[78]

Moreover, although Anselm's repute and influence were such that his theology of "satisfaction" quickly gained many followers, and eventually became classical in Western theology, not all of his immediate followers were as theologically nuanced as Anselm in their presentations. For example, the Bishop of London Gilbert Foliot develops the punishment-satisfaction schema in terms of a conflict between God's justice and mercy, projecting onto God the kind of conflict of values that humans experience. He even presents this conflict as being expressed temporally: the time before Christ was the reign of God's justice, which was then replaced by mercy after humanity had suffered long enough.[79] Richard of St. Victor divides the matter among the persons of the Trinity: the Father punishes and demands satisfaction, the Son makes expiation, the Spirit forgives.[80] On the other hand, in Richard, as in others of his generation, it is the humility of Christ that is the counterbalance to Adam's

pride, and is thus the crucial element in satisfaction, rather than Christ's death itself. Finally, as we shall see, in the new way of doing theology that came to be known as "Scholasticism," significant modifications and additions were made to Anselm's ideas.

ABELARD. Foremost among those who offered an alternative to Anselm's schema was his younger near-contemporary Abelard (1079 to ca. 1142). The reason for the incarnation, according to Abelard, was to "illuminate the world with [God's] wisdom and inflame it with love toward God."[81] Humanity is saved and reconciled by the grace that first accepted our nature, and then by word and example drew us to God by love.[82]

Like Anselm, Abelard bluntly rejects the notion that the devil had some kind of rights over humanity. Sin was an offense against God; the devil functioned as a kind of jailer, but had no claim on us. (This idea had a precedent in St. John Chrysostom.)[83] Any idea of a price paid to the devil, or of reversing a just dominion of the devil over humanity, is therefore rejected. The price of our liberation could only be paid to God. But on the other hand, Abelard also raises questions (some of which had also been raised by Anselm) about the whole mechanism represented by the scheme of "redemption" as a price paid to God. Since humanity belonged to God, why could God not simply forgive and remit punishment without the punishment of the sinner, as Christ forgave during his ministry? Why should God demand a price for our sins in the first place, if God's intention was to pay the price for us? Moreover, Abelard astutely points out, the incarnation itself took place by God's grace, not through human merit. Christ was conceived without sin, was born sinless, and persevered through life without sin, all because of grace of the One who took on this humanity. If God, for our salvation, could grant the humanity of Christ the grace of being united with God in person, why could God not do something *less* than this—that is, simply forgive our sins? Echoing the objection already posed by Anselm, Abelard asks: does it not seem cruel and evil to demand the blood of an innocent person as a kind of price? Could the Father in any way be pleased by the death of his Son, so that it could serve as the world's reconciliation?

Abelard proposes a forthright solution that cuts through the difficulties raised by the metaphor of "payment."

> It seems to us that this is how we are justified by the blood of
> Christ, and reconciled with God: in that God drew us closer to him-
> self by love, through this unique grace given to us, namely, that
> God's Son should take on our nature, and that he should teach us
> both by word and example, persevering to the point of death; so
> that, enflamed by such a great gift of divine grace, true love [*charitas*]
> should have no dread to undergo it.[84]

Abelard cites John 15:13: "no greater love has anyone than to lay down his life for his friends." The cross is the sign of God's love, by which the punishment for sin is taken away and we are given both the grace and the example that make it possible for us to respond in love.

Although Abelard stresses Christ's role as teacher and example, in the context of the whole of his *Commentary on Romans* it seems that this should not be understood in an exclusive sense (as it was understood by Bernard of Clairvaux, who accused Abelard of Pelagianism and of reducing Christ's death to an example). Indeed, at least on a verbal level, Abelard explicitly endorses the Athanasian notion of "penal substitution": Christ took our place in accepting the punishment for sin, that is, death.[85] But his primary emphasis is on salvation through God's gift of grace, which converts our hearts to the love of God.[86] The incarnation itself is a sign of God's love, and it is the gift of supernatural love—charity—that reforms our lives in response to Christ. Moreover, although he opposed the idea of a "just dominion" of Satan over humanity, Abelard clearly saw salvation in terms of a defeat of the devil: in his hymn for Easter, he celebrates the Christus Victor theme, and even refers to the old Patristic image of the "hook" that catches the devil.[87]

Hence we can see in Abelard's theology what might be called a "sacramental" view of salvation: Christ's life and death are the sign of God's love, which manifests itself both in the sign and in our response to it.

THE CRITIQUE OF ABELARD: WILLIAM OF ST. THIERRY AND BERNARD OF CLAIRVAUX. However, Abelard's theology smacked of heresy to some of his contemporaries. William, abbot of St. Thierry, complained of Abelard's lack of respect for tradition, and decried several "errors" he found in Abelard's work: most important, that Abelard saw no objective salvation in Christ's death, but only an example for us. William speaks explicitly of God's just "anger" against humanity because of the inheritance of original sin, although at the same time he sees redemption as the act of God's love. He thus makes a contrast between God's justice and mercy. Like Abelard, he holds a theory of penal substitution: Christ took on himself the punishment for all sins.[88] Moreover, Christ won for us his grace: because of this, the "children of anger" are given the spirit of adoption. William denies that the death of Christ was a payment to the devil; rather, it was the means of taking humanity from the devil's clutches (as we have seen, Abelard actually agreed with this). Christ's blood, says William, was not "paid" to the devil, nor was it demanded by the Father for "satisfaction": however, the self-offering of Christ was in fact full satisfaction, part of the plan of love of the whole Trinity.[89] William wishes to absolve God of any accusation of cruelty or blood-lust with regard to Christ's death: God only permitted this act, which was the doing of the devil. On the other hand, he also wants to preserve the notion of Christ's innocent death as sacrifice and satisfaction to God.

More vehement in his criticism of Abelard was (St.) Bernard (1090–1153), the powerful and highly influential abbot of Clairvaux. Bernard accused Abelard of Pelagianism: the non-Augustinian (and formally condemned) view that human freedom is able of its own power to perform salvific acts. Moreover, it was at Bernard's instigation that the Council of Sens (1141) condemned another aspect of Abelard's theology: the denial that the devil had a just dominion over humanity, from which Christ delivered us. (As Gustav Aulén points out, this condemnation was actually equally relevant to the teaching of Anselm,[90] who formulated his "satisfaction" theory precisely in order to move away from the notion of the "rights" of the devil.)

In Bernard's criticism, delivered in violent and insulting language (he calls Abelard's theology "stupidities" and "lies"), we can discern not merely a difference in positions but a clash of theological paradigms. In fact, although he seems not to have realized it, Bernard's positions are very close to Abelard's conclusions. But the two differ in the context and methods of their theologies. Bernard represents the traditional Patristic theology, passed on in the monasteries; Abelard (as well as Anselm) is in the vanguard of the emerging Scholastic method that would predominate in the universities. This difference led to conflict on various levels: between a theology that used concrete imagery and a theology that used abstract theoretical concepts; between a theology based on the repetition and interiorization of the authorities, and one based on an effort to use reason critically, even if this meant questioning the established authorities. It is notable that Bernard does not give answers to Abelard's questions; he criticizes him for having asked them. Abelard, like Anselm, is engaged in faith's pursuit of understanding (*fides quaerens intellectum*, in the famous paraphrase of Anselm's description of theology). For Bernard, it is enough to know what faith teaches about salvation; it is not licit to ask why it is so.[91]

Bernard is most vehement in denouncing Abelard's presumption in rejecting the authority of the Fathers. And he accuses Abelard of what would later be called "rationalism": trying to make plainly intelligible what can only be a mystery.[92] Bernard does not grasp the subtlety of Abelard's arguments and criticisms; he sees them simply as the rejection of tradition. In his anger, he does not attend to the theological nuance of Abelard's argument, which, in respect to the dominion of the devil, is same as Anselm's.[93] Bernard also seems to misread Abelard, taking individual statements out of their context. He accuses him, for example, of saying that Christ gave us the example of charity, but did not bestow charity itself on us.[94] But in fact Abelard quotes St. Paul in affirming that this charity is God's gift, effected by the outpouring of the Spirit. Moreover, Abelard's great emphasis, the moral effect of Christ's passion on us, is exactly what Bernard himself most stresses. Like Abelard, Bernard essentially espouses a "sacramental" view of redemption. But unlike Abelard or Anselm, Bernard does not question precisely how or why the "objective" element in redemption takes place; this is a mystery.[95] Bernard uses

Anselm's term "satisfaction"; but he does not inquire more deeply into its meaning. He is content to repeat the affirmation of St. Paul and the Fathers: just as our guilt derives from another (Adam), so does our justification come from another (Christ). Yet he also repeats the Pauline and Patristic rationale for this: there is an intimate solidarity of all humanity, as expressed in the metaphor of the body and its members. In Christ's passion, the head made satisfaction on behalf of the members.[96] That this could take place is not a matter of justice; rather, it means that God's justice has been overcome by his mercy.[97]

Despite the fact that Abelard and Bernard represent different theological paradigms, they are united in their emphasis on the humanity of Christ and the example of love that he gave. Aesthetically, they both represent the developing paradigm of affective personal love for the Savior shown in the transitional period from the Romanesque to the Gothic.

Bernard, like Rupert of Deutz and others in the monastic tradition, engaged in a mystical interpretation of the *Song of Songs*. But Bernard's exegesis goes a step beyond that of his predecessors. He develops a theological theory to undergird the practice of imaginative meditation directed specifically at a personal relationship with the human Christ. In his *Sermon on the Song of Songs*, he speaks of the "carnal love of Christ": our hearts must be attracted first to the humanity of Christ, in order to ascend to the divinity. For this purpose, the soul should have an image to attend to; indeed, this was the reason for the incarnation itself (*Song of Songs* 20:6).[98] The intensity of Bernard's devotion to the crucified is witnessed by a legend recounted by Herbert of Clairvaux that is reminiscent of the earlier vision of Rupert (and perhaps derived from it): as Bernard honored and kissed the crucifix, Christ freed his arms from the cross and drew Bernard to him in embrace.[99]

Bernard's writings on the cross and redemption center on the unspeakably great love of God for us that is shown in Christ's passion.[100] Willingness to suffer is seen as the sign of love. Like Anselm, he sees this love in very personal terms: Christ suffered *for me*, and was willing to undertake every possible suffering for the salvation of each of those he loves:

> How great was this love! If Christ the Son of the living God had as many parts to his body as there are stars in the firmament of heaven, and if each of these parts had its own body, Christ would have exposed all of them to the passion, rather than leave a single soul unredeemed from the clutches of the devil. O what mercy, and how great is the mercy of the Lord!
>
> Ah, most kind Jesus! Take away from me what I have created [i.e., sin], so that there may remain only what you have created; let not perish what you have created; let not perish what you have redeemed by your precious blood on your cross. Amen.[101]

The same affective stance toward the crucified is shown by Abelard, despite the differences of his theory of salvation from Bernard's. In his famous hymn *Solus ad Victimam*, written for the Holy Week services of the nuns of the Paraclete convent, Abelard enunciates the theme of Christ's substitution for us in punishment, and asks that we in turn may share in his saving passion:

Solus ad victimam procedis Domine,	Alone you go to be a sacrificial victim, Lord
Morti te offerens Quam venis tollere;	Offering yourself to the death you came to take away;
Quid no miserrimi Possumus dicere	What can we say, we wretched people,
Qui, quae commisimus Scimus te luere?	Who know that you pay the penalty for the sins we committed?
Nostra sunt, Domine, Nostra sunt crimina	Ours, Lord, ours are the sins
Qui tua criminum Facis supplicia	Whose punishment you bear.
Quibus sic compati Fac nostra pectora	Make our hearts suffer along with you So that by that very suffering we may deserve forgiveness. . . .
Ut vel compassio Digna sit venia. . . .	
Nox ista flebilis Praesensque triduum,	May this tearful night and the triduum we celebrate
Quo demorabitur Fletus, sit vesperum,	In sorrow be a vigil Until joy be returned to the sorrowful
Donec laetitiae Mane gratissimum	On the welcome morn when the Lord rises.
Surgente Domino Sit maestis redditum	
Tu tibi compati Sic fac nos, Domine,	Lord, make us so to suffer along with you
Tuae participes Ut simus gloriae.	That we may share also in your glory
Sic praesens triduum In luctu ducere	May the present triduum guide us in our struggle
Ut risum tribuas Paschalis gratiae.	So that you may grant us the smile of Easter grace.[102]

It is clear from our earlier considerations that the context of academic theology was frequently different from that of the theology of images. Academic theology in this period was largely apologetic: first in the attempt to convince the non-Latin peoples who inherited the territories of the Roman Empire of the superiority of Christianity, and later in disputes with Islam and Judaism. Theology became increasingly cosmopolitan and intellectual. The

context of art was rather affective, and was directed more *ad intra*, toward the spiritual needs of those who already believed. Moreover, we can see in the images of this period a confirmation of the general observation that images are polyvalent: the very same image can serve very different theologies and can be seen and interpreted in light of different aspects of the complex mystery of salvation.

4

The Theology of High Scholasticism and Gothic Art

The Crucifix of Giunta Pisano

In the year 1236, Brother Elias of the Franciscan order commissioned a panel cross for the newly constructed basilica of St. Francis in Assisi. Significantly, Francis's followers did not choose to follow the model of the triumphant crucifix in Assisi's church of San Damiano, whose smiling victorious Christ had spoken to Francis at the beginning of his mission. Instead, they erected an image in a new style, reminiscent of Byzantine icons: a portrayal of the dead Christ painted by Giunta Pisano.

Giunta's original work for the basilica has been lost, but we can imagine its appearance from the surviving crucifixes by Giunta in the church of San Damiano in Bologna, painted in the 1240s, or the similar crucifix in the church of Santa Maria degli Angeli in Assisi, which is thought to have been painted at about the same time as the lost basilica crucifix.

Inspired by Byzantine art, Giunta painted what would become a model for the classic Gothic image of the *Christus patiens*—the suffering Christ on the cross. The body forms an arch (significantly more pronounced in the Bologna crucifix), as though sagging forward. The arms, however, show no tension, but are extended in the "orans" position. The feet are nailed separately to the *suppedaneum*, on which they appear as though standing. The body emphatically shows musculature. The wound in Christ's side is visible, but there is no flow of blood.

The head is inclined gently to one side, resting on the right

shoulder. It is the face above all that shows the suffering of Christ. The eyes are closed and darkly shadowed. The mouth is turned downward. The expression is more evocative of sadness than of pain.

The *suppedaneum* is a rectangle that visually balances the inscription above the cross and the similarly shaped extensions of the arms of the cross. In these box-like rectangles appear half-figures of Mary and John. "The two living witnesses invite the beholder to emulate their mourning as they point to the dead hero."[1] The whole crucifix symbolizes Franciscan passion meditation, making present the suffering of Christ in order to lead the viewer to *compassio*, an affective appreciation of what Jesus underwent for our sakes and a spiritual sharing in the passion, along with Mary. It represents a major step in the "humanization" both of art and of devotion.

Of course, Giunta's crucifix was not the first representation of the *Christus patiens*—the suffering Christ—to appear in the West. As we have seen, the genre was known both in Italy and in northern Europe since the tenth century. And elements of the Byzantine style so prominent in Giunta's work had already been seen as well: for example, in the crucifixion scene in the Passion window at Chartres, constructed nearly a century earlier.[2] However, by its prominent

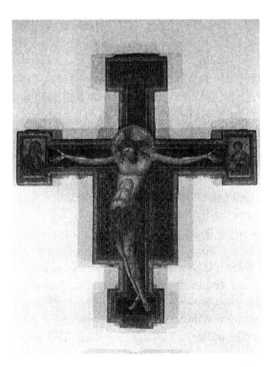

Giunta Pisano, crucifix from San Domenico, Bologna. Credit: Scala / Art Resource, New York.

placement in the basilica in Assisi, one of the major devotional sites in Europe, Giunta's image of the crucifixion was able to exert extraordinary influence on subsequent painting. More to our point, it is emblematic of the new aesthetic and spiritual sensibility that valued the representation of Christ's sufferings. As we shall see, the relationship of this kind of image to the theoretical dimension of theology was complex.

The Theoretical Mediation of Theology in the Thirteenth Century

The Cross in the Theology of the Great Scholastics

Already in the vehement rejection of Abelard's theology by Bernard of Clairvaux we have seen the conflict between the older monastic/Patristic paradigm of theology and the new emerging Scholastic model of university theology. The two differed radically in their method. The theology of Scholasticism was based upon the drive to understand. The *quaestio* that was its typical genre was aimed at disputation and the attainment of systematic theoretical understanding, rather than at the reverent repetition of authorities and the appropriation of their spiritual insight.

In the matter of soteriology, the High Scholastics of the twelfth and thirteenth centuries, representing the new "university" theology, present a synthesis of the language of satisfaction with the insights of Abelard. Above all, they see soteriology within the context of a theology of grace, now conceived in a theoretical way. The influence of the newly recovered philosophy of Aristotle is clearly seen. Salvation is not merely the forgiveness of sins but the elevation of humanity to a new "sanctified" level of existence, in communion with God's Son, and anticipating final glory.

PETER LOMBARD. The *Sentences* (*Sententiae*, "opinions"—a collection of Patristic ideas, with commentary) of Peter Lombard (1100–1164) provided a structure for the great scholastics, who developed their own theologies in their commentaries on it. Peter Lombard's theology of the passion and redemption synthesizes many Patristic themes and places the question within a context of the kind of systematic understanding anticipated by Anselm.

Peter does not use Anselm's notion of "satisfaction." He employs the word *satisfactio* only in its penitential sense.[3] Nor does he refer to God's "honor." The principal explanatory idea in his theology of atonement is "merit." This is in essence parallel to the idea of satisfaction, but the emphasis is on deserved reward, rather than on payment: on what Christ deserved by his saving acts, rather than on what God (or the Father) deserved or demanded because of humanity's offense. Still, these two perspectives—Anselm's and Lombard's—

correspond with each other. At bottom, we have essentially the same metaphor of exchange. Both are based on the New Testament notion of "redemption," which is also explicitly used by Peter Lombard. As in the Fathers, it is the notion of "sacrifice" that provides the understanding of the objective cause of the merit that leads to our salvation.

Peter sees the merit of Christ as being the result of his virtues, that is, his interior disposition: his humility and obedient will toward God. These were present from the beginning of his life.⁴ There is nothing that could be added to the degree of Christ's merit or his virtues. In that case, Peter asks, why did he wish to suffer and die, since his virtues sufficed to merit for him immortality and exaltation? The Lombard makes the answer personal, directed to the reader: "For you, not for himself." He continues:

> "In what way for me?" So that his passion and death could be for
> you an exemplar [forma] and cause. The exemplar of virtue and hu-
> mility; the cause of glory and freedom; the exemplar of obedience to
> God even unto death; and the cause of your liberation and beati-
> tude."⁵

By his passion and death, Christ merited something more than he had merited previously for himself: namely, our salvation. He could not gain any higher *degree* of merit than he had simply by his virtuous life; but in the passion Christ obtained *more* merit—namely, for us. He did so by making himself, in death, a sacrificial offering for our liberation.

We see the same stress on both the "objective" and "subjective" sides of salvation in the Lombard's theoretical explanation of the efficacy of the passion. That is, he includes elements of both salvation by another—that is, by Christ as "cause"—and the need for our personal appropriation of salvation by following his example.

Like Anselm, Peter Lombard also wishes to inquire more exactly *how* Christ through his death redeemed us from sin and from the devil and opened paradise to us. His first answer is traditional: he cites the "mystery" of God's plan of salvation. God mysteriously decreed that humanity would not be admitted to paradise—that is, to the vision of God—unless a human could be found with humility equal in measure to the pride of Adam's sin, which harmed us all. But no human being could fulfill this role but Christ, who alone could be the perfect sacrifice of humility and virtue, far surpassing the pride of Adam.

> If therefore the pride of that one [Adam] resulted in the destruction
> of all, driving him from paradise and closing its doors for others—
> so much more did Christ's humility, by which he tasted death, avail
> to open the kingdom of heaven for all those belonging to him,
> having fulfilled God's decree and erased the writing of the decree.

He quotes the phrase found frequently in the Glosses, and attributed to Ambrose: "So great was our sin, that we could not be saved unless the only Son of God would die for us debtors to death."[6]

However, Lombard makes a curious distinction: this is not to be understood as though there were no other way Christ could have saved us except through his death; rather, it means that no other sacrifice could accomplish our salvation but the death of the Son, whose humility and suffering merited our admission to God's kingdom. (Presumably, Lombard means that Christ's death was necessary, given that God willed our salvation only through such a sacrifice; but that God could have chosen other means.) Peter also repeats the doctrine of penal substitution: Christ bore our sins in the sense that he bore the temporal punishment for our sins in the suffering he endured on the cross.[7]

But, having repeated the traditional doctrine, the Lombard continues his reasoning in a way reminiscent of Abelard. Christ's death merits for us the opening of God's kingdom, closed (by God's mysterious decree) because of Adam's pride. But how does Christ's death save *us* from (our) sin, by which the devil held us enchained? By showing us God's love. "We are shown a sign of such love that we are moved and enflamed to the love of God, who did so much for us; and by this we are justified, that is, we are made just, freed from sins." (Note the use of the metaphor "enflamed," as in Abelard.) "Christ's death justifies us, since through it charity is aroused in our hearts."[8]

In another sense, one can say that we are justified by *faith* in Christ's death (Peter cites Rom. 3). Just as the ancient Hebrews were saved from snakebite by looking at the brazen serpent raised on a wooden staff, so we, if we look with faith at Christ, who hung for us on the wood of the cross, will be saved from the chains of the devil, that is, from sin.

The Lombard joins the moral and exemplary dimension of Christ's death with the ancient theme of the defeat of the devil. "Through his death, the one true sacrifice, Christ extinguished all the guilt for which the devil could hold us liable to punishment." After Christ's death, the devil may still tempt us, but he cannot be victorious, as before. As in the parable in Luke 11, Christ, being stronger, has invaded the house of the strong man—that is, our hearts, where the devil inhabited—and has bound him so that he can no longer seduce us. But along with this image of forceful victory, Peter also repeats the Patristic trope of the tricking and trapping of the devil. Like Abelard, the Lombard holds that the devil has no real rights over humanity: he has violently seized and held God's creature. At the same time, humanity, because of sin, deserved to be held under the devil's tyranny.[9] Peter is careful to point out that this is by God's permission, and not because the devil has power against God. But God is just in allowing the devil's dominion, since humanity had freely subjected itself to the devil.

For this same reason, the defeat of the devil must come through a human

being: in this way, we are freed justly, and not by violence. This is why the incarnation and passion, although not the only means possible for our redemption, are the most fitting.[10] God has saved us by justice, and not by violence, in order to give us an example to follow. The cross serves as a "mousetrap" for our captor the devil, with Christ's blood as bait. Because he is sinless, there is nothing in Christ deserving death; but the devil kills him. Hence we can justly be removed from his power.[11] But, true to his emphasis on the subjective side of redemption, the Lombard also explains this schema of liberation in moral terms: the chains that the devil held us in were nothing other than our sins. Through the passion, Christ has entered into our hearts, where the devil had dwelt, and has filled us with sweetness in place of the bitterness that the devil had placed in us, making us now God's children by adoption.[12]

Several aspects of Peter Lombard's theology should be noted. Like Bernard, he sees the solidarity of humanity in Pauline terms: we are the body of Christ. It is for this reason that Christ could merit for his members redemption from the devil, from sin, and from punishment, and restoration into God's kingdom.[13] The cause of this merit was primarily the humility Christ exhibited in the passion. Here again we see a Pauline theme: Christ humbled himself and was obedient and therefore was exalted and became the source of salvation. In both of these respects, Peter Lombard's theology accords with the growing emphasis on Christ's humanity, on our relation to him, and on the need for following his example.

ALEXANDER OF HALES. Alexander of Hales (ca. 1185–1245), an Englishman teaching in Paris, was the first of the Scholastics to introduce Aristotle as a prime authority. After becoming a Franciscan, he remained at the university, where he was the teacher of Bonaventure. He also greatly influenced Aquinas. Alexander substantially repeats the doctrine of Anselm, but with a more technical vocabulary of distinctions. He amplifies Anselm's reasoning regarding the necessity of satisfaction: were God to allow sin to go unpunished, this supposed benignity would actually be an injustice and a vice.[14] God did not have to redeem humanity; but redemption could not have taken place without satisfaction, and satisfaction could not have taken place without the passion. But Alexander goes beyond Anselm in reasoning that the Son would have become incarnate even if humanity had not sinned. He sets the stage for later thinking by emphasizing not only satisfaction but also Christ's merit, because of which we are given grace. And, like Abelard and Peter Lombard, he also gives significant place to the human appropriation of salvation. The passion inspires us to love, faith, compassion, and imitation.[15]

ALBERT THE GREAT. Aquinas's master Albertus Magnus asks whether our justification is accomplished by Christ's passion, and answers by making some careful distinctions.[16] These are based on the different types of causality enu-

merated by Aristotle. The only "efficient" cause of our justification—what makes it happen—is God, who alone can forgive sins or make anyone holy. The "formal" cause of justification is grace: that is, grace and the virtues constitute justification or holiness; they are its essence or definition. It is highly significant that Albert places the question of salvation in a metaphysical context, and understands it primarily in terms of the concept of "grace," which is God's gift. This represents a significant shift in the mode of operation of theology itself: it is now concerned with explanatory theoretical concepts, like grace, rather than figures and metaphors that are directly related to affect and imagination. How is the passion of Christ related to that gift of grace? It is the "condign meritorious cause": that is, Christ's passion adequately ("condignly") merits for us the forgiveness of sin, which is the prelude to justification. We can see here a continuity with the Patristic notion of substitution and the Anselmian satisfaction theory, but understood in a theoretical framework of "causality." Our own merits also cause our justification, but only in a "congruous" way: they are not sufficient in themselves for the forgiveness of our "debt" in Adam, but in the light of Christ's merit, they are acceptable to God for our individual justification. Albert also speaks of sacramental causes of justification. On the part of those freed from the debt of original sin, the sign and cause is baptism; on the part of the one doing the justifying, the sacramental cause is the resurrection of Christ, which signifies the new life of our souls and bodies.

Likewise with regard to the question of our liberation from the devil, and the related issue of the devil's "rights" over humanity, Albert's position is nuanced. "Liberation" means different things. On the one hand, we have all been liberated from our natural tendency to evil by the death of Christ. On the other hand, we are only *effectively* liberated by faith and charity:[17] that is, by our acceptance of grace. This means that our ability to fight against evil is greater; but we still have to struggle. The passion of Christ aids us in this struggle. Albert includes in this aid not only the fortitude that comes from meditating on the passion but even the external act of making the sign of the cross, which drives away demons.

With regard to the devil's "rights," Albert's position is similar to Abelard's and Peter Lombard's: the devil really had no right to possession over humanity, but God justly permitted his ascendancy because of our sins. God could have justly taken away the devil's power whenever God willed. However, humanity would not have been justly rescued, since we deserved to be in the devil's power, even though the devil had no rights over us.[18]

Could God then have rescued us by some other means than the incarnation and passion of Christ? Here Albert quotes Anselm in favor of a negative answer. As far as God's power is concerned, Albert says, some other mode of salvation is possible. But from our side (*ex parte nostra*), it was impossible for us to be redeemed except by God made human. It seems, then, that another

mode of salvation is both possible and impossible. Albert concludes that another kind of salvation is not suitable (*conveniens*) to our situation, although it would be possible for God. He gives an example of what he means. Is it possible for a tree trunk to become a calf? No. Is it possible for God to make a tree trunk into a calf? Yes.[19] So—can our sins only be forgiven through the God-man offering satisfaction for us? Yes. But, on the other hand, another means might have been possible for God.[20]

If other means of liberation are theoretically possible, can we then say that there are other possible means of *redemption*? This question is answered by examining the meaning of the word. To "redeem" means to get something back, either by paying a just price or by conquest. (Interestingly, in his definition Albert includes both the "payment" and the "warfare" models of salvation, although in his answer he considers only the former possibility). But (as Anselm argued) a just price would have to be equivalent to the offense and damage given. But the offense was infinite, because it was against God. Therefore, the just price of redemption can only be paid by someone who is both human and divine. As human, such a person would owe the price; as divine, he is able to pay it.[21] Significantly, Albert cites especially the humility of Christ as being satisfaction for all of humanity.

Like Alexander of Hales, Albert raises the question whether the Son of God would have become incarnate even if humanity had not sinned. He replies modestly and sensibly that there is no certain response to this question. "But insofar as I may venture an opinion, I believe that the Son of God would have become human, even if there had never been sin."[22]

THOMAS AQUINAS. St. Thomas's thought on the passion integrates the "objective" salvation emphasized by Anselm with the "subjective" response stressed by Abelard. His position is well and succinctly summarized in his *Collationes*:

> Was it needful for the Son of God to suffer for us? Yes, it was very
> needful, and we can establish a double necessity: first, as a remedy
> for our sins, and second, to give us an example of how we should
> act. As a remedy, because through the passion of Christ we find a
> remedy against all the evils that we incur because of our sins. But
> its utility is not less with regard to example. Because the passion of
> Christ suffices to give form to the whole of our life. (*Collatio* 6, *super*
> "Credo in Deum")

Aquinas's thought on redemption through Christ's passion develops in the same lines as Albert's. Absolutely speaking, God could have liberated humanity in another way, even without any satisfaction on humanity's part. Furthermore, this would not have been contrary to the divine justice (*S.T.* 3, q. 46, a. 2, ad 3). But it was suitable (*conveniens*) to *both* the mercy and justice of God for humanity to be liberated by the passion of Christ (significantly, Aquinas

does not see a conflict between the divine attributes of mercy and justice). It was more merciful for God to redeem us through Christ's satisfaction for sin than it would have been for God to forgive sins without satisfaction (S.T. 3, 9.46, a. 1, ad 3). For through our liberation by Christ's passion, "many things occur for our salvation besides liberation from sin." For example, we learn how much God loves us, and are inspired to love God in return; and this is what the accomplishment of salvation consists of. Furthermore, by the passion Christ gave an example of obedience, humility, constancy, justice, and other virtues. Moreover, the passion not only freed us from sin but merited the grace of justification and glory. The passion also teaches us how important it is to avoid sin, since we have been redeemed by such a great price (1 Cor. 6:20). And, although the devil had no rights over humanity, humanity was justly given into his power because of sin; so it is more honorable for a human to overcome death and the devil by dying, just as a human incurred the penalty of death because of the devil's deception. It was particularly fitting for Christ to overcome the devil's pride by his humility (S.T. 3, 9.46, art. 3, c and ad 3).

From the point of view of this study, it is significant that Aquinas gives primarily symbolic reasons for the eminent suitability of the mode of Christ's death: that is, on the cross, rather than by fire or the sword, as sacrifices were slain and offered. First, the cross gives us an example of virtue even in the face of death, since crucifixion was the most horrible of deaths. Second, it was most suitable for satisfaction to take place on a tree, for the sin of Adam consisted in eating the forbidden fruit of a tree. Third, it was fitting for Christ to be "lifted up" on the cross in order to purify and sanctify the region of the air (which was considered to be the domain of evil spirits). Fourth, the "lifting up" of Christ prefigures his ascent to heaven and his drawing of all to himself (John 12:32–33). Fifth, the figure of the cross symbolizes the universality of salvation: from a central point, the power of Christ extends in all directions (Gregory of Nyssa); and the extension of Christ's hands symbolizes his drawing to himself both Jews and Gentiles (Chrysostom). Sixth, as Augustine says, this form of death symbolizes different virtues corresponding to the "breadth, and length, and height, and depth" mentioned by St. Paul (Eph. 3:18). Breadth, signified by the crossbeam, represents good works, symbolized by the extension of the hands. Length is the vertical dimension that goes into the ground, and signifies perseverance and patience, in which virtues are grounded or set up. Height is the upper part, above the crossbeam, behind the head of the crucified, and symbolizes our hope for things from above. Depth is the part of the cross that is hidden in the ground, from which the whole arises, and signifies the depth of gratuitous grace. Moreover, the wood of the cross also signifies the "cathedra," the chair of the teacher. Seventh, Christ's death on the cross corresponds to a number of symbolic prefigurations: the wooden ark (Gen. 6); the staff with which Moses divided the sea (Exod. 14:16); the wood that Moses put into the bitter water to make it sweet (Exod. 15:25); the staff with which Moses strikes

the rock to obtain water (itself a symbol of salvation) (Exod. 17:5–6); the staff that Moses extends to obtain victory over the Amalekites (Exod. 17:9); the wood of the Ark of the Covenant (Exod. 17:25). The cross was more suitable symbolically than an altar of sacrifice, since the altar of holocaust was itself made of wood, and the fire of Christ's charity took the place of material fire (*S.T.* 3, 9.46, art. 4).

Aquinas also sees symbolic significance and "suitability" in the timing of Christ's passion (in conjunction with Passover), in its place, and in its circumstances. Of particular interest is Thomas's treatment of the place of crucifixion. Jerusalem was a suitable location for Christ's death because it is the place selected by God for sacrifices to be offered. It also signifies the universality of salvation, since it is at the center of the physical world (!). Moreover, Christ's humility is more apparent in a city of such fame, and the guilt of those who killed him is shown there to stem from the leaders of the people, who dwelt there. (It is interesting that Aquinas stresses the guilt of the leaders, rather than the people as a whole. He states that the "great" [*maiores*] or "princes" [*principes*] among the Jews knew that Jesus was the promised Messiah, although they did not know his divinity. The common people, however, did not know the Scriptures, and could not fully recognize the Messiah—even though some did believe in Jesus. But the multitude, even if they were attracted to belief by Jesus' miracles, were deceived by their leaders [*S.T.* 3,q. 47, a 5]. Hence Thomas places the primary blame on the Jewish leaders; the common people and the Romans were less guilty, because of their ignorance [*S.T.*3, 9.47, a. 6].) On the authority of Jerome, Aquinas accepts that Calvary was not the burial place of Adam, as many thought.[23] But since Christ's cross was the remedy not merely for the personal sin of Adam but for the sins of the world, it is more appropriate that he should have died, as he did, in a common place of execution, rather than over the bones of Adam (*S.T.* 3, q. 46, a. 10).

Christ is head of the church, and to varying degrees of all humanity (*S.T.* 3, q. 48, a 1, 3). Hence by his passion he merited—that is, deserved—salvation not only for himself but for all his members. Aquinas concedes that Christ actually merited salvation by his whole life of love, from his very conception: but, as already explained, the passion was suitable for our salvation because it better provides for our collaboration (*S.T.* 3, q. 48, a. 1). Christ's passion is also the cause of our salvation by being satisfaction for all sins. Aquinas does not explicitly mention God's honor in this regard (although he does later connect it with the notion of "sacrifice"). To "satisfy" for an offense is to give something that the offended party loves equally, or more, than he hates the offense. In this sense, Christ offered not merely satisfaction but superabundant satisfaction, going far beyond the offense: through his love that led him to suffer for us, through the worthiness of his life, which was both human and divine, and through the extent of his suffering. Thomas explains that Christ can be satisfaction *for us* because he is our "head": and the head and members are like a

single mystical body. The reason for this union is love (*S.T.* 3, 9.48, a. 2). The passion was also a true sacrifice: that is, something done to render the honor due to God, and for the sake of pleasing God. The passion was a sacrifice not because of the evil deed of Christ's death, but because of the love with which he underwent it (*S.T.* 3, 9.48, a. 3).

Aquinas explicitly unites the idea of "redemption" with that of "satisfaction." To "satisfy" for oneself or for another is to pay a sort of price (Aquinas is clearly aware of the metaphorical nature of the idea). Christ's suffering was "like a kind of price" (*quasi quoddam pretium*) paid to free us from our sins and their punishment. What Christ actually gives, however, is himself. Like Abelard, Thomas holds that the devil was only a kind of jailer for humanity: the "price" of redemption is not paid to the devil, but to God (*S.T.* 3, q. 48, a. 4). At the same time, Thomas adds that the principal cause of our redemption was the entire Trinity (*S.T.* 3, 9.48, a. 5).

Like his teacher Albert, he holds that the principal "efficient" cause of salvation is God. But Christ's actions, including the passion, are God's instrument, and in this instrumental sense can be called the efficient cause of salvation (*S.T.* 3, 9.48, a. 6). Yet in his consideration of how the passion frees us from sin, it is significant that Aquinas gives first place to its inspiring us to love. Only second does he consider it as "redemption" of Christ's members through the merit of the "head"; and only third does he consider the passion as the instrumental efficient cause (*S.T.* 3, q. 49, a 1).

With regard to Christ's sufferings, Aquinas teaches that although Jesus did not undergo every possible pain, he endured every *kind* of human suffering (*S.T.* 3, q. 49, a. 5). Furthermore, these sufferings, physical and spiritual, exceeded all other human sufferings in this life. The *Summa* gives four reasons.

First, the cause of the pain. Physically, crucifixion was a most painful form of death. Spiritually, Christ suffered because he died for the sins of all humanity, bearing them as though they were his own and giving satisfaction for them. Moreover, he suffered interiorly because of his abandonment by his own people, and especially by his disciples. And death itself was horrible to his human nature.

Second, Christ's sufferings were greater than any other's because of his perfection: his body, formed by the Holy Spirit, was most sensitive in its perceptions, and therefore felt pain more than others. His human soul was likewise perfectly able to apprehend all the causes of sorrow.

Third, Christ's suffering was supremely pure. In others, pain is mitigated by the admixture of our lower and higher faculties: but in Christ each interior and exterior sense suffered perfectly, each according to its highest powers of perception.

Fourth, Christ's suffering was assumed freely, for the sake of freeing humanity from sin. "And therefore he took on a magnitude of suffering proportionate to the greatness of the result that it would produce" (*S.T.* 3, q. 49, a. 6).

Nevertheless, Aquinas explicitly denies that Christ's sufferings could be compared to the pains of hell (*S.T.* 3, 9.49, ad 3). Indeed, Christ did not suffer according to the higher functions of the soul, because the object of the soul, God, was not the cause of pain to Christ, but rather of joy and delectation. Hence the superior part of Christ's soul enjoyed beatitude even in the passion (*S.T.* 3, 9.46, q. 46, a. 7, c.; a. 8).

Moreover, Aquinas teaches that Christ did not suffer in his humanity the greatest of human sufferings in order simply to *satisfy* God's justice—the smallest suffering on his part would have sufficed to redeem us (*S.T.* 3, 9.46, 6 and ad 6). Nor was the "descent into hell" to be taken literally: Christ "descended" into the hell of damnation only by the *effects* of his passion—that is, he confounded the devil, saved the ancient just who were in hell because of original sin, and gave the hope of glory to those in purgatory. But in its essence, the soul of Christ when separated from his body went only to the place of the just (*S.T.* 3, 9.46, 6 and ad 6).

BONAVENTURE. Bonaventure's *Breviloquium* gives a concise summary of his theology of atonement.[24] It was needful that Christ heal humanity in an "orderly" way. This means that three values had to be preserved: human freedom, the honor of God, and the order of the universe. (Note that the last, which Anselm treated briefly in connection with God's honor, has here become an explicit theme on the same level.) In order to preserve human freedom—that is, our part in salvation—Christ saved us by giving an effective example. He invites us to supreme virtue, and gives us the grace to attain it. Specifically in his death, he gives us the example of undergoing death for the sake of justice and obedience to God. Because humanity had to be saved in such a way that God's honor is preserved, Christ healed us by offering a sacrifice in satisfaction.

"To satisfy," Bonaventure explains, means to render to God the honor that we owe God. God's honor had been taken away by the pride and disobedience of humanity with regard to its obligation to God. (Since Bonaventure has defined "honor" as something owed to God by creatures, rather than as an intrinsic quality of God, he is not troubled by the idea that God's honor can be "taken away.") Therefore, there is no better way for God's honor to be restored than by humiliation and obedience with regard to something that was not obligatory (i.e., the death of a sinless human, Christ).

Because Christ was full of perfect plenitude from the first instant of his conception, he immediately merited for himself all that was possible. But in his life and passion he gained further merit, not for himself, but for us, so that we might be justified by grace, advance in holiness, and attain the final state of glory. Therefore Christ's merits are the root of all our merits, whether in satisfaction of the penalties we deserve, or in being made worthy of eternal life (*Breviloquium*, pt. 4, chap. 7, 9).

In his commentary on the *Sentences* of Peter Lombard, Bonaventure gives a more extensive treatment of several of these points.

Bonaventure adopts but also nuances Anselm's notion that Christ's passion was "satisfaction" for sin. Absolutely speaking, God could have saved humanity by another means (*Sentences* 3, d. 20, art. 1, a. 6); but this is the most suitable (*conveniens*) way, because it combines justice with mercy. If God did not forgive sin, the divine mercy would not be manifest; but if God forgave sin without satisfaction, then justice would not be served. Justification by satisfaction is also "congruous" to humanity. Sin dishonored God by a lie and by disordered love. It is most proper to satisfy God's justice by payment of a penalty, and it is better to win glory this way. For in this way we are moved to love God more, because God gave the Son for us (*Sentences* 3, distinction 20, art. 1, q. 2). No pure creature could make this satisfaction, even with grace, because the offense was so great (*Sentences* 3, distinction 20, art. 1, q. 3).

Strictly speaking, however, the passion is not the "cause" of our salvation. Bonaventure understands salvation primarily through the metaphysical/theological category of "grace." Justification is through grace, which is infused into us only by God. But Christ merited that grace for us through his passion; and in this sense we can say that we are justified by the passion of Christ (*Sent.* 3, dist. 19, 1, a. 1, ad 3), and that by the passion we are freed from the devil and given the Spirit (*Sent.* 3, d. 19, art. 1, q. 1). Christ's passion can also be said to save us, according to Bonaventure, because of the example he gave to us. In his passion, Christ justifies us as the sacrificial victim that is not only offered, but also believed in and loved. Hence Christ justifies us not only through the forgiveness of sins, but through the faith and love that thereby become possible for us (*Sent.* 3, dist., 19, a. 1, q. 1, conclusio).

Because of the importance of the passion not merely as an objective event, but also as an inspiration to our conduct, Bonaventure places great stress on it in his spiritual works. We shall return to these at a later point. For the moment, we may merely note that in his systematic treatment he asserts that Christ's suffering was most bitter, for three reasons: the manner of the torments themselves, their causes (i.e., our sins, which were known to Christ), and the status—that is, the sensitivity—of the one suffering (*Sentences* 3, art. 16, a. 1, q. 2). Because Christ was both *viator* and *comprehensor*—that is, he was "on the way" toward God, but already enjoyed the beatific vision during his lifetime on earth—the "higher" part of his rational soul rejoiced, even in the passion. But it also suffered according to its human nature (*Sentences* 3, 16, art. 2, q. 2).

Moreover, although he places much emphasis on the passion, Bonaventure is not forgetful of the place of the resurrection as a "principle" of our justification and salvation, along with Christ's sufferings. Our justification is attributed to the passion with respect to merit; but it is attributed to the resurrection

from the point of view of its goal, and to both passion and resurrection as examples and motivations (*Sentences* 3, distinction 19, art. 1, q. 1). Although neither is, strictly speaking, the "cause" of salvation (as we have seen, grace alone is the metaphysical cause), both passion and resurrection function in a way somewhat like causes. Using the Aristotelian divisions, we might say that Christ's merit in the passion, which disposes us to salvation, is like a material cause. The example of Christ in both passion and resurrection inspires and motivates us, and is thus like an efficient cause. As an exemplar and model, the suffering and glorified Christ is like a formal cause. And as a goal, the resurrection is like a final cause. (Note that "merit" for Bonaventure is only attributed to the passion, while the function of goal, of course, belongs only to the resurrection, not the passion) (*Sentences* 3, distinction 19, q. 1, art. 1, ad 3).

Bonaventure is particularly clear in affirming and distinguishing salvation as God's work in Christ, and as human responsibility. These two are not opposed; rather, Christ's merit allows us to merit salvation. Through the passion Christ "satisfied" and paid the price for sin. The passion was in this sense penal. But Christ also "merited"—not for himself, for he needed nothing— but for us. All human merit with God is founded on the merit of Christ. Hence the merit of our charity does not in any way exclude Christ's merit; rather, it depends on it (*Sentences* 3, distinction 18, art. 2, q. 3, conclusion). On the other hand, our own merit is necessary for salvation: Christ's satisfaction is "sufficient" for all humanity, but it is *effective* only for those who cooperate with his grace (*Sentences* 4, distinction 3, pt. 1, art. 2, q. 3). (This is in continuity with the teaching of Augustine, but now expressed within an explicit theory of merit and grace.) In order to explain how the grace of Christ affects us and makes possible our virtues, Bonaventure, like Aquinas, has recourse to the metaphor of the body. Christ's grace is the "grace of the head" (*gratia capitis*), which flows into all the members (*Sentences* 3, distinction 13, art. 2, q. 2). This means that the Savior is connected to the saved by love, through the mediation of our faith in Christ (*Sentences* 3, distinction 19, art. 1, q. 1).

JOHN DUNS SCOTUS. The soteriology of Franciscan theologian John Duns Scotus (ca. 1270–1308) stands in line with the affirmations of the previous great Scholastics. In particular, we find once again an echo of the positions of Abelard, although now synthesized with the vocabulary of "satisfaction." Scotus, however, effects this synthesis through a "voluntarist" understanding of God.[25] That is, for Scotus it is God's absolute freedom that is primary: the intelligibilities we discern within the actual world are the result of God's free determination. Hence, like his predecessors, Scotus holds that it would be within God's absolute power to save the chosen without the incarnation or the passion of Christ. God could give a "first grace" to humans without Christ's meritorious self-offering. As Abelard had already said, this is shown by the fact that God

did in fact give grace—indeed, supreme grace—to the human soul of Christ himself, prior to any merit on his part. Moreover, there was no absolute necessity for God to demand "condign" or "adequate" satisfaction for human sin. God could will to accept from humanity merely "congruous" or inadequate merit, combined with attrition (sorrow for sin arising from fear of punishment). Through the gift of grace this could be turned to perfect "contrition" (whose cause is charity, the love of God for God's own sake). This, according to Scotus, would "satisfy" for sin: that is, would restore to God the equivalent of what Adam took away by sinning. Thus what Anselm designated metaphorically as God's "honor" is seen by Scotus in a more ontological theology in terms of "charity," the love of God above all things, which is "owed" to God as infinite Goodness.

But in the actual order of the world, God disposed not to give any sinner grace except in virtue of Christ. According to Scotus, this is not because of willful hardness on God's part, but because it is the incarnation that has "priority" in God's plan of creation and redemption of the world. God creates, permits sin, and wills redemption precisely for the sake of the greater love possible through the incarnation. According to the "law" posited by the divine wisdom, our salvation had to be accomplished by Christ's passion as the instrument and "secondary cause" of salvation. But Scotus insists that the primary source and performer is the Trinity. In fact, then, and by the Trinity's loving will, it is the death of Christ that accomplished our salvation. Christ's passion and death gave to God fullest possible satisfaction for sin and earned condign merit for our salvation. And although God could have saved us without such a meritorious cause for grace, the divine majesty is more honored through the worship of a mediator.

The death of Christ is understood by Scotus as a "sacrifice" for sin. But he defines "sacrifice" as an act of supreme worship or reverence toward God and subjection to God's lordship, along with petition for the good. Christ's sacrifice, therefore, consisted above all in his *interior* act of self-offering: that is, in his supreme love. Christ pleased God more than all sins offended God precisely because of the love Christ showed for God and for humanity in his passion. It was this charity that saved us from sin and that merited for him all grace and glory. Christ's self-offering was also our "redemption" and can be called the "price" of salvation, because it removed the obligation for a penalty for sin and took us from the power of the devil, to which we were subject. But Scotus is careful to specify that Christ's offering is to the Trinity, not to the devil. And indeed, since that offering consists in an act of love and submission to God, it could not be otherwise.

As we have noted earlier, already in the theology of the Fathers, as also in Anselm's "satisfaction" theology, the cross was seen not merely as an objective act on God's part for our salvation: it is also a message for us, eliciting a

response. Because of his emphasis on the interiority of Christ's sacrifice, Scotus is able to make a close association between the cross and Christ's function as teacher, revealer, and example to humanity. Because humans have to be led to the spiritual through the sensible (the great theme of St. Bernard), it was needful for us to have a revealing word to teach us the way and life. Some pure human, or even an angel, might have satisfied this need. But God gave his own Word in flesh. The death of Christ was "fitting" (*conveniens*) because by death, Christ showed the reality of the body assumed by the Word, hence confirming the truth of his real humanity—a major theme, as we have seen, in Franciscan devotion. Most important, the cross that he suffered gives us the supreme exemplification of Christ's message of love of neighbor, even love of our persecutors. The death of Christ was a "fitting" way for God to accomplish our salvation, because it gives a supreme example of love. Scotus, like Abelard before him, cites John 5: "no greater love has anyone than to lay down his life for his friends." Because of Christ's passion and death we are more moved to the love of God, because we find ourselves more obligated by the immensity of love shown for us.

Scotus's positions, it will be seen, are not radically different from those of Aquinas and Bonaventure, except on one basic point: for Scotus, all this is so because God willed it to be this way; there is no intrinsic necessity to the actual economy of salvation. In his voluntarism, Scotus departs even more radically than his predecessors from Anselm's fundamental idea. Indeed, since for Scotus the incarnation would have taken place even without sin, redemption is no longer, as Anselm had entitled his book, "Why God Became Human" (*Cur Deus Homo*).[26] Ironically, however, this allows Scotus to place an even greater emphasis on Christ's passion: precisely because Christ's death was *not* necessary for our salvation, its reality becomes more significant as a sign of God's love.

Scotus's theology therefore gives further theoretical grounding for the Franciscan devotion to the humanity of Christ, especially in his passion. Naturally, Scotus held, with the tradition, that Christ's passion took place in his humanity, and not in any sense in his divinity. Furthermore, he presumes that Christ's human soul enjoyed the beatific vision, so that even during the passion its "higher part" was filled with unspeakable joy. But this did not prevent pain in Christ's sensitive appetite or sorrow in the "lower" part of the soul. (At one point Scotus even affirms that Christ's suffering affected his entire human soul, and not just the lower part). Moreover, Christ in his passion suffered every kind of suffering, and more intensely than any other human being, because the perfection of his humanity made him more sensible to pain and suffering. Furthermore, he suffered spiritually in a way no other person could, because the sins of the whole world were present to him, and he could appreciate the extent of their discord with the infinite goodness of God.

Several features stand out in Scotus's treatment of the passion. As in Aquinas and Bonaventure, the theological context is theoretical, rather than imaginative. Salvation is through grace, that is, it consists in the attainment of a supernatural state, rather than simply in the forgiveness of sin. The humanity of Christ is recognized as a creature that also receives grace—albeit at a higher level than any other. And the death of Christ is the salvific will of the entire Trinity, which is the primary worker of salvation—not merely the will of a Father who imposes a sentence on the Son. On the other hand, Scotus's voluntarism makes the entire economy of our salvation through the passion and cross depend on God's will, rather than on anything intrinsic either to human sin or to Christ's "meriting" of a new engraced form of existence.

Salient Features of the Scholastic Paradigm of Soteriology

Despite the undoubted and oft-proclaimed influence of St. Anselm, we find that the theology of the Scholastic period does not simply repeat the "satisfaction" schema, but develops a nuanced theoretical view of the relation of the cross to salvation. On the one hand, distinctions were added to Anselm's theory and vocabulary; on the other, the major insights of Abelard's theology were incorporated. There is a strong recognition of the need for a response on our part to God's initiative in the process of salvation. The notions of "satisfaction" and "sacrifice," while prominent, are demythologized, and are understood in terms of God's love and the human response of self-giving in love.

Although there is agreement that the passion of Christ is in some way the reason for the forgiveness of the "debt" of original sin, the scholastics are far from taking a merely juridical view, or of reducing salvation to a matter of "satisfaction." On the contrary: they present salvation primarily in terms of the theoretical concept of "grace." And their explanations of grace are metaphysical, involving a change in the ontological status of the creature because of a new level of participation in the divine being. The "horizontal" and "vertical" dimensions of grace are complementary: grace is a gift that enables and demands a human response.

That salvation takes place through the *grace* of Christ implies that it involves not merely a sentence of forgiveness on God's part but the genuine transformation of the individual. Aquinas and Scotus have moved away from both the older and more recent Anselmian juridical notions of payment by death. Emphasis shifts from what was essentially a juridical metaphor—redemption or satisfaction—to the complex theoretical notion of "grace," the ontological gift of new life, merited by Christ's life and appropriated through the imitation of his example. Although salvation by merit and grace is satisfaction for sin, it also implies an "elevation" of humanity to a new status, which

demands in turn a new way of living. In this sense, we find here a return to the theme of *metanoia*, conversion, that was central to Jesus' preaching of the Kingdom. At the same time, we are presented also with a different context: one that is metaphysical-theological rather than simply imaginative and metaphorical.

There is also a complementarity between the "objective" and "subjective" aspects of salvation. Grace is "merited" by Christ: that is, Christ's life is the instrumental and exemplary cause by which God's love is given to humanity. But grace must also be appropriated by each Christian. Hence there is strong emphasis on Christ's example of virtue—in particular, the virtues of love, humility, and obedience (not coincidentally, virtues especially cultivated by the friars, in opposition to the feudal and chivalric ideals of pride, strength, power, and independence).

As we have seen, even in Anselm the emphasis is on God's love as the motivation for the economy of salvation, including the cross. But in the theology of the great Scholastics, as opposed to that of Anselm, it was not necessary for Christ to die. On the other hand, the fact that God in fact chose this way of salvation is a sign of God's love. Hence, even while repeating the New Testament message that the Father "handed over" his Son for us, Scholastic soteriology avoids the image of the heartless father or the inflexible judge bent on satisfaction.

Precisely because of its complexity and its metaphysical context, however, the Scholastic theories of salvation are farther removed from popular imagination than the imaginative theology of an earlier era. Because more abstract and theoretical, it was less capable of direct imaginative or aesthetic expression. At the same time, elements of this theology, taken out of the context of the whole, could produce quite a different reaction from that intended. The fact that theology now teaches that God *chose* death for Christ, although it was not strictly necessary for our salvation, could reinforce rather than eliminate a bloodthirsty image or a sadistic/masochistic association of suffering with love. As we have seen, the voluntary element in Christ's death, as well as the connection of suffering with the manifestation of love, are emphasized more strongly in Scotus than in Thomas. At the same time, we also find in Franciscan theology a tendency to promote the idea of a kind of conflict between God's mercy and justice (a contrast already found in St. Bernard)—a tendency that, combined with voluntarism, could militate against the intrinsic intelligibility of the soteriological schema. And, as we have seen, the theoretical understanding of salvation was accompanied by an increased emphasis on the extent of Christ's (voluntary) suffering. As we shall see, such factors were influential in the development of later extremes of passion piety.

The Aesthetic Mediation of Theology in the
Early and High Gothic Periods

The Expansion of Devotion to the Humanity of Christ
in the Passion

In the previous chapter we noted that devotion to the humanity of Christ, and specifically devotion focused on the passion, predated the Gothic period and the diffusion in art of pictorial representations that corresponded to the new piety. Nevertheless, it was the thirteenth century, the period of High Scholasticism in theology and of Gothic style in art, that witnessed the development of a widespread, popularized, and aesthetically developed form of that devotion.

Hans Belting, among others, characterizes the thirteenth century as one of the greatest periods of change in European history.[27] The new freedom of citizens of the growing and increasingly independent cities, the expansion of markets, and the opening of horizons through the Crusades were among the sociological factors that allowed a rapid development of the humanistic tendencies already initiated in the "renaissance" of the twelfth century. In religious life, the recently instituted orders of Franciscans and Dominicans played a crucial role in creating a spirituality oriented to the laity. That spirituality capitalized on the new emphasis on sense experience, and focused on an affective relationship to Christ. For this reason, pictures began to play a more important and a different role.[28]

Given the new focus on the laity, as well as the general cultural stress on sense experience and on affectivity, it is not surprising that in the thirteenth century the passion became the primary focus of the developing devotion to Christ's humanity.[29] Like the nativity, the other great focus of devotion, it offered a dramatic object for emotion; and its prominence in the gospels, the liturgy, and current soteriological theory made it an even more central theme. Moreover, as we shall see, the new images of the crucifixion concentrated specifically on the humanity of Christ, and invited the viewer to meditate on his similarity to us—in contrast with the triumphal older images that stressed his divinity and apocalyptic lordship. The new images corresponded to a spiritual appreciation of the individual, no matter what his or her social standing. The model of the suffering Christ allowed for a universal identification. In addition, the emphasis on the humanity of Christ and the salvific value of his death were a response to the doctrines of the widespread sect of the Cathars, who denied both of these doctrines.

While Bernard and the early scholastics provided both a theological rationale and an eloquent model for affective devotion to Christ's humanity, the development and diffusion of the new spirituality were largely due to the influence of Francis of Assisi (1181–1226). Francis's own life was characterized

by intense personal "dialogue" with Christ and imitation of his life, including the passion. It was from the cross that Jesus spoke to Francis, giving him his mission. And toward the end of his life, so intense was Francis's association with the crucified that he was said to have received on his own body the marks of Christ's wounds, the stigmata: the visual sign of the imitation of Christ's passion that was the goal of Francis's spirituality.

> At the first hours of the day, Francis, kneeling, with his arms extended as on a cross and his eyes turned toward the east, addressed to the Lord this prayer: "O Lord Jesus, there are two graces that I ask you to grant me before my death. The first is that, as much as possible, I should feel the sufferings that you, my sweet Jesus, had to undergo in your cruel passion. The second is that I should feel in my heart, as much as it is possible, the infinite love with which you burn, you, the Son of God, and which led you to suffer voluntarily so many pains for us miserable sinners."[30]

Francis and his followers, as well as the newly formed Dominican friars, developed a style of devotion that was more popular and emotional than the older monastic form of contemplation.[31] The Franciscan spirituality in particular centered on visualizing the dramatic moments of the beginning and the end of Jesus' life, emphasizing devotion to the infant Jesus and to the suffering Savior on the cross.[32] (Significantly, both of these moments also included Mary, whose role as mother and as cosufferer with Christ received increasing attention in spirituality and in art.)

Despite the clear influence of the Franciscans on passion piety, historian Georges Duby insists that the piety of Francis himself was not fixed specifically on the torments of the passion. Rather, like that of the mystics of the twelfth century, it centered on the generosity and humility of God, seen in the mystery of the incarnation. Christmas was more important for Francis than Easter.[33] What Duby calls the "obstinate" meditation on the outrages suffered by Christ and on his death was not from Francis, but from later Franciscans after the death of their founder. Duby contends that it was the friars who concluded that the best way to lead ordinary people to real contrition and to prepare them for death was to excite compassion and remorse by placing before their minds (and before their eyes, through art) the flesh of Christ, offered as victim on their behalf.[34]

A major example of and influence on this tendency in preaching (and hence indirectly its expression in art) was the "second founder" of the Franciscan order, Bonaventure. As minister-general of the Friars Minor, Bonaventure imposed a new version of the life of Francis, stressing the stigmata, the signs of Christ's passion that Francis received on his body.[35] Bonaventure's book *The Tree of Life (Lignum Vitae)* provides an eloquent example of the kind of meditation on the passion that typified Franciscan preaching and spirituality

in his time and thereafter.[36] The "tree" referred to in the title is not immediately identified with the cross, but with Christ himself: he is the "tree of life with twelve fruits" mentioned in the Book of Revelation (22:1–2). The entire middle section of the book ("fruits," 5 to 8) deals with the passion. The "fruits" that are manifest in this mystery are: Jesus' confidence in his trials, his patience in maltreatment, his constancy under torture, and his victory in the conflict with death. These are what the Christian should meditate on and take as examples.

We see in Bonaventure's meditations the practical implications of his theology of the passion. A major reason for the sufferings of Christ is precisely to give us a sign of God's great love and an example for our lives. The passion is not merely God's way of working our salvation; it has a didactic value for us. So, for example, in his meditation on the "fifth fruit," Jesus' confidence in the midst of his trials, Bonaventure asks the Lord, who is imagined as prostrate in prayer: " 'Ruler, Lord Jesus, whence comes to your soul such vehement anxiety and such anxious supplication? Have you not offered to the Father an entirely willing sacrifice?' [Pseudo-Anselm, meditations, 9]." Bonaventure immediately gives the answer:

To shape us in faith by believing that you have truly shared our mortal nature, to lift us up in hope when we must endure similar hardships, to give us greater incentives to love you—for these reasons you exhibited the natural weakness of the flesh by evident signs which teach us that you have truly borne our sorrows and that it was not without experiencing pain that you tasted the bitterness of your passion.[37]

The passion, for Bonaventure, not only gives us a positive example of virtue but also leads us to a deeper appreciation of our sinfulness and a more affective contrition. Bonaventure tells us that "The first thing that occurs to one who wishes to contemplate devoutly the passion of Jesus Christ is the perfidy of the traitor" (first fruit: Jesus' confidence in his trials).[38] To the medieval mind, the enormity of betrayal was particularly horrendous. We recall that Dante would reserve the deepest part of hell—the very mouth of Satan—for those who committed this sin, with Judas receiving the worst punishment of all (*Inferno*, 34). Perhaps the natural horror at the betrayal of a friend and the shame of ingratitude to a benefactor was reinforced by social circumstances: the feudal system was entirely based on personal loyalty. In any case, it is significant that Bonaventure understands sin precisely in this context. Sin is not merely disobedience; it is personal betrayal of a friend and benefactor. Meditating on the denial of Jesus by his own disciples (sixth fruit: Jesus' patience in maltreatment), Bonaventure writes: "O whoever you are who . . . have shamelessly denied Christ, who suffered for you, remember the passion of your beloved Master and go out with Peter to weep most bitterly over yourself . . . so that having

atoned with Peter for the guilt of your crime, with Peter you will be filled with the spirit of holiness."³⁹

It is we who, like the disciples, have betrayed Jesus, and we can learn from the passion the depth of our shame and the degree of God's compassionate forgiveness. Bonaventure's meditations vividly describe and emphasize the degree of Jesus' innocent suffering, with the explicit aim of inculcating a highly affective appreciation of these realities. In the contemplation of Jesus' condemnation we read:

> [Pilate] issued an even crueler order that Jesus should stand stripped
> in the sight of men who mocked him so that savage scourgers could
> lash that virginal and pure-white flesh with fierce blows, cruelly in-
> flicting bruise upon bruise, wound upon wound. The precious blood
> flowed down the sacred sides of that innocent and loving youth [!] in
> whom there was found absolutely no basis for accusation. And you,
> lost man, the cause of all this confusion and sorrow, how is it that
> you do not break down and weep? Behold the most innocent Lamb
> has chosen on your account to be condemned by an unjust sentence
> in order to rescue you from a sentence of just damnation. Behold,
> he pays back for you what he did not steal [Ps 68:5]. And you, my
> wicked and impious soul, you do not repay him with gratitude and
> devotion nor do you recompense him with compassion.⁴⁰

However, although Bonaventure's meditations for the most part place responsibility for Christ's suffering on the sins of all people, and aim at bringing the reader to an emotive recognition of his or her own guilt, they also contain passages in which blame is directed toward "the Jews." Considering the handing over of Jesus to Pilate, for example, Bonaventure exclaims, "O horrible impiety of the Jews." He speaks of "the reprobate Jewish people"⁴¹ and identifies the synagogue with the "Egyptian prostitute."⁴² It is not unreasonable to see the widespread influence of such spiritual writings—Bonaventure's, of course, are not unique in this—as one of the contributing factors to the resurgence of virulent late medieval anti-Semitism. The Patristic and medieval reading of the gospel of John already provided justification for the longstanding official persecution of the Jews. The emphasis given in the high Middle Ages to the contemplation of Jesus' suffering very probably provided an even more emotional motivation and rationalization for the various popular pogroms against Jewish communities—like the fanatical "crusade" of the *pastoureaux* in the early fourteenth century, in which many urban populations joined, despite the condemnations of the pope, the bishops, and the king of France.

With regard to the theology of the passion, Bonaventure's meditations make it clear that the notion of substitution, even after the wide acceptance of its sophisticated form in Anselm's "satisfaction" theory, did not simply replace

the other notions of how salvation takes place—especially through victory over the demonic powers. In the meditation on "Jesus triumphant in death" (ninth fruit), Bonaventure writes:

> Now that the combat of the passion was over, and the bloody dragon and raging lion thought that he had secured a victory by killing the Lamb, the power of the divinity began to shine forth in his soul as it descended into hell. By this power our strong Lion of the tribe of Judah (Apoc. 5:5), rising against the strong man who was fully armed (Luke 11:21), tore the prey away from him, broke down the gates of hell and bound the serpent. Disarming the principalities and powers, he led them away boldly, displaying them openly in triumph in himself (Col. 2:15). Then the Leviathan was led about with a hook (Job 40:25), his jaw pierced by Christ so that he who had no right over the Head which he had attacked, also lost what he had seemed to have over the body.[43]

We recognize here many Patristic themes and images. In other meditations, we find further Patristic ideas that were frequently repeated in the Middle Ages. Jesus is presented as the new Adam (seventh fruit)—as Adam sinned by a tree, it is fitting that Jesus should triumph through the wood of the cross; he dies so that "the church might be formed out of the side of Christ sleeping on the cross," as Eve was formed from the side of the sleeping Adam (eighth fruit).[44] He is also the High Priest (eighth fruit). Bonaventure addresses the Father: "look upon this most holy Victim, which our High Priest offers to you for our sins, and 'be placated over your people's wantonness' [Exod. 32:12]."[45] "So that with God there might be plenteous redemption (Ps. 129:7), he [Jesus] wore a priestly robe of red; his apparel was truly red and his garments [were] like those of the wine presser (Is. 63:2)."[46] (Significantly, Bonaventure explains that the "garment" here is to be taken not merely in its literal sense; rather, the "garment" is Jesus' earthly flesh itself, which is "put on" by his divinity.)

Obviously, we also find in Bonaventure's meditations a stress on the subjective side of redemption—the need for human acceptance of God's salvific work, for repentance, and for virtuous living. Indeed, the affective encouragement of repentance and of the imitation of Christ is the prime purpose of meditation on the passion.

Despite the endurance of other theological images of the passion's saving efficacy, it was above all the image of personal vicarious suffering that was peculiarly adapted to the new spirit of affective association with Christ. However, it was the love of God and of Christ that received the greatest emphasis, rather than the theories of how exactly the sacrifice of Christ "worked" to save us. The incarnation and the cross were obviously signs of God's enormous love for humanity, reasons for hope.

The Catalan philosopher, mystic, and missionary to the Muslims Ramon

Llull (ca. 1233–1315)—the first Western European to write serious theology in the vernacular, namely Catalan—expresses it explicitly and succinctly:

> The Saracens say that Jesus Christ did not die. And do you know why they say this? Because they think they are giving him more glory by his not dying. But they do not understand the honor that Jesus Christ takes in being the hope and the consolation of every person, however poor or sinful; and there would not be such a true hope for such people, if Jesus had not been God, and had not been human, and had not died to save humanity.[47]

Not coincidentally, Llull had strong contacts with the Franciscans, particularly the "Spirituals," who wished to preserve a radical spirit of poverty. (Since Llull was a layman, and married, he could not join the order, even after he left his family to devote himself to a missionary vocation; but it is likely that he became a Franciscan tertiary.)

Llull's theology of redemption (which he calls "re-creation"), like that of the Fathers, centers on the incarnation; but its most direct sources and its emphases seem more Franciscan than Patristic. Llull stresses the humility and poverty of Christ as the opposites to original sin, and therefore as examples to us, and he stresses particularly the suffering of Christ as the means of our salvation:

> this re-creation is the union of the Son of Our Lady Saint Mary . . . with the union of [sic] the Son of God. By which union, and by the suffering of Jesus Christ's human nature, the world was re-created from original sin which we had from the first man, that is, Adam, who disobeyed God's command. . . . And if the Son of God had not become incarnate and had not died when he was a man, we would all have gone to Hell's fires for ever and ever. But by the sanctity of the union of the Son of God with Christ's human nature, who are one person, and by the sanctity of the precious blood Christ spilled to re-create the world, all those who believe in re-creation are delivered from the power of the devil and are called to glory without end.[48]

The Role of Art in the New Devotion

IMAGES OF THE SUFFERING CHRIST IN ART. The Crusades for the recovery of the Holy Land no doubt also contributed to the growth of affective remembrance of Christ's martyrdom. Already in the twelfth century, a certain Theodoricus writes in his *Libellus de Locis Sanctis* (1164–1174) about the mosaic of the crucified that stood over the door of the Latin church of the Holy Sepulcher in Jerusalem: "he was so portrayed as to induce great compunction in all those who saw [the image]."[49]

Nevertheless, Western depictions of the crucifixion still remained primarily symbolic in nature: they were intended to call to mind the sacrificial Lamb who is still offered in the eucharist, rather than draw attention to Jesus' human suffering.[50] Christ's sacrifice was still recalled pictorially in the context of his ultimate glorification, as indicated by the golden halo that crowns the head of the dead Christ. And, as we have seen, the more usual presentation of the crucifixion in the Romanesque period showed Christ not suffering or dead, but in glory. He is shown alive, often dressed in priestly or kingly robes, open-eyed, standing straight with arms outstretched, frequently crowned, and sometimes smiling or laughing in victory, as in the famous crucifix of San Damiano that spoke to St. Francis.

From the thirteenth century onward, however, the situation began to change. We have already considered the revolution in theology and spirituality that began in the twelfth century. It was to reach a culmination in the thirteenth, with High Scholastic theology and Gothic art.

An artistic representation of the crucifixion that corresponded to the new affective form of devotion that we have spoken of was not far to seek. Its main elements were already present in Eastern Christian art. As we have seen, the Quinisext council "in Trullo" of 692 had legislated that henceforth Christ should be portrayed in his human form, rather than under the symbolic figure of the Lamb (of the Apocalypse), as in the "old" custom. This move was possibly intended as a response not only to the iconoclasts but also to the Monophysites, who refused to portray Christ on the cross.[51] Polemical considerations were probably also at work in Byzantine art's shift to the portrayal of Christ dead on the cross, rather than triumphantly alive (as in earlier art).[52] The affirmation of Christ's real death was the ultimate guarantee of belief that a genuine human nature was hypostatically united with the Word.

The fall of Constantinople to the Crusaders in 1204 precipitated a flight of artists to Italy, where a renewed Byzantinism took hold. As we have seen, Byzantine painting had already shifted to the portrayal of the dead Christ, for dogmatic reasons, and had already begun to develop under "humanistic" impulses. This led to a more emphatic portrayal of pathos in the crucifixion scene. But the shift to the image of the suffering Christ in the West went beyond these influences, and was connected above all with a new function of the image in the developing affective spirituality oriented to the laity.[53]

As we noted in the last chapter, depictions of Christ dead on the cross can also be found in the West from the ninth century onward, especially in northern Europe. One of the most famous and earliest examples of the type is the great Ottonian crucifix donated by the archbishop Gero to the cathedral at Cologne in about the year 970. Christ, although regal, is clearly dead on the cross. As in the East, theological considerations (as well as imitation of Eastern models) were probably influential in this choice of depiction. Exegesis in the ninth century (Candidus, Paschasius Radbertus) taught that the death of Christ

on the cross was not merely victory over death but also the saving work of our redemption. This idea was connected with the theology of the eucharist worked out by theologians of the court of Charlemagne, which emphasized the real presence of Christ's body.[54] (From the ninth century on, some representations of the crucifixion include a female figure, representing the church, collecting the flowing blood of Christ into a chalice.)[55] It also was in accord with the allegorical explanation of the mass provided by Carolingian theologian Amalars of Metz, who saw in the gestures of the eucharistic celebration a concrete symbolic representation of the death, burial, and resurrection of Christ: the altar represents the tomb, the chalice covering symbolizes the linen cloth of burial, the three prayers before the sign of peace are the three days in the tomb, the sign of peace signifies Christ's descent to hell to liberate the just, the communion (when the body of Christ leaves the altar, the tomb) represents the resurrection, and so on.[56] Such factors clearly favored an increased consciousness of the sufferings and death of Jesus.

It was only in the thirteenth century, however, that the image of the suffering or dead Christ, based on the Byzantine Good Friday icon, became widespread (and eventually predominant) in the West.[57] Obviously, this style of representation did not immediately replace the older triumphant images. The two forms coexisted for some time.[58] A striking Italian processional cross from this period exemplifies the complementarity of the two images and their respective theologies: on one side of the cross is painted the dead Christ, with evidence of his suffering; on the other, the triumphant living Savior. Significantly, both figures have almost exactly the same posture, with the exception

Processional cross with Christus Victor (left) and Christus Patiens (right).
Credit: Cameraphoto / Art Resource, New York.

of the placement of the head and the position of the hands. Musculature is indicated, but much less emphatically than in the highly stylized conventions of later Byzantine models. The dead Christ is portrayed with his head gently inclined onto his shoulder. Blood streams from the wounds in hands and feet, but there is no indication of agony. The feet are nailed separately to a *suppedaneum*. The legs form a slight arch, and the hips and abdomen are swayed to the side, as though bearing pressure from above. Nevertheless, the torso is upright; despite the position of the hips and legs, the body appears to be standing upright, not sagging down as a dead weight. The arms extend nearly straight out from the shoulders. The triumphal Christ has his head erect, looking outward through open eyes. The blood from the wounds is present here as well. The nailed hands of the triumphant Christ are opened upward, in the "orans" position, while those of the dead figure are flat to the crossbeam. It is the same Christ who has really suffered and died for us who is also the living victorious Lord over death.

Further examples of the earlier triumphal type can still be found, alongside contemporary images of the *Christus patiens*, well into the thirteenth century, especially in Italy. However, from this time, the Gothic version of the Byzantine portrayal of Christ began to prevail, eventually to become the normal and indeed nearly exclusive form of the crucifix.[59] Although there is a certain amount of variety, expecially in northern Europe, the new Byzantine-inspired crucifixes typically show Jesus with closed eyes, sometimes wearing a crown of thorns, the head drooping onto the chest, the body visibly hanging and contorted into the shape of an *S* or a *Z* (a symbolic reminder of the bronze serpent raised up by Moses,[60] but also an exaggerated expression of the graceful "Gothic curve" seen frequently in the posture of statues), the feet crossed and nailed with a single nail.[61] The depiction corresponds to the new sensibility and emphasis on feeling that we have noted in the spiritual writings and preaching of the era, and that was also evident in the new "humanism" in secular literature. The face, which even in the repose of death bears the marks of suffering, draws our particular attention. Some artists evoke an emotional response by giving Christ's face a beauty that underlines the tragedy of his death.[62] More, it bespeaks a new ideal of beauty itself, identified now with self-giving love.

In the interplay between the narrative and iconic elements that are both present in every representation of the crucifixion, the emphasis shifts toward the iconic.[63] Of course, in an important sense the representation of the crucifixion remains fundamentally within the genre of "historia." Indeed, in the Gothic period there is an increasing emphasis on portraying "what actually happened," as it was known through the testimony of supposed eye-witness sources. (So, for example, the Dominican preacher Fra Giordano da Rivalto remarked in 1306 that the new passion icons from Greece showed things as they actually were, since they were modeled on a crucifixion painted by Nicodemus, who was there.)[64]

However, there are significant differences from earlier pictorial "narratives" of the event. In very early Christian art, as we have seen, the crucifixion is only one element in the passion, and the passion only one element in a larger narrative that culminates in the resurrection. With the emergence of the *croce dipinta* or *Tafelkreuz*, the crucifix begins to be removed from its larger narrative context. Elements are of the larger story are explicitly recalled (as in the cross of Fernand and Sancha or the cross of San Damiano) but are visually subsidiary. With the self-standing crucifix, the moment of crucifixion is effectively removed from this larger narrative. Its culmination is not forgotten: in the Romanesque period, the cross is primarily portrayed not merely as an element in the earthly story of Jesus but in the light of his resurrection and his divinity. In the Gothic crucifix, by contrast, we see an increasing emphasis on the *human* story of Jesus, and on a particular *moment* in that story. This means that we are dealing with a different kind of art: an art whose idea of "representation" is more naturalistic, rather than ideal and Platonic. Such portrayal is in line with the tendency to seek in art not merely a presentation of doctrines or facts but a dramatic reliving of events. It is in this sense that the narrative elements serve an increasingly "iconic" purpose. The *historia* here is one that is also suprahistorical, one that can be made present.

By the same token, because it is not simply a portrayal of past history, the Gothic crucifix invites a living engagement, a dialogue, centered on affective sympathy. As Alex Stock remarks, what St. Francis's reception of the stigmata represented was the visual expression of what meditation on the passion was supposed to accomplish in each person.[65] The image is meant to awaken the viewer's human sympathy for a fellow human being—in the context of the knowledge that in this case that being was perfect and perfectly lovable, and that he freely chose to suffer out of love for us. (This point is emphatically made in a number of manuscript illuminations in which Jesus is symbolically crucified by the Virtues. In an illustration in the Bonmont Psalter [ca. 1260],[66] for example, a crowned and living Christ is nailed to the cross by Humility, Justice, and Obedience, while Love pierces his side and Ecclesia, the church, fills a chalice from the stream of blood from his side. As we have seen, the church frequently emphasized the Johannine and Patristic idea that Jesus voluntarily gives up his life. One could therefore say that it was his goodness that led to his suffering, and we are to imitate his self-giving. The virtues will likewise lead us to the cross and to salvation. This line of thought was particularly encountered among religious.)

Such images at least implicitly teach the notion of God's sympathy for us: God has willingly known suffering like ours, and even greater. (Of course, this idea glosses over the problem that arises from the doctrinal insistence on the distinction of the "natures" in Christ in an "unmixed" union, and treats him simply as God experiencing human reality). The corresponding human sympathy aroused on the viewer's part is meant first to awaken a consciousness of

the gravity of sin, which caused this suffering, and of the greatness of the divine love that undertakes it. But it goes beyond this: the viewer's identification with Christ is to become a kind of *com-passio*, a suffering along with him, an entry into his attitude and therefore into the work of redemption itself.

Examples of the "humanistic" crucifix abound in the high Middle Ages. Of particular interest is the panel cross by Giunta Pisano that was discussed at the beginning of this chapter. At the same time, similar themes began to be treated by other artists in a more typically Western style. As we have seen, Byzantine icons of the crucifixion purposely retained a sense of moderation, nobility, and dignity, even in the portrayal of suffering and sorrow. In this they were the heirs of the Hellenistic tradition, which saw even tragic art as calm and poetic. Christ and the Virgin are always "decorous" in their grief.[67] In the West, beginning in Italy, the humanization of the sacred drama of the Byzantine crucifixion icons was carried to a new level. Western painted and sculpted crucifixes gradually aspired not only to more emotional depth but also to greater naturalism and realism, although without completely losing the symbolic dimension that marks sacred art.

At the same time as the development of the self-standing crucifix, we also see in narrative paintings and in stained glass the introduction of new passion themes. The descent from the cross, which was portrayed in Byzantine art at least from the twelfth century, seems to have entered Western iconography by the thirteenth. The portrayal of the entombment of Christ, deriving from the third "station" of the Good Friday liturgy, would lead to the portrayal of the extrabiblical theme of the reception of the dead body of Jesus by Mary, and thence, by the thirteenth century in northern Europe, to a new genre of sacred art: the meditative scene eventually to be known as the *pietà*. We shall have more to say about such scenes when we look at the Marian devotion that developed in connection with the passion scene.

SOURCES OF CRUCIFIXION IMAGERY. Not surprisingly, such uses of imagination eventually led authors to go far beyond the canonical gospel texts in recreating the scenes of the passion. As F. P. Pickering notes, the gospels themselves give us minimal information about how the crucifixion took place: indeed, in the Vulgate version they tell us of the event in a single word: *crucifigerunt*—"they crucified [him]."[68] Where then did preachers and artists get their ideas of what occurred? And how is it that there is such remarkable unanimity in their portrayals?

Pickering points out a number of common sources that are responsible for the imaginative tradition of the crucifixion and of the passion in general. Above all, as we might expect, it was the Scriptural interpretations of the Fathers that were most fundamental. Patristic exegesis and commentary explained and amplified the New Testament accounts of the passion in several ways. There was a certain amount of lore associated with the Holy Places in

Jerusalem that allowed the concretizing of the setting of events.[69] In some cases details were inferred from the text. So, for example, in the account of the flagellation the number of soldiers present is derived from the idea that the Law required two witnesses to support an accusation: hence it is appropriate to posit two soldiers for each of the charges against Jesus.[70] If a text refers to an action by a group of people, later commentators could easily divide the action, ascribing parts to individuals: one did this, another did that.

Above all, however, the Fathers expand the New Testament text by seeing in it the fulfillment of Old Testament prophecies, especially from the Psalms, the prophets, and the lamentations of Jeremiah, which were applied to both Jesus and Mary. The key to such exegesis is given in what were taken to be the words of Christ himself: "it is necessary to fulfill all that is written about me in the law of Moses, and in the prophets, and in the psalms" (Luke 24:44). Obviously, the gospel writers, who were uneducated men, had not recorded every fulfillment of these prophecies (although, as we have seen, modern scholarship sees the passion accounts as having been constructed to some extent precisely by such considerations). Hence it was legitimate to seek out texts that were a divinely inspired foretelling of later events. These texts were thought to be a source of factual information about those events—sometimes even more than the New Testament itself.[71]

Moreover, Christ had given examples of the use of Old Testament texts about himself: Jonah as a sign of the resurrection, the brazen serpent in the desert as a prototype of the crucifixion (this reference may explain the curved S or Z shape of the corpus in many Gothic crucifixes).[72] This justified the method of seeking Old Testament figures and types for Christ. According to the widely accepted Patristic and medieval theory of exegesis, one could discern different "senses" of the Scriptures: literal, tropological (moral), anagogical (referring to future eternal glory), and allegorical. The last was concerned with expounding the relationships between the "veiled" revelation of Christ in the Old Testament and its full unveiling in the New. On this basis one could find both factual and symbolic "types" or prefigurings of Jesus' death throughout the Scriptures. These could then be used to form a more adequate image of the latter.

Some of these "types" of the crucifixion represented fairly obvious and ancient associations: even in catacomb paintings, for example, we find the image of Abraham's preparation for the sacrifice of Isaac, and the latter's replacement by a ram, as a prefiguring of the sacrifice of the Lamb, Jesus, by the Father. Other associations may strike us as less obvious, if not actually fanciful: for example, the drunkenness of Noah and his subsequent nakedness (Gen. 9:20 and following) is taken as a prefiguration of the passion, in which Christ drank the inebriating wine of suffering and was shamed and mocked.[73] Some exegesis of this kind seems positively perverse. In an early thirteenth-century *Bible Moralisée*, a tropological or moral reading of the biblical text, the incident

of the mocking of the prophet Elisha by a group of children and his subsequent cursing of them (4 Kings 2:22–24) is taken as a prefiguration of the mockery of Christ at the crucifixion:

> That Elisha was on a mountain and the children came before him and mocked him and asked to see his miracles, and Elisha cursed them signifies Jesus Christ who was on the mount of Calvary on the Cross and the Jews came around him and mocked Him and said in derision: "If you are that which you say, descend from the cross and we will follow you," and Jesus Christ was angered by them and cursed them and their foolishness.[74]

Here we have a mutual influence of texts: the Elisha passage makes no association of the children's mockery with a demand for miracles: this is read into the text from the gospels. On the other hand, the anger and curse of the prophet, attributed now to the crucified Christ, are nowhere found in the gospel accounts of the passion; indeed they contradict the attitude of Jesus expressed in the saying in Luke 23:34: "Father, forgive them, for they do not know what they are doing!"[75]

A sermon of St. Bernard on the passion further illustrates the allegorical method of interpretation at work in reconstructing as well as understanding the events. Bernard does not mention his Old Testament sources, which I have included, using the Vulgate Latin version:

> [Christ showed his] unique long-suffering, as sinners worked upon his back [Ps. 128:3: "super cervicem meam arabant arantes prolongaverunt sulcum suum," (On my back the plowers have plowed, they have lengthened their furrow), a reference to the scourging]; when they so stretched him out on the cross, that all his bones could be counted [Ps. 21:18: "numeravi omnia ossa mea," (I have counted all my bones)]; when that most strong fortress, that guards Israel, is pierced on all sides [freely using *Song of Songs* 4:4: "Your neck is a tower of David, built like a fortress," and Ps. 121:4: "He neither slumbers nor sleeps, the guardian of Israel"]; when, with his hands and feet bound [Ps. 21:17: "vinxerunt manus meas et pedes meos," (they have bound my hands and my feet)], he is led like a lamb to the slaughter, and like a sheep before the shearer, he did not open his mouth [Isa. 53:7: "sicut ovis ad occisionem ducetur et quasi agnus coram tondente obmutescet et non aperiet os suum," (Like a lamb he is led to the slaughter, and like sheep before the shearers he is silent and does not open his mouth)].[76]

As we see here, Psalm 21 (in the Vulgate; Ps. 22 in many modern versions) was taken to be a direct prophecy of the events of the passion. One could therefore take from it descriptive details that are not given in the gospel ac-

counts. Likewise, the prophecies about the "suffering servant" in Isaiah were thought to refer directly to Christ in his passion. Indeed, Jerome and Augustine, followed later by Isidore of Seville, say of Isaiah that he is so rich in prophecies about Christ that he may be thought of as an evangelist, rather than merely a prophet.[77]

Bernard says, furthermore, that Christ suffered these things mentioned in the Old Testament "not figuratively, but really" (non figurative, sed substantialiter)—illustrating, as Pickering says, "the fateful ease with which important and revered metaphors and figures of prophecy could be translated into 'realistic' incident."[78]

Similarly, symbols and allegories of the passion were "desymbolized" and used in a literal way to concretize or expand the story.[79] One such symbol that had an effect on the visual portrayal of the crucifixion was the harp. We have seen already that the verse from Psalm 2, "all of my bones are counted," was taken to mean that Jesus was stretched on the cross so that his ribs were visible—as indeed we see in so many crucifixes. From this arose a symbolic (and perhaps to the modern mind rather fanciful) interpretation of the verse of Psalm 57:9, "awake, harp and lyre." Cassiodorus writes: "the harp signifies the glorious Passion which with stretched sinews and counted bones sounded forth his bitter suffering as a spiritual song."[80] Naturally, an association was also made with David, the harpist, who was thought to be the author of the psalms, and was both an ancestor and prefiguration of Christ. The harp itself is like the crucifix, since it is made of wood, with animal gut stretched on it; Christ on the cross is like the harp of God, on which God's "music" of salvation is played—by the striking of the strings. The parallel is made in a middle high German poem, Die Erlösung (written about 1300): "the Savior was nailed and fastened to the cross, spanned and sorely stretched, struck again and again." It is even more explicit in a contemporary Passion Book (Passional) from East Prussia: "He stretched himself between the nails like a tautened string. . . . God the almighty Father would draw your heart to him, and with that intent spanned his strings on the harp of the cross. . . . All nature was spellbound by the Father's music."[81] Hence every mention of the harp in the Old Testament could be taken as a symbolic reference to the crucifixion, and the depiction of Christ on the cross frequently evokes the ideas of stretching, with Christ's arms taut and/or with his ribs showing like the strings of the instrument.

A further source of "information" about the passion and crucifixion was the apocryphal gospels, especially the Gospel of Nicodemus, whose contributions we have mentioned earlier. These writings often explicitly make the statement that a particular event in the passion took place "so that the Scriptures might be fulfilled."

However, the Christian imagination did not limit itself even to the traditions from the apocrypha. The stories were expanded and filled out by works of pious artistry. The most influential of these in the thirteenth century

were the *Dialogue of the Blessed Mary and Anselm about the Passion of the Lord*, and the *Meditations on the Life of Christ*, a late thirteenth–century popularization, ascribed to Bonaventure, of the latter's affective contemplations, and the *Book of the Passion of Christ*, ascribed to St. Bernard. These meditations often add elements of pathos. For example, the *Dialogue* (which, we recall, claims to be a private revelation to Anselm by Mary herself) tells us that Christ's cross was made in advance, with holes bored to receive the nails. The cross is laid on the ground, and Christ is thrown onto it. At this point it is discovered that the holes have been made too far apart. So Christ's arms are stretched (implicitly invoking the "harp" theme). Then the cross, with Christ on it, is dropped into the deep hole that has been prepared to receive it. As it settles with a jolt, Christ's hands, muscles, and veins are torn asunder.[82]

MARY IN THE PASSION. Many of the details in the narratives of the Apocrypha and their expansion in pious passion literature are especially connected with Mary. In the instance just cited, Mary tells Anselm that the events that took place before her eyes were a fulfillment of the words of the psalm, "Hear, daughter, and see" (Ps. 44:11):

> As though my Son were saying, "Hear, my dearest mother, the
> sound of the hammers, and see how they have fixed my hands and
> my feet, and no one has compassion on me, except you only my
> chosen mother. Hear, daughter, and have pity on me." And hearing
> and seeing these things, the sword of Simeon pierced my body and
> soul.[83]

The increasing emphasis on the sufferings of Mary in paintings of the crucifixion reflects such literature.

Another example: the *Gospel of Nicodemus* tells us that Jesus was stripped naked by his executioners, and then girded with a linen cloth. A further detail is added to the legend by the authors of the *Dialogue* and the *Meditations*. These sources tell us that it was Jesus' mother Mary who, seeing him naked and feeling his shame, girded him with the veil from her head[84]—a detail that may explain the diaphanous loincloth worn by Jesus in a number of late medieval depictions.[85]

Similarly, Christian writings, preaching, and art began to extrapolate from the brief mention of Jesus' mother in the New Testament narrative to an imaginative reconstruction of her part in the passion. The sorrows of Mary and her sharing in the passion were themes already present in the writings of Anselm and Bernard, and she figured significantly, as we have seen, in icons of the crucifixion that were imitated by Western paintings. Through the Gothic period we can see in these paintings an increasing emphasis on her emotions and a corresponding appeal to the viewer for sympathy with her feelings.

We have mentioned already that Byzantine icons purposely retained a

sense of decorum and dignity in their representations of the crucifixion. This was true also of their portrayal of Mary. She retains a dignified and noble bearing. The Scriptures say nothing about the Virgin's reactions to the crucifixion. As St. Ambrose wrote: "Holy Mary stood by the cross of her son, and the Virgin beheld the passion of her only begotten. I read that she stood there; I do not read that she wept."[86] But the perception of Mary's reaction changed in the Middle Ages. Hans Belting demonstrates how the image of Mary in the crucifixion icon derived from developments in the Great (Good) Friday liturgy. A ritual liturgical lament (threnos) of Mary composed by Symeon Metaphrastes inspired a homily by George of Nicomedia that by the eleventh century had become part of the monastic liturgy at Constantinople. From there it entered into the liturgy of the Byzantine church as a whole.[87]

In this ritual, Belting tells us, "the Virgin's lamentation for the dead Son, sung by the choir for Mary in the first person, was addressed to a double-sided icon on which Mary performs the role of a grieving mother." In the texts, Mary learns the meaning and necessity of the passion: "the Virgin learns to subordinate her personal feelings to the necessity of the events of salvation."[88] Michael Psellus (eleventh century), in a treatise (sermon) on an icon of the crucifixion, writes: "Does not the Virgin, the Mother of the Lord, appear here as the living ideal image of the virtues? In her grief she has not given up her dignity. Rather, she seems to be musing within. Her eyes are fixed on inexpressible ideas."[89] This idea seems to be the key to interpreting the portrayal of Mary in many icons of the period. It is presumed, as we have seen earlier, that Mary knew her Son's divinity, and understood already that he would rise from the dead. Her dialogue with Jesus centers on her learning the reason for the indignity and suffering inflicted on a divine being. Belting cites as an example a twelfth-century icon in Mt. Sinai, in which the Virgin, lamenting and pondering, also raises her hand, to indicate that she is speaking "as in the sermon, to the Son, asking him to explain the contradiction between the deity immune to suffering and the pains of the flesh on the cross."[90] Jesus instructs Mary, from the cross, about the necessity of his death for the salvation of humanity, and she is finally convinced of the need for the passion.[91] A further symbolic meaning is added by the fact that the position of Mary's arms and hands parallels the shape of the liturgical spoon (labis) used for communion.[92]

Behind the Byzantine portrayal of Mary's dialogue with Christ, then, there is a doctrinal point. In Western paintings, on the other hand, the portrayal of Mary's grief focuses more on emotional identification, in the manner of the devotional literature like Bonaventure's Lignum Vitae, the Dialogue of pseudo-Anselm, and the Meditations. The emphasis here is less doctrinal—although this is certainly still presupposed—and more affective: the point is to feel with Mary the sufferings of her Son, as well as her own. The suffering of Mary at the foot of the cross, although not mentioned in the passion accounts, was identified with the sword that Simeon had prophesied would pierce her heart

(Luke 2:35). Hence already in the thirteenth century, we see Western portrayals of the crucifixion in which Mary is no longer standing in dignity, but fainting in an excess of grief. (See for example Nicola Pisano's celebrated relief in the baptistry at Pisa, made ca. 1260.)

In addition to the expressive portrayal of Mary at the foot of the cross, Western art developed a new genre, the depiction of the dead Christ in Mary's arms (the *pietà*). This scene, of course, is not found in the New Testament accounts. It evolved from the introduction of Mary into the depiction of the descent of Christ from the cross. In both Eastern and Western paintings, we can see the mother of Christ grasping the hand of her son as his disciples take down his body. First in northern Europe, and then in Italy, this scene was extended into another, in which Mary receives the body of her son, as recounted by various legends, including the *Dialogue of the Blessed Virgin and Anselm*, which recounts the incident in detail, including also the miraculous glorification of Christ's dead body for the consolation of his mother:

> Mary: "While Joseph took down the body, I stood near the cross looking on. I was waiting for the arm to be loosened, so that I might touch it and kiss it, as I did. And when he had been taken down from the cross, they placed him on the ground at three paces from the place of the cross. And I, receiving his head in my lap, began to weep bitterly, saying, 'Alas, my sweetest son, what consolation shall I have, who see my dead son before me?' . . . And my son, for my consolation and that of the disciples, was glorified there before his people: so that no mark or bruise appear on his body except for the scars of the five wounds, which he will retain until the day of Judgment; and he appeared as whole in his body as though he had never suffered. From this I and the disciples received immense consolation."[93]

As we shall see, in music as well, an emotional identification with the sorrows of Mary becomes an eloquently expressed focus of Western piety. This tendency in spirituality was to become more and more central, to reach a peak in the Marian devotion of the late Middle Ages.

THE AFFECTIVE CONTEXT OF THE ART OF THE PASSION. The early spirituality of the passion was essentially positive: the cross is still seen as the means of God's triumphant work of redemption and the sign of the divine love. Bonaventure speaks explicitly of the feelings that should be aroused by beholding the crucifix: "Whoever turns his face fully to the Mercy Seat [Christ] and with faith, hope and love, devotion, admiration, exultation, appreciation, praise and joy beholds him hanging upon the cross, such a one makes the Pasch, that is, the passover with Christ."[94] The purpose of devotion to the passion was manifold. It awakened gratitude for our redemption; it aroused repentance for the

sin that caused such suffering; it provided an example for our imitation in facing suffering with patience, fortitude, and constancy; and it drew the Christian into the redemptive process through active com-passion—"suffering along with" Christ.[95]

Moreover, compassion for the sufferings of Christ on the cross was connected with compassion and charity toward the continuing sufferings of the whole "body" of Christ. Gerard Sloyan remarks that Bernard "cannot think of Christ as separate from us. There is only a corporate Christ, head and members. There is no isolated Redeemer out of the past whose sufferings we look back upon with gratitude for the benefits they represent to us. The suffering Christ of *then* is identical with the suffering Christ of *now*."[96] The new world-oriented evangelical movements, represented especially by the Franciscans, transferred this identification from the monastic realm of meditation to the field of practical charity, especially toward the poor and suffering. To the legend of Bernard embraced by the wounded Christ while contemplating in the monastery we may pose as a counterpoint and complement the legend of Francis embracing Christ encountered in the world in the form of a leper:

> One day while he was riding on horseback through the plain that lies below the town of Assisi, he came upon a leper. This unforeseen encounter struck him with horror. But he recalled his resolution to be perfect and remembered that he must first conquer himself if he wanted to become a knight of Christ. He slipped off his horse and ran to kiss the man. When the leper put out his hand as if to receive some alms, Francis gave him money and a kiss. Immediately mounting his horse, Francis gave a look all around; but although the open plain stretched clear in all directions, he could not see the leper anywhere. Filled with wonder and joy, he began devoutly to sing God's praises.[97]

The recollection of and dialogue with the suffering Christ were meant to reinforce the recognition of Christ in his "brothers and sisters" still suffering among us. However, as we shall see, a spirituality centered on the passion bore with it the danger of concentrating instead on the suffering itself, on the sin that was its cause, and on the personal sharing of suffering—rather than the alleviating of it—as the proper response.

IMAGES AND PRESENCE. The method of imaginative, affective meditation that developed especially from the twelfth century onward encouraged a mental and spiritual "presence" to the events. "The one meditating perceives this event not as something in the distant past that is being viewed from the standpoint of the present. Rather, he enters into the event, either as an eyewitness or as an actor in the drama of the event. He is present to the event and the event is present to him."[98] As we have seen, Bonaventure's *Lignum Vitae* (*The Wood of*

Life—i.e., the cross) attends closely to the details of Christ's death, and it encourages the reader to identify with Mary, sharing her feelings of compassion for her dying son.[99] According to an anonymous book of meditations from around 1300, ascribed to the Venerable Bede, "readers must imagine that they are present at the very time of the passion and must feel grief as if the Lord were suffering before their very eyes."[100] They were also to imaginatively act out their reactions to the events, seeing themselves as sitting by Jesus to comfort him, attempting to save him from his pains, and so on.[101]

Largely because of the influence of the preaching friars, this style of devotion spread from the monasteries to the laity of all classes. The preaching of the friars, in particular the Franciscans, tended to concentrate on feeling, emotion, and sensation, by which the affections of people could be more easily reached and their wills turned to God. But even on an intellectual level, the emphasis on sensation fit with the thirteenth-century appropriation of Aristotelian philosophy, with its emphasis on empirical knowledge as the starting point for all intellectual activity. At the same time, cities were becoming more prominent in social life. This permitted a certain distance from "nature" that at the same time fostered its appreciation. (It is probably not accidental that St. Francis, who was to be known for his closeness to creatures, was not brought up on a farm, but was a child of a merchant, living in a city.)

As we have seen, prominent in the spirituality that developed after the "Anselmian revolution" was "devotion" (*devotio, Andact*): an affective and direct presence and dialogical relationship to God, especially in the humanity of Christ. Painting was well adapted to serve the emphasis on feeling and affect that characterized this newly popularized form of devotion, and the increasing naturalism in portrayal reflected both the philosophical and the popular turn to sensation.[102] As Hans Belting remarks, it is widely accepted among art historians that from the thirteenth century, pictures not only began to use new means but also had a new end to accomplish. In Belting's words, pictures began to "speak."[103] Pictures begin to make present the dialogue partner as a living other.[104] The Dominican Gerardus de Frachet, writing before the year 1260, says in his *Lives of the Fathers* that "they had in their cells the image of Mary and of her crucified son before their eyes, so that while reading and praying and sleeping they might look upon them *and be looked on by them*."[105] Even if we take the last phrase metaphorically, it indicates how the function of the picture was conceived: it is a kind of eye from the other world into this, and from this into the other: it puts us in the presence of the one(s) it represents, making a living dialogue possible.

This is of course not to say that the function of mediating presence is new in Gothic art. In fact, as Belting has convincingly argued, it is this mediation of presence that typifies pre-Renaissance religious art in general, and sets it apart from the modern understanding of art. The basis of that mediation is the notion of "memory" (*memoria*). Gregory the Great tells us that painting,

like writing "induces remembrance."[106] But "remembrance" or "memory" is a much more inclusive idea for the medieval mind than the modern use of the word implies. It can include not only the mind's recall of the past but also its "recall"—its calling to mind—of transcendent realities. These transcendent realities, being beyond time, may also include what is for us the future. The religious image appeals to "memory" of the past events of salvation history, and remembers their orientation to the future:

> In the medieval context the image was the representative or symbol of something that could be experienced only indirectly in the present, namely, the former and future presence of God in the life of humankind. An image shared with its beholder a present in which only a little of the divine activity was visible. At the same time, the image reached into the immediate experience of God in past history and likewise ahead to a promised time to come.[107]

At the same time, the image appealed to "memory" in the theological sense spoken of by Augustine, as the self-presence of consciousness in which the transcendental presence of the eternal God is experienced:

> As regards things past one means by memory that which makes it possible for them to be recalled and thought over again; so as regards something present, which is what the mind is to itself, one may talk without absurdity of memory as that by which the mind is available to itself, ready to be understood by its thought about itself, and for both to be conjoined by its love of itself.[108]

Memory, then, is the mind's self-presence, the implicit self-awareness that is the essence of consciousness. But the mind is the image of God because it is not only able to "remember" itself but is able to remember God.[109] This is so because God is the *interior intimo meo*—closer to me than I am to myself, the root of interiority. Augustine's doctrine of memory is thus an existential and theological rendering of Plato's myth of "anamnesis," in which we remember the divine world from which the soul is fallen. This sense of the immanence of God in the creature, and of our ability to become aware of God in the self, God's image, is the theological source behind the multiple meanings of "memory." It is this memory, as Belting intimates, with its temporal dimensions of past, present, and future, that is awakened by art.

To this mediation of God's presence through "memory" evoked by images, Gothic art adds a new and expanded *means* of "remembering": namely, through a direct and naturalistic presentation of the sensible form of Christ's humanity, as though it were temporally and physically visible. Earlier art, even though it certainly served an "iconic" function, tended to be essentially narrative. It presented the other in the third person, so to speak. The narration and recollection in the image *led to* a dialogical presence, especially one of thanksgiving—as in

the eucharistic prayer. Now, by contrast, art begins to be a direct address, in the second person: it is the direct medium of an "I-Thou" exchange, and not merely the prelude to it. We have seen that this new "speech" on the part of pictures was first encouraged, as Belting points out, in Byzantine texts and liturgy. And we find already a degree of psychological empathy and realism in the icons they inspired. But Byzantine art never went as far in this direction as Gothic art was to go in its naturalistic portrayal of events.

Moreover, the new "speech" of pictures was involved with a new religious content.[110] In particular, as we have seen, Gothic art is concerned with the humanity of Jesus. It is notable that in the increasing "naturalism" of the Gothic crucifix, the viewer is now implicitly invited to experience his or her *similarity* to Jesus as a human being,[111] rather than being confronted with the majesty of the immortal divine Logos (although the latter is still presupposed and is visually implied in the supernatural attributes given to the crucified, like the halo, the gold background, etc.).

If religious art in general begins to "speak" in the Gothic era, the prime example of this speaking is to be found in the crucifix. The legends of the saints recount several instances in which the figure of Christ represented on the cross *literally* speaks—in particular, to St. Francis and to St. Thomas Aquinas. (The crucifix that spoke to St. Francis is in the church of San Damiano in Assisi; the one that spoke to St. Thomas is in S. Domenico Maggiore in Naples.) But if Christ's command to St. Francis is the first known instance of a crucifix addressing words to a person, there are prior examples of "speech" in the metaphorical sense of a lived "dialogical" encounter: as we have seen, prior to the time of St. Francis, the Christ figure from the cross is reported to have actively (although wordlessly) embraced Rupert of Deutz and Bernard of Clairvaux.

Of particular interest from an art-historical point of view is the vision of the crucifix seen by Ramón Llull. Although Christ does not literally speak, the appearance illustrates well what Belting means by the new "speech" of Gothic art. In one of the West's first autobiographies, Llull describes how he had been living a worldly life at the court of James II of Majorca. One night, as he was composing a worldly song in the manner of the troubadours, "he looked to his right and saw our Lord Jesus Christ on the cross, as if suspended in midair. This sight filled him with fear."[112] The same vision was repeated on four subsequent occasions, and, according to one version of the text, the image of the crucified became "larger than before, and more terrifying" (major quam ante et magis terribilis). Notably, the figure of Christ did not speak any words. But the visions conveyed a clear message: "his conscience told him that they could only mean that he should abandon the world at once and from then on dedicate himself totally to the service of our Lord Jesus Christ"—which he eventually did. At first he thought of seeking martyrdom, but then (more realistically, perhaps) he decided to devote himself to scholarship and to the effort to convert

the Muslims. (Ironically, he was in fact finally martyred by those he was trying to convert.)

Because Llull found the vision "terrifying" and because of his subsequent emphasis on Christ's suffering, we may probably presume that (unlike Rupert of Deutz) he was confronted in his vision with the suffering and dying Christ on the cross. An illustration of the event in a manuscript of Llull's works compiled shortly after his death shows exactly this: the vision is of a Gothic crucifix, with blood pouring from Christ's wounds.[113]

Llull's visions illustrate the metaphorical sense in which the crucifixion and its images began to "speak" in a new way: the crucifix becomes the "sacrament" of a "dialogical" encounter with the living Christ, even if no words are spoken. They also illustrate another important point: The intense personal dialogue with Christ is no longer confined to a special class of people in monasteries and convents: in part through the use of images, this kind of spirituality becomes available to the laity (significantly, Llull was a layman at the time of his visions, and, being married, remained one all his life).

Llull's vision of the crucifix is presented as a revelatory appearance: a miracle, like the dialogues of Christ with Rupert, Bernard, Francis, Thomas Aquinas, and others. But the physical image of the crucified was intended to accomplish in a nonmiraculous way, through art, the same kind of personal encounter.

The story of Llull's conversion through the vision of the crucifix invites reflection on two related novelties of the early Gothic era: new developments in the spirituality of the laity, centered on the cross, and a new sort of artwork that served it.

The figure of the suffering Christ was well adapted to a spirituality of the laity. Suffering, after all, is a universal experience. The image of the suffering Christ also invited the viewer to imitation, as in the case of St. Francis. Hence the suffering crucified Lord was one that people could identify with, no matter what their social standing or form of life. And in the thirteenth century there emerged—or continued to emerge—a heightened consciousness of the individual, the person, without regard to rank or status.[114]

The new function of the picture in lay spirituality thus corresponded to a new *genre* of picture—the suffering crucified—and also to a new form of artwork: the independent, portable flat painting (*Bildtafel*). Such paintings were rare in the West before the thirteenth century, because they had no function.[115] The first known Western example of a painted flat crucifix (*croce dipinta, Tafelkreuz*) dates from 1138 (a triumphant Christ by Maestro Guglielmo, at Sarzana in Italy). But it is in the thirteenth century—especially after the cross of Giunta discussed at the beginning of the chapter—that such crucifixes became common and were transformed in their content and function.[116] The typical Western cult image, after the Roman age of mosaic, was in the form of sculpture. This began to change with the importation of icons from the East, especially

in Italy.[117] In the thirteenth century, such portable pictures began to have a function: namely, to serve private devotion. Lay confraternities and individual lay people could possess such images. And from this personal devotional use of the picture outside the church, the same function—a new mode of "reception"—began to be attributed to pictures within churches.[118]

Belting sees this new form and new function as corresponding to the new "speech" of images that we considered earlier, as well as to the shift from a narrative to an "iconic" function. The narrative picture in a book or on the wall of a church was tied to the context of the text it illustrated or to the context of the other images in the series. But the independent image is separated from any such context, except in memory. It is "scenically" undetermined. It must therefore "speak" on its own. It is true that frequently the image still retains elements of the narrative: for example, the figures of Mary and John, as in the crucifix of Giunta. But these are increasingly in the form of portraits joined to the cross, rather than integral parts of a scene. Such figures imply, as Belting says, a double address: they "speak" narratively to Christ, and iconically to the viewer.[119] Thus the image of the crucifixion, separated from the passion-resurrection narrative, becomes an icon, an *imago*, a devotional image (*Andachtsbild*), rather than (primarily) a narrative or *historia*. Its function is to provide the occasion for a direct dialogue, in which the viewer as well as the image has a new role.[120] The content of that dialogue, as we have seen, would concentrate on appreciation of the suffering of Christ, awareness of and sorrow for the sin that caused it, appropriation of the salvation it effected, and imitation of the virtues it exemplified. In this way the Gothic crucifix implicitly contained a summary of the soteriology of scholastic theology.

The Cross in Liturgy and Music

THE CELEBRATION AND THEOLOGY OF THE SACRAMENTS. We have seen that there is a certain correlation between the Gothic image of the suffering Christ and Scholastic theories of salvation. The predominance of the theme of Christ's suffering in art also coheres with the High Scholastic understanding of how that salvation is made present to us in the sacraments, especially the eucharist.

We have mentioned earlier the allegorical conception of the eucharistic liturgy that prevailed in both Byzantine and Western theology from at least the ninth century. The entire liturgy was seen as a symbolic re-presentation of the events of Christ's life, centering on his sacrificial death. We have also noted the connection of the pictorial representation of the blood and water flowing from Christ's side with both baptism and the eucharist. By the thirteenth century, the relationship of these sacraments to the passion of Christ had been thought out systematically and expressed in theological terms. As we have seen, Scholastic soteriology saw the means of salvation largely in terms of sacrifice and merit. Sacramental theology was concerned to understand the way in

which Christ's sacrifice was made present and effective for believers. In this respect—that is, in content—we can see a confluence of theology with an iconography that stressed Christ's voluntary death. Moreover, the Scholastic understanding also saw in the sacraments a mode of operation that we may regard as being in some respects parallel to that of art: for it emphasized the use of *signification* to effect a personal appropriation of "grace."

The exposition of Thomas Aquinas in the *Summa Theologiae* is exemplary for its clarity and precision, and is important as well as for its later influence. We shall deal first, briefly, with Thomas's conception of sacramentality, and then examine the relation of the specific sacraments of baptism and eucharist to the passion.

As we have seen, Thomas's soteriology is centered on the complex theoretical notion of "grace." Hence he is particularly concerned to explain the causality of the sacraments: that is, how they "effect" or "give" grace. His basic principle, enunciated already in his early commentary on the *Sentences* of Peter Lombard, is that the sacraments cause *by signifying.*[121] More expansively: the principal cause at work in the sacraments is God, who alone can give grace. The sacrament is an "instrumental" cause: it is the sensible sign of the invisible cause, God (*S.T.* 3, q. 62, a. 1).

Moreover, and most significantly for our theme, the power that is at work in the sacraments is that of the merits of the passion and death of Christ:

> The sacraments of the church have power [*virtus*] in a special way
> because of the passion of Christ, whose power is in some way com-
> municated to us through the reception of the sacraments. As a sign
> of this, from the side of Christ hanging on the cross there flowed
> water and blood, the former referring to baptism, and the latter to
> the eucharist, which are the principal sacraments. (*S.T.* 3, q. 62, a. 5)[122]

The passion, in turn, is the "efficient" and "meritorious" cause of justification, insofar as Christ's humanity, in which he suffers, is the instrument of the divinity (*S.T.* 3, q. 64, a. 3). Hence the humanity of Christ, precisely as that which suffers the passion, is the crucial means by which God communicates forgiveness and new life.

This is seen especially in the two greatest sacraments, baptism and eucharist. Baptism is the sacrament of the death and passion of Christ insofar as a person in regenerated in Christ by the power of his passion (*S.T.* 3, q. 73, a. 3).

> Through baptism one is incorporated into the passion and death of
> Christ, as it says in Romans 6:8: "if we have died with Christ, we
> believe that we shall also live with Christ." From which it is clear
> that to every baptized person is communicated the passion of Christ
> as a remedy, as though that person had suffered and died. For the

passion of Christ . . . is a sufficient satisfaction for all the sins of all people. (*S.T.* 3, q. 69, a. 2)

By baptism one is also incorporated into Christ, given grace and virtue, illumined, made fruitful (*S.T.* 3, q. 69, a. 4, 5). But all of these elements of new life are consequent upon the principal effect of baptism, incorporation into the death of Christ.

The eucharist is even more strongly associated with the passion: for here the passion is not only the cause of the sacrament's efficacy—it is also what is re-presented or memorialized in the sign. Aquinas pays particular attention to the idea of the "real presence" of Christ in the eucharist. But he also makes it clear that it is *Christus passus*—Christ who suffered for us—who is really present. That is, for Aquinas the eucharist is not merely the presence of the body and blood of Christ, but of the body that was given for us, the blood that was poured out, as the words of institution themselves proclaim. Naturally, for Aquinas, the Christ who is present is the glorified Christ (see for example *S.T.* 3, q. 76, a. 8); but his body and blood are present sacramentally, as sign, under the aspect of their having suffered the passion—that is, as sacrifice.

The texts that expound these ideas are many. "The eucharist is the perfect sacrament of the Lord's passion, insofar as it contains Christ himself who suffered" (*ipsum Christum passum*; *S.T.* 3, q. 73, a. 5, ad 2). This sacrament is the "memorial of the Lord's passion" (*memoriale Dominicae passionis*; *S.T.* 3, q. 74, a.1). Christ who suffered (*Christus passus*) is contained in this sacrament, and it is prefigured by all the sacrifices of the Old Testament; but its primary type was the paschal lamb (*S.T.* 3, q. 73, a. 6). What is represented in this sacrament is the passion of Christ (*S.T.* 3, q. 79, a. 1).

As we have seen, according to St. Thomas, the eucharist can be called a sacrifice—but more strictly speaking, it is the *sacrament of* a sacrifice: a memorial of the passion. In reply to the question "whether Christ is sacrificed" (*immolatus*) in the eucharist, Aquinas makes an interesting comparison with art: [Augustine says that] images are frequently called by the names of the things that they represent; so, seeing a picture or a wall painting, we say "that's Cicero," or "that's Sallust." But the celebration of this sacrament, as we have said, is a kind of image that represents the passion of Christ, which is a real sacrifice [*immolatio*] (*S.T.* 3, 9.83, a. 1).The eucharist is a sacrifice, then, in the sense that it represents a sacrifice, in the way a painting represents a person. In this sense, one could say Christ was sacrificed even in the prefigurations found in the Old Testament. Aquinas's comparison of the eucharist with painting is suggestive for our study: it invites further reflection on the mode of "presence" or of "re-presentation" in each. We shall return to this theme shortly.

Thomas adds that the eucharist can also be called a sacrifice because of its effect: by this sacrament we are made participants in the fruit of the Lord's

passion (*S.T.* 3, q. 82, a. 1). The eucharist is the sacrament of the passion of Christ, insofar as one is perfected in union with Christ who has suffered. As baptism is the sacrament of faith, the eucharist is that of love; both re-present the passion and death of Christ, as the source of salvific grace and virtue (*S.T.* 3, q. 73, a. 3).

At the same time, Aquinas teaches that the eucharist is not merely a memorial of Christ's sacrifice, but has several complementary aspects: insofar as it is a commemoration of the Lord's passion, which was a true sacrifice, it is called a sacrifice; but it is also communion, viaticum (food for our journey), and eucharist or thanksgiving (*S.T.* 3, q. 73, a. 4). The purpose of the sacrament is not merely to "make present" the sacrifice of Christ (which, we recall, consisted for Thomas above all in Christ's attitude of obedience to the Father) but also to make us participants in it in the unity of love (*S.T.* 3, q. 74, a. 1).

This is the reason that the memorial of the sacrifice takes place not in the form of a bloody sacrifice, like those of the Old Law, but in the form of food. The sacrifices of animals in the Old Testament expressly represent what took place in Christ's passion, that is, a true sacrifice; but bread and wine better express the *use* of the memorial of that sacrifice, which is to signify the unity of the church (*S.T.* 3, q. 74, a. 1). The eucharist is a memorial of the passion. Yet it was instituted not on the cross, but at the last supper, because its purpose is the unity of the disciples, signified by this meal (*S.T.* 3, q. 73, a. 5). In difference to the sacrifice on the cross that it represents, the sacrament was not instituted for the sake of satisfaction, but for spiritual nourishment; and this union is in love (*S.T.* 3, q. 79, a. 5).

What this sacrament represents is the passion of Christ; "hence this sacrament produces in the person the effect that the passion of Christ had on the world." But it does so in a way analogous to the way food and drink affect the body (*S.T.* 3, q. 79, a. 1). It gives us the spiritual nourishment of grace, not merely as a "habitus" but as something that urges us to act. Insofar as it is sacrifice—that is, makes present the one sacrifice of Christ—it has the power of satisfaction; but only according to the devotion of the one offering (*S.T.* 3, q. 79, a. 5). That is, the eucharist allows us to appropriate the salvation won by Christ through entering into the communion of love. The passion of Christ served to bring forgiveness, grace, and glory to all; but it only has effect on those who are united to that passion by faith and charity. Similarly, this sacrament, which is the memorial of Lord's passion, has no effect except for those who are united to the sacrament in faith and love (*S.T.* 3, q. 79, a. 7).

This point brings us back to a consideration of the way in which the sacrament "operates." As we have seen, Thomas's general principle is that the sacraments "cause" grace instrumentally, by being signs. Put the other way around, sacraments do not operate as instrumental cause (of grace) except by

exercise of their own proper causality as signs (*S.T.* 3, q. 62, a. 1). "If we posit that a sacrament is the instrumental cause of grace, we must likewise posit that in the sacrament there exists some instrumental power [*virtus*] through which it can produce the sacramental effect" (*S.T.* 3, q. 62, a. 4). Sacraments "produce" what they signify (*efficiunt quod figurant—S.T.* 3, q. 62, a. 1): hence, they cannot mediate the grace offered by God, except by signifying or functioning as signs.

This principle might serve as the grounds of an "aesthetic" theology of the sacraments. This project is beyond our present scope. It also provides us with a basis for reflecting on the relationship between sacrament and art, especially between the eucharist and pictorial representations of the passion. Both of these are meant to have the functions that we have named "narrative" and "iconic": they re-present to memory (in its usual sense) an event of the past, in order to evoke in "memory" (in its extended ontological sense) a present encounter with the divine. But there is a significant difference. The eucharist makes "really present" *Christus passus*; but it does so under the form of bread and wine. As we have seen, St. Thomas adverts to this fact, and explains it in terms of the difference between what the sacrament represents (the passion) and the use to which it is put (creation of a union of love). But the focus on the salvific value of Christ's death as a sacrifice and the comparative infrequency of communion among the laity—to name only two factors—seem to be signs that the medieval religious imagination was focused largely, if not predominantly, on the former aspect. The allegorical interpretation of the liturgy in both East and West, the idea that the altar represents the cross (in the West) or the tomb of Christ (in the East), the extension of the celebrant's arms in the Roman liturgy to represent the crucifixion, all cohere with this emphasis. Pictures of the passion then served a purpose complementary to the eucharist: they made psychologically real and present what was affirmed to be "really present" in that sacrament.[123] By the same token, images of the crucified invariably would carry an implicit reference to the eucharist.

THE PASSION IN DRAMA AND MUSIC. It is well known that the origins of modern Western theater lie in extensions of the liturgy. As we have seen, the eucharistic celebration itself was over the course of time increasingly understood as a kind of dramatic allegorical representation of the events of Christ's life, in particular of the passion. However, it was above all the Holy Week liturgies that lent themselves to paraliturgical expansion and eventually to the derivation of nonliturgical theatrical presentations.[124]

Of particular relevance to our topic is the liturgy of Good Friday. The ritual of the honoring of the cross during this ceremony is ancient. By the thirteenth century, however, a new perspective was added: the new devotion to the humanity of Christ and the theological emphasis on his suffering meant that a

realistic portrayal of the dying Christ was found desirable.[125] The honoring of the cross as the instrument of God's triumph now assumed the additional aspect of personal affective relation to the Savior who had suffered and died for us, and a com-passionate appreciation of his suffering love.

Even outside the Holy Week liturgy, the preaching of the mendicant orders stressed the passion of Christ, and spread devotion to the crucified. Such preaching often took place in the church, under a crucifix showing the suffering Christ. The preacher could appeal to the image at appropriate moments to give visual confirmation to his words, and thus add emotional appeal. This kind of dramatic passion preaching led to the development of the musical forms of the *planctus* (lament) and *laude* (praise) as congregational reactions to the preaching.[126]

In connection with the Good Friday liturgy, the theatrical and musical possibilities were even greater. The rite of the adoration of the cross—with hymns like the *Crux Fidelis*—led to a dramatic extension: a ritual burial of Christ (sometimes including the "burial" of the crucifix, and even of the eucharistic host),[127] visitation of the sepulcher, and, on Easter, the discovery of the empty tomb and proclamation of the resurrection.[128] At the start, the Good Friday liturgy and the passion plays that derived from it were mixed: there was a kind of illustrated preaching or drama with preached commentary. However, first in Italy and later in other parts of Europe, the passion play was separated from the liturgy and moved out of the hands of the clergy into those of the laity, with confraternities taking over the dramatic presentations and singing vernacular *laude*.[129]

As we have seen, the new emphasis on the human sufferings of Christ was accompanied by an increased association of Mary with those sufferings. The connection of Mary with the cross not only led to a more dramatic presentation of her traditional inclusion in the crucifixion scene but also gave rise to new genres of sculpture and painting, in particular the *pietà*, of which we will have more to say in the next chapter. In music also, there were developments. The Lamentations of Jeremiah, traditionally sung during Holy Week, were applied not only to Christ but also to Mary. By the early thirteenth century, at the latest, the *planctus Mariae*, or lament of the Virgin, modeled on Byzantine hymns, had been introduced into the Good Friday liturgy.[130]

The Virgin's lament also survived as an independent musical genre. These songs were commonly in Latin, like the famous "Planctus ante Nescia," attributed to Godfrey of St. Victor (died 1194).[131] Sometimes, however, they were in the vernacular, as in the case of the famous "Plant de la Verge" (Lament of the Virgin) of Ramón Llull. In this work by the founder of Catalan poetry, the Virgin recounts the story of the passion, and rhetorically addresses various figures, including Judas and the Jewish people, protesting Jesus' innocence and lamenting his betrayal.

A remarkable early English "lament" follows the Byzantine dialogue in

which Jesus instructs Mary from the cross on the reason for his sacrifice.[132] He begins by telling her to rejoice in his salvific death:

"Stond wel, moder, under roodë, "Stand well, mother, under the cross;
bihold Þi child wiÞ gladë moodë, behold thy child with glad spirit;
bliÞë moder miztu be." joyous, mother, mayest thou be."

Jesus goes on to tell Mary that her tears afflict him worse than his own death, which he undergoes for the salvation of all humanity, including her: "Moder, if i dar Þe telle, if i ne dey, Þu gost to hellë" ("Mother, if I dare tell thee, if I die not, you will go to hell"). Jesus proclaims the theology of redemption through the cross: Mary repeatedly replies in terms of her feelings. But she finally understands the compassion of God for humanity, and in her pain becomes a source of compassion herself.

Of paramount importance for its subsequent history was the famous late thirteenth–century sequence (a hymn sung before the gospel reading) "Stabat Mater Dolorosa" ("The weeping mother stood by the cross"). It has been traditionally (but doubtfully) attributed to the Franciscan Jacopone da Todi (died 1306) and also to Pope Innocent III (died 1216). This poem quickly became widely known throughout the West, and inspired many (presumed) imitations as well as vernacular translations.[133] In contrast to the laments that present a dialogue between Jesus and Mary, and which are aimed at teaching the need for the passion, it gives classic expression to the believer's spiritual identification with Mary at the foot of the cross, suffering along with her son:

Stabat Mater dolorosa The sorrowing mother stood
Juxta crucem lacrimosa Weeping by the cross
Dum pendebat filius. While her Son hung there.
Cujus animam gementem Her grieving soul
Contristatam et dolentem Sad and sorrowing
Pertransivit gladius. Was pierced by a sword.

O quam tristis et afflicta O how sad and afflicted
Fuit illa benedicta Was that blessed
Mater Unigeniti! Mother of the Only-begotten Son!
Quae moerebat et dolebat She mourned and sorrowed
Pia Mater dum videbat That loving mother, as she saw
Nati poenas inclyti. The punishments of the glorious Son.

Quis est homo qui non fleret What person would not weep
Matrem Christi si videret Seeing the mother of Christ
In tanto supplicio? In such torment?
Quis non posset contristari, Who would be incapable of sorrowing with
Christi matrem contemplari her
Dolentem cum Filio? To see the mother of Christ
 Sorrowing with her Son?

Pro peccatis suae gentis,
Vidit Jesum in tormentis,
Et flagellis subditum.
Vidit suum dulcem natum
Moriendo desolatum
Dum emisit spiritum.

For the sins of his people
She sees Jesus in torment
And subjected to scourging.
She sees her sweet child
Dying abandoned
As he gave forth his spirit.

Eia, Mater, fons amoris
Me sentire vim doloris
Fac, ut tecum lugeam.
Fac ut ardeat cor meum
In amando Christum Deum
Ut sibi complaceam.

O Mother, fount of love
Make me able to feel the power of sorrow
So that I may lament with you.
Make my soul burn
In loving Christ God
So that I may please Him.

Sancta mater, istud agas
Crucifixi fige plagas
Cordi meo valide.
Tui nati vulnerati
Tam dignati pro me pati
Poenas mecum divide.

Holy mother, do this:
Affix the wounds of the crucified
Deeply into my heart.
Of your wounded Son
Who for me deigned to suffer so much
Share with me the pains.

Fac me vere tecum flere
Crucifixo condolere
Donec ego vixero.
Iuxta crucem tecum stare
Te libenter sociare
In planctu desidero.

Make me truly weep with you
Sorrow along with the crucified
For as long as I may live.
To stand beside the cross with you
To freely share with you
In your lament is what I desire.

Virgo virginum plaeclara
Mihi jam non sis amara
Fac me tecum plangere.
Fac ut portem Christi mortem
Passionis fac consortem
Et plagas recolere.

Virgin greatest among virgins,
Do not reject me now
Make me lament with you.
Make me bear the death of Christ
Make me share in his passion
And recollect his wounds.

Fac me plagis vulnerari
Cruce hac inebriari
Ob amorem Filii.
Inflammatus et accensus
Per te Virgo sim defensus
In die iudicii.

Make me bear his wounds
Make me inebriated by this cross
For the love of the Son.
Inflamed and afire
By you, Virgin, may I be defended
On the day of judgment.

Fac me cruce custodiri
Morte Christi praemuniri
Confoveri gratia.
Quando corpus morietur
Fac ut animae donetur
Paradisi gloria. Amen.

Make me to be protected by the cross
To be defended by the death of Christ
To be sheltered by grace.
When the body dies
Make the soul be given
The glory of paradise. Amen.

We began this chapter with Giunta's crucifix; we end it with the "Stabat Mater." In between, we have seen the correlation between the Scholastic theology of atonement and the affective relationship to Christ symbolized in the Gothic representations of the passion. In our final chapter, we shall see how the decline of that theology and the augmentation of that affective relationship influenced—some would say distorted—the theological aesthetics of the passion.

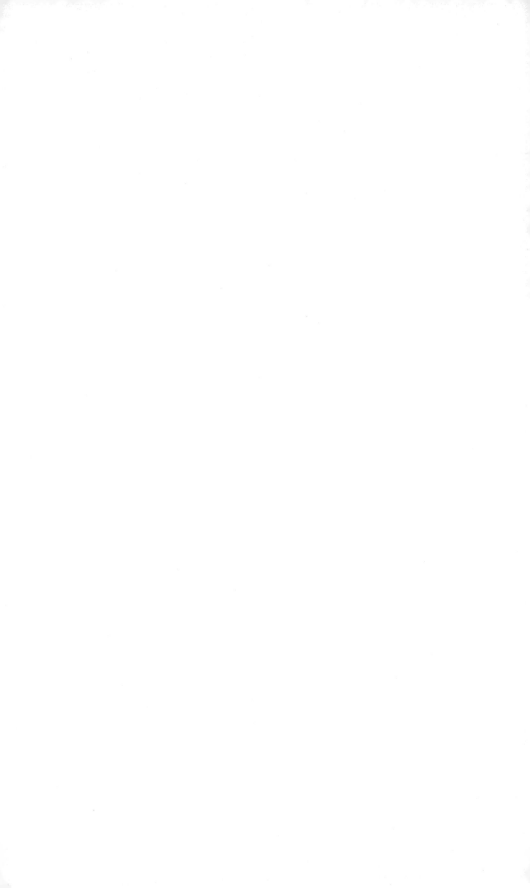

5

Nominalism, Naturalism, and the Intensification of Passion Piety

The Crucifixion by Giotto

Some time shortly after the great jubilee year of 1300,[1] the Floren-
tine painter Giotto received a commission to paint what was to turn
out to be perhaps his greatest masterpiece: a fresco series on the
walls of the Arena Chapel in Padova. The patron was a prominent
citizen of that city, Enrico Scrovegni, whose family wealth derived
from the practice of money-lending—or usury, as it was traditionally
considered by the church. In fact, in accord with the legislation of
the Lateran Council of 1176, reaffirmed in 1274, Enrico's father Re-
ginaldo had been denied a Christian burial because of this practice.
The building of the chapel was ostensibly Enrico's way of making
reparation for his father's sins. (This splendid act of expiation, how-
ever, did not prevent Dante from placing Reginaldo prominently
among the usurers in the seventh circle of Hell.)[2] There may also
have been practical motivations for the construction of the chapel:
Enrico's inheritance was tied up because of Reginaldo's lack of
Christian burial, and the bishop of Padova was willing to release
part of the estate's funds in return for this act of piety.[3]

The decoration of the chapel comprises a series of frescos show-
ing the culmination of the history of salvation. The series consists of
three tiers of fresco panels. The topmost shows the life of Mary
(with themes taken from the noncanonical gospels, especially the
"Protoevangelion" of James, as retold in the *Golden Legend* of Jaco-
bus de Voragine). The fresco of the Annunciation in the arch over
the altar celebrates the chapel's patron (Our Lady of the Annuncia-

tion) and provides the link with the second tier, which proceeds through the infancy narratives and the ministry of Christ, up to the cleansing of the Temple. The bottom series is devoted to the last supper, passion, resurrection, and ascension. The narrative ends with a grand fresco of the Last Judgment above the entranceway. The spaces between the major paintings are filled with decorative panels containing small figures representative of Old Testament prefigurations of Christ, and the space below the narrative is painted with *trompe-l'oeil* architecture containing symbolic figures of the vices and virtues.

Any one of a number of the paintings of this cycle might be taken as an example of Giotto's mastery and of the new style that he introduced into Italian painting. But his portrayal of the passion, and in particular of the crucifixion, is of course of most special interest to our study.

If we compare Giotto's crucifixion with earlier examples of the theme, it is clear that theologically Giotto is in continuity with the tradition of meditation on the passion that became associated especially with St. Francis and his followers, and that was realized so frequently in Gothic art. We are confronted with the dead Christ on the cross, surrounded by more or less stylized portrayals of grief, both among the angels in heaven and Jesus' followers at the foot of the cross.

But what may impress us immediately is the naturalism of Giotto's portrayal of the human figure. If we compare this corpus with that of Giunta's crucifix, we are struck by the comparative realism of Giotto's work. Here we have a picture of a man hanging by his arms, his body dragged down by its dead weight. Mario Bucci says of Giotto's earlier panel cross in Santa Maria Novella, the first in the series of Giotto's crucifixes: "This Christ is the first

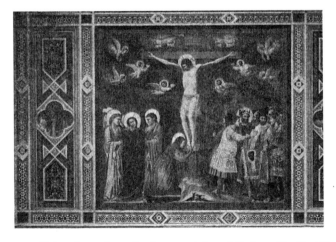

Giotto, crucifixion fresco from the Scrovegni chapel, Padova. Credit: Allinari / Art Resource, New York.

modern Christ to be portrayed: the man on the cross is one of us, a human being who suffers."⁴ This judgment is certainly exaggerated: the humanity of Christ had figured prominently in highly realistic sculpture of the thirteenth century, including representations of the crucifixion. Even in painting, there are crucifixions that stress Christ's human suffering. Moreover, although Giotto's corpus represents a dead human body, it is not gruesomely realistic. On the contrary, it has a sorrowful meditative beauty that in itself conveys a theological and affective message. Yet it is true that Giotto's Christ is "modern" in a way that the earlier representations are not, for it not only portrays Christ's humanity but does so in a visually convincing way, after the manner of sculpture, and not solely as a theological statement.

In this picture, Jesus' hair hangs flatly at the sides of his head, as though matted—in contrast to the treatment of the hair on all the other figures (and of Christ himself, in other panels in the series).⁵ There is no crown of thorns. The head is inclined to the side and forward. The impression that it is resting on the chest, the top advanced toward the viewer, is achieved not only by the angle but also by a judicious use of very dark line of shadow under the beard. The halo around Christ's head has the appearance of a golden plate with its top edge tipped toward us (the result of the slightly raised plaster on which it is painted), further emphasizing the effect of depth. The arms are stretched taut, the body pulling them to their limit. The legs are bent at the knee, not supporting the sagging body but held by the nails in the feet and forced outward at an angle by the pressure from the hips. The forward jutting angle of the upper legs is made visible through a diaphanous loincloth, decorated with golden embroidery—according to legend, as we have seen, the veil that had covered Mary's head. The body is given contour and depth by a consistent use of shadow, which shows the light coming from above and left. The fact that the light in the painting is seen as though shining from high above the viewer's left shoulder—in fact, from an actual source of light, the window in the entrance wall of the chapel⁶—draws us into the scene: we share its space.

Another significant aspect of Giotto's painting is the psychological interest manifest in his portrayal of figures. As we have seen, Gothic portrayals of the crucifixion scene began to place more emphasis on the subsidiary actors in the drama—especially on the grieving Mary. The very nature of the crucifixion scene, as a composite narration of events, provided room for several subsidiary dramas. Even the self-standing crucifix frequently included portrayals of Mary and John, either standing next to the cross or in small truncated portraits added to decorative extensions of the lateral beam, as in Giunta's crucifix. Giotto's incipient naturalism extends to these subsidiary figures. They are portrayed not merely as iconic types but as real people. Their psychological reactions can be read in their gestures and facial expressions. In some cases, they inter-react humanly and realistically with each other, rather than focusing on the primary

event of the picture. Giotto does not merely tell us about these narrative elements; he shows them, and in such a way as to engage our attention in their individual stories.

Thus we see around Jesus' cross the figures of flying angels, symmetrically placed, all expressing grief, but with a variety of expressions. The faces are individual and human. At the left side of the panel, we see Mary, who has apparently fainted, and is supported by John and a female disciple. At the foot of the cross, Mary Magdalene kneels, embracing the footrest, and in the act of bending her face toward Christ's feet to kiss them. On the right, the soldiers divide Jesus' clothing. They are entirely occupied among themselves, and their faces and attitudes allow the viewer not only to recall the narrative but to enter into the psychological action. The centurion, distinguished with a halo, gestures toward Christ, but faces away from him, addressing to another bystander his declaration that this truly was the Son of God. Of the faces visible in the picture, only one—that of a figure with a staff, presumably the rod on which Christ was offered a sponge to drink from—looks directly at the body of the crucified. Despite the indication of a crowd of figures, the crucified stands out as though alone. The sense of pathos that typifies the Gothic approach to the passion is heightened in Giotto by the naturalism of the figures and the addition of psychological interest. This pathos is seen in even more intense form in other "passion" panels of the series, notably in the scene of Mary mourning over the dead Christ—a motif that would become more and more important in fourteenth-century art.

The painting of the crucifixion does not yet provide the single fully consistent point of view that characterizes later illusionistic naturalism. In some ways the representation is still iconic. There is no sense of peripheral vision: each element may still be looked at separately. Moreover, this painting, unlike some others in the series, lacks any organizing architectural space or natural setting. The horizon does not recede, but begins immediately at the feet of the figures. There is no scenery. Golgotha is represented as small mountain with the skull (of Adam) seen under it through a fissure in the rock. The figures are arranged in a carefully staged and visually balanced manner to the right and left of the cross. The scene is narrative: the painting portrays several elements of the story at once, rather than "capturing" a single moment. While some of the figures interact on a human, rather than a symbolic level,[7] the main actors are represented in characteristic symbolic poses: the centurion speaks his testimony and gestures toward the dead Christ; the soldiers divide his clothing; Mary Magdalene embraces his feet; Jesus' mother faints from grief, and is supported by John and a woman disciple. Visually all the events appear to be happening simultaneously: it is presumed that the viewer knows the flow of the story.

Despite the painting's iconic elements, in the portrayal of the relation of the crucified and the human figures around him, there is a unity that ap-

proaches that of physical vision. The figures are not all portrayed on one plane: some are visually behind others (but none behind the cross or in front of it). The halos of John and Mary Magdalene are foreshortened and tilted, as though they consisted of a flat surface seen at an angle. This creates a sense of depth and solidity in the figures' heads. The halo of Jesus' mother is shown as a solid disk that cuts off the view of the person behind her. The sense of depth is increased by the portrayal of the cross as though from below and to its right: we can see the dark underside of the crossbeam, the sign above the cross, and the *suppedaneum*; likewise, we see the side of the upright beam.[8] The whiteness of Christ's body and its rounded contours make it stand out as visually closer than the flat, straight, dull-colored cross and the dark blue background.

In the words of art historian Bruce Cole, Giotto "decisively broke the iconic bonds of Italian art."[9] Comparing Giotto to his older contemporary Duccio, Cole remarks: "Duccio, like Cimabue, is not interested in defining his figures in relationship to the spectator; they exist in a world of their own—a world that is not part of the human experience, as it is in all Giotto's pictures."[10] I would say rather that in Giotto we are confronted with a different valuation of what "human experience" is. With Giotto, we are still in the age of spiritual "presence" rather than merely visual representation; but we see the birth of a different medium for evoking that presence. As we have seen, even in visual ways Giotto's paintings are, in important respects, still "iconic." But above all, their purpose remains tied to the mediation of presence through mental representation, rather than portrayal of a visual moment. We can see this clearly in the crucifixion scene in the lower basilica of Assisi, which is strikingly similar to the Arena crucifixion. It was probably designed by Giotto, and very likely painted largely by his hand. Here we can see on the right side of the painting the figures of St. Francis and several of his followers, kneeling in adoration of the crucified Lord.[11] They are present at the event of the crucifixion—as every Christian can be. This is the purpose of the artistic representation of the event.

Nevertheless, Giotto's paintings evoke presence in a physical sense, while the icon presents a "mystical" presence: a vision that at the same time reminds us of its invisibility, its otherness. The icon is the medium of a metaphysical "memory" of a dimension of reality—even historical reality—that is not reducible to empirical experience. In this respect, Giotto's painting is still iconic. But at the same time, he represents figures in space in a way that suggests the experience of physical presence. In this respect, he represents the beginning of a new age for Western art. In the words of Luciano Bellosi:

> There can be no doubt that such a coherent conception of space was regarded as a discovery. . . . The idea of reconstructing three-dimensional space illusionistically on a two-dimensional surface restored importance to that reality perceived by the senses that had been lost in the intervening years [since classical antiquity], when

the only true reality was considered to be that of the spiritual world. Giotto's reversal of this concept paralleled certain trends of thought, especially prominent among Franciscan intellectuals, that were to culminate in the Nominalist philosophy of Giotto's English contemporary, William of Ockham.[12]

We shall return to this parallel later in the present chapter.

While recognizing the radical nature of the change Giotto effected in painting, we should recall that it is not entirely without precedent in his artistic context. Already in Cimabue (who was, according to tradition, Giotto's teacher) and in Cavallini (whose work Giotto presumably saw during his stay in Rome) we can see the beginnings of a more naturalistic portrayal of the human form. But above all, while painting remained under the sway of Byzantine style, the step from expressionism toward naturalism had already taken place in Gothic sculpture. And it is precisely the influence of French Gothic sculpture—along with a discovery of Roman fresco painting—that is thought to have moved

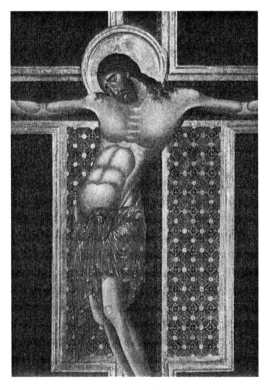

Cimabue, crucifix from San Domenico. Credit: Scala / Art Resource, New York.

Giotto away from the style of his predecessor (and presumed teacher) Cimabue toward his revolutionary incipient naturalism.[13]

Since religious sculpture was not a major part of the Byzantine iconic tradition, but was for a long time the primary public visual art of the West, it was able to develop in relative independence. We can see in Romanesque church sculptures the influence of manuscript illustration—for example in the elongated figures and the conventionalized swirling lines that indicate the folds of garments and even the contours of human figures. But Gothic sculpture had already broken away from these conventions. Even the very early cross of Gero shows a degree of naturalism in portraying the dead Christ. The corpus of the crucified in high Gothic sculpture often showed a great degree of naturalism. In Italy, we find a dramatic example of realism applied to the crucifixion in the famous marble pulpit sculpted by Nicola Pisano for the baptistry in Pisa (1260)—although the posture and the Herculean musculature of the dead Christ here is more evocative of heroic triumph than of the Gothic pathos represented by the fainting Mary.

Nevertheless, it is significant that with Giotto, the depth of sculptural realism has moved into the traditional field of the icon: the flat surfaces of the panel painting and the fresco. It is one thing to portray a three-dimensional body in sculpture; it is quite another to portray the solidity and depth of a body on a flat surface. And it is something yet more to place that body within a pictorial illusion of a three-dimensional, perspectival perception of space— even if the perspective is limited and the depiction of space is not yet totally visually realistic.[14] Such a move further erodes and indeed almost destroys the distinction—already tenuous, as we have seen—between the iconic and the narrative, as well as between the symbolic and the representational functions of religious art. And all this is—within limits—what Giotto has done. Not without reason is he considered the "father of Renaissance painting."

Moreover, we may take this shift toward naturalism or illusionism in painting as emblematic—or "paradigmatic"—of a continuing shift in mentality. In Hans Belting's terminology, Giotto begins the period of "art" in Western painting: that is, art primarily as aesthetic representation of the empirical world, even when used as symbol of the divine. Not, of course, that there was necessarily an explicit connection with the new philosophical empiricism represented first by Aristotelianism and then more radically by nominalism. Rather, we can see in both philosophy and art different manifestations of a general cultural tendency, at least in some elements of society. There is a further step away from the Platonic worldview, which valued the ideal: the "really real" is the invisible, the transcendent. There is a step toward the empirical mentality: the real is what is evident, bodily, sensible. Obviously, we do not see here a full-fledged naturalism, nor does it betray an attitude of materialistic empiricism: Giotto's art is still iconic, and nominalist philosophy, as we shall see, is

still combined with faith. But both represent a rapprochement of the intellectual world with the world of common sense and of sensation.

The Fourteenth Century: The Age of Modernity and Newness

In his *Handbook of Painting*, written in 1390, Cennino Cennini wrote that "Giotto brought painting to the modern [style]." Indeed, the movement in painting inspired by Giotto's stylistic innovations came to be called the *ars moderna*—"modern art." This name was one of a number of instances of the widespread consciousness that something new, something "modern," was happening in the fourteenth century—a significant break with what had gone before, the treading of new paths. While it is obviously beyond the scope of this work to engage in a social history of the fourteenth century, some of the aspects of this "modernity" are directly relevant to what happened in art and in theology, and it will therefore be profitable to consider some of the broad contours of that history.

It is striking how frequently people of the fourteenth century used the words "new" and "modern" for the cultural and artistic movements of their times. Alongside the "modern art" of Giotto in painting, which "changed the art of painting from the Greek to the Latin" (Cennini), there was the "new art," in music, a movement self-consciously proclaimed in 1316 by the treatise *Ars Nova (The New Art)* of Philippe de Vitry. A scholar, moral theologian, musician, diplomat at the court of three kings, and finally bishop of Meaux, Vitry invented a new style of motet with different voices singing at once, in different rhythms and sometimes with different texts: music not for the unlearned, but for connoisseurs. (Pope John XXII in 1327 wrote a bull against this new "lascivious" form of music—with the unintended consequence of driving many musicians out of the service of the church and into the employ of secular princes.)

In literature, this was the century of the *dolce stil nuovo*—the "sweet new style"—of Italian poetry: only one instance of the flowering of vernacular literature during this period. Dante's *Divine Comedy* was completed in 1321; Boccaccio's *Decameron* in 1348; Petrarch's "Epistle to Posterity" in 1350 and his "Canzoniere" in 1366. In France, the romance of *Aucassin et Nicolette* appeared toward the beginning of the century; the biting social satire *Le Roman de Fauvel* in 1320; the prose romance *L'Histoire de Lusignan* of Jean d'Arras in 1387. Middle English literature included the bitter social and moral complaint "Piers Plowman," which appeared in 1362, and Chaucer's works from midcentury on, culminating in the *Canterbury Tales* in 1387.

Much of society was dominated, especially in the later part of the century, by *homines novi* (new people)—or, as they were called in Italy (where they were markedly prominent), *gente nuova*. These were people, like Giotto's patrons the Scrovegni family, who attained prominence above all through success in the

new money economy that was beginning to undermine the structures of feudalism.

It was an age of social unrest and changes. These were prompted both by social factors, like the growth of trade, and by natural forces—for example, the famines following the crop failures that were possibly the indirect result of the pollution of the atmosphere caused by gigantic volcanic eruptions in southeast Asia in 1316–17.[15] Above all, society was radically affected by the Black Plague that afflicted most of Europe in the middle of the century. Killing off as much as a third to a half of the population in some places, the plague was thus a major factor in making further room for the "new people" in society. It also had an important direct and indirect influence on societal attitudes, and hence also on religion and religious art. We shall explore its repercussions on the representation of the passion later in this chapter.

Through the century, power began to shift from the feudal countryside to the cities, which enjoyed increasing freedoms and privileges. In Italy, the free cities took advantage of the conflicts between pope and emperor to establish their independence. Within the cities, the recently founded orders of Franciscans and Dominicans drew large congregations through their preaching and spirituality addressed to the laity. The Franciscans in particular also undertook a mission to the rural peasantry, preaching at crossroads and other public places as well as in the churches.

In England and in France, the abundance of labor provided by the population explosion of the thirteenth century made paid farm labor more economical than the feudal system of serfdom, and led to the widespread freeing of serfs.[16] In an act of enormous symbolic as well as practical significance, French king Philippe le Bel engineered the destruction of the order of Knights Templars, whose rule was written by St. Bernard and who represented the ideals of chivalry and crusade—and whose vast wealth the king coveted for his treasury. He also attempted to regularize the laws of the kingdom on the pattern of Roman law, and raised men from the bourgeoisie into government. Another accomplishment of Philippe le Bel, the removal of the papacy from Rome to Avignon and the virtual captivity of the papacy to the French king (1309–1376), prompted calls for reform as well as revisionary theories of authority in the church. Meanwhile, in Rome, Cola di Rienzo proclaimed a restoration of the Republic, and some city states of northern Italy practiced a kind of Athenian democracy (much tinged with oligarchy). The Scholastic distinction between "nature" and "grace" began to have practical consequences in the development of a "secular" sphere independent of church authority. In politics, this corresponded to the theory of the "two swords" (an image taken from Luke 22:38). Ockham's contemporary Marsilio of Padova went farther, and theorized the superiority of the Christian state to ecclesiastical authority.

Radical social thought emerged in other ways as well. The *fraticelli*, a branch of the "Spiritual" Franciscans, not only attempted to renew the order's

spirit of poverty but took an active role in siding with the poor against their lords, sometimes fomenting open revolution and the seizure of lands. (The *fraticelli* claimed, perhaps with some justice, to be more true to the spirit of Francis than were the mainstream post-Bonaventure Franciscans. Nevertheless, they seem in some respects to have changed the significance of the founder's devotion to "Lady Poverty." Francis wanted not so much to improve the lot of the poor as to share it, and his spirituality saw obedience to authority as an important aspect of the poverty he espoused. This is arguably why his order was approved by the church, while the other early medieval evangelical movements—the Béguins and Bégardes, the Poor Men, Waldensians, and so on—were seen as revolutionary threats and persecuted—as the *fraticelli* later were.) England in 1381 experienced the most significant worker's rebellion of the Middle Ages, the Peasants' Revolt, in which dissatisfied laborers were encouraged by scholars from Oxford who preached a new kind of Christian commonwealth.[17]

A new social consciousness arose among the lower classes with the shift of population toward urban centers and the alliance between these cities and central rulers, to the detriment of the feudal lords. But these developments did not necessarily bring about what twenty-first-century people would consider social "progress" in every area. The role of women in the fourteenth century, for example, seems in some respects to have become more restricted. As compared with rural women in a farming economy, urban women had, at least at first, a significantly lesser part in the support of the family[18]—although this situation had begun to change by the end of the century. It seems also that the "Franciscan" virtues of humility and submission began to be applied in preaching particularly to women. In politics, women receded from positions of power. In France, the largest and most prosperous Christian kingdom, jurists determined that a woman could not rule the country—despite the example of Blanche of Castille in the previous century—nor could royal succession be passed through the female line.[19]

Furthermore, the rise of "new people" in society after the Black Death in midcentury did not in general bring about advancement for the masses of people. As Norman F. Cantor puts it succinctly in his popular history of the period,

> the main social consequence of the Black Death was . . . further progress along the road to class polarization in an early capitalist economy. The gap between rich and poor in each village widened. The wealthiest peasants took advantage of the social dislocations caused by the plague and the poorer peasants sank further into dependency and misery.[20]

Philosophy and religion during the fourteenth century also became "modern." Philosophy was dominated by the *via moderna* ("the modern way"), which

emphasized logic and began a turn toward the empirical as the proper subject of human study. We shall return to this movement at some length. Religion likewise underwent a "modernization." Through the course of the century, new religious devotions were introduced or popularized: the rosary, the stations of the cross, and, most significantly for our study, new symbolic representations of the passion. And toward the end of the century there arose a spiritual movement that explicitly declared its "modernity," the *devotio moderna*, "modern spirituality," which would so widely affect the religious context of the early Renaissance.

From a present historical perspective, the fourteenth-century epochal consciousness of newness and "modernity" can be seen to have been well founded. In many ways, the century marked the beginning of the end of the Middle Ages, and began to anticipate the Renaissance and Reformation that would follow. "Natural philosophy" began to turn to nature in the concrete, and to have some of the contours of empirical science; similarly, in the arts we find an increasing naturalism based on observation, and the beginnings of dramatic realism. We must recognize, however, that "modernity" does not necessarily denote progress beyond or in the same direction as what went before. The fourteenth century saw an expansion of horizons, but at the cost of the loss of a unified worldview and synthesis. There was social advance for some, but a loss of status for others—in particular, women. It was also a century of hardship and tragedy: the spread of the plague in midcentury was a nearly unprecedented calamity that brought about a spiritual crisis and a reversion to what we might today regard as a more "fundamentalist" kind of faith.

The Theoretical Mediation of the Theology of the Cross

The content of theological theories of atonement showed little novelty in the fourteenth and fifteenth centuries. In general, theologians tended to follow the great scholastics. More significant than new theories was a changed philosophical context for the understanding of redemption. Specifically, there was a significant move toward voluntarism: an emphasis on the absolute freedom of God, rather than on intelligible necessity. The Franciscans in particular tended to follow the theories of Scotus, which were adopted by Oxford scholar William of Ockham (1270–1347), the Venerabilis Inceptor, or "venerable beginner," the most prominent philosophical and theological thinker of the fourteenth century. (Ockham's traditional title Venerabilis Inceptor, however, does not refer to the fact that he "began" a new way of thinking. Indeed, Ockham's influence is perhaps more due to the way in which his thought suited his period than to any great originality. His title *inceptor* refers to the fact that he remained a "beginner" in theology: he never finished the process toward becoming a "master" of theology, because of an accusation of heresy.) The voluntarist ten-

dencies of the followers of Ockham allowed a different intellectual and affective appreciation of the meaning of the passion from that which typified the earlier Scholastic and Gothic period.

The Redemptive Value of the Passion in Later Scholasticism

As we have seen, Scotus did not think that the merit of Christ's human suffering could be infinite. Moreover, he denied that there was any intrinsic need for infinite satisfaction for human sin. Rather, the incarnation and passion were God's freely chosen plan for salvation; and God likewise freely chose to accept Christ's merit as satisfaction for all sin. In line with Franciscan preaching, the fact that God chose this means of salvation, namely through the suffering of Christ, could be taken as even greater evidence of God's love for us. On the other hand, it introduced an element of arbitrariness into God's relation to humanity, and ultimately raises again the question that Anselm had tried to answer: that is, what kind of intelligibility is there in a love that demands suffering?

Ockham and his followers gave theoretical grounds for a spirituality based on an appreciation of God's free love: not by answering the question of the intelligibility of God's plan, but by undermining the very basis for asking it.

The philosophers of the "modern way" are frequently called "nominalists." The usefulness of this term has sometimes been questioned, since a strict nominalism hardly seems to have existed in the Middle Ages. Nevertheless, the term has the benefit of situating the differences between the thought of this period and that of High Scholasticism in their epistemological context.

That context concerns the place and value of universal concepts in our knowledge. Plato had called the world of Ideas the "really real," compared to which our empirical knowledge of this world is but shadows and reflections. Aristotelianism had insisted on the empirical basis of knowledge and the abstract character of concepts. While agreeing that what we know by ideas is real, it also held that this reality has concrete existence only in individual things. We abstract from things their intelligible character or form, which is grasped in universal concepts.

The great Scholastics of the thirteenth century proposed a synthesis that could be called "moderate realism" (Aquinas) or "moderate nominalism" (Scotus). To a certain extent, the difference between the two was a matter of priority: Aquinas stressed the centrality of intellect in the human spirit, while the Franciscans saw the will as the more fundamental reality. But both schools of thought agreed that what is designated by universal terms is real, but it exists only in individual things, not in substantial "Platonic" realities in a separate realm. (St. Thomas did affirm that the "ideas" or intelligibilities of things exist in "the mind of God," as St. Augustine had said; but he was careful to add that

the "mind of God" was actually identical with the divine essence itself, insofar as it is imitable by creation, not a discrete locus in which ideas existed as substantial realities.)

For the High Scholastics, names designate realities, but realities that exist only in individual things. The epistemological issue between the moderate "realist" and moderate "nominalist" tendency was a technical (but philosophically significant) one: are names identical with or are they subsequent to the act of understanding? That is, is the act of understanding restricted to the concept or name that is given to a thing, or does the act of understanding go beyond the name, at least implicitly acknowledging its own limitation and pointing to a "real" that lies beyond it? In the realist view, the concept is logically (but not necessarily chronologically) subsequent to the act of understanding. That is, the genuine act of knowing goes—or at least points—beyond what is "contained" in the concept. Understanding is not identical to conceptualization. Besides concepts, there is the act of grasping an intelligibility, an "intentionality" that reaches for and partially touches a reality beyond what we can say in the name. Only God fully and directly understands all reality. We have at best a partial understanding that is attained with difficulty, is prone to error, and is subject to inadequate formulation.

What is primary for the "realist," then, is the dynamism of the act of knowing, rather than its particular imperfect and partial instances in concepts. That essential dynamism is toward being itself, and the object of its "intention" is named not in ordinary concepts, but in the "transcendentals" (being, the one, the true, the good, the beautiful), which are real in *all* things. These transcendentals, unlike normal concepts like "horse," "tall," "redness," are not merely abstract names for the perceived similarities and the real intelligibilities in individual things. Rather, they name (but cannot grasp) a universal reality, perceived and affirmed under its different aspects in every existent thing: being itself. They are concerned with the necessary conditions of existence itself: what we are affirming at the most basic level when we affirm any intelligibility or existence at all. So, the abstract quality "redness" or the quality of being a "horse" exists only in concrete things in which we perceive them. Despite the Platonic language of "exemplars" existing in the "mind of God," inherited from the Fathers, Aquinas held that there is no substantial "Platonic" redness or ideal horse existing in some superempirical world of ideas, and serving as the exemplar for all particular realities of that kind. But the transcendentals, on the other hand, are not ordinary concepts. Although they are attained in explicit form by the process of abstraction, they refer not to some particular quality, but to the basis for every quality in every existent. Therefore, they alone presuppose an *existent* exemplar: God, the ultimately intelligible and the source of all finite and partial intelligibility, truth, goodness, and beauty. This insight is what is explicitly formulated in Aquinas's "fourth way" for demonstrating

the existence of God, and—it is implicit in all the arguments, insofar as they presuppose the validity of the human grasp of intelligibilities (including causality) itself.[21]

The epistemological synthesis of "moderate realism" represented by Aquinas and (with some difference of emphasis) by Bonaventure lasted for only a short time, and in fact was never universally accepted. By a century later, most of the philosophical and theological faculties of Europe were nominalist. On the issue of universal concepts, the "nominalism" of Ockham himself was not far removed from the moderate theory of his Franciscan predecessor Scotus. Although Ockham denied the objective reality of "intelligible species," he acknowledged the validity of knowledge by abstraction. However, he seems to have overlooked the difference between the ordinary "concepts" and the transcendentals, treating the latter as simple abstractions. Obviously, this would undercut the very basis for the traditional arguments for God's existence.

Perhaps even more significant was Ockham's emphasis on logical argumentation, and his enunciation of the famous principle that would become known as "Ockham's razor": "entia non sunt multiplicanda praeter necessitatem" (existent things are not to be multiplied beyond necessity), that is, one cannot posit the existence of things unless one can show that they are necessary. This means that nothing can be presumed to exist unless one can give an unanswerable argument for it. Moreover, the argument must be from direct experience. Ockham held that we cannot deduce an existence from another existence. What we call "causality," therefore, is reduced to the observation that some things regularly happen in succession to others. And the concepts of "nature" and "substance" are eliminated, since there is no provable necessity for positing them as existent realities.

In consequence of Ockham's analysis of knowledge, any "natural theology" becomes impossible. The existence of God, the immortality of the soul, the relationship between actions and values (morality)—all things that St. Thomas had thought demonstrable by reason—are now considered beyond the reach of the human intellect. They are affirmed only on the basis of faith. God is rationally unknowable and utterly free.

Theology and philosophy, therefore, are separated. Faith becomes an act of will; it is nonrational, if not irrational. With the epistemological foundations of metaphysics undermined, philosophy becomes primarily a matter of logic: the relation of terms and concepts to one another. (While this development led to some great advances in logic as a discipline, it also resulted in the characterization of philosophy as arid logic-chopping, with no connection to life.) Similarly, ethics is reduced to positive law. Morality is not something intrinsic to divine or human "nature" (an unusable concept). Rather, it depends on God's arbitrary decree, revealed to humanity, which is commanded to obey.

Evidence of this separation of faith from reason can be found elsewhere in the culture of the times. Indeed, the success of Ockham's philosophy may

primarily be due to the degree to which it gave intellectual support to common attitudes. We see the radical separation of faith and reason, for example, in the motet "Tuba sacre fidei," a work of the early *Ars Nova* attributed to Philippe de Vitry. It contains the following texts, sung simultaneously by three voices in three different tempos:

> (Triplum): The trumpet of holy faith, the very words of God, the herald of secret mysteries, calls out in the theater that Reason, the support of sinners, hesitates. It is to be simply stated and firmly believed (or otherwise die) that God is One in Three equal Persons, and that the three are one; that the Virgin conceived, not by the seed of man, but by the spirit of the Word, and that remaining always a virgin, she brought forth one who was both God and man. But since these things, which are the life of believers, are supernatural [*transnaturalia*], Reason, which is by nature acquired in ignorant and neglectful steps, produces doubt, and is therefore grounded in guesswork. And one should always follow faith, through which we have a clearer way to the mysteries.
>
> (Motet): Virginity sits on the treetops, flourishing, bearing a child. In the middle, Faith mediates, while Reason, its vision obscured by the tree trunk, followed by the seven sisters [i.e., the seven liberal arts], practicing their sophisms, tries to ascend higher; but the branches break because of weakness. So she [reason] must either ask for the helping hand of faith, or forever strive in vain.
>
> (Tenor): Deliver me, O Lord.[22]

All would agree, of course, that the mysteries of faith that the song mentions are beyond reason. What is striking here is the extent to which reason is depreciated and even mocked (note the "sophisms" attributed to reason's "sisters," the seven liberal arts), and faith is exalted as a higher means of knowing. For St. Thomas, faith surpasses reason, but also presupposes it and perfects it. Faith is at a new level, as intellect is above sense knowledge. But just as intellect presupposes sensation, faith presupposes reason. And reason, for its part, leads toward faith, understands it, and shows its believability. Here, on the other hand, there is a clear dichotomy. Faith is preferred to reason, which falls to ground without her aid. Indeed, reason on her own may be an obstacle to faith, and a cause of sin. We are still perhaps a step removed from Luther's calling reason a "whore"; but nominalism, when it is combined with religious faith, already devalues reason as a means of progress in the sphere of spiritual insight. On the other hand, the stage is set for asking whether faith is in fact a "higher" form of knowing, or whether the human mind should confine itself to its proper object, the sensible world.

With the loss of a conviction of the ultimate intelligibility of God and God's relation to humanity—or, to put it inversely, with the loss of confidence in the

correspondence of humanity's intellectual powers to the reality of their crea-
tor—human reason is freed from theological concerns to concentrate instead
on what is within its scope: the empirical world.[23] Theological emphasis falls
instead not on intelligibility but on God's freedom and power, and on the
revealed nature of God's will. In this regard, Okhamism (developing the
thought of Scotus) made a crucial distinction: between God's absolute power
and God's "ordinate" power—the latter designating the limits that God freely
sets on God's relation to us. For example: absolutely speaking, God need not
reward goodness; but in the actual world, God decides to do so. Having so
decided, God must then be consistent with God's free decision, and must
reward goodness. But there is no *intrinsic* connection between goodness and
reward: absolutely speaking, God in sovereign freedom could decide to reward
evil, and punish the good.

Some forms of "nominalism" pushed the ideas of Ockham to their log-
ical conclusions. Radical nominalists denied that we have any knowledge of
the extramental world except intuitions of individual things, each of which is
so individual as to be incapable of relation or connection with any other in-
dividual thing. General concepts are nothing but convenient names or terms
for the designation of similar characteristics of individuals. Concepts, then,
do not refer to anything "real." They are simply useful tools, constructs of
the mind for dealing with the world. "Transcendental" concepts likewise are
simply the most general of names; one cannot proceed from them to an ex-
istent reality, God.

Thus the Dominican Robert Holcot taught that all knowledge comes from
sense experience. Hence we cannot know the existence of God, of the soul, or
of spirit. Faith affirms God's existence and omnipotence. In Holcot's view, this
means that God can command anything whatsoever. If God wished it, morality
could consist in hating God and one's neighbor, instead of loving them. John
of Mirecourt reduced certainty to immediate experience, and philosophy to the
principle of noncontradiction; all else can be at best merely probable. Nicholas
of Autrecourt expanded on Ockham's thought to explain that "cause" and "ef-
fect" are only the record of sense experiences. Hence we cannot conclude to
the existence of God on the basis of causality. Furthermore, neither substance,
nor form, nor matter, nor faculties of the soul, nor mind can be affirmed to
exist. Nicholas was condemned by Rome in 1346, and John of Mirecourt by
the University of Paris in 1347. However, these condemnations were excep-
tional, and regarded as extreme cases. By the middle of the century, nominal-
ism was the common opinion in most faculties across Europe.

The implications of nominalist philosophy for theology were significant.
The supernatural life of "grace," which St. Thomas had understood as a new
principle of life and experience, is now relegated to a purely religious sphere
of belief. Grace may be present in us, but because it is not empirical, it is

unknowable and inexpressible. Grace is seen as an "aid," an "entitative" change, not an experienced part of psyche or of living.

The nominalist spirit also had religious implications. With little or no knowledge about ultimate things available through the use of reason, the pious were left to appeal to faith, in the form of traditional religion and/or of mysticism. Certitude could be sought not in the intellect, but in special mystical experiences that gave an emotional feeling of security. Mysticism suited the nominalist separation of the secular world from the supernatural. In mystical theology, God is radically apart from the world; the "supernatural" is a sui generis reality that is reached intuitively. It is fundamentally different from our sense experience of the world and of our mind.[24] On the other hand, for the same reason one could live in the world as a totally secular place. As John Mundy remarks, "the men of the Ockhamist *via moderna* were often profoundly conservative. Their separation of heaven from earth often enabled them to live without too great a straining of conscience among fallible men and confessedly imperfect institutions."[25] But many such consciences were understandably struck with panic when the great plague appeared as an apparent judgment of God.

Nominalist thinking also had direct effects on the doctrine of salvation. Once again, a contrast will be helpful. For St. Thomas, the context of the doctrine of salvific grace was the conviction of the efficacy of God's loving and creative will. To exist is to be loved by God. That is, to be created is to be freely posited by the divine will. When God loves, God creates. This is true analogously of the level of grace as well: if God loves us as God's children, he makes us God's children. The divine love is effective.[26] Hence for Thomistic thinking, the remission of sin is not an amnesty, but a change in the human person, from a sinner to a child of God, with the attitude of such a child, that is, living in charity or love. Grace imparts a real intrinsic similarity to God. Salvation is impossible without this transformation; because salvation is precisely an assimilation to God's way of being.

In the theology of Scotus, however, the context is somewhat different. Salvation occurs because of God's free *acceptance* of the sinner—although the latter is still called to a change of life. For St. Thomas, God's acceptance is identical with the infusion of charity, which makes us children of God. For Scotus, on the other hand, the infusion of charity is only the *condition* for God's definitive acceptance: one that is de facto willed by God, but that is not absolutely necessary.[27] The connection between charity and salvation depends on God's willing it: there is no intrinsic relation.

Here we see already a tendency to "voluntarism": the evaluation of will and freedom as more primal than intellect and intelligibility. The unity of the intelligible and the good is weakened, if not lost. Ockham and his disciples pushed this aspect of Scotism to its logical conclusion. What is important is

the absolute liberty of God. Absolutely speaking, God could accept a human being without grace, without charity, and ordain such a person to eternal life. Or, God could freely elect to damn a person who had both charity and merit. We know by revelation (and only by revelation) that in the existent world God in fact wills that charity is required for attaining eternal life, and that sin is unworthy of it. But it need not be so. The essence of justification is that God accepts the creature; freely and arbitrarily giving him or her the right to eternal life.[28] Justification depends uniquely on an arbitrary act of God—who decides to accept some people as just. The supernatural virtues are only presuppositions for acceptance by God because of God's positive law.

It will be apparent that these theological positions are intimately connected with nominalist epistemology. It is presumed that our "natural" intellect cannot reach supernatural reality in itself, but only factual conditions. Hence what we call "good" is not necessarily an ontological reality. The real nature of "the good" is determined by God's will, and this cannot be reached by reason: it must be revealed to us as God's positive "law." The law for our world has in fact been revealed. But this does not indicate anything intrinsic about what "the good" is, for God could create different worlds, with different rules.

These views obviously accord with and reinforce the Scotist view of redemption: Christ's suffering and death were not intrinsically necessary to our salvation. Rather, they manifest God's will. This theology, although it rejects a basic presupposition of Anselm's theory of atonement, can nevertheless be expressed in terms of the latter, with the modification that the need for Christ's sacrifice in "payment" for human sin was not somehow intrinsic to God's justice, but was rather posited freely by God. As we have said previously, such a theory might be used to reinforce the perception of the depth of God's love—provided that one takes it for granted that suffering is a sign of love. And in that case, spirituality is open to taking on the masochistic form that has sometimes been seen in passion piety. On the other hand, if combined with the notion of an unknowable and arbitrary God, it might equally lead to the suspicion of a sadistic and terrifying deity. The sense of guilt that accompanied the plague in the middle of the century—which was seen, as we have noted, as a judgment by God against sin—reinforced the image of an angry and vengeful God. In this context, as we shall shortly see, the wounds of Christ became a warning, rather than a sign of love.

The Aesthetic Mediation of the Theology of the Cross

The later Middle Ages witnessed a significant expansion and change in the spirituality of the cross. The sufferings of Christ became even more central to Christian piety, and forms of devotion that focused on them multiplied.[29] Historian Richard Kiekhefer calls devotion to the passion "ubiquitous" in late me-

dieval piety.[30] Moreover, this devotion was increasingly focused on Christ's suffering itself, and increasingly invited believers both to identify with that suffering and to regard themselves in its light as sinners, and hence as the cause of the passion and death of God's Son. As we shall see, the religious art and music of this period were largely preoccupied with conveying these messages, and in doing so they created a new affective context for Christian spirituality. The changes that the fourteenth century saw in the art of the passion involved both content and style. In the following sections, we shall look at a number of examples in visual art, in music, and in new dramatic expressions that in this period became independent of their liturgical origins.

The Passion in Fourteenth-Century Visual Art

The expansion of interest in the passion in the "modern" art of the fourteenth century is apparent in a number of ways. We may discern four major overlapping elements in this expanded interest: (1) in style, a new naturalism in portraying the suffering humanity of Christ; (2) in content, expanded attention to details of the passion story, frequently going beyond the canonical sources; (3) the introduction of new themes and images, in particular the icon of the Man of Sorrows and the *pietà*; and (4) increased attention to the place of Mary in the passion.

The tendency to naturalism that was initiated by Giotto was quickly adopted in Italian painting, and eventually spread throughout western Europe. As we have noted, sculpture had already for some time incorporated naturalistic elements. But as the century progressed, this naturalism was increasingly used to draw attention specifically to the human suffering of Jesus.

The reasons for this emphasis are probably multiple. We might cite among other factors the influence of Franciscan preaching, popular appropriation of the notions of "satisfaction" and substitution, the sense of guilt inspired by the midcentury scourge of the plague (thought of as God's punishment for sin), and the increasing "humanistic" and empirical emphasis on sensation and feeling in general. As we have seen, the suffering of Jesus was already conceived to be more intense than that of any other human. Yet Christ was also thought to have enjoyed the beatific vision, even during his passion.[31] Early Gothic representations of the crucifixion made it clear that it was the divine Son who suffered.

Giotto's art, like much art already in the thirteenth century, attempted to induce a sense of pathos. What Giotto added was the naturalism of his representation. Still, his crucifixes, however naturalistic, retain a sense of quiet dignity. Later representations, however, frequently placed more value on conveying the magnitude and horror of Jesus' pain. As we have seen, the theology of the Fathers and the Scholastics spoke of the pain of Jesus on the cross. But their emphasis was on the shame of his execution, and the mental suffering

caused to Jesus because of his betrayal by his own.[32] It is sorrow, rather than physical pain, that predominates in the early Gothic crucifix. In the course of the fourteenth century, however, there is an observable shift toward the portrayal of intense physical pain of all kinds.

Especially in the period following the Black Plague, paintings and statuary representing the way of the cross and the crucifixion emphasized the intensity and horror of these sufferings.[33] The so-called *Pestkreuz* ("plague cross") or "leper cross" depicted the scourged and tormented Jesus as similar to the victims of the plague.[34] Throughout the century, the portrayals of the crucifixion increasingly emphasize the complete dereliction of Jesus. This is not to say, of course, that we can find a uniform and universal progression in a single direction in style or thought. Toward the end of the century, for example, the so-called *Schöner Stil* ("beautiful style") in the German lands tended to idealize the figures and to lessen the graphic depiction of pain. But in many paintings of the fourteenth century, Christ is shown with no beauty or dignity, and sometimes without any exterior sign of his divinity beyond the usual halo around his head; he is (to all appearance) a common criminal, abandoned to a horri-

Wooden cross with suffering Christ, German, dated 1304. Credit: Foto Marburg / Art Resource, New York.

fying death. As the theory of "substitution" held, he suffered punishment in our stead; and the cross is the reminder of what our sins deserve (even though, as we have noted, Christ was not thought to have suffered the pains of the damned, as some Reformation versions of "penal substitution" would later hold). It is surely significant that the crucified Jesus begins to be portrayed the way artists imagined the eyes might have seen him, even though the mind of faith knows a different reality. This contrasts with earlier eras, in which art attempted to portray precisely what faith affirmed, rather than what the eyes would have seen. The new naturalism in representation applied to other figures as well: Mary, for example, is now sometimes portrayed as an older matron, rather than the idealized young woman of most earlier Gothic art.[35]

Art historians have noted a major shift in style in Italian religious painting in the period after the Black Death.[36] The works of the major painters became more hierarchical, stylized, formal. Obviously, stylistic changes have many causes, and we cannot simply attribute the new formalism to a change in religious mentality caused by the plague, any more than we may attribute stylistic naturalism to a single cause. But certainly this new style is suited to the religious attitudes of the later part of the century, which in turn were at least in part caused by the plague and its social consequences: the arising of new fortunes, the move to the cities of country people with more conservative artistic and religious tastes, and the replacement of earlier "humanism" with a more hierarchical vision of the sacred.[37] In any case, this brief generational change in style did not affect the general tendency toward portraying the crucified in a naturalistic way. On the contrary: despite differences in style, generally speaking, passion scenes and crucifixes even more strongly aim at affective reaction to the suffering of Christ.

The new naturalism in painting added a further dimension to the practice of meditation on Christ's suffering. As we saw in the previous chapter, this was already an important element in early Franciscan spirituality, and was explicitly encouraged by the writings of Bonaventure. The fourteenth century expanded on this form of devotion. Pseudo-Bede, writing about 1300, says: "readers must imagine that they are present at the very time of the passion and must feel grief as if the Lord were suffering before their very eyes." Moreover, they should imaginatively act out their presence at the events of the passion: they should sit beside Jesus, comfort him, take his place in carrying the cross, and so on.[38] The Franciscan author of the *Meditationes Vitae Christi* (*Meditations on the Life of Christ*)[39] added many concrete details to the accounts of Christ's life, some of them from the Apocrypha and some from his own imagination. Visual realism would obviously be an aid in the practice of the imaginative meditation encouraged particularly by the Franciscans and Dominicans, and would be invited by the precise detail of some new accounts.

In addition to a new naturalism in presentation, there was also expanded attention to the details of the passion. Representations of the crucifixion itself

became more complex, with more action and more characters, including even postbiblical saints and contemporary figures (in keeping with the idea of spiritual "presence" to the events of the passion).[40] We have seen this tendency already in Giotto, although his crucifixions retain a certain economy and simplicity compared to the crowded scenes of some of his contemporaries and especially his successors.

Gruesome portrayals of the details of the crucifixion and of other events of the passion could be justified by appeal to biblical passages, taken as literal prophecies of the passion. Isaiah 1:6, for example, justified a gory portrayal of the wounds inflicted by the flagellation: "from the sole of his feet to his head, there is no health in him: wounds, bruises, open sores." These passages were standard references in medieval exegesis. But the graphic portrayal of their content was an innovation. In addition, there was increased dependence on nonbiblical sources, like the meditations of Pseudo-Bonaventure and others, sometimes concretized in the visions of certain passion-centered mystics, including St. Birgitta (Brigid) of Sweden.[41] (In the latter cases, it may also be that the influence went the other way. Indeed, although she claimed to have received her accounts from the Virgin Mary herself, it has been remarked that St. Brigid's visions read like a catalogue of literary and painted depictions of the passion.) In any case, the "mystical" passion visions seem to be generally derived from the common stock of biblical commentary, but with an added graphic dimension in the descriptions of events.

Fourteenth-century art intensified and expanded passion devotion through meditation on postcrucifixion events, now sometimes portrayed in isolation, rather than as elements in a narrative series: the deposition from the cross, the placing of Jesus in the arms of Mary, the burial of Jesus, and so on. We also find emblems of the passion (the scourge, the cross, the lance, the nails, the sponge, etc.) and even the crucified Jesus himself portrayed outside the narration of the events.[42]

Two images in particular represented new genres that became widespread in this century and endured in subsequent passion art: the *imago pietatis* and the *pietà* (*Vesperbild*). The former enjoyed a comparatively brief vogue; the latter became a classic genre of Western religious art. Both of them, as their titles suggest, are explicitly aimed at producing compunction and compassion in the viewer: they are devotional images (*Andachtsbilder*), used for private devotion. Both appeal to the notion of *pietas*, which could be applied ambiguously to Christ or his mother or the viewer.

In its ancient Latin sense, *pietas* referred to duty and loyalty, first of all toward the gods, and then to country or family (recall Virgil's *pius Aeneas*). It could also refer to the gods' compassion for humanity. In short, it referred to the ties that arise from familial-type loyalty relationships, whether between gods and humans or among humans. In medieval Latin the word retained

these basic meanings, but with the nuances added by the Christian concept of God's mercy on the one hand and human love of God on the other. By the later Middle Ages, this "familial" kind of love was not understood merely in terms of duty: it also had a strong affective component. Hence the *imago pietatis* ("image of pity" or "image of compassion") is at once an image of the divine compassion (*pietas*), manifest in Christ's sufferings, and an image aimed at producing loving compassion (*pietas*) for Christ in the viewer. The *pietà* is at once the image of the suffering compassion of Mary for her dead son, and an invitation to the viewer to share the same attitude.

THE "MAN OF SORROWS." The *imago pietatis* in the East is generally called the icon of "extreme humility" (or "extreme humiliation"). In the West it is known as the Man of Sorrows. It shows the wounded and dead Christ, usually shown from the waist up as though standing in a sepulcher. The tomb is sometimes portrayed unnaturally as an upright box-like structure. When it retains the identifiable shape of a Roman sarcophagus lying flat, it is frequently portrayed in miniature, out of proportion with the figure rising out of it. The arms of Christ are usually crossed, but sometimes open to exhibit his hands. He bears the marks of the crucifixion. This image has been the subject of an exhaustive study by Hans Belting.[43] In what follows, I will not attempt to reproduce even the major points of his fascinating and insightful book, but will merely summarize some of the principal data relevant to our theme, referring the reader to Belting for more detail.

The expansion of the Byzantine "Great Friday" (Good Friday) liturgy from the eleventh century on produced a need for new icons expressing its themes, in particular the descent from the cross, the mourning over the dead Christ, and the burial. These eventually led to the "extreme humiliation" icon.[44] The oldest known icon of the type is a twelfth-century panel from Kastoria. Its reverse side shows Mary with the child Jesus. This is consonant with the Great Friday liturgy, which contrasts Mary's joy at childbirth with the sorrow of the cross.[45] There may also be present the idea that despite her joy, Mary mourns Christ even as a child: she is conscious of the purpose of the incarnation,[46] at least in such timeless iconic portrayals.

The "extreme humiliation" icon also fit with other Byzantine themes. As we have seen, the Byzantine church had early come to think of the actions of the liturgy as an allegory for Christ's passion, death, and resurrection. In line with this symbolism, the cloth placed on the altar for the Eucharistic celebration (the *epitaphios* or *aer*)[47] was thought of as the burial sheet in which Christ was laid in the tomb.[48] By the thirteenth century, the figure of the dead Christ lying on his burial sheet was portrayed on the *aer*, and carried in the great entrance as a covering for the bread and wine.[49] In these images, Christ is lying flat, and generally seen from the side, rather than standing and seen frontally,

as in the "extreme humiliation" icon. But the thematic content and context are similar, and it seems that both were used in the Holy Week liturgy by the time of Patriarch Athanasios I (1289–1293 and 1303–1310).[50]

(Somewhat before 1204 a cloth from Palestine reputed to be the burial sheet of Christ—possibly the same that would later be known as the Shroud of Turin—was exhibited in Constantinople. Belting states unequivocally that it was not the model for the "extreme humiliation"-type icon, which had appeared earlier.[51] However, the figure on the shroud shows some visual similarities to the icon, as well as to portrayals of the dead Christ on the liturgical *aer*. Carbon dating places the origin of the Shroud of Turin in the fourteenth century; hence its identity with the shroud seen in Constantinople by the crusaders is thrown into question, although not excluded. In any case, we may speculate that the shroud and its earlier prototype, if there was one, were created—painted, presumably: remnants of pigment have been found on the shroud—in imitation of the "extreme humility" type icon.)

The meaning of the Byzantine icon is clear. Although Jesus is shown as though emerging from the sepulcher, there is no action implied: this is not a resurrection scene. The portrait is iconic, rather than narrative: it does not visually represent an event, but rather the *idea* of Christ's death and entombment. Christ is dead, at rest—not yet risen.[52] He is in the "sleep" of death. This metaphor is found in the liturgical texts of the Threnodes Kanon of Great (Good) Friday, as well as in many homilies. It is used in Eastern theology for human death, but also for the presence of the divine life in Christ: the divine power and glory are present, but as though asleep, invisible and (usually) inactive. On the other hand, while the humanity of Christ "sleeps" in death, the divinity is ever-awake. Christ is compared to the lion, which was thought to sleep with eyes open; or to the lion's cubs, which are born dead and come to life after three days.[53] In short, the icon refers to what is expressed in the words of the Eastern liturgy referred to earlier: Christ's body is in the tomb, his soul is in hell, but his divinity remains enthroned with the Father, filling all things. The height of humility is for the divine to efface itself and submit to human existence, suffering, and death.

The "pietas" image was first seen in the West in the thirteenth century,[54] and became common in the fourteenth. The different titles of the picture in East and West indicate the difference in emphasis between the originating Eastern icon and the Western mentality that received it. In the Oriental church, as we have mentioned, this figure is called the icon of Akra Tapeinosis (Ακρα Ταπείνωσις): "extreme humiliation" (in the classical meaning of the noun) or "extreme humility" (in New Testament Greek). Whether taken as referring to what Christ underwent in his passion, or to his spiritual state in being willing to undergo it, the title is in conformity with the Patristic emphasis on the indignity of the cross and the condescension of God in the incarnation.[55]

In the West, on the other hand, the picture is generally referred to as the

Man of Sorrows: the emphasis is on Christ's sufferings and feelings. There is an ironic and paradoxical juxtaposition: Jesus is dead, but not dead; he is the object of compassion, yet he is the one who can exercise compassion.[56] As in the East, the idea of Christ both dead and yet alive has a connection to the eucharist.[57] Implicit, then, is Christ's divinity and resurrection. But in the Western use of the icon, the affective emphasis seems to be on suffering, offering. The connection to the eucharist resides in the presence of a sacrifice that is still going on. It is as though—for the viewer—somehow even the resurrected Christ is still suffering the pains of Calvary.

The portrayal of Christ as "the crucified" or as the Man of Sorrows, even outside the context of the passion narrative, had other expressions as well. Christ is even shown in this form in the arms of God the Father, in a sort of transferal of the deposition and *pietà* themes to heaven. Images of the Trinity with the cross date from at least the thirteenth century.[58] Such images commonly showed a crucifix, held aloft by the Father. Now, however, it is not the historical act of Christ's sacrifice that we see "eternalized" in the representation of the Trinity, but the broken body of the crucified, separated from the cross. In the "Holy Trinity" of the Master of Flémelle (ca. 1410), the Father stands holding the drooping lifeless body of Christ under the arms, while the Spirit, as a dove, hovers above.[59] In stark reversal of the early church's "contrast" theology, in which the Father raises Jesus precisely to defeat and negate the evil of his suffering and death, this image seems to imply that the suffering of Christ is somehow eternal, and reaches even into the realm of glory. The power of sin and the sorrow and suffering it causes—we seem to be told—are so great as to touch the very beatitude of God.

THE *PIETÀ* AND THE (COM)PASSION OF MARY. As we saw in the previous chapter, the genre of the *pietà*, the depiction of the dead Christ in the arms of his mother, was derived from the involvement of Mary in the scene of the removal of Christ from the cross—a theme introduced in the West in the pious literature of the twelfth and thirteenth centuries.[60] Visual representations appeared first in northern Europe and in Spain. In the fourteenth century, this kind of representation became widespread, especially in Italy, as a private devotional image (*Andachtsbild*).[61]

The *pietà* image serves a dual purpose in devotion. In the figure of Mary mourning her son, the viewer finds an example of what he or she should feel. But beyond this, the image also presents the object of compassion: that is, our feeling is directed not merely toward the dead Christ but to the sorrow of the mourning mother. We feel compassion with Mary and for her. The *pietà* is the visual realization of the message of the "Stabat Mater."

Through the fourteenth century, association with the suffering of Mary became an increasingly common means of relating to the emotional element in the passion. The *Meditationes Vitae Christi*, one of the main sources of visual

art in the period, was probably written for a woman, and contains a great deal about the life and the feelings of Mary.[62] Scenes like the meeting of Jesus with his mother on the way to Calvary (see for example Giotto's portrayal in the Arena chapel) are given a new dramatic emphasis, drawing the viewer into the psyche of the actors and inviting participation in their feelings. From the 1300s, Mary began to be introduced into scenes where there was no scriptural foundation for her presence—not only the deposition and burial but even the flagellation of Jesus.[63]

As we have noted earlier, one of the purposes of meditation on the passion of Jesus was to remind the Christian of his or her own sinfulness. This then could become the occasion for gratitude for the divine compassion and love in giving Christ as our ransom. But the recollection of sin in the context of responsibility for the passion could easily become above all a reminder of the divine wrath at sin, rather than a sign of God's love. In the context of the divine wrath, Mary sometimes became the refuge of sinners who would not dare turn to Christ himself.

A striking example of this tendency is seen in the story of the dream of Brother Leo (a companion of St. Francis), related in the *Chronicles* of the Franciscans (*Chronica XXIV Generalium Ordinis Minorum*), compiled in the 1360s and 1370s by an anonymous friar (possibly Arnoldus de Serrano). Leo dreams of the Last Judgment. He and his Franciscan brethren are gathered before two ladders leading to heaven: one is red and the other white. At the top of the red ladder stands a wrathful Christ. St. Francis calls his disciple to climb the red ladder; but he is unable: he falls. Francis prays for him, but Christ displays his wounds and declares, "Your brothers have done this to me." Francis then leads Leo to the white ladder, which he climbs easily, to find the Virgin Mary awaiting him at the top.

Obviously, the story's replacement of Christ by Mary as the symbol of divine love is highly significant for the history of Catholic piety. But what is notable from the point of view of our study is the fact that the sins of humanity are seen as the direct cause of the sufferings of Jesus: he suffers in his person what our sins deserve.[64]

It is curious that in this story, and the piety that it represents, the sufferings of Christ have become a motive of fear for the sinner who caused them: for, after all, the premise of the satisfaction theory is that Christ voluntarily undertook these sufferings precisely for our salvation. St. Anselm, as we have seen, took them as the sign of God's infinite love. The Scotist theology of redemption, by stressing the nonnecessary nature of the actual plan of salvation, meant to emphasize God's free love even more strongly. At the same time, there is a certain logic to the reaction of guilt and fear: if Christ's sufferings should be the cause of limitless gratitude for the saved, it is because he underwent them in our place; hence they show us the enormity of our sins. For those who are not saved, then, the wounds of Christ are a source of terror.

The iconography of the Last Judgment in the medieval period commonly shows Christ manifesting his wounds: the means of salvation. (See, for example, the thirteenth-century mosaic in the baptistry of Florence cathedral.) In the later Middle Ages, however, Christ shows his wounds specifically to the damned, as though declaring the reason for their condemnation (as in the fourteenth-century Last Judgment scene attributed to Traini in the Camposanto at Pisa).

The popularity of the *pietà*, with its emphasis on compassion and motherly feeling, seems to reflect the changing status of women in the fourteenth century. Although Mary is still queen of heaven and protectress, there is great emphasis on her power of intercession, which is based on her motherhood.

The Cloisters museum in New York displays a remarkable Italian painting of the 1300s that illustrates this aspect of Marian devotion. At the top of the painting we see God the Father, who sends the Spirit, in the form of a dove, descending onto Christ, who kneels before Him on the bottom left side of the panel, showing the wounds of the passion. Christ is speaking words (in Italian) that appear in golden letters directed toward the Father: "Padre mio, sieno salvi costoro pei quali volesti ch'io patesse passione"—"My Father, may those be saved for whom You wished that I should suffer the passion." Meanwhile, on the right side, Mary kneels, facing Christ, holding her bared breast, and addressing him: "Dolce mio figlio, pel lacte ch'io ti die, abbi misericordia di costoro"—"Sweet son of mine, by the milk that I gave you, have mercy on these." Her free hand gestures toward a group of people, smaller in size, who are gathered at her knees. Mary here acts not as queen, but as humble suppliant. She appeals for humanity on the basis of her motherhood, her service to Christ. Christ likewise appeals to the Father, asking for the reward of his obedient suffering. In the background is God's salvific will: it is the Father who wished Christ to suffer for humanity. Salvation appears directly linked to the passion; yet both Christ and Mary must plead. Is it reading to much into such a painting to see in it a popular religious expression of the same mentality that produced nominalism in theology? God appears as an inscrutable arbitrary Will, and our only hope is in making a kind of familial connection—*pietas*—with powerful intercessors.

The Passion in Music, Liturgy, and Drama

The two new genres we have discussed are strongly represented in visual art. They also connect with other aspects of piety: liturgy, music, and drama.

LITURGY: THE EUCHARIST AND THE MAN OF SORROWS ICON. The most obvious connection, perhaps, is that of the *imago pietatis* with the "sacrifice of the mass." Hans Belting remarks that the image of Christ dead, yet alive, makes no sense without connection to the eucharist.[65] As we have seen, the image arose in Byzantium in exactly that context. More precisely, the image presup-

poses Christ's divinity and resurrection. The body in the image is meant to be understood as still being in the tomb; but it is also understood that it will rise. This is a Holy Saturday image that anticipates Easter. However, the affective emphasis is clearly on Christ's suffering and death: his self-offering. And it was the eucharist that was conceived as repeatedly re-presenting the eternal moment of that offering—or, in a more popular understanding, as repeating it, so that "each Mass throughout the year might constitute a reenactment of the sacrifice of Calvary."[66] It is not surprising, then, that the *imago pietatis* sometimes represents the figure of Christ within the Eucharistic host.[67] And although St. Thomas says that the Eucharist is the sacramental presence of the glorious resurrected body of Christ (*S.T.* 3, q. 76),[68] there is strong evidence that much of medieval piety associated that presence—imaginatively, at least—with the crucified body.

Angela of Foligno (1248—1309), for example, saw in the host at the elevation the image of the dead Christ: "there appeared to me the image of that blessed crucified God and man, as though just taken down from the cross." As a result of this vision, she was "transfixed with great compassion."[69] Ludolph von Sachsen, whose *Vita Jesu Christi* replaced Pseudo-Bonaventure's *Meditations* as the most popular account of Christ's life, at least in northern Europe, writes that

> it is greater to receive Christ's body from the sacrificial altar (*ara*) of the [Eucharistic] altar (*altaris*) than to receive it from the sacrificial altar of the cross. For those [who took Christ from the cross] received him in their arms and hands, while these [who receive the Eucharist] take him into their mouths and hearts.[70]

It is notable that both the cross and the eucharistic table are conceived as an altar of sacrifice (*ara*), and that receiving the eucharist is compared to receiving the sacrificed body from the cross.

It would seem that there was little room in popular imagination for the subtleties of High Scholastic teaching on the mode of presence of Christ in the sacrament. Moreover, even on the theoretical level, nominalist theology left little room for ontology, for the analogy of being, or for the metaphysical concept of "substance," all of which are crucial to the Thomistic understanding of "transubstantiation." Without a theoretical basis for an ontological dimension to signification and sacramentality, the "real presence" of Christ in the eucharist easily becomes understood as the miraculous physical presence of an object. Moreover, the notion of the mass as sacrifice leads easily to the notion that the object present is the crucified body of the God-man Jesus.

In any case, in the fourteenth century arose the custom of showing the host outside mass: the "exposition of the Blessed Sacrament." As Belting says, the eucharistic host is now seen more as a unique kind of relic,[71] rather than as an element in an aesthetic/symbolic act.

The connection of the eucharist with passion-centered piety is also seen in the writings of Angela of Foligno (1248–1309), Birgitta of Sweden (1303–1373), and Catherine of Siena (1347–1380). As we have noted earlier, the visions of these mystics both influenced and were apparently influenced by the iconographic as well as the literary traditions of passion piety.

MUSIC: EXTENSION OF THE "STABAT MATER." The *pietà*, although a newly discovered genre in the West in the fourteenth century, was clearly not without precedent or connection to Marian piety. Meditation on Mary's sorrows, as we have seen, constituted a major way of relating affectively to the passion.

As in art, in fourteenth-century music we find deepened attention to Mary's role in the passion. The musical *planctus*, or lament of Mary, was a major genre of devotional expression and meditation. Like painting, music seeks an ever deeper emotional appeal in its portrayal of the mother's grief.[72]

There are also texts that expand upon the great and very popular Franciscan hymn "Stabat Mater," depicting Mary at the foot of the cross and explicitly attempting to identify with her in compassion. One such text is of particular interest for the sake of comparison with the original. Called *Von unnser vrawen mitleiden* ("On Our Lady's Compassion"),[73] it was written by an anonymous monk (called the Monk of Salzburg) in the last third of fourteenth century. It is a vernacular (German) paraphrase of the "Stabat Mater," written in strophes in the same meter, and intended to be sung to the same tune. As will be apparent, however, the author goes considerably beyond the original in his appeal to sentiment. (I give here a loose modern translation facing the original text. For comparison, the text of the "Stabat Mater" may be found at the end of chapter 4).

Maria stuend in swindem smerczen	Mary stood with deep pain
pey dem kreucz und waint von her-czen	by the cross where her dear son hung,
da ir werder sun an hieng	and wept with all her heart.
Ir geadelte zartte sele	A cutting sword sharply pierced
ser betruebt in jamers quele	Through her noble, tender soul,
scharff ein sneyduntz swert durch-gieng.	Her soul so afflicted, shaken with wailing.
o wie sere mit laid bestricket	O how greatly stricken with grief
was dy mueter gebenedictet	Was the blessed mother,
mueter des aingeporen.	The mother of the Only Begotten Son!
Wie sy laid in jamer iaget	How she wails her sorrow,
wie sy wainet wie sy klaget	How she weeps, how she cries out
pein ires sunes auserkorn.	At the pain of her beloved Son!

Welich mensch wainen versmehe
der dy mueter Gotes sehe
in so swindem iamer stan.
Wer möcht laides ane wesen
der dy mueter auserkesen
sehe den sun it leiden an.

Her der sünder sünd und schuld
sach sy Jhesum mit gedult
sere gegaiselt nemen ab
Sy sach iren süessenn troste
alles trostes erloste
do er seinen geist aufgab.

Sy sach an der selben state
den thron der Trinitate
das ist kristi prust unde hercz
Ein Jud mit ainem scharffen spere
swind durchstach awe der sere
und des pittern grossen smercz.

Wie da smercz in smerczen drungen
und hiet ich hunderttausent czungen
und redt ich aller engel sprach
So kund ich doch nicht volsagen
soleich wainen soleich klagen
do geschach ach in ach.

o ursprung rainer mynne
pring mich deines smerczen inne
hilf das ich dein laid bewain
Das mein hercz werd enczundet
und in kristi mynn verwundet
das ich im gefall allain.

Hilf das ich mit dir bewaine
den gekreuczten nicht klag saine
alle dy weil ich leb auf erd
Pey dem kreucz mit dir beleiben
hilt mir kron ob allen weiben
pis dein laid mein hercz versert.

Who would not weep
To see the Mother of God
Standing in such great lamentation?
Who would be without sorrow
To see the beloved mother,
As she suffered along with her son?

She saw how Jesus patiently
Was brought forth from the scourg-
 ing,
For the sins and guilt of sinners.
She saw her sweet comfort
Deprived of all comfort
As he gave up his spirit.

She saw in the same holy place
The throne of the Trinity:
That is, Christ's breast and heart.
A Jew with a sharp spear
Stabbed him through. Alas for the
 wound,
And alas for the great and bitter pain!

How pain led on to pain!
And had I a hundred thousand
 tongues,
And if I spoke all the languages of
 the angels,
I could never tell sufficiently
Such weeping, such crying.
There were sorrow and lamentation.

O fount of pure love,
Let your sorrow permeate me;
Help me to bewail your sorrow,
So that my heart may be kindled
And wounded in love for Christ,
So that I may please him in all things.

Help me to lament the crucified with
 you,
So that I may not stint in my sorrow,
As long as I may live on earth.
Help me, Queen of all women,
To remain at the cross with you,
Until your sorrow transforms my
 heart.

o magt aller magt gimme	O Virgin, jewel of all virgins,
hilf das ich deins smerczen werd inne	Help me to make your pain my own,
das ich ymmer mit dir klage	So that I may always weep with you;
Das ich deines sunes tode	So that I may meditate
marter wunten pluet so rote	On your son's death,
hoch betracht und sein plage.	His martyrdom, his wounds, his red blood.
Das sein wunden mich verwunden	That his wounds may wound me,
und sein kreucz mich hail von grunden	And that his cross and rose-colored blood
und sein rosenfarbes pluet	May be for me a means of healing,
das die hellisch ewig flammen	That the eternal flames of hell
ob mir nit slahen zusammen	Do not close over me,
o gute fraw halt mich in huet.	O good Woman, shield me.
Starkcher Got als ich verschaide	Powerful God, when I die
tail mit mir durch die werden maide	Give to me your palm of victory,
dy palme der signunft dein	Because of the noble Virgin.
Wann der leib allhie ersterbe	When my flesh dies here below,
das sy sele dort erwerbe	Let my soul attain
des paradises klaren schein.	The bright radiance of paradise.
Amen.	Amen.

Just as in painting, there is a new emotionality in the hymn's evocation of pathos. Mary's grief is portrayed not as the sad but dignified lamentation that typified earlier poetic settings, but rather as the unrestrained wailing of a woman who loses her child. The text has become "vernacular" in more than the literal sense. The portrayal of Mary's grief is modeled on what the hearer might feel in a similar situation. The text goes beyond the original in its description of the indescribable depth of Mary's pain, and the vehemence of its expression. Like the painting of the period, it appeals to the audience's emotions to evoke a sentimental identification first of all with Mary, and then through her with Christ. (Note also that the soldier sent by Pilate in John's gospel—who was traditionally identified with the Roman centurion of Mark and Luke, and was given the name "Longinus" in early apocrypha—has here been replaced by "a Jew with a sharp spear": an unsubtle reminder of the anti-Semitism that was often occasioned or exacerbated by passion meditations.)

DRAMA: THE PASSION PLAY. Already by the eleventh century there were translations and retellings of the passion story in the vernacular languages, both in prose and in verse. These contributed to the development of the various passion plays.[74] The dating of these is often uncertain. But by about the fourteenth century they had lost their original liturgical character and emerged in vernac-

ular forms, with imaginative expansions of the narrative.[75] Just as in the art of
the period, there was an increased interest (to reach a culmination in the fif-
teenth century) in the whole sequence of events leading up to and following
the crucifixion[76]—leading to devotions that would eventually become the mod-
ern "stations of the cross."[77] In addition, these plays gave an opportunity to
dramatize the meeting of Jesus with Mary, the dialogue between them, and
the sorrows of Mary encapsulated in the *pietà* scene.

A full study of the passion plays would take us beyond both the period and
the scope of this book. A few brief remarks must serve to relate this genre to
the other art and music of the period. With their separation from the liturgy,
the passion plays passed into the hands of the laity. They were generally pro-
duced by the city authorities, and were therefore less under the control of the
clergy. On the whole, therefore, they tend to be more popular and less theo-
logically sophisticated than the high art of church painting or ecclesiastical
music.

> Here we are not dealing with university theologians who were
> schooled in dogma. Hence the purpose of the plays is not to set
> forth and explain a specific church doctrine, nor to educate the view-
> ers by dramatically presenting a particular article of faith in contem-
> porary terms. This kind of teaching is not envisaged. Rather, it is a
> matter of a general representation of soteriologically important
> events. . . . The passion plays do not envisage an incarnation—that
> is, the making present in a perceptible way of the timeless presence
> of the liturgy . . . but rather, the representation of a central event of
> salvation history, with the purpose of bringing the willing viewers
> into the event through this act of representative repetition, and
> through *compassio* to dispose them for salvation.[78]

In this sense, the plays share the goal of so much fourteenth-century art:
they attempt to relate the viewer to salvation through engagement of the affects.
To this end, they frequently use expository figures—including the players of
Mary and Jesus himself—and also sometimes a commentator, to encourage
the public to weep, cry out, and emotionally share in Christ's and Mary's suf-
ferings.[79] They wish to make the point already stressed by St. Anselm in his
exposition of the theory of "satisfaction": that Christ died not simply for the
releasing of humanity in general from original sin but for the sins of each
individual person.[80] Like the paintings and the theological commentaries, they
visually concretize the events of the passion by filling out the gaps in the gospel
accounts with details from the Psalms and the prophets. This graphic drama-
tization, as many have pointed out, was not without its dangers. The unbloody
self-sacrifice of Christ in the mass becomes here a bloody representation of
death on the cross.[81] There was a danger of a popular misunderstanding of the
former in terms of the latter. Moreover, the encouragement of strong affective

at work.[85] In particular, they should meditate on the passion during the celebration of mass.

The brothers were encouraged to use imagination to provide a sensible and affective grasp of the object of meditation—although in theory this was to be a first step that would be surpassed, as in the mystical theology of Pseudo-Dionysius, by a purely spiritual apprehension.[86] Groot advises the person meditating to imagine "all things as though in the present time and as though present to us, as though we saw his [Christ's] deed and heard him speaking."[87] On the other hand, he warns against thinking that such imaginings are an actual presence of Christ or a personal revelation.[88] Groot recommends that works of art may be useful in this process. Similarly, he advises that typological thinking may be used to fill in the details lacking in the gospel accounts—as was indeed common in art. He acknowledges that such details may not be factual; but this does not matter, as long as they serve the purpose of bringing about a loving affective encounter with Christ.[89] The producing of *compassio* was the goal; art—whether physical pictures or the individual's imagination—was the means.

The Cross and the Spirituality of Suffering

During this period, devotion to the cross sometimes took on a somewhat dark character. Particularly in the period of penitential fervor that followed the Black Death, the sufferings of Christ as the punishment for our sins—and the need for us to share in it—sometimes became the nearly exclusive focus of spirituality. Saints like Catherine of Sienna might insist—in accord with Scholastic theology—that what delighted God was not the suffering itself, but the love it showed;[90] nevertheless, the presumption was that love must suffer. In the words of Ewert Cousins, we find in the lives of many of the period's saints a "morbid fascination with pain and humiliation." "From a psychological point of view," he continues, "this late medieval devotion to the passion of Christ is one of the most problematic phenomena in the history of Christian spirituality."[91] This is true also theologically: "Emphasis on the passion led to forgetfulness of the resurrection. Focus on the suffering humanity of Christ overshadowed the Trinity and its outpouring of divine love in creation."[92]

In his excellent book on the crucifixion, Gerard Sloyan wonders how such a one-sided view of the cross could have arisen in Christianity. "How did the crucifixion get separated from the resurrection?"[93] He suggests two reasons. First,

> Augustine's version of the total Bible narrative was the one available
> to most people through vernacular homilies. It featured a primordial
> sin and its debilitating effects more successfully, it would appear,

than the corrective supplied by the proclamation of the evangelists and Paul and his school that humanity was victorious in the risen Christ.[94]

Second, suffering, death, and sin were ever-present realities for medieval people, and Sloyan speculates that the image of a God who suffered along with them was more psychologically appealing than the theological notion of glory.

> A Savior in blissful repose with his Father and the Spirit, surrounded by the angels and saints, consoled them as a distant dream they aspired to, not as a present reality. But a crucified Savior who could not forget the agonies he had endured for love of them was a different matter.[95]

A number of other factors may have played into the two mentioned by Sloyan. Anselm's "satisfaction theory," which eventually dominated both academic and popular Western theology, despite the nuances added to it by the scholastics, built on the Augustinian emphasis on the fall and its consequences. With the overshadowing of the great scholastic theological synthesis in the academic world by nominalism and above all by a more popular religious understanding, the dramatic and emotive schema of "satisfaction" seems to have become more powerful. As we have seen, it made the death of Christ the exclusive cause of what was seen as central to redemption: the forgiveness of sin. The medieval theology of the eucharist, which stressed the presence of both Christ's body and his sacrifice, reinforced and was reinforced by this emphasis.[96]

At the same time, we must recall that for much of medieval spirituality and art of the cross, the resurrection is not entirely forgotten, even if it remains in the background (frequently literally so, in the form of the golden or decorated panels on which the crucifixion is portrayed, and which remind us that this drama is God's act of salvation).

Conclusion and Anticipation

Our consideration of late Gothic art, the theology of nominalism, and the piety of the *devotio moderna* has brought us to the threshold of the Renaissance and the Reformation. Luther was a Canon of St. Augustine, and inherited the theology of the nominalists. The art of the quatrocento, in which the imitation of nature became the criterion for visual representation, is directly descended from Giotto. The essential forms of graphic representation of the passion were established in a way that would endure until the twentieth century. In music, on the other hand, the Reformation would produce entirely new genres of passion meditation: in particular the musical passion, of which the greatest

exemplars remain the passions of J. S. Bach. The Enlightenment and the challenges it posed to biblical faith; the encounter of theology with modern philosophy; the introduction of technology into art with the photograph and then the moving picture, and the subsequent rethinking of the meaning of art itself—all of these had profound consequences for the Christian imagining of Christ's passion and its relation to salvation. These demand the opening not merely of a new chapter but of a new volume.

Appendix: Web Sites for Viewing Artworks

Unfortunately, Web sites are notoriously unstable, and there is no assurance that those listed in the notes will still be online at the time of publication. But excellent examples of images of the crucifixion will be found at the following sites.

> The Ecole Initiative: http://cedar.evansville.edu/~ecoleweb. Look under "Images."
> The Web Gallery of Art: http://gallery.euroweb.hu. Search under "Crucifixion."
> The New Testament Gateway: www.ntgateway.com/. Look under "Art and Images."
> Artcyclopedia: www.artcyclopdeia.com. Search under "Crucifixion."

Many libraries have access to the online collection "Artstor," which has a wealth of materials relevant to this theme as well as to the history of art in general. In addition, there is an excellent published collection of full-color images entitled *Crucifixion* (London: Phaidon Press, 2000). Unfortunately, only a few of the pictures are from the period covered in this book.

Notes

ABBREVIATIONS

DS Henricus Denzinger and Adolfus Schönmetzer, S.J., *Enchiridion Sym-
 bolorum, Definitionum et Declarationum de Rebus Fidei et Morum*,
 33rd ed. (Freiburg: Herder, 1965.
PG Jacques-Paul Migne, *Patrologia Graeca* (Paris: J.P. Migne, 1857–1866).
ML Migne, *Patrologia Latina*. Full text database. (Chadwick-Healey, 1996).

PREFACE

1. See my *Theological Aesthetics: God in Imagination, Beauty, and Art*
(New York: Oxford University Press, 1999), and *Theology and the Arts* (New
York: Paulist Press, 2000).

CHAPTER 1

1. Patrick O'Brian, *Post Captain* (New York: Norton, 1972), 470.

2. See Antonio Damasio, *Descartes' Error: Emotion, Reason, and the Hu-
man Brain* (New York: Avon Books, 1994).

3. For a fuller discussion of the relationship of different forms of art to
theological texts, see my *Theological Aesthetics* (New York: Oxford University
Press, 1999), 141–82; *Theology and the Arts* (New York: Paulist Press, 2000),
chap. 3.

4. William Durand, *Rationale of the Divine Offices* (*Rationale Divinum
Officiorum*), bk. 1 (Venetiis, 1581).

5. Iris Murdoch, *The Fire and the Sun: Why Plato Banished the Artists*
(Oxford: Clarendon Press, 1977), 70.

6. On the tensions between sacred art and music on the one hand and

verbal/conceptual theology on the other, see my *Theological Aesthetics*, 39–72; *Theology and the Arts*, chap. 1.

7. See my *Theological Aesthetics*, especially chaps. 3 and 5, and *Theology and the Arts*, chap. 5.

8. See Tertullian, *Apologeticus adversus Gentes pro Christianis*, chap. 16, PL 1, 365–366: Christians are *crucis religiosi* (those who are devoted to the cross).

9. The meaning of this Qur'anic passage is open to another interpretation: namely, that it is not certain that Jesus was crucified. But most commentators take this as a negation of the event.

10. Quoted in Edward Rice, *Eastern Definitions* (Garden City, N.Y.: Doubleday, 1978), s.v. "Jesus Christ (and Christianity) in oriental religions," 203–205, at 204.

11. Rice, *Eastern Definitions*, s.v. "Jesus Christ (and Christianity) in Oriental Religions."

12. In Shi'ite Islam, on the other hand, a "passion" motif is present because of the martyrdom of the first imams.

13. The same theme recurs elsewhere in Paul's theology: in Christ crucified God's power and wisdom are revealed to those who are called, although the cross is a stumbling block and a folly to those headed for perdition (1 Cor. 1:18, 23). The cross of Christ seems absurd in the light of the world's "wisdom"; but it is where God's mysterious wisdom is revealed (1 Cor. 1:17, 2:6–7). Those whose way of life is oriented to "the things of this world" show themselves to be enemies of the cross of Christ (Phil. 2:18–19). The celebrated hymn of Philippians proclaims (in terms relevant to our concern for revelation) that Christ did not appear in divine form, but in the form of a slave, obedient even to death on the cross (Phil. 2:6–8). Paul explicitly counsels the Philippians that this attitude should be a model for their own (Phil. 2:5).

14. Hans Urs von Balthasar, *The Glory of the Lord: A Theological Aesthetics*, vol. 1, translated by E. Leiva-Merikakis, edited by Joseph Fessio and John Riches (San Francisco: Ignatius Press, 1982), 124.

15. "[D]as Schöne ist nichts / als des Schrecklichen Anfang"; cf. Balthasar, *Glory of the Lord*, 65.

16. It seems clear that this passage, which is still used liturgically as the first reading of the Good Friday service, already colored the passion narratives in the gospels, and was considered in the early church to be a prophetic foretelling. It is possible that the figure of the Isaian "servant" also formed part of Jesus' own self-consciousness as he approached the end of his life. For discussion of these points, see Raymond Brown, S.S., *The Death of the Messiah* (New York: Doubleday, 1994), especially 234, 1457–1459, 1471–73, 1480, 1485–1487.

17. Karl Barth, *Church Dogmatics*, Part 2, vol.1: *The Doctrine of God*, edited by G. W. Bromiley and T. F. Torrance, translated by T.H.L. Parker, W. B. Johnson, Harold Knight, and J.L.M. Hare (Edinburgh: T and T Clark, 1957), 665.

18. Balthasar, *Glory of the Lord*, 117.

19. Balthasar, *Glory of the Lord*, 656.

20. For Aquinas's typically nuanced and many-sided approach to the "beauty" of Christ, see *In Psalmos Davidis Expositio, Super Psalmo 44*, n. 2.

21. *In Psalmum XLIV Ennaratio, Sermo*, ML 36. This passage is quoted by Aquinas in his treatment of Christ's beauty. Augustine speaks similarly in numerous places: *In Ps. 43*: "As a human, he had no beauty or comeliness; but he was beautiful

in form in that he is beyond all the sons of man." In Ps. 118: "And he, the Bridegroom, is beautiful not in the flesh, but in his virtue." In Ps. 127: "He is the Bridegroom than whom none is more beautiful; but he appeared as ugly in the hands of his persecutors, as Isaiah said before: 'And we saw him, and he had no beauty or comeliness.' Then is our Bridegroom ugly? Of course not. How then could he be loved by the virgins who have sought no earthly spouse? So, to his persecutors he appeared ugly. And unless they had thought him ugly, they would not have leapt on him, flogged him, crowned him with thorns, insulted him with spitting. But because he appeared to them ugly, they did all these things: for they did not have eyes to see Christ as beautiful" (ML 36).

22. *S. Aurelii Augustini Hipponensis Episcopi In Epistolam Joannis Ad Parthos Tractatus Decem. Tractatus 9*, ML 35.

23. Hieronymus Stridonensis: *S. Eusebii Hieronymi Stridonensis Presbyteri Commentariorum In Isaiam Prophetam Libri Duodeviginti*, (C) bk. 14, ML 24).

24. Alain Besançon, *L'image interdite: Une histoire intellectuelle de l'iconoclasme* (Paris: Gallimard, 1994), 410.

25. See my *Theology and the Arts*, chap. 2: "Paradigms in Theology and in Art."

26. Thomas S. Kuhn, *The Structure of Scientific Revolutions* (Chicago: University of Chicago Press, 1962).On the theological use of the idea, see especially the collection of symposium papers edited by Hans Küng and David Tracy, *Paradigm Change in Theology* (New York: Crossroad, 1984). Küng's programatic essay, "Paradigm Change in Theology: A Proposal for Discussion," also appears, with few changes, in his *Theology for the Third Millennium*, translated by Peter Heinegg (New York: Doubleday, 1988).

27. Kuhn, *Structure of Scientific Revolutions*, 175; quoted in Küng, *Theology for the Third Millenium*, 132.

28. C. S. Lewis, "On the Reading of Old Books," in *God in the Dock: Essays on Theology and Ethics*, edited by Walter Hooper (Grand Rapids, Mich.: Eerdmans, 1970), 202.

29. Küng, "Paradigm Changes," 27.

30. Küng, "Paradigm Changes," 28.

31. A helpful diagram is given in Küng, *Theology for the Third Millenium*, 128.

32. "Daß die Welt *meine* Welt ist, das zeigt sich darin, daß die Grenzen *der* Sprache (der Sprache, die allein ich verstehe) die Grenzen *meiner* Welt bedeuten." Ludwig Wittgenstein, *Tractatus logico-philosophicus* (Suhrkamp Verlag, 1966 [Vienna, 1918]), 5.62. Emphasis original. The later Wittgenstein, of course, radically changed his ideas. Yet the fact that we play "language games" whose rules are received from outside does not preclude the validity of Wittgenstein's earlier insight that my (i.e, each person's) *understanding* of "our" language has an element of irreducible individuality that makes it "my" language. As the virtual "solipsism" of the early Wittgenstein needs the corrective of his later linguistic philosophy, so the sometimes apparently linguistically deterministic statements of adherents of a "cultural-linguistic" approach stand in need of the corrective of a phenomenology of language and philosophy of the person.

33. Georg Wilhelm Friedrich Hegel, *Vorlesungen über die Ästhetic* (Stuttgart: Philip Reclam June, 1971), 1, 166.

34. José Ortega y Gasset, "Sobre el Punto de Vista en las Artes," in *La*

Deshumanización del Arte y Otros Ensayos Estéticos (Madrid: Revista de Occidente, 1967).

35. Paul Tillich, "Art and Ultimate Reality," in Tillich, *On Art and Architecture,* edited by John Dillenberger, translated by Robert P. Scharlemann (New York: Crossroad, 1987), 143.

36. Hans Belting, *Likeness and Presence: A History of the Image before the Era of Art,* translated by Edmund Jephcott (Chicago: University of Chicago Press, 1994).

37. David Tracy, *The Analogical Imagination: Christian Theology and the Culture of Pluralism* (New York: Crossroad, 1981), 163.

38. Frank Burch Brown, *Religious Aesthetics: A Theological Study of Making and Meaning* (Princeton, N.J.: Princeton University Press, 1989), 168.

CHAPTER 2

1. An online image and brief bibliography may be found at the Web site of Rodney J. Decker, available online at: http://faculty.bbc.edu/rdecker/alex_graffito.htm.

2. Tertullian testifies that the pagans of his day "foolishly imagine that our God has the head of an ass" ("Somniastis caput asininum esse Deum nostrum"; *Apologeticus* 16, ML 1, 364). Marcus Minucius Felix, in the beginning of the third century, also mentions it (*Octavius* 9, ML 3, 260).

3. For what follows, see especially Martin Hengel, *Crucifixion in the Ancient World and the Folly of the Message of the Cross* (Philadelphia: Fortress Press, 1977). For a more concise summary, see Raymond E. Brown, S.S., *The Death of the Messiah* (New York: Doubleday, 1994), 2:945–952; Gerard S. Sloyan, *The Crucifixion of Jesus: History, Myth, Faith* (Minneapolis: Fortress Press, 1995), 14–18.

4. Flavius Josephus, *The Jewish War,* 2.241, 2.75, 5.451.

5. Josephus, *Jewish War,* 1.79, 113.

6. The cross of Christ was thought by some of the Fathers to have been in the shape of a capital *T* (the Greek letter tau)—the so-called *crux commissa* or *crux patibulata*. Others, including Irenaeus and Augustine, presumed a "Latin" cross (*crux immissa* or *capitata*). Henri Leclercq, "Croix et crucifix," in *Dictionnaire d'Archéologie Chrétienne et de Liturgie,* edited by Fernand Cabrol and Henri Leclercq (Paris: Librairie Letouzey et Ané, 1948), vol. 3, pt. 2, 3045–3131, at 3062.

7. This is at least a possible interpretation of the horizontal line immediately under the feet of the crucified figure, which seems to be standing upright, even though the *stipes* or upright beam seems to extend lower. The higher line across the buttocks would seem to represent a sort of undergarment, rather than the *sedile*. Obviously, however, it is difficult to draw firm conclusions from such a roughly incised sketch. The first literary allusion to a footrest on the cross is found in the sixth century, in Gregory of Tours's *De Gloria Martyrum*. It is first found in Christian art in the seventh century. See Paul Thoby, *Le Crucifix des Origines au Concile de Trente: Étude Iconographique* (Nantes: Bellanger, 1959), 3.

8. See Brown, *The Death of the Messiah,* 2:953. Brown points out that the normal Roman practice was to crucify criminals naked. But this would not necessarily preclude the presence of a kind of loincloth (*subligacculum*), which was worn both by gladiators and by those condemned to death in the arena (Thoby, *Crucifix des Origines,* 6). Moreover, the fact that the evangelists report that the Romans clothed Jesus for

the journey to Golgotha might indicate a concession to "the Jewish horror of nudity" (Brown cites Jubilees 3:30–31; 7:20. Further evidence is found in the Talmud. Rabbi Judah [born about 135 A.D.], describing the practice of execution by stoning, specifies that a male was covered in front, and a female both front and rear [Sanhedrin, fols. 42, 49, 52]). In light of Jewish customs and feelings, the Romans might also have permitted the use of some kind of covering on the cross.

9. Sloyan, *Crucifixion of Jesus*, 99.

10. Brown, *Death of the Messiah*, 1:11.

11. The Byzantine Liturgy of St. John Chrysostom emphasizes even more dramatically that the passion was willed by God and voluntarily accepted by Jesus. Immediately before the words of institution, it thanks the Father for Jesus, "who, having come and having fulfilled the whole divine plan concerning us, on the night when He was betrayed, or rather, when He surrendered Himself for the life of the world. . . ."

12. Sloyan, *Crucifixion of Jesus*, 100.

13. Edward Schillebeeckx, *Christ: The Experience of Jesus as Lord*, translated by John Bowden (New York: Seabury Press, 1980), 468–514.

14. Sloyan, *Crucifixion of Jesus*, 98–100; for the Old Testament background to Pauline soteriology, 45–71.

15. As Sloyan notes, however, the New Testament's use of the idea of sacrifice contains no trace of the primitive notion of the placating of an angry God through blood. On the other hand, the apocalyptic view of averting the divine wrath is present. *Crucifixion of Jesus*, 71. We may probably surmise that even when shorn of the mythic understanding of appeasement, the notion of sacrifice retained a powerful hold on the imagination as the expression of human submission to the divine lordship over all things. This would especially be true when that lordship has implicitly been challenged by sin.

16. *Crucifixion of Jesus*, 101–102. According to Sloyan, this explains Paul's relatively greater emphasis on Jesus' rising than on his death; while the latter is never mentioned without being coupled with the resurrection, the resurrection is frequently mentioned alone. *Crucifixion of Jesus*, 102.

17. See for example the works cited by Thomas F. Mathews, *The Clash of Gods: A Reinterpretation of Early Christian Art* (Princeton, N.J.: Princeton University Press, 1993), 38–39, 109–111, and passim.

18. See for example Irenaeus, *Contra Haereses*, bk. 5:19, 1.

19. Sloyan, *Crucifixion of Jesus*, 108–112. Sloyan attributes the lasting presence of the theme of the "deceit of the devil" in the West to the influence of Rufinus of Aquileia.

20. *Crucifixion of Jesus*, 110.

21. Cyril of Jerusalem, *Catechesis*, lecture 13, PG 33, 771.

22. Cyril of Jerusalem, *Catechesis*, lecture 13, PG 33, 771.

23. The notion of a mystical union with Christ is also presupposed by Aquinas's theory of the "grace of the Head" communicated to Christ's total "body," and by theories of the sharing in his "merit" (Gregory the Great, Anselm, Aquinas, the Council of Trent).

24. John of Damascus, *The Orthodox Faith*, 3, 20, PG 94, 1081.

25. John of Damascus, *The Orthodox Faith*, 3, 20, PG 94, 1081.

26. Augustine, *The Trinity*, translated by Edmund Hill, O.P., in *The Works of*

Saint Augustine: A Translation for the Twenty-First Century, edited by John E. Rotelle, O.S.A. (Brooklyn: New City Press, 1991), bk. 4, chap. 3, p. 163.

27. Augustine, *The Trinity*, bk. 4, chap. 3, p. 163.

28. Augustine, *The Trinity*, bk. 4, chap. 3, p. 163.

29. This incensation is first mentioned as a regular part of the liturgy in the thirteenth century; but its occasional use is earlier, and the practice can be traced back as far as the end of the fifth century. The prayer is taken from the Canon of the Resurrection, tone 4, ode 1, 2nd troparion, and its occurrence at the incensation of the altar stems from the symbolic association of the latter with the tomb of Christ (a theme that will be discussed later). See Hugh Wybrew, *The Orthodox Liturgy: The Development of the Eucharistic Liturgy in the Byzantine Rite* (Crestwood, N.Y.: St. Vladimir's Seminary Press, 1996), 154.

30. It is significant that in the Byzantine tradition the gospel for Easter, the culmination of the drama of salvation, is the prologue of John's gospel: "In the beginning was the Word . . . and the Word became flesh." The death of Jesus is a miracle; the resurrection is the necessary consequence of the hypostatic union of Jesus' mortal nature with the immortal Word.

31. "Hymns at the Praises," Hymn 4. *Strasti—Matins for Holy and Great Friday* (Pittsburgh: Byzantine Seminary Press, 1976), 33.

32. "Hymns of the Vespers," Hymns 1–5. *Solemn Vespers for Holy and Great Friday* (Pittsburgh: Byzantine Seminary Press, 1976), 9–16.

33. "Hymns at the Praises," Hymns 1–4. *Solemn Vespers for Holy and Great Friday* (Pittsburgh: Byzantine Seminary Press, 1976), 30–35.

34. The Good Friday service includes a procession with and veneration of an altar cloth depicting the dead Christ; it remains on the altar through the entire Easter season. This is in line with the symbolic conception of the altar itself as the "tomb" of Christ, from which his resurrected body emerges. The whole is conceived as both a remembrance and a symbolic re-presentation of the heavenly liturgy.

35. For some Byzantine theologians, following the teaching of Origen, the death of Jesus itself has the nature of a "miracle," since, possessing an integral and sinless human nature, Christ was not subject to death, and indeed could not die except by the power of his own divine will: "his soul . . . was separated from his body, not by virtue of any human necessity, but by the miraculous power which was given Him for that purpose."As Jesus says in John's gospel: "I have the power to lay [my life] down, and I have the power to take it up again." (Origen, *Against Celsus*, bk. 3, chap. 32). The resurrection, on the other hand, is seen as inevitable and "natural": Christ literally could not be held by death (see Acts 2:24).

36. Cyril of Jerusalem, *Catechesis* 13, PG 33, 779.

37. Andrew of Crete, *Sermon* 9, PG 97, 1002.

38. A recording of both hymns is found on the CD *Music for Holy Week in Porportional Rhythm*, Schola Antiqua, L'Oiseau-Lyre, catalogue number 417 324–2. The earliest music we now have for the hymn is early "Gregorian" (actually Carolingian music from the ninth or tenth century). This recording attempts to reconstruct the proportional rhythm used in the chant of the Carolingian period (i.e., before the numes or notes were given equal value, which occurred by the eleventh century).

39. Alex Stock, *Poetische Dogmatik: Christologie: Figuren* (Paderborn: Ferdinand Schöningh, 2001), 348. Stock points out that this desire for material means of salva-

tion was an element not only in the cult of relics but also in the depiction of the cross. The Frankish liturgist Alamar of Metz (755–ca. 852) wrote that the power of the true cross resides also in images made in its likeness. Alamar of Metz, *Liber Officialis*, I, 14, 10, quoted in Stock, *Poetische Dogmatik*, loc. cit.

40. Note that three of the original verses (2, 7, and 8) were left out of the hymn in its later liturgical use; while the last two verses in the current liturgical version are not by Fortunatus but by a later poet of the tenth century. The hymn in its entirety was revised under Urban VIII for the sake of prosody. The version given here is the original.

41. Venantius Fortunatus, "In honorem sanctae crucis, hymnus," ML 88, col. 0088. A final doxology, not given here, was later added to the hymn.

42. Stock, *Poetische Dogmatik*, 349.

43. Psalm 95 (96), verse 10, reads: "Say among the gentiles, that the Lord reigns." Fortunatus quotes an early Christian version that add the words "from the wood." See Stock, *Poetische Dogmatik*, 354.

44. See 1 Peter 4:13: "If you participate in the sufferings of Christ, rejoice; so that when his glory is revealed, you may also rejoice exultantly."

45. Tertullian, *On the Soldier's Crown*, chap. 3, PL 2.80; Origen, *Selections on Ezechiel*, chap. 9, PG 13.801; cited in Sloyan, *Crucifixion of Jesus*, 125.

46. Cyril of Jerusalem, *Catechesis*, lecture 14, PG 33, 77.

47. "For Paul 'the cross' is a shorthand expression for the salvation accomplished by the death of Christ, an 'ideogram for the event of salvation' (H. Schlier)." J. Blinzler, "Kreuz 3. Bibeltheologisch," in *Lexikon für Theologie und Kirche* 6:607. Cited in Stock, *Poetische Dogmatik*, 318, 459 n. 8.

48. In fact, as we have seen, the criminal did not carry the upright beam, but only the crossbeam, the *patibulum*. But although the word *stauros* originally designated specifically the upright beam, it was later used to mean the cross as a whole, so this discrepancy does not detract from the symbolism of the evangelists.

49. Stock, *Poetische Dogmatik*, 316. For the history of the symbol of the tav/cross, see the literature cited by Stock, *Poetische Dogmatik*, 459 n. 1.

50. *Poetische Dogmatik*, 316. See also 318 for a discussion of Paul's reference to the cross as "stigma" and "stigmata" (Gal. 6:17), a marking like that given to slaves to designate their owner.

51. Stock sees in this practice a parallel to the Jewish idea of bearing the Torah on one's body, as commanded in Deut. 11:18: "So now inscribe these my words in your heart and soul, and bind them as a sign on your hands and bear them on your forehead as a mark." *Poetische Dogmatik*, 319.

52. In the catacomb frescos of the Jonah cycle, the last scene generally shows Jonah lying nude under a vine. The unbiblical nudity of the figure would be inexplicable unless we recognized it as a symbol of the resurrected body in paradise. Sloyan, *Crucifixion of Jesus*, 125.

53. See for example Cyril of Jerusalem's brief reference to such typologies: "On each occasion life comes by means of wood. For in the time of Noah the preservation of life was by an ark of wood. In the time of Moses the sea, on beholding the emblematical rod, was abashed at him who smote it; is then Moses' rod mighty, and is the Cross of the Savior powerless? But I pass by the greater part of the types, to keep within measure. The wood in Moses' case sweetened the water; and from the side of

Jesus the water flowed upon the wood." Cyril of Jerusalem, *Catechesis*, lecture 13, PG 33, 771.

54. There are several gems, dated from the second and third century and apparently used as seals, that depict a naked Christ with extended arms, and, in one case, with a crossbar behind his shoulders. See Leclercq, "Croix et crucifix," 3050. A brief description, derived from Leclercq, is given in Sloyan, *Crucifixion of Jesus*, 124; Brown, *Death of the Messiah*, 2:947.

55. See Mathews, *Clash of Gods*, for an interpretation of the various early depictions of Christ in the context of comparison with the pagan gods.

56. Eusebius, *Vita Constantini*, 1, 1, chap. 28 and following, PG 20, 943 and following.

57. Eusebius, *Vita Constantini*, 1, 1, chap. 31. For portrayals of the *labarum* on Roman coins, see the images at: http://myron.sjsu.edu/romeweb/rcoins/sub1/art6 .htm, and at the Web site of Edmond Holroyd, available online at: www.ccu.edu/ biblicalcoins/Bag58.htm. By the end of the fourth century, the orginal chi-rho monogram (the Greek letter *P* superimposed on the letter *X*) began to give way to the so-called monogramatic cross (an upright cross replacing the *X*, surmounted by the letter *P*). In the beginning of the fifth century, the rho was in turn dropped, leaving a simple Latin or Greek cross. H. Quilliet, "Croix (Adoration de la)," in *Dictionnaire de Théologie Catholique*, edited by A. Vacant and E. Magnenot (Paris: Letouzey et Ané, 1911), 3:2349. (Both Latin and Greek crosses are forms of the *crux immissa*—see note 13. The Greek form is more stylized, consisting of two intersecting bars of equal length.)

58. *Eusebii Pamphili de Vita Beatissimi Imperatoris Constantini*, 3, ML 8, 50.

59. *Eusebii Pamphili de Vita Beatissimi Imperatoris Constantini*, 3, 49, 62.

60. *Eusebii Pamphili de Vita Beatissimi Imperatoris Constantini*, 1, 40, 27.

61. See Leclercq, "Croix et crucifix," 3062–3063, for a catalogue of such coins and their symbols.

62. Leclercq, "Croix et crucifix," 3067. The first great example of such a bejeweled cross is seen in the apse mosaic in the basilica of S. Pudentiana in Rome (ca. 400), which was apparently modeled on the golden and gem-encrusted cross erected on Golgotha by the emperor Theodosius II. A similar cross, with an image of the head of Christ in the center, is placed in a cosmic context in the apse of S. Apollinare in Classe in Ravenna. The image reflects an image similar to that expressed by Justin: the world-soul is now in the form of the cross (*Apol.*, 1, 60, 1) (cf. Plato's *Timmaeus*, 36, where the world-soul is manifested as a heavenly letter chi). See Sister Charles Murray, "Kreuz 3: Alte Kirche," in *Theologische Realenzyklopädie*, edited by Gerhard Müller (Berlin: de Gruyter, 1990), 19:726. See also Stock, *Poetische Dogmatik*, 323, for a more extended discussion of the cross as symbol of the cosmic mystery in the early Fathers.

63. See the figure at at the Web site of Turismo Ravenna, available online at: www.mosaicoravenna.it/mosaici_ravenna/index.htm, or at the Web site of Leo Curran, available online at: www.wings.buffalo.edu/AandL/Maecenas/italy_except_rome _and_sicily/ravenna/ac861138.htm. Note the similar treatment of the cross in other Ravenna mosaics, notably the "Good Shepherd" in the mausoleum of Galla Placida.

64. See the garlanded monogram, with symbols of paradise, from an early

Christian sarcophagus; available online at: www.christusrex.org/www1/vaticano/PC1
-Christiano.html.

65. See the sites mentioned in note 60 for photographs.

66. Leclercq speculates that the introduction of the crucifixion scene by oriental
artists (possibly Syrian monks) was a response to Docetist and Monophysite tenden-
cies in the church: the purpose is to show the true humanity of Christ and the reality
of the passion he endured for us. Leclercq, "Croix et crucifix," 3080. This theory co-
heres with the fact that the Coptic and Jacobite traditions use the cross without a cor-
pus. See Murray, "Kreuz 3," 731.

67. The ivory is a fragment of a box or a reliquary. The scenes portrayed,
therefore, once formed part of a cycle. See the representations at the Web site of the
Museum of Antiquities, available online at: www.usask.ca/antiquities/Collection/
Condemnation_Christ.html, and at: www.usask.ca/antiquities/Collection/Death_Judas
.html.

68. The depiction of the crucifixion is part of a series of thirty-eight panels
showing the "concordance" of events of salvation history in the Old and New Testa-
ments. Unfortunately, ten of the panels are missing. The dating of the doors of Santa
Sabina has long been a subject of dispute. Dates as early as the fifth and as late as the
thirteenth century have been given. Contemporary scholarship favors a date not too
far removed from the building of the basilica (424). The Web site www.uic.edu/
classes/ah/ah441/slides.html contains pictures of this and a number of other impor-
tant examples of early Christian and medieval art. The crucifixion panel is at: www
.uic.edu/classes/ah/ah441/jpgs/Ah441–097.jpg, and the doors on which it is found
are at: www.uic.edu/classes/ah/ah441/jpgs/Ah441–096.jpg.

69. The panel above the crucifixion scene portrays a cross encircled by a crown,
held by the apostles Peter and Paul over the head of a female figure that probably
represents the church.

70. See Leclercq, "Croix et crucifix," 3071.

71. See Leclercq, "Croix et crucifix," 3079, for an incident of the late sixth cen-
tury recounted by Gregory of Tours (De Gloria Martyrum, 23, ML 71, 725), in which
Christ appears in a vision to protest his being exhibited unclothed on the cross, even
though the figure in question was clothed with a loincloth (quasi praecinctum linteo).

72. At the Web site of the University of Illinois, available online at: www.uic
.edu/classes/ah/jpgs/Ah441–098.jpg. See also the very similar image in the Chludoff
Psalter, painted some three hundred years later.

73. Thomas Mathews argues convincingly that past scholarship has over-
estimated the influence of imperial images and symbols on early Christian depictions
of Christ. (See for example Clash of Gods, 101, where he discusses the lack of impor-
tant imperial insignia in the portrayal of Christ's dress.) Nevertheless, as we have
seen in the hymns of Venantius Fortunatus, there are clear references to Christ as
"King" and to the imperial purple. Such references need imply neither an identifica-
tion of Christ with the emperor nor a derivation of the ideas from any specific impe-
rial images: they are clearly applied to Christ in a transferred sense, signifying his
divine "kingship."

74. Belting, Likeness, 158.

75. The iconoclasts claimed, on the contrary, that it was the iconodule position

that betrayed an unorthodox Christology. As the iconoclast Council of 754 explains, in portraying the Christ a picture must either attempt to portray the divinity itself (which, as everyone admitted, is impossible, and which is further forbidden by the First Commandment), or omit his divinity (which would be heresy), or somehow "mix" it with his material and visible humanity (which is also heresy). It is notable that the objections of the iconoclasts presume a particular function for religious art: namely, to display or manifest what is known in faith. Its purpose is not merely to portray what could be seen physically. This view is in accord with the general function of religious art as symbolic, and indeed with the characteristics of pre-Renaissance art in general. (By the same token, it is striking that the iconoclasts do not make the objection to portrayals of Christ that might occur most naturally to us: namely, that we do not know what he looked like.) On the other hand, the iconodules do not reply by taking refuge in a conception of art as naturalistic representation—for this would make the icon nonreligious, by omitting what faith knows of its object. A physically realistic portrayal of Jesus' human form as it might have appeared (had such a possibility even occurred to artists of the period) would give no grounds for the acts of reverence that were at the heart of the controversy. So John Damascene, for example, holds that while it is impossible to portray God *in se*, God as united hypostatically to the flesh can be portrayed. His reasoning is not that Jesus' humanity can, of course, be portrayed as human, but on the contrary, that the *divinity* can be portrayed through the image of this humanity. This flesh, the Damascene says, is divine; this body is the body of God, since Christ's humanity is united "by hypostasis" with God. Such language about "God's body," even if technically orthodox in the light of the doctrines of "hypostatic union" and the "communication of idioms," could easily sound implicitly Monophysite. At the very least, it may make one wonder whether there may have been plausible reasons behind the iconoclast fear about a "mixing" of natures in the theology and the practices of the iconodules. It is in any case significant that both sides in the dispute presumed that the function of a religious image is to present the *reality* of its object, not merely its appearance. In this they are at odds with the idea of art that has prevailed in the West since the Renaissance.

76. Belting, *Likeness*, 142

77. Aloys Grillmeier, S.J., *Der Logos am Kreuz: Zur christologischen Symbolik der älteren Kreuzigungsdarsstellung* (Munich: Max Hueber Verlag, 1956). See also L. H. Grondijs, *Autour de l'iconographie Byzantine du crucifé mort sur la croix* (Leiden: Brill, n.d.), 65.

78. Grondijs notes that Hugh of St. Victor was first to publicly blame Ambrose for teaching the complete dissociation of the man-God. Grondijs, *Autour de l'iconographie Byzantine*, 61.

79. Grillmeyer, loc. cit. We should remember, however, that as Grillmeyer himself points out, these representations are theological, not "realistic": they refer not merely to a moment in time, but to the victorious Christ event as a whole, including the present mediation of Christ in heaven (Hebrews) and the future apocalyptic coming.

80. See for example Augustine, *Ad Marcellinum de Civitate Dei Contra Paganos*, bk. 17, 18, ML 41, 552; *De Natura Boni contra Manichaeos*, 20, ML 42, 551.

81. John distinguishes between two senses of the Greek word *phthoras* (corruption). If it is taken to mean the ability to die, i.e., for the soul to be separated from the

body, or to suffer bodily need (hunger, thirst, etc.) and pain, then before the resurrection Christ's body was corruptible, like ours. Here the Damascene explicitly rejects the Aphtharodocetism of Julian. But if we take the word in a second sense, where "corruption" means the dissolution of the body into its elements, then Christ's body even in death was incorruptible. This follows from what John had just affirmed previously: the body of Christ was never a separate substance on its own, existing apart from the person of the Logos, even when the human soul temporarily departed in death. See John of Damascus, *Expositio Fidei Orthodoxae*, bk. 3, 28–29, PG 94, 1099.

82. Belting, *Likeness*, 271. See George of Nicomedia, *Oratio 8*, PG 100, 1457–1490.

83. Grondijs, *Autour de l'iconographie Byzantine*, xiii. For the relation of Niketas's doctrine to the mystical teachings of Symeon the New Theologian on the inhabitation of the Trinity, see 31–33.

84. Nicetas Stethatos, *Cujusdam Nicetae presbyteri et monachi monasterii studii libellus contra Latinos*, PL 143, 974–983. Quoted in Grondijs, *Autour de l'iconographie Byzantine*, 51. At the pouring of the *zeon*, the celebrant said the words "The warmth of the Holy Spirit." However, the word "warmth" could also be interpreted as "fervor." In light of this interpretation, Clement XI in 1716 approved the retention of the rite for Uniates: the warm water was a sign of the "warmth of faith." The meaning of the rite was assimilated to that of the adding of water to wine (before the consecration) in the Roman liturgy, as expressed in the prayer that accompanies it: "May this mixture of water and wine make us share in the divinity of Christ, who humbled himself to partake of our humanity." The *zeon* was now taken to signify the union of all the faithful with Christ. When the rite of the zeon was restored to the contemporary Ruthenian liturgy, the ritual specified that the pouring of the warm water should be accompanied with the prayer "Blessed is the fervor of your saints." We have here, then, an interesting case of the polyvalence of symbols.

85. Niketas's theology was cited by the patriarch Michael Cerularius in defense of Byzantine liturgical practice in contrast to that of the Western church. The pope's representative to Emperor Constantine IX, Cardinal Humbert of Sylva Candida, argued against Niketas's hypothesis that if Christ's body was vivified by the Spirit, then he did not really die; and if he did not die, there was no resurrection and no redemption. Moreover, he argues, the flow of warm water would be an additional miracle: why did the evangelist not explicitly mention it? Finally, the water that flowed from Christ's side was a symbol of baptism, not of the eucharist (while in the East the eucharist was referred to as "drinking from the side of Christ"). See Humbertus Silvae Candidae: *Humbertus Silvae Candidae Adversus Graecorum Calumnias*, PL 143, 973. On the dispute between Humbert and Niketas see also chapter 4, note 50. Interestingly, Niketas seems to have been convinced by Humbert's argument, although his thesis perdured for some centuries in the Byzantine church. According to Grondijs, the circulation of blood in Christ's dead body was commonly taught in Orthodox theology until the sixth century.

86. Grondijs, *Autour de l'iconographie Byzantine*, xiv.

87. Hans Belting, *Das Bild und sein Publikum im Mittelalter: Form und Funktion früher Bildtafeln der Passion* (Berlin: Gebr. Mann Verlag, 1981), 160. Belting cautions us to remember, however, that there was at the time no single Byzantine liturgy, and that the mode of celebration in the great church of the capital (Hagia Sofia) was dif-

ferent from that of the monasteries, which tended to absorb Palestinian influences sooner. And even the monastic liturgies were not uniform. *Das Bild,* 155.

88. Belting, *Das Bild,* 148–50.

89. Belting considers it unlikely that the shroud was the source of the Man of Sorrows icon, although it may have encouraged its use.

90. Belting, *Das Bild,* 154.

91. Belting, *Likeness,* 263.

92. Belting, *Likeness,* 271, 261.

93. Quoted in Belting, *Likeness,* 529.

94. Belting, *Likeness,* 269.

95. Quoted in Belting, *Likeness,* app. 28, "A Literary Description of an Icon," 528–529. See *Byzantina* 14 (1987).

96. Belting, *Likeness,* 271.

97. Belting, *Das Bild,* 157.

98. Belting, *Das Bild,* 178.

99. Belting, *Das Bild,* 143, 146, 176.

CHAPTER 3

1. The cross is now in the Museo Arqueológico Nacional in Madrid. For the background of the cross and the treasure of the basilica, see Angela Franco Mata, "El tesoro de San Isidoro y la monarquia Leonesa," *Boletín del Museo Arqueológico Nacional* (Madrid) 9 (1991), 35–68. The cross was probably made between 1050 and 1060. Mata points out similarities to the cross of Gunhild, now in National Museum in Copenhagen, and to the Cloisters cross of the Metropolitan Museum in New York.

2. Mata, "El tesoro de San Isidoro," 36–37. Mata specifies the northern French manuscripts of St. Bertin, now in the Pierpont Morgan collection, and the Bible of St. Vaas, Arras, as inspirations of the reverse of the cross (59).

3. Mata, "El tesoro de San Isidoro," 57–58.

4. Mata speaks of "subconscious remembrances" of the Mozarabic style in the crafting of the nude figures on the front of the cross. Specifically, they recall the Beatus manuscripts. "El tesoro de San Isidoro," 59. The biting animal figures are reminiscent of many manuscripts, and are frequently found reproduced in sculpture, for example on the capitals of Romanesque columns of the period.

5. Hilarius Pictavensis, *Commentarius in Evangelium Matthaei*, ML 9, 1075. "illuminans enim mortis tenebras, et infernorum obscura collustrans, in sanctorum ad praesens conspicatorum resurrectione mortis ipsius spolia detrahebat."

6. *Post Sanctus: Oratio.* "Vere Sanctus et verus Jesus filius Dei: qui ascendit patibulum crucis: ut omnes vires suas mors in sua perderet morte. Descendit ad inferos: ut hominem veteri errore deceptum: et regno peccati servientem victor abstraheret: serasque portarum potenti manu confringeret: et secuturis sue resurrectionis gloriam demonstraret. Ipse Dominus ac redemptor eternus." *Liturgia Mozarabica secundum regulam sancti Isidori*, ML 85, 474.

7. "[A]d inferos tota potestate descendit, ut accensa exstingueret, clausa protinus aperiret, protoplasti facinus aboleret. Hinc est quod arietem suae crucis portat aggressurus infernum, ut conterat et confringat ipsas tartari januas aere munitas, et ferro." Petrus Chrysologus, *Sermo* 123, ML 52, 538.

8. Mata, "El tesoro de San Isidoro," 62.

9. Mata, "El tesoro de San Isidoro," 59.

10. Maria Giovanna Muzj, *Transfiguration: Introduction to the Contemplation of Icons*, translated by Kenneth D. Whitehead (Boston: St. Paul Books and Media, 1991), 134.

11. At the Web site of the University of Illinois, available online at: www.uic.edu/classes/ah/jpgs/Ah441–101.jpg. Perhaps the supreme example of the genre is the famous twelfth–century "Tree of Life" mosaic in the apse of the Roman church of San Clemente. Here Jesus is portrayed dead, after the Byzantine style; but the cross flowers into a mystical vine that produces abundant life. Its spirals surround symbolic figures of the soul and of paradise, as well as portrayals of everyday life. Encircled by the vine are both religious and secular figures, including the lord of a manor, his family, and farm laborers.

12. For excellent and detailed study of the cross, see Elizabeth C. Parker and Charles T. Little, *The Cloisters Cross: Its Art and Meaning* (New York: Metropolitan Museum of Art, 1994).

13. See the excellent translation by G. Ronald Murphy, S.J., *The Heliand: The Saxon Gospel* (New York: Oxford University Press, 1992), as well as the commentary by the same author, *The Saxon Savior: The Germanic Transformation of the Gospel in the Ninth-Century Heliand* (New York: Oxford University Press, 1989).

14. *Heliand*, song (*fitt*) 57, 157.

15. Murphy, *Saxon Savior*, 95.

16. *Heliand*, song (*fitt*) 58, 160.

17. *Heliand*, 182 n. 286.

18. *Heliand*, 187 n. 297.

19. Murphy, *Saxon Savior*, 110.

20. *Heliand*, 198 n. 319.

21. Claudius Taurinensis, *Apologeticum atque Rescriptum Claudii episcopi adversus Theutmirum Abbatem*, PL 105, 459–466, 461–462.

22. Claudius Taurinensis, *Apologeticum atque Rescriptum Claudii episcopi adversus Theutmirum Abbatem*, 462, 463.

23. Michel Roquebert, *Histoire des Cathares* (Paris: Editions Perrin, 2002), 55. The rejection of the cross by the Cathars was a logical consequence of their theology, which both denied the reality of the incarnation and the redemptive value of Christ's death.

24. Dungalus, *Dungali Responsa contra perversas Claudii Taurinensis episcopi sententias*, PL 105, 465–468.

25. For examples of the variety in northern European art of the Carolingian and Ottonian periods, see Evelyn Sandberg-Vavalà, *La Croce Dipinta Italiana e l'Iconografia della Passione* (Rome: Multigrafica Editrice, 1985), 41–44.

26. "And when they were come to the place they stripped him of his garments and girt him with a linen cloth and put a crown of thorns on his head." *The Gospel of Nicodemus, or Acts of Pilate*, in *The Apocryphal New Testament*, chap. 10, translated by Montague Rhodes James (Oxford: Clarendon Press, 1975), 104. In earlier figures, as we have seen, Jesus was either totally nude (on the small carved gems) or clothed in a simple undergarment (*subligaculum*). In the Roman world, the *subligaculum* could be a long cloth passing under the crotch and hung over a belt in front and rear, as ap-

pears to be the case in the representations on the Santa Sabina doors and the British Museum reliefs; or it could be a rectangular cloth with ties at the corners, forming a kind of underpants; or it could be an apron or kilt. In the latter cases, it was also called a *perizoma*. How frequently any of these were used is unknown. The passage in the *Gospel of Nicodemus* seems to presume that Jesus would have been completely nude if it were not for his executioners' girding him with a cloth. The long, skirt-like *perizoma* seen in many images of the crucifixion appears to be the invention of artists; it first appears only in the eighth century. See Paul Thoby, *Le Crucifix des Origines au Concile de Trente: Étude Iconographique* (Nantes: Bellanger, 1959), 6.

27. Parker and Little, *Cloisters Cross*, 146. There is some dispute concerning whether the appearance of such images may be attributed to Byzantine influence. Images of the dead Christ had already appeared in the Eastern church by the mid–ninth century, as we have noted in the preceding chapter. Their influence seems clear in certain Italian works—for example, a celebrated enamel plaque of the crucifixion from San Marco in Venice, dated circa 976. Some scholars point to the continued contacts between the courts of the two great "Roman" empires, Germanic and Byzantine, as a source of artistic models, including the new type of crucifix. Others see here an original development of Western art. John Beckwith, for example, writes regarding the crucifix of Gero: "in this great new sculptural concept there is no trace of Byzantine influence; once again evidence is to hand of a wholly western tradition coming to fruition without the direct participation of Constantinopolitan art. This development is important since scholars in the past have been too ready to see in the medieval art of the West the constant presence of Byzantium. This was not the case. During the course of the eleventh century at Regensburg, at Cologne, possibly at Echternach, at Milan, there may be in certain undertakings an intervention of Byzantine artistic influence, but a large proportion of the work done under the Ottonian emperors evolved out of the western artists' own perception of late antique and Carolingian models." *Early Medieval Art* (New York: Praeger, 1973), 152. However, Beckwith's remarks concern primarily the style of the crucifix; even admitting originality in this regard, it remains possible that the theological idea and the affective attitudes behind the representation of the dead Christ may have owed something to prior Byzantine models.

28. Parker and Little, *Cloisters Cross*, loc. cit.

29. For a later example of the type, see the late twelfth–century Spanish crucifix from Palencia (Castille-León) in the Cloisters collection of the Metropolitan Museum of Art. At the Web site of the Metropolitan Museum of Art, available online at: www .metmuseum.org/collections/department.asp?dep=7&fullo&item=35%2E36ab.

30. Some scholars (notably Dom René-Jean Hesbert and L. H. Grondijs) have attempted to explain the portrayal of the flow of blood from an apparently living Christ on the basis of a variant in the manuscripts of the New Testament. Some of these (Codex Sinaiticus; Vaticanus 4c; Ephraem rescriptus 5c; Regius; as well as some other majuscules and minuscules and the Ethiopian translation) interpolate John 19:34 ("and another taking a spear pierced his side and there flowed out blood and water") between Matthew 27:49 ("let us see if Elijah will come to save him") and Matthew 27: 50 ("But Jesus, crying out again in a loud voice, yielded up his spirit"). This interpolation was diffused from Western Ireland, and was widespread in Europe, both West and East, from the fourth to the twelfth centuries. (It was only finally rejected in the

West in Pope Clement V's declaration in 1307 that it was John's gospel that contained the correct chronology. See DS 901.) This reading clearly gives the impression that Christ died after the spear thrust, or because of it. Hence it would be logical to portray the flowing blood from the still-living body of Christ. However, as Grillmeyer points out, variants in the manuscript tradition do not suffice to explain the iconographic tradition. The famous Rabula manuscript, for example, with its paradigmatic image of the crucified with eyes open and blood flowing, does not have the interpolated text. On the other hand, it is clear that the illustration in this manuscript is intended to be read both narratively and symbolically: it does not portray a single moment in time, but includes in a single image elements that are chronologically successive (the spear thrust and the offering of vinegar, for example), no matter what reading one takes; and it portrays Jesus (dressed in the colobium, with a halo, etc.) in a theological, not "realistic" manner. It is the last point that is decisive: the attempt to explain the images on the basis of manuscript variants, attractive and partially illuminating as it is, ignores the genre of the religious art of this period. See Aloys Grillmeier, S.J., *Der Logos am Kreuz: Zur christologischen Symbolik der älteren Kreuzigungsdarstellung* (Munich: Max Hueber, 1956), 9–10.

31. See for example Hilary of Poitiers, "In Librum Psalmorum Prologus," in *Tractatus Super Psalmos*, PL 9, col. 0236.

32. Hilary of Poitiers specifies more completely: "Those who bore false testimony [against Christ], who bargained for his betrayal, who called for his blood to be upon themselves and their children, who cried out 'Crucify him!' and said "Descend from the cross, if you are the son of God, who sealed the tomb, who bought the silence of the guards concerning the resurrection and the spreading of the rumor of the stealing of the body, have lost the labor of so much impiety. It was God whom they nailed to the cross: it was the eternal one whose tomb they sealed. Their impiety is laughed at." *Tractatus Super Psalmos*, PL 9, col. 0268.

33. In *LXXV Davidis Psalmos Commentarius Rufino Aquileiensi Olim Attributus*, PL 21, col. 0650.

34. See also Ps. 59:8: "Thou, O Lord, shalt laugh at them; thou shalt have all the heathen in derision." It is notable that God "laughs" only four times in the Old Testament—Ps. 2:4; Ps. 37:13; Ps. 59:8; Prov. 1:26 (where Wisdom laughs)—and in each case, the laughter indicates derision. The word used in the LXX (*gelaō*) can mean either joyous laughter or scorn. But in the LXX it always expresses superiority to the one laughed at.

35. The *Breviarium in Psalmos*, of uncertain authorship (attributed to both Augustine of Hippo and Jerome) describes "derision" (*subsanatio*) as expressed by "a wrinkled brow and contracted nose." It continues: "Far be it from us to attribute to God a corporeal attitude that we would judge reprehensible even in a dignified man" (PL 26, col. 0826). Augustine in particular was insistent that such phrases were not to be taken literally of God; hence he attributes the laughter and derision to the members of the church, in whom God dwells as in "the heavens." See *Sancti Aurelii Augustini Hipponensis Episcopi Enarrationes in Psalmos*, PL 36, col. 0070. On this anthropomorphism see also Peter Lombard: *Commentarius in Psalmos Davidicos, Psalmus Secundus*, PL 191, col. 0070.

36. *Breviarium in Psalmos*, loc. cit.

37. See for example the ivory of Adalberon, bishop of Metz (929–962).

38. Gregorius I Magnus, *Hymni: In Passione Domini*, ML 78, 851.

39. Gregorius I Magnus, *Moralia*, ML 76, 32.

40. Gregorius I Magnus, *Expositio in Job*, pt. 6, bk. 33, 7, ML 76, 680.

41. Anselm of Canterbury, *Cur Deus Homo*, in *Obras Completas de San Anselmo*, edited by P. Schmidt, O.S.B. (Madrid: Biblioteca de Autores Cristianos, 1952), vol. 1, "Praefatio," 742; English translation in *St. Anselm: Basic Writings*, translated by S. N. Deane, 2nd ed. (La Salle, Ill.: Open Court, 1962), preface, 192.

42. Bruno of Segni, *Tractatus Primus: De Incarnatione Domini et Ejus Sepultura*, ML 165, 1079.

43. Bruno of Segni, *Tractatus Primu*, 1082.

44. *Cur Deus Homo*, 1.7, 201–203. See also "Meditation on Human Redemption" (Meditatio 11, *De redemptione humana*, PL 158, 762–769): "Good Lord, living Redeemer, mighty Saviour, why did you conceal such power under such humility? Was it that you might deceive the devil, who by deceiving man had thrown him out of paradise? But truth deceives no one. . . . Or was it so that the devil might deceive himself? No, even as truth deceives no one, so it does not mean anyone to deceive himself. . . . Or has the devil in justice anything against either God or man, that God had to act in this secret way for man, rather than openly by strength? Was it so that by unjustly killing a just man the devil should justly lose the power he had over the unjust? But clearly God owes nothing to the devil except punishment, nor does man owe him anything except to reverse the defeat which in some way he allowed himself to suffer by sinning. . . . But that also man owed to God alone, for he had not sinned against the devil but against God, and man was not of the devil, but both man and devil were of God." Anselm of Canterbury, *The Prayers and Meditations of St. Anselm with the Proslogion*, translated and with an introduction by Sister Benedicta Ward, S.L.G. (London: Penguin Books, 1973), 231.

45. *Cur Deus Homo*, 1.11, 215–217; 1.20, 239–242; 2.6, 7, 258–260. A brief recapitulation of the argument is given in 2.17, 293. Note that in his "Letter on the Incarnation of the Word," Anselm uses the soteriological images of combat against the devil and (priestly) intercession for humanity. "Epistola de Incarnatione Verbi," 10, in *Obras Completas*, 1, 716–720.

46. "Quid est ergo reverti ad Dominum, quam in Christum credendo, per eum qui est via veniendi ad patrem, Deo reconciliatum posse salvari? Quomodo autem reverti ad Deum possunt, qui ei per quem est agnitio et reversio ad Deum, voluntatem Dei praedicanti credere noluerunt? Aut quomodo Deum satisfactione aliqua placare potuerint, qui eum qui est satisfactio et placatio pro nobis apud Patrem, sacrilega impugnatione persequi maluerunt?" *Celsi in Altercationem Jasonis et Papisci Praefatio de Judaica Incredulitate, ad Vigilium Episcopum*, ML 6, col. 51.

47. "Tertia causa [utilitatis nobis incarnationis] est ut de prima praevaricatione satisfaceret . . . oportuit ut ad satisfactionem illius superbiae aliquis homo humiliaretur ab altitudine divinitatis usque ad humilitatem hominis." *Homilia 10. In Natale Domini*, ML 155, 1700. Rivière counts Radulfus as the first to use the word and the idea "satisfaction" in connection with the atonement—although he also shows that nearly equivalent ideas were already present in the Fathers. Jean Rivièrem *The Doctrine of the Atonement* (London: Herder, 1909), 2:18.

48. Michael S. Driscoll, *Alcuin et la Pénitence à l'époque Carolingienne*, doctoral thesis, Université de Paris–Sorbonne, 1986, 195.

49. See for example Cyprian, *Epistola ad Pompeium*, ML 3, 1133; Hilary of Poitiers, *Tractatus Super Psalmos*, ML 9, 413; Augustine, *Collatio cum Maximinio*, ML 42, 739.

50. See for example Augustine, *De Trinitate*, 4, 3, 19, where he speaks of the "honors of sacrifice" and of Christ's "true sacrifice."

51. On the comparison of the Germanic and Roman ideas of honor, see James C. Russell, *The Germanization of Early Medieval Christianity: A Sociohistorical Approach to Religious Transformation* (New York: Oxford University Press, 1994), 119–120. Anselm indeed associates honor with power and majesty; but whether these characteristics are more associated with a Germanic than a Roman idea is difficult to judge.

52. Timothy Gorringe, *God's Just Vengeance: Crime, Violence and the Rhetoric of Salvation* (Cambridge: Cambridge University Press, 1996), 89.

53. Tacitus, *Germania*, 21.

54. In the England of Anselm's time, the "worth" of a peasant was four pounds; that of a thane, twenty-five. Gorringe, *God's Just Vengeance*.

55. Gislebertus Crispinus, *Disputatio Judaei cum Christiano de fide Christiana*, PL 159, 1005, at 1021. It is interesting that Gilbert's explanation of the necessity of the incarnation does not appeal to Anselm's satisfaction theory, but on the contrary repeats the Patristic idea of a legal defeat of the devil's legitimate claims on humanity because of his unjust pursuit of Christ's death. "Because he [the devil] presumptuously brought about an unjust death to him over whom he had no rights at all [because of his sinlessness], he justly lost that rule [jurisdictionem] that the sin of the first human had given him over both the first man and his posterity." Gislebertus Crispinus, *Disputatio*, PL 159, 1023.

56. *Cur Deus Homo*, 1.3, 197; 2.2, 255.

57. *Cur Deus Homo*, 2.11, 269–273; 2.14, 275–277. See also 2.19, 297–298, where Anselm speaks of the reward of Christ's death, bestowed by him on humanity.

58. *Cur Deus Homo*, 10, ML 138, 374; English translation 214.

59. "Meditation on Human Redemption," translated by Sister Benedicta Ward, 232.

60. "Meditation on Human Redemption," translated by Sister Benedicta Ward, 234.

61. "Causa tuae mortis fuit iniquitas mea, vulnera tua fecerunt crimina mea." Anselm of Canterbury (attrib.), *Sermo de Passione Domini*, PL 158, 675. Although the authorship of the sermon is disputed, it is in the spirit of Anselm's theology.

62. Cf. Thomas of Celano's hymn, the famous *Dies Irae*, in which the sinner facing judgment prays to Christ: "Recordare Jesu pie, quod sum causa tuae viae"— "Remember, loving Jesus, that I am the cause of your way [on earth: i.e., Jesus' life and death]."

63. *Cur Deus Homo*, 2.20.

64. Sister Benedicta Ward, S.L.G., introduction to *The Prayers and Meditations of St. Anselm with the Proslogion*, translated by Ward, 39.

65. For a concise overview, see Ewert Cousins, "The Humanity and the Passion of Christ," in *Christian Spirituality: High Middle Ages and Reformation*, edited by Jill Raitt in collaboration with Bernard McGinn and John Meyendorff, vol. 17 of *World Spirituality: An Encyclopedic History of the Religious Quest* (New York: Crossroad, 1987), 375–391.

66. Cousins, "Humanity and Passion of Christ," 377.

67. Ward, introduction to *The Prayers and Meditations of St. Anselm*, 18.

68. Anselm of Canterbury (attrib.), "Sermo de Passione Domini," PL 158, 675–676.

69. Anselm of Canterbury (attrib.), "Sermo de Passione Domini," PL 158, 676. Cf. "Meditation": "How can I rejoice in my salvation, which would not be without your sorrows? . . . But if I grieve because of their cruelty, how can I also rejoice in the benefits that I only possess because of your sufferings? . . . I must condemn their cruelty, imitate your death and sufferings, and share them with you, giving thanks for the goodness of your love. And thus may I safely rejoice in the good that thereby comes to me" (235).

70. Anselm of Canterbury, *Orationes*, Oratio 27, PL 158, 917.

71. Anselm of Canterbury, *Orationes*, Oratio 27, PL 158, 918.

72. Anselm of Canterbury, *Orationes*, Oratio 28, PL 158, 920.

73. Rupert of Deutz, *Commentarium in Matthaeum*, bk. 12, PL 168, 1601.

74. Rupert of Deutz, *Commentarium in Matthaeum*, bk. 12, PL 168, 940.

75. Cousins, "Humanity and Passion of Christ," 377.

76. Ulrich Köpf, "Kreuz IV: Mittelalter," in *Theologische Realenzyklopädie*, edited by Gerhard Müller (Berlin: de Gruyter, 1990), 19:735.

77. Anselm of Canterbury, *Orationes*, Oratio 43, PL 939.

78. See for example Anselm of Canterbury, *Orationes*, Oratio 15, PL 158. This prayer, once ascribed to Anselm, is now thought to have been written by Ralph, abbot of Battle (died 1124). In light of the "deceit of the devil" motif, we may assume that Ralph either did not know or rejected Anselm's work on soteriology.

79. "Et fuit haec mirabilis obviatio, justitia hominem ad inferna trahente, illa hominem ad amissa reducere cupiente. Sed invalescente justitia, in poenas homo datus est, miserias, et aerumnas, et mortem gustans in seculo, corruptionem in sepulchro, et post omnia, tenebras in inferno. Cumque magna jam parte satisfactum esset justitiae, punita jamdiu culpa, post annorum multa curricula, pulsanti semper et instanti, plurimum misericordiae tandem locus datus est in excelsis." Gilbertus Foliot, *Expositio in Cantica Canticorum*, PL 202, 1160.

80. "Ex praedictis itaque patet satis, ut arbitror, quia nulli alii personae in Trinitate magis conveniebat ab alia propitiari quam Patri, nulli alii causam hominis apud Patrem expiare magis congruebat quam Filio. Divisit itaque inter se summa illa personarum Trinitas unus Deus negotium salutis humanae, ut unam eamdemque hominis culpam Pater puniret, Filius expiaret, Spiritus sanctus ignosceret. Ad majorem igitur lapsi hominis gloriam ut possit resurgere per justitiam, Pater satisfactionem exigit, Filius exsolvit, Spiritus sanctus se medium interponit." Richardus Santi Victoris, *Liber de Verbo Incarnato*, PL 195, 1005.

81. *Petri Abaelardi commentariorum super S. Pauli epistolam ad Romanos libri quinque*, bk. 2, PL 178.

82. For a comprehesive discussion of Abelard's theory of redemption and grace, see Thomas Williams, "Sin, Grace, and Redemption in Abelard," in *The Cambridge Companion to Abelard*, forthcoming.

83. *Opus Imperfectum In Matthaeum*, homil. 2.

84. *Petri Abaelardi commentariorum super S. Pauli epistolam ad Romanos libri quinque*, bk. 2, PL 178, col. 835.

85. "Duobus modis propter delicta nostra mortuus dicitur [Christus]; tum quia nos deliquimus propter quod ille moreretur, et peccatum commisimus cujus ille poenam sustinuit, tum etiam ut peccata nostra moriendo tolleret, id est poenam peccatorum introducens nos in paradisum pretio sua mortis auferret, et per exhibitionem tanatae gratiae, quia, ut ipse ait, majorem dilectionem nemo habet, animos nostros a voluntate peccandi retraheret, et in summam suam dilectionem intenderet." *Commentariorum*, ML 178, col. 859. Note that here Abelard interprets Christ's taking away our sin as the taking away of the *punishment* for sin. He immediately adds his major theme: the cross shows forth God's grace that turns our hearts to love.

86. However, as Thomas Williams points out, there is still a suspicion of "Pelagianism"—or perhaps better, "semi-Pelagianism"—in Abelard, insofar as he does not sufficiently differentiate grace as a "supernatural habit" from the "natural" capacities of humanity, which are also God's gratuitious gift. The explicitation of this theoretical development is carried out in the great scholastics of the thirteenth century.

87. "Victo mortis principe, Christus imperat. . . . Fraus in hamo fallitur—resurrexit Dominus!" Petrus Abaelardus, *Hymni et Sequentiae per totum anni circulum ad usum Virginum monaseterii Paraclitensis*, 41, ML 178, 1794.

88. "[T]ranstulit in se poenam omnium peccatorum in ipso spiritualiter regenerandorum, sicut Adam peccaverat in poenam omnium de ipso carnaliter generandorum." Gullielmus abbas: *Disputatio adversus Petrum Abaelardum ad Gaufridum Carnotensem et Bernardum*, PL 180, 269–276.

89. "Nec a Deo Patre quasi ad satisfaciendum est requisitus [sacer ille sanguis], cum tamen ei plenissime satisfecerit oblatus." Gullielmus abbas: *Disputatio adversus Petrum Abaelardum ad Gaufridum Carnotensem et Bernardum*, PL 180, 269–276.

90. See Aulén's now classic work *Christus Victor: An Historical Study of the Three Main Types of the Idea of Atonement*, translated by A. G. Herbert (New York: Macmillan, 1969), 95.

91. For example, on the question of why Christ suffered for us, instead of employing another means of salvation: "Mihi scire licet quod ita: cur ita, non licet." Bernardus Claraevallensis, *S. Bernardi Abbatis contra quaedam capitula errorum Abaelardi epistola, seu tractatus ad Innocentem II Pontificem*, 7, PL 182, 1069.

92. "Incomparabilis doctor, qui etiam profunda Dei sibi aperiens, et ea quibus vult lucida et pervia faciens, altissimum sacramentum, et mysterium absconditum a saeculis, sic nobis suo mendacio planum et apertum reddit, ut transire leviter per illud possit quivis, etiam incircumcisus et immundus: quasi Dei sapientia cavere nescierit aut neglexerit quod ipsa prohibuit, sed dederit et ipsa sanctum canibus, et margaritas porcis." Bernardus Claraevallensis, *S. Bernardi Abbatis contra quaedam capitula errorum Abaelardi epistola, seu tractatus ad Innocentem II Pontificem*, 7, PL 182, 1067.

93. See Bernardus Claraevallensis, *S. Bernardi Abbatis contra quaedam capitula errorum Abaelardi epistola, seu tractatus ad Innocentem II Pontificem*, 5, PL 182, 1062.

94. "Ergo docuit iustitiam, et non dedit; ostendit charitatem, sed non infundit." Bernardus Claraevallensis, *S. Bernardi Abbatis contra quaedam capitula errorum Abaelardi epistola, seu tractatus ad Innocentem II Pontificem*, 7, PL 182, 1062.

95. "Redemptionis sacramentum"—using the word "sacramentum" as a synonym for "mysterium". Bernardus Claraevallensis, *S. Bernardi Abbatis contra quaedam capitula errorum Abaelardi epistola, seu tractatus ad Innocentem II Pontificem*, 7, PL 182, 1067.

96. "Satisfactio unius omnibus imputetur, sicut omnium peccata unus ille portavit; nec alter jam inveniatur qui forefecit, alter qui satisfecit: quia caput et corpus unus est Christus. Satisfecit ergo caput pro membris, Christus pro visceribus suis." Bernardus Claraevallensis, *S. Bernardi Abbatis contra quaedam capitula errorum Abaelardi epistola, seu tractatus ad Innocentem II Pontificem*, 6, PL 182, 1065.

97. "Non est justitia, sed misericordia." Bernard of Clairvaux, "De Laude Novae Militiae ad Milites Templi Liber," PL 182, 934.

98. Cousins, "Humanity and Passion of Christ," 379.

99. "Notus est mihi monachus quidam, qui beatum Bernardum abbatem aliquando reperit, in ecclesia solum orantem. Oui dum prostratus esset ante altare, apparebat ibi quidam crux cum suo crucifixo, super pavimentum posita coram illo. Quem isdem vir beatissimus devotissime adorabat ac deosculabatur. Porro ipsa majestas separatis brachiis a cornibus crucis, videbatur eumdem Dei famulum amplecti, atque astringere sibi." Herbert of Clairvaux, *Herberti de Miraculis libri III*, bk. 2, chap. 19, PL 185, 1328. A depiction of the scene from a fourteenth-century Cistercian manuscript is given by Köpf, "Kreuz IV," in table 9, following p. 736.

100. We are concerned here with "the cross" as the symbol of Christ's passion, and with its place in human salvation. But the figure of Bernard of Clairvaux reminds us that there is another sense of "the cross": namely, its use as a symbol for Christianity as a religion and in particular for militant Christianity. We have already seen the use of the cross as an insignium of the Roman army from the time of Constantine. As Alex Stock comments: "The arrival of the cross of victory in the realm of Christian art coincides with the political victory of Christianity and its establishment as the religion of the Empire in the time of Constantine and Theodosius. The 'mythical' victory of Christ over death and the devil is manifest as the religious/political victory of Christianity over pagandom and its gods." *Poetische Dogmatik: Christologie: Figuren* (Paderborn: Ferdinand Schöningh, 2001), 333. The cross as a symbol of a literally militant church took on a new dimension when in 1095 Pope Urban II proclaimed the first "crusade": a military operation in aid of the Byzantine Empire against the Muslim invaders who had taken the Holy Land. Christian knights were encouraged to literally "take the cross," that is, bear it on their bodies as an emblem of their sacred military mission. "The idea of the 'army of Christ,' which has its grounds in St. Paul and which was understood in early Christianity in a purely spiritual sense, and especially in relation to martyrdom and asceticism, is now transferred to soldiers fighting a real war" (335). Bernard of Clairvaux was one of the great proponents of the idea of crusade in the next century, and formulated the constitution of the military Order of Knights Templar ("De laude novae militiae," "Of the praise of the new army"). The use of the cross as a symbol in this military sense extends beyond the Holy Land crusades to the Spanish *reconquista* and even to the conquest of the New World. The pursuit of this theme goes beyond the scope of the present work. I refer the reader to the brief but excellent section entitled "Militia Christi" in Stock, *Poetische Dogmatik*, vol. 4.

101. Bernardus, "Super hymnum: *Jesu nostra redemptio*," PL 182, 1133–1134.

102. Petrus Abaelardus, *Hymnarius Paraclitensis, In Parasceve Domini*. Helen Wadell's elegant English translation of this hymn was set to music by Kenneth Leighton. (Recording: Howells and Leighton, *Sacred Choral Music*, Choir of Queen's College, Oxford, directed by Matthew Owens, ASV CD DCA 851.)

CHAPTER 4

1. Hans Belting, *Likeness and Presence: A History of the Image before the Era of Art*, translated by Edmund Jephcott (Chicago: University of Chicago Press, 1994), 358.

2. The Passion window at Chartres is dated ca. 1150. Here Christ is portrayed dead on the cross; his head is inclined to the side; the body is arched, although not so dramatically as in later examples; Mary and John stand on the two sides lamenting. However, this crucifixion also has individual features that differentiate it from later instances of the genre. For example, there is no *suppedaneum*, and cross itself is green, indicating the "tree of life" theme. The face of Christ, although possibly modeled on Byzantine icons, already has the gentle quality of the *beau Christ* of the French Gothic.

3. See for example Petrus Lombardus, *In Epistolam II ad Corinthios*, 7, PL 192, 51.

4. Petrus Lombardus, *In Epistolam II ad Corinthios*, 7, PL 192, 51).

5. Petrus Lombardus, *Sententiarum Libri Quatuor*, distinction 18, PL 192.

6. Petrus Lombardus, *Sententiarum Libri Quatuor*, distinction 18, PL 192.

7. Petrus Lombardus, *Sententiarum Libri Quatuor*, distinction 19.

8. Petrus Lombardus, *Sententiarum Libri Quatuor*, distinction 19.

9. Petrus Lombardus, *Sententiarum Libri Quatuor*, distinction 20.

10. Petrus Lombardus, *Sententiarum Libri Quatuor*, distinction 20, 798.

11. Petrus Lombardus, *Sententiarum Libri Quatuor*, distinction 20, 798.

12. Petrus Lombardus, *Sententiarum Libri Quatuor*, distinction 20, 798.

13. Petrus Lombardus, *Sententiarum Libri Quatuor*, distinction 18, PL 192.

14. Alexander Alensis, *Summa Theologiae*, pars. 3, q. 1, memb. 1–5; cf. q. 2, memb. 6–7. Quoted in Rivière, *The Doctrine of the Atonement* (London: Herder, 1909) 93.

15. Rivière, *Doctrine*, 94.

16. "Utrum justificatio nostra a peccato sit opus passonis Christi?" in *B. Alberti Magni Opera Omnia*, edited by Stephanus Caesar Augustus Borgnet (Paris: Ludovicum Vivès, 1894), vol. 18, *Commentarii in III Sententiarum, In III Sententiarum*, dist. 19, A, art. 1.

17. *B. Alberti Magni Opera Omnia*, vol. 18, *Commentarii in III Sententiarum, In III Sententiarum*, distinction 19, A, art. 4.

18. *B. Alberti Magni Opera Omnia*, vol. 18, *Commentarii in III Sententiarum, In III Sententiarum*, distinction 19, A, art. 5.

19. *B. Alberti Magni Opera Omnia*, vol. 18, *Commentarii in III Sententiarum, In III Sententiarum*, distinction 20, B, art. 1.

20. *B. Alberti Magni Opera Omnia*, vol. 18, *Commentarii in III Sententiarum, In III Sententiarum*, distinction 20, art. 7.

21. *B. Alberti Magni Opera Omnia*, vol. 18, *Commentarii in III Sententiarum, In III Sententiarum*, distinction 20, art. 3.

22. *B. Alberti Magni Opera Omnia*, vol. 18, *Commentarii in III Sententiarum, In III Sententiarum*, distinction 20, art. 4.

23. The idea that Christ was crucified at the burial-place of Adam goes back as far as Origen. The skull often portrayed at the foot of the cross of Christ refers to this legend, as well as to the meaning of Calvary ("place of the skull"). See Alex Stock,

Poetische Dogmatik: Christologie: Figuren (Paderborn: Ferdinand Schöningh, 2001), 379.

24. Bonaventura, *Opera Omnia*, edited by A. C. Peltier (Paris: Ludovicus Vivès, 1866).

25. Ioannes Duns Scotus, *Oxoniense*, 3, distinctio 9, 13, 15, 16, 19, 20, 34; *Oxoniense*, 4, distinctio 2, 15.

26. Henry Nutcombe Oxenham, *The Catholic Doctrine of the Atonement: An Historical Review*, 4th ed. (London: W. H. Allen, 1895), 213.

27. Hans Belting, *Das Bild und sein Publikum im Mittelalter: Form und Funktion früher Bildtafeln der Passion* (Berlin: Gebr. Mann Verlag, 1981), 21.

28. Belting, *Das Bild*, 21–22.

29. Ewert Cousins, "The Humanity and the Passion of Christ," in *Christian Spirituality: High Middle Ages and Reformation*, edited by Jill Raitt in collaboration with Bernard McGinn and John Meyendorff, vol.17 of *World Spirituality: An Encyclopedic History of the Religious Quest* (New York: Crossroad, 1987), 375–391, at 382.

30. Quoted in Georges Duby, *L'Art et la société: Moyen Age: XXe siècle* (Paris: Gallimard, 2002), 765.

31. For concrete examples of the types of passion meditation in the mendicant orders, see Georg Steer, "Die Passion Christi bei den deutschen Bettelordern im 13. Jahrhundert. David von Augsburg, 'Baumgarten geistlicher Herzen,' Hugo Ripelin von Salzburg, Miester Eckharts 'Reden der Unterweisung,' " in *Die Passion Christi in Literatur und Kunst des Spätmittelalters*, edited by Walter Haug and Burghart Wachinger (Tübingen: Max Niemeyer Verlag, 1993), 52–75.

32. Cousins, "Humanity and Passion of Christ," 384.

33. Duby, *L'Art et la société*, 1280.

34. Duby, *L'Art et la société*, 1280–1281.

35. Duby, *L'Art et la société*, 1281.

36. Bonaventure, *Lignum Vitae (The Tree of Life)*, translated by Ewert Cousins (New York: Paulist Press, 1978).

37. Bonaventure, *Lignum Vitae*, translated by Ewert Cousins, 142.

38. Bonaventure, *Lignum Vitae*, translated by Ewert Cousins, 140.

39. Bonaventure, *Lignum Vitae*, translated by Ewert Cousins, 144–5.

40. Bonaventure, *Lignum Vitae*, translated by Ewert Cousins, 146–7.

41. Bonaventure, *Lignum Vitae*, translated by Ewert Cousins, 155.

42. Bonaventure, *Lignum Vitae*, translated by Ewert Cousins, 156.

43. Bonaventure, *Lignum Vitae*, translated by Ewert Cousins, 159.

44. Bonaventure, *Lignum Vitae*, translated by Ewert Cousins, 154.

45. Bonaventure, *Lignum Vitae*, translated by Ewert Cousins, 154.

46. Bonaventure, *Lignum Vitae*, translated by Ewert Cousins, 156.

47. Ramon Llull, *Libre del gentil e los tres savis*, art. 10.

48. Ramon Llull, *The Book of the Gentile and the Three Wise Men*, bk. 3, art. 6, in *Doctor Illuminatus: A Ramon Llull Reader*, edited and translated by Anthony Bonner (Princeton: Princeton University Press, 1985),132.

49. Quoted in Belting, *Das Bild*, 20. Theodoricus also tells us that the image was accompanied by an inscription, in which Christ says to the viewer: "Look, you who enter, for you are the cause of my sorrow. So much have I suffered for you that life for me has become pain."

50. Mitchell B. Merbeck, *The Thief, the Cross and the Wheel* (Chicago: University of Chicago Press, 1998), 16.

51. See J.-C. Broussolle, "Le Crucifix," in *Le Christ: Encyclopédie populaire des connaissances Christologiques*, edited by G. Bardy and A. Tricot (Paris: Bloud et Gay, 1946), 985.

52. See Belting, *Likeness*, 120.

53. Belting, *Das Bild*, 22.

54. Ulrich Köpf, "Kreuz IV: Mittelalter," in *Theologische Realenzyklopädie*, edited by Gerhard Müller (Berlin: de Gruyter, 1990), 19:752.

55. See for example a drawing in the Utrecht Psalter (ca. 830), as an illustration of the verse from Ps. 114 (115), "I shall take the chalice of salvation and call on the Lord's name." See also the representation in the Drogo Sacramentary from about the same period. Stock, *Poetische Dogmatik*, 366, 389.

56. See Amalarius Fortunatus Trevirensis, *Eglogae Amalarii Abbatis in Ordinem Romanum*, PL 78, 1371–1380. This interpretation probably came to the Carolingian court as a result of its contacts with Byzantium, where a similar tendency to allegorical interpretation of the liturgy became dominant. Already in the fifth century, Theodore of Mopsuestia interpreted the entire liturgy as a reenactment of the passion, with the altar as the "tomb" of Christ. Elements of symbolic interpretation of the liturgy are found in Maximus the Confessor (580–662). But it was the liturgical commentary of Germanos of Constantinople (died 733) that promoted an understanding of each action performed by the priest as representing a specific event of Christ's life. From this time on, the faithful were taught to see the divine liturgy as a concrete dramatization of the death, burial, and resurrection of Jesus—a drama performed by the clergy, with the laity as onlookers.

57. Hans Belting asserts that prior to the crusades, Westerners had been "offended" by the Eastern portrayal of Christ alive-in-death on the cross. However, he seems to base his assertion primarily on a statement by Humbert of Silva Candida (one of Leo IX's representatives to Constantinople at the time of the schism of Michael Cerularius in the mid–eleventh century) to the effect that the Byzantines portray a mere mortal on the cross: "When he proclaimed the schism of the church in Constantinople in 1054, the papal legate criticized the Greeks for presenting the image of a mortal man on the cross, thereby depicting Jesus as dead" (Belting, *Likeness*, 1). But Humbert's statement is ambiguous. The Latin text reads: "hominis morituri imaginem affigitis crucifixae imagini Christi, ita ut quidam Antichristus in cruce Christi sedeat ostendens se adorandum tanquam sit Deus" (Humbertus Silvae Candidae: *Humbertus Silvae Candidae Adversus Graecorum Calumnias*, PL 143, 973). Literally translated: "you [namely the Greeks] affix the image of a man who is to die to the crucified image of Christ, so that a kind of Antichrist is seated on the cross, showing himself to be adored as though he were God." What does Humbertus mean by "[homo] moriturus"? Literally, *moriturus* means "one who is about to die"; but it could also mean "one who will some day die," i.e., a [merely] mortal man [as opposed to the incarnate but essentially immortal Word of God?]. This is how Belting takes it. He thinks therefore that Humbertus is complaining that the Greeks portray Christ as a mortal man on the cross, rather than as the victorious and immortal Logos. But Humbert says that the Greeks affix the image of a mortal *to* the image of the crucified. Perhaps this is simply Humbert's Latin: Humbert is also careless in saying the

"crucified image of Christ," rather than "the image of the crucified Christ." Certainly the sentence is susceptible to Belting's interpretation. But are there other possible interpretations? Belting's reading would imply that Humbert was scandalized by the image of the dead or dying Christ. But this would mean he was ignorant of the Western images of the same kind, which had existed in northern Europe for at least two centuries. Is this likely—especially given that Humbert was a native of Burgundy? (Although he is called Humbertus of Silva Candida, from his bishopric outside Rome, he came to Italy from Burgundy with Leo IX. His original name was Humbertus of Moyen-Moutier.) Moreover, in his more extensive treatment of the *zeon*, the warm water added to the consecrated wine to symbolize the warm water flowing from Christ's side, Humbert criticizes the Byzantine conception of the crucifixion (as stated by Niketos Stathetis) for exactly the opposite reason: the belief that the body of Christ was warm because vivified by the Spirit even after his death amounts to a denial of the reality of his death, and is thus heretical. (The Orthodox Armenians had rejected the *zeon* rite for this reason, and apparently Niketos himself was convinced by Humbert's argument: he converted). It is of course possible that Humbert was inconsistent: that he wished to insist on the real death of Christ as a dogma, but objected to an image that showed it. But the case seems open to question.

58. Compare, for example, the *Christus patiens* in the Passion window at Chartres (ca. 1150) with the living triumphal Christ in the nearly contemporary window at Poitiers Cathedral (ca. 1165–1170).

59. Köpf, "Kreuz IV," 755. As we have seen, however, there was already a tradition of images of the dead Christ in northern Europe. During the Gothic period we find images, especially in sculpture, that seem more influenced by this tradition than by the Byzantine forms that so strongly influenced Italian painted crucifixes. A more detailed comparison of sculpted and painted representations would no doubt reveal significant points of difference in the chronology, as well as the style of representations of Christ's death.

60. Num. 21:8–9; cf. John 3:14 and the conflated text Ps. 22:6. See Gerard S. Sloyan, *The Crucifixion of Jesus: History, Myth, Faith* (Minneapolis: Fortress Press, 1995), 183.

61. Köpf, "Kreuz IV," 755.

62. See for example the ivory thirteenth-century French corpus in the Cloisters collection of the Metropolitan Museum of Art.

63. Panovsky divided religious pictures into two types. *Historia* is narrative; it teaches, has detail, and is alive. *Imago*, on the other hand, mediates presence; it is timeless. But, as Belting points out, the relationship between the form and function of images is more complex than Panovsky saw; and the function itself is complex. It is true that *historia* narrates; but it also leads to devotion. And the devotional *imago* is necessarily linked to the narrative, at least in memory; the context is implicitly present. Already with Gregory the Great we can see a recognition of a combination of ends in art; and the thirteenth–century Johannes Balbus (John of Genoa) speaks of a "threefold reason" for pictures in churches: (1) to instruct; (2) to commemorate, and keep what is portrayed before the eyes of the viewer; and (3) to arouse the affect of devotion. Belting, *Das Bild*, 70, 72, 76–77, 91.

64. Belting, *Das Bild*, 42.

65. Stock, *Poetische Dogmatik*, 367.

66. Now found in the Bibliothèque Municipale, Besançon (Ms. 54, fol. 15 verso). Later examples of the theme portray a more Gothic corpus of the dead or dying Christ.

67. Evelyn Sandberg-Vavalà, *La Croce Dipinta Italiana e l'Iconografia della Passione* (Rome: Multigrafica Editrice, 1985), 8.

68. F. P. Pickering, "The Gothic Image of Christ: The Sources of Medieval Representations of the Crucifixion," in *Essays on Medieval German Literature and Iconography* (Cambridge: Cambridge University Press, 1980), 6.

69. Pickering, "Gothic Image of Christ," 6.

70. Pickering, "Gothic Image of Christ," 5.

71. Pickering, "Gothic Image of Christ," 12.

72. Pickering, "Gothic Image of Christ," 13.

73. This interpretation is found already in Walafrid Strabo's gloss on Genesis: "Christ also was inebriated, when he suffered; stripped [*nudatus*] when he was crucified." PL 113, col. 112A.

74. *Bible Moralisée: Codex Vindobonensis 2554* (Vienna, Österreichische Nationalbibliotek), facsimile ed. with commentary and translation of biblical texts by Gerald B. Guest (London: Harvey Miller, 1995), pl. 57 and p. 143. The interpretation of the Elisha passage as refering to the crucifixion also appears in Walafrid Strabo's gloss on the passage, which in turn depends on Isidore of Seville. A connection is made between the insult used by the children, "Go up, baldhead" (in the Latin of the Vulgate, *ascende calve*) and Christ's "going up" onto the cross on Calvary, the place of the skull. See PL 113, 849.

75. The next scene in the *Bible Moralisée* continues the typology, likening the eating of Elisha's tormentors by a bear (the original text does not say they were eaten, but mauled) to the destruction of Jerusalem by Vespasian and Titus. We may probably surmise, therefore, that the "cursing" of Jesus' persecutors has been read into the crucifixion scene from the prediction of the destruction of Jerusalem (Matt. 23:37–24:2 and parallels).

76. *Bible Moralisée*, 19. The citations are according to the Vulgate.

77. Hieronymus Stridonensis, *Liber Isaiae*, PL 28, 771, and 24, 18; Augustine, *De Civitate Dei*, 18, 24; Isidore, *Etymologogiarum*, bk. 6, 2, 22. Citations given in Pickering, "Gothic Image," 17 and 204 n. 20.

78. Hieronymus, *Isaiae*, PL 28, 771, and 24, 18.

79. For a list of symbols, see Migne, *Index de allegoriis*, PL 219, cols. 130–143.

80. Marcus Aurelius Cassiodorus, *In Psalterium Expositio*, PL 70, col. 404. Pickering, "Gothic Image," 21.

81. Pickering, "Gothic Image," 22–23.

82. *Dialogus Beatae Mariae et Anselmi de Passione Domini* (*Dialogue of the Blessed Mary and Anselm on the Passion of the Lord*), chap. 10, PL 159, 282.

83. *Dialogus Beatae Mariae et Anselmi de Passione Domini*, chap. 10, PL 159, 282.

84. *Dialogus*, PL 159, chap. 10, PL 159, 282. See also *Meditations on the Life of Christ*, 78 (quoted in Cousins, "Humanity and Passion of Christ," 386), where there are slight differences in detail. The *Meditations* were integrated by Ludolph of Saxony into the *Vita Jesu Christi Redemptoris Nostri*, which in turn influenced the *Spiritual Exercises* of Ignatius of Loyola (Cousins, "Humanity and Passion of Christ," 382).

85. Why then is Mary depicted at the foot of the cross with her head still cov-

ered? In the *Dialogue*, after telling Anselm about girding Jesus with her head-veil (*velamen capitis*), Mary explains that she was also wearing "a certain kind of clothing, which women in that region customarily used, that covers the head and the whole body." Hence we are to understand that Mary hid Jesus' shame with her inner head-covering (the Roman *velum*) but was still modestly covered from head to toe by a large mantle (*palla*). In many representations of the Madonna and child, Mary is shown wearing an inner veil, frequently white, which is covered by a large blue mantle.

86. Ambrose, *De Obitu Valentiniani Consolatio* 39, PL 16, 1371; *De Insitutione Virginis Liber Unus* 49, chap. 7, PL 16, 318. Quoted in Stock, *Poetische Dogmatik*, 371.

87. Belting, *Das Bild*, 150, 176.

88. Belting, *Likeness*, 262.

89. Quoted in Belting, *Likeness*, 529. See *Byzantina* 14 (1987).

90. Belting, *Likeness*, 271.

91. Belting, *Likeness*, 157, 175.

92. Belting, *Das Bild*, 178.

93. *Dialogus Beatae Mariae et Anselmi de Passione Domini* (*Dialogue of the Blessed Mary and Anselm on the Passion of the Lord*), chap. 16, PL 159, col. 0287.

94. Bonaventure, *The Soul's Journey into God*, in *The Soul's Journey into God, The Tree of Life, the Life of St. Francis*, translated by Ewert Cousins (New York: Paulist Press, 1978), 7.2. Quoted by Cousins, "Humanity and Passion of Christ," 389.

95. Cousins, "Humanity and Passion of Christ," 388.

96. Sloyan, *Crucifixion of Jesus*, 135.

97. Bonaventure, *The Life of St. Francis* (*Legenda Major*), chap. 1:5, in Bonaventure, *The Soul's Journey into God*, translated by Ewert Cousins, 189.

98. Cousins, "Humanity and Passion of Christ," 383.

99. Cousins, "Humanity and Passion of Christ," 384–386. Cousins cites Aelred of Rievaulx (1110–1167) and Eckbert of Schönau (1132–1184) as sources of Bonaventure's work. "Humanity and Passion of Christ," 380.

100. Richard Kieckhefer, "Major Currents in Late Medieval Devotion," in Raitt, McGinn, and Meyendorff, *Christian Spirituality*, 86.

101. Kiekhefer, "Major Currents in Late Medieval Devotion," 87.

102. Belting, *Das Bild*, 22.

103. Belting, *Likeness*, 126.

104. Belting, *Das Bild*, 14.

105. *Vitae Patrum*, 4. Quoted in Belting, *Das Bild*, 96 n. 45.

106. Belting, *Das Bild*, 9.

107. Belting, *Likeness*, 10–11.

108. Augustine, *The Trinity*, translated by Edmund Hill, O.P., (Brooklyn: New City Press, 1991), bk. 14, chap. 3, p. 382.

109. Augustine, *The Trinity*, translated by Edmund Hill, bk. 14, chap. 4, p. 383.

110. Belting, *Das Bild*, 22.

111. Belting, *Likeness*, 18.

112. Ramon Llull, *Vita Coetanea*, 3, 4, in *Doctor Illuminatus*, edited and translated by Anthony Bonner, 11–12.

113. The image is one of a number of striking illustrations found in a manuscript (St. Peter perg. 92) produced between 1321 and 1336 in France, and now in

Karlsruhe, at the Badische Landesbibliotek. It contains the *Breviculum*, a collection of Llull's works compiled by his disciple Tomàs le Myésier in about 1311. This illustration, as well as the others, can be viewed online at the Web site of the Library of the University of Barcelona, available online at: www.bib.ub.es/imatges. In the picture the same crucifix appears five times, getting successively larger, representing all the visions in one image. The crucified is presented in the "humanistic" Gothic style that will be discussed later. Although the figure itself is "realistic" (but with a golden halo) the cross is thin and has decorated ends, like a processional cross.

114. Belting, *Das Bild*, 224.

115. Belting, *Das Bild*, 25.

116. Belting, *Das Bild*, 219.

117. Belting, *Das Bild*, 28.

118. Belting, *Das Bild*, 39.

119. Belting, *Das Bild*, 222.

120. Belting, *Das Bild*, 28–32.

121. "Sacramenta significando efficiunt," in *Super Libros Sentiarum Magistri Petri Lombardi*, bk. 4, dinctinction 23 quaestio 1 art. 2 qc. 2s. c. 2.

122. See also *S.T.* 3, quaestio 64, art. 1: "*Est Sacramenti effectus . . . ex merito passionis Christi.*"

123. Belting, *Das Bild*, 263.

124. As Alex Stock points out, the passion narratives in the gospels are themselves already dramas, with different characters and emphases. See Stock, *Poetische Dogmatik*, 382–387, 390–393.

125. Stock, *Poetische Dogmatik*, 242.

126. Stock, *Poetische Dogmatik*, 244–247.

127. Stock, *Poetische Dogmatik*, 234. A Zurich *Ordo* from 1250 polemicizes against the burial of the host, as if it were dead. Stock, *Poetische Dogmatik*, 104.

128. Stock, *Poetische Dogmatik*, 108.

129. Stock, *Poetische Dogmatik*, 235.

130. Stock, *Poetische Dogmatik*, 137.

131. Stock, *Poetische Dogmatik*, 236.

132. The full text may be found in E. J. Dobson and F. L. Harrison, *Medieval English Songs* (New York: Cambridge University Press, 1979), 152.

133. See for example the texts of "Stabat Juxta Christi Crucem" ("[She] stood by the cross of Christ") and the English version "Stood the Moder under Roode," in Dobson and Harrison, *Medieval English Songs*, 146. The former keeps the meter and tune of the Latin sequence "Stabat Mater."

CHAPTER 5

1. As is frequently the case with art of this period, the exact date of the commission is unknown. It seems, however, that the painting—or at least most of it—must have been completed by the year 1306. See Bruce Cole, *Giotto and Florentine Painting 1280–1375* (New York: Harper and Row, 1975), 63–65.

2. *Inferno*, canto 17, 64–78. Although Reginaldo's name is not given, he is identified by his heraldic device of an azure pregnant sow.

3. Sariel Eimerl, *The World of Giotto c. 1267–1337* (New York: Time-Life Books, 1967), 109.

4. Mario Bucci, *Giotto* (London: Thames and Hudson, 1968), 12.

5. The treatment of the hair is one of the elements that distinguishes this crucifixion from the others painted by Giotto before and after. It is beyond our scope here to enter into a discussion of these differences, or of the advance in Giotto's style that can also be discerned in these paintings. But a listing of the entire series may be of interest to the reader, for the sake of comparison. It should be recalled that the method of learning art in the Middle Ages and Renaissance involved a long apprenticeship in which the student's goal was to imitate as exactly as possible the techniques and style of the master. This sometimes included collaboration with the latter. Hence, although the following portrayals of the crucifixion are generally attributed to Giotto, in some cases they may have been partially or wholly painted by his assistants or members of his school. For details on attribution, see Sandrina Bandera Bistoletti, *Giotto: Catalogo completo dei dipinti* (Florence: Cantini Editore, 1989).

(1) Panel crucifix, Santa Maria Novella in Florence (ca. 1300)

(2) Crucifixion fresco, Arena Chapel, Padova (probably between 1302 and 1305)

(3) Panel crucifix, Tempio Malatestiano, Rimini (between 1310 and 1317; sometimes attributed to an unknown follower of Giotto)

(4) Crucifixion fresco, Lower Church, Basilica of St. Francis, Assisi (after 1314; most of this fresco cycle is thought to have been executed by Giotto's school, under his supervision; some scholars see the hand of Giotto himself in this panel; others attribute it to the so-called Parente di Giotto, a member of his studio with close affinities—and possibly family ties?—to the master)

(5) Panel crucifix, Louvre, Paris (second decade of fourteenth century)

(6) Panel crucifix, Museo Civico, Padova (made for the Arena Chapel, ca. 1317? In any case, later than the frescos in the chapel; possibly executed by Giotto's studio)

(7) Panel crucifix, San Felice in Piazza, Florence (date unknown; attribution contested)

(8) Crucifixion panel, Chiesa di Ognisanti, Florence (date unknown; sometimes attributed to the Parente di Giotto)

(9) Crucifixion panel, part of an altarpiece (possibly painted for the Bardi chapel in Santa Croce in Florence), Alte Pinakotek, Munich (1320–1325?)

Two other crucifixion panels are mentioned as either by Giotto or having close affinities with his work. They may be examples of a late style, influenced by Simone Martini, or may be by one of Giotto's followers:

(10) Gabled crucifixion panel, probably originally part of a diptych, Staatliche Museen, Gemäldegalerie, Berlin (date unknown)

(11) Rectangular crucifixion panel, Musées Municipaux, Strasbourg (date unknown)

6. Bruce Cole notes that Giotto has consistently placed the source of light in each panel as though it came from this single source, thus giving both "realism" and unity to the entire series (Cole, *Giotto and Florentine Painting*, 83). However, Cole does

not mention here that there are other sources of light than the window in the entrance wall: the wall on the right side (facing the altar) contains six large windows. Hence while there is a visual plausibility in regarding the entrance window as the consistent source of light in the paintings, the choice of this direction for the lighting is to some extent artificial.

7. This is more apparent in other scenes in the series. See Leonetto Tintori and Millard Meiss, "Observations on the Arena Chapel and Santa Croce," in *Giotto: The Arena Chapel Frescoes,* edited by James Stubblebine (New York: Norton, 1969), 210–211.

8. When we see this painting in a reproduction, our eyes are probably drawn to the area of Christ's waist: the meeting point of the converging lines of perspective indicated by the inclination of the head (and the vertical beam of the cross behind it) from the top and the angle of the *suppedaneum,* reinforced by the arm of Mary Magdalene, from the bottom. That is, our eyes are attracted to a point a little above the middle of the panel. But in the chapel itself, the painting is seen from below and at a distance, and it is the whole body of Christ, seemingly closer to us than the cross, that draws one's eye.

9. Cole, *Giotto and Florentine Painting,* 7.

10. Cole, *Giotto and Florentine Painting,* 6.

11. There is no universal agreement on exactly how much of this painting is by the hand of Giotto himself, and how much by his pupils. But the crucified Christ seems most clearly attributable to Giotto, while the figures standing on the right are frequently ascribed to a specific student, the so-called Maestro della Vele. See Luciano Bellosi, *Giotto* (New York: Riverside, 1981), 59.

12. Bellosi, *Giotto,* 4.

13. So, for example, James Stubblebine, "Giotto and the Arena Chapel Frescoes," in Stubblebine, *Giotto,* 71. But Stubblebine does not speculate as to where Giotto might have seen such sculpture. We know that as an established artist he traveled widely in Italy, to Rome, Milan and the court of Naples, and perhaps as far as Avignon; but virtually nothing is known of the years of his apprenticeship or of early influences. We can only surmise that Giotto was somehow in contact with the wide diffusion of French Gothic style.

14. On the limitations of Giotto's use of perspective, see for example Roberto Salvini, *Giotto: Cappella degli Scrovegni* (Florence: Edizioni Arnaud, 1970), 6: "la spazialità di Giotto è tutt'altro che prospettica anche quando si vale di rudimentali mezzi di prospettiva lineare: essa non è invece che un aspetto, direi quasi l'altra faccia o il rovescio, della sua visione plastica, con l'assoluta exclusione d'ogni intento di verificabilità oggettiva, di misurazione certa."

15. Norman F. Cantor, *In the Wake of the Plague: The Black Death and the World It Made* (New York: HarperCollins, 2000), 74.

16. Cantor, *In the Wake of the Plague,* 70–73.

17. Cantor, *In the Wake of the Plague,* 90.

18. Marina Warner, *Alone of All Her Sex: The Myth and Cult of the Virgin Mary* (New York: Vintage Books, 1983), 186.

19. This questionable jurisprudence, highly influenced by powerful men of the court, was the basis of the succession of Philippe V to the throne instead of his niece

Jeanne, and later was the basis of the passing of the throne to the Valois branch, in the person of Philippe VI, in despite of the claims of Edward III of England, a direct descendant of Philippe IV through his mother, Isabel of France.

20. Cantor, *In the Wake of the Plague*, 91.

21. This is not to say, however, that Kant was right in reducing all the arguments to what he called the "ontological" argument. On this see my *Theological Aesthetics* (New York: Oxford University Press, 1999), 112–119, 121–124, and, more specifically on Kant, *The Reason for Our Hope* (New York: Paulist Press, 1984), 103–106 and 110–111.

22. A fine recording of the motet has been done by the group Sequentia: Philippe de Vitry, *Motets et Chansons* (Deutsche Harmonia Mundi, 77095-2-RC).

23. Norman Cantor, among others, stresses this positive side of the nominalist movement. He writes in his popular history: "The Black Death helped to make apparent that Thomism was an intellectual dead end. It failed to perceive the necessity for quantification in determining natural processes. It had no inkling of the crucial importance of experimentation. It was burdened with a strictly observational and rhetorical approach to science and furthermore remained specifically committed to Aristotle's error-driven physics. . . . [Thomism] led to liberal dogmas, happy dispositions, and intellectual nullity" (*In the Wake of the Plague*, 120–121). On the other hand, nominalism, particularly as exemplified by the Oxford school, led—albeit "over long time"— to the development of modern science, and specifically bio-chemically grounded medicine (120–121). Both the critique of Aristotelian Thomism and the positive evaluation of the effects of nominalism are well taken with respect to the development of empirical science and the replacement of dependence on ancient "authorities" with experimentation. But Cantor's comments prescind from any specifically philosophical or theological critique—except to admit that nominalism led to the idea that the world is governed by "an incomprehensible and awful deity whose actions, such as the Black Death, made no sense to humans" (120–121). It seems to be true that the spirit of nominalism promoted a new interest in the physical world, in individual things, for their own sake. Similarly, the revolt against scholastic method led to the development of an empirical spirit, with its insistence on experience, and eventually to the empirical methods of modern science. The empirical spirit, in turn, militated against the acceptance of ideas simply on the basis of authority. On the other hand, the larger issues—the unity and purpose of the world and of life—were relegated to a sphere outside "knowledge": to the realm of faith. In such ways the nominalism of the fourteenth century already to some extent anticipated the philosophy of Kant, both in its metaphysical agnosticism and in its critique of dogmatism.

24. Hans Belting, *Das Bild und sein Publikum im Mittelalter: Form und Funktion früher Bildtafeln der Passion* (Berlin: Gebr. Mann Verlag, 1981), 21.

25. *Columbia History of the World*, edited by John A. Garraty (New York: Columbia University Press, 1990), 412.

26. The converse of this is the methodological principle of Thomistic "empiricism" that Bernard Lonergan formulates as the "principle of contingent predication": anything that is truly and contingently predicated of the divinity is constituted by the divine essence, but in such a way that it demands a suitable created term. More simply put, we cannot say anything about God's free acts or determinations unless there is evidence of the effects of such acts within our experience.

27. Nevertheless, for St. Thomas the virtue of love is "really distinct" from sanc-tifying grace, while for Scotus they are identical. The reason for this seeming reversal of opinions is a difference in what is meant by "real distinction" and whether the soul is really distinct from its potencies. The question we are dealing with in our text, however, is whether love is intrinsic to grace (Thomas) or merely juridically necessary (Scotus, Ockham, and the Franciscans in general).

28. We might venture that the dispute between intellectualism and voluntarism goes back to the problem posed already by Plato: are things good because the gods love them, or do the gods love them because they are good? Scotus opts for the for-mer; Thomas for the latter—with the understanding, however, that the "good" is de-fined by God's being, which is both free and intelligible. The point here is that the goodness of things is rooted in God's very being, not in an arbitrary act of will. In God, freedom and intelligibility, for the Thomist, are one. "Freedom" is not equated with an arbitrary choice, but with a level of being. Hence, while there are things in the finite world that could be different, and while God could create a different uni-verse with different "rules," any such creation would necessarily have the same *tran-scendental* values that are perceived by our intellects in the actual world. This is so because the "transcendentals," as understood by Thomas, are not concepts, but are a finite intellectual participation in the "light" of God's very being. Therefore, although the categorical content of goodness or truth or beauty may vary—even in this world—the "intentionality" that they express is always one. This insight, however, must be understood in the light of Thomistic "mysticism": what we participate in is precisely the ungraspable mystery of God. The theology of Karl Rahner, I believe, is a faithful modern restatement of this "Thomistic" insight.

29. Richard Kieckhefer, "Major Currents in Late Medieval Devotion," in *Chris-tian Spirituality: High Middle Ages and Reformation*, edited by Jill Raitt in collaboration with Bernard McGinn and John Meyendorff, vol. 17 of *World Spirituality: An Encyclo-pedic History of the Religious Quest* (New York: Crossroad, 1987), 75. Kiekhefer goes so far as to say that devotion to the passion was "ubiquitous" in late medieval piety (83).

30. Kieckhefer, "Major Currents in Late Medieval Devotion," 83.

31. See for example Thomas Aquinas's affirmative answer to the question "Whether the suffering of Christ's passion was greater than every other suffering." *S.T.*, 3, q. 46, a. 6. Nevertheless, Thomas also held that Christ's soul, even in the passion, was united to God in such a way as to enjoy perfect beatitude. *S.T.*, 3, q. 46, a. 8.

32. See for example the section on "The Passion of the Lord" in Jacobus de Vora-gine's *Legenda Aurea* (mid-thirteenth century). This work encapsulates in popular form the teachings of earlier theologians and spiritual writers, especially St. Bernard. The first three forms of pain that Christ suffered, according to Voragine, were all mental. Only in fourth place does he mention physical pain. And even in the consid-eration of how the pain of the passion permeated all Jesus' five senses, the emphasis is on the mental suffering he underwent.

33. See for example the "Kreuztragung" by Breughel in the Kunsthistorisches Museum in Vienna: Jesus not only carries a large cross but is tormented by the sol-diers; he walks barefoot on planks studded with nails; he is crowned with thorns of enormous length. Breughel increases the sense of horror by introducing grotesque images, and by associating the theme with a contemporary execution by hanging.

206 NOTES TO PAGES 156–160

34. The most famous (albeit late) example of the type is Grunewald's 1512 cruci-fixion from the Isenheim altarpiece.

35. Georg Satzinger and Hans-Joachim Ziegeler, "Marienklagen und Pietà" in *Die Passion Christi in Literatur und Kunst des Spätmittelalters*, edited by Walter Haug and Burghart Wachinger (Tübingen: Max Niemeyer Verlag, 1993), 241–276, at 274.

36. See the classic study by Millard Meiss, *Painting in Florence and Siena after the Black Death: The Arts, Religion and Society in the Mid-Fourteenth Century* (New York: Harper and Row, 1951).

37. Cole, *Giotto and Florentine Painting*, 138–139. Some examples of this post-plague style in representing the crucifixion: a panel crucifixion by Nardo di Cione (1350–1360); a triptych by Alberegno (1360–1390); a fresco by Andrea da Firenze (1365–1368); an altarpiece by Altichiero da Zevio (1376–1379); a crucifixion panel by Antonio Gaddi (1390–1396). All of these can be found at the Web Gallery of Art, available on-line at: http://gallery.euroweb.hu.

38. Kiekhefer, "Major Currents in Late Medieval Devotion," 86–87.

39. This writer is frequently called Pseudo-Bonaventure. He has sometimes been identified with the thirteenth–century Franciscan Johannes de Caulibus. More re-cently, however, this ascription has been questioned, and the work placed in the first part of the fourteenth century. See Peter and Linda Murray, *The Oxford Companion to Christian Art and Architecture* (New York: Oxford University Press, 1996), s.v. "Medita-tiones Vitae Christi."

40. See the works referred to in note 36.

41. F. P. Pickering, "The Gothic Image of Christ: The Sources of Medieval Rep-resentations of the Crucifixion," in *Essays on Medieval German Literature and Iconogra-phy* (Cambridge: Cambridge University Press, 1980), 9. The iconographic influence of the *Revelations* of Saint Birgitta, however, was greater after their diffusion in printed form over a century after her death (1492).

42. Kiekhefer, "Major Currents in Late Medieval Devotion," 85–86.

43. Belting, *Das Bild*, 21.

44. Belting, *Das Bild*, 160.

45. Belting, *Das Bild*, 143, 146.

46. Belting, *Das Bild*, 146.

47. From the time of Symeon of Thessalonika the term *"epitaphios"* was used as another name for the *"aer."* For a detailed discussion of the development of the use of these icons in the Byzantine liturgy, see Demetrios I. Pallas, *Die Passion und Bestat-tung Christi in Byzanz* (Munich: Institut für Byzantinistik und neugriechische Philolo-gie der Universität München, 1966). On this point, 43.

48. Belting, *Das Bild*, 192.

49. Belting, *Das Bild*, 154.

50. Pallas, *Die Passion und Bestattung Christi in Byzanz*, 62.

51. Belting, *Das Bild*, 162–163.

52. Belting notes that the standard categories of portrait icon (*Bildnisikone*) and narrative or scenic icon (*Scenische Ikone*) are insufficient for the *imago pietatis*: it is neither a timeless portrait nor the narration of event. The tomb suggests a time; but the scene is not identifiable as any "station" of the passion. *Das Bild*, 143. I would extend this observation to many crucifixes: although they do ostensibly portray a mo-ment or scene, they also transcend it, not only by evoking the entire passion but also

by serving as the "portrait" of an eternal character and act, which the portrayal itself mediates into presence.

53. Belting, *Das Bild*, 161.

54. Belting, *Das Bild*, 199.

55. The Greek word for "humility" or "humiliation" in the title of the icon is from the same root as the verb used by St. Paul in the famous "kenosis" hymn in Philippians (Philippians 2:8: 'ἐταπείνωσεν 'εαυτόν, "he humbled himself"), which was taken in Patristic exegesis to refer to the Word's incarnation.

56. Belting, *Das Bild*, 60.

57. Belting, *Das Bild*, 125.

58. Siccard of Cremona (1160–1215) mentions that in some books, "the majesty of the Father and the cross of the crucified are depicted [together], so that we may see as though present the one that we pray to, and so that the passion that is represented may pour in through the eyes of the heart" (majestas Patris et crux depingitur crucifixi, ut quasi praesentem videamus quem invocamus et passio quae representatur, cordis oculis ingeratur), PL 213, 124c. Quoted in Belting, *Das Bild*, 19. An example of such a picture may be seen in the Breviary of Martin of Aragon, illuminated in the late fourteenth century. Perhaps the most celebrated example of this type is Masaccio's fresco of the Trinity in the church of Santa Maria Novella in Florence (1425–1428).

59. The painting is in the Städelsches Kunstinstitut, Frankfort. An image can be found at the Web Gallery of Art.

60. The term *pietà* can also be used more extensively, including scenes in which the dead Christ is received by angels. Our interest here will be restricted to the Marian *pietà*, by far the most popular.

61. We must recall, however, that art remained largely local. The image was apparently unfamiliar to some artists even in the following century. See Murray, *Oxford Companion to Christian Art and Architecture*, s.v. "Pietà."

62. See Murray, *Oxford Companion to Christian Art and Architectur*, s.v. "Meditationes Vitae Christi."

63. Evelyn Sandberg-Vavalà, *La Croce Dipinta Italiana e l'Iconografia della Passione* (Rome: Multigrafica Editrice, 1985), 21.

64. *Chronica Generalum Ordinum Minorum*, 24, vol. 3. Quoted in Warner, *Alone of All Her Sex*, 326.

65. Belting, *Das Bild*, 125.

66. Kieckhefer, "Major Currents in Late Medieval Devotion," 83.

67. Kieckhefer, "Major Currents in Late Medieval Devotion," 109.

68. St. Thomas is also clear in saying that anything that happens to the body exteriorly—such as being crucified, or suffering—cannot be attributed to Christ's mode of presence in the Eucharist (*S.T.*, 3, q. 81, a. 4, c); Christ is present in the sacrament in an impassible way (*S.T.*, 3, q. 81, a. 3), and in a way that can neither be seen nor imagined (*S.T.*, 3, q. 76, a. 7).

69. Arnaldus, *Life of Angela of Foligno*, quoted in Belting, *Das Bild*, 112, 113 n. 10.

70. Quoted in Belting, *Das Bild*, 110.

71. Belting, *Das Bild*, 127.

72. For a discussion of the development of the lament of Mary, especially in German, see Satzinger and Ziegeler, "Marienklagen und Pietà," 241–276.

73. A recording of this song, as well as other passion music of the late Middle Ages, may be found on the CD *Planctus Mariae: Spätmittelalterliche Musik der Karwoche*. Performers: Ensemble für Frühe Musik Augsburg (Christophorus CHR 77147).

74. Kurt von Fischer, "Passion. A.," in *Die Musik in Geschicte un Gegenwart* (Kassel: Bärenreiter, n.d.), 1453.

75. Kiekhefer, "Major Currents in Late Medieval Devotion," 88. The Palatinus Codex in the Vatican Library testifies to the existence of some form of Passion drama in Byzantium at an earlier date. Written between the seventh and thirteenth century, it contains scenic descriptions and stage directions for the actors in the drama, but no text. See Christodoulos Halaris, "Melodists of the Passion," notes to the recording *Melodists of the Passion, Eleventh Century A.D.–Eighteenth Century A.D.*, Orapath CD, catalogue number 1011.

76. Kiekhefer, "Major Currents in Late Medieval Devotion," 85–86.

77. Kiekhefer, "Major Currents in Late Medieval Devotion," 75. A list of fourteen stations "identical to those used in modern devotion" was composed by the Belgian Carmelite John Pascha early in the sixteenth century. Kiekhefer, "Major Currents in Late Medieval Devotion," 85.

78. Joerg O. Fichte, "Die Darstellung von Jesus Christus im Passionsgeschen der englischen Fronleichnamszyklen und der spätmittelalterlichen deutschen Passionspiele," in *Die Passion Christi in Literatur und Kunst des Spätmittelalters*, edited by Walter Haug and Burghart Wachinger (Tübingen: Max Niemeyer Verlag, 1993), 277–296, at 280.

79. Fichte, "Die Darstellung von Jesus Christus," 280–281.

80. Fichte, "Die Darstellung von Jesus Christus," 284.

81. Fichte, "Die Darstellung von Jesus Christus," 281.

82. Fritz Oskar Schuppisser, "Schauen mit den Augen des Herzens: Zur Methodik der spätmittelalterlichen Passionsmeditation, besonders in der Devotio Moderna und bei den Augustinern," in Haug and Wachinger, *Die Passion Christi*, 169–210, at 173.

83. Schuppisser, "Schauen mit den Augen des Herzens," 198.

84. Schuppisser, "Schauen mit den Augen des Herzens,"200.

85. Schuppisser, "Schauen mit den Augen des Herzens,"170.

86. Schuppisser, "Schauen mit den Augen des Herzens,"172.

87. Quoted in Schuppisser, "Schauen mit den Augen des Herzens,"183.

88. Schuppisser, "Schauen mit den Augen des Herzens,"184.

89. Schuppisser, "Schauen mit den Augen des Herzens,"186.

90. Gerard S. Sloyan, *The Crucifixion of Jesus: History, Myth, Faith* (Minneapolis: Fortress Press, 1995), 176.

91. Ewert Cousins, "The Humanity and the Passion of Christ," in Raitt, McGinn, and Meyendorff, *Christian Spirituality*, 375–391, at 387.

92. Cousins, "Humanity and Passion of Christ."

93. Sloyan, *Crucifixion of Jesus*, 184.

94. Sloyan, *Crucifixion of Jesus*, 185.

95. Sloyan, *Crucifixion of Jesus*.

96. The "high" theology of the Middle Ages understood these ideas in a very nuanced way. Already St. Augustine had enunciated the "sacramental" understanding of the renewed presence of Christ's single sacrifice. Commenting on the yearly cele-

bration of the Lord's Passion in Holy Week, he writes: "'Qui traditus est propter de-licta nostra, et resurrexit propter justificationem nostram.' (Rom. 4. 25) Hoc semel factum est, optime nostis. Et tamen solemnistas tanquam saepius fiat, revolutis temporibus iterat, quod veritas semel factum tot scripturarum vocibus clamat. Nec tamen contraria sunt veritas et solemnitas, ut ista mentiatur, illa verum dicat. Quod enim semel factum in rebus veritas indicat, hoc saepius celebrandum in cordibus piis solemnitas renovat. Veritas quae facta sunt, sicut facta sunt aperit: solemnitas autem non ea faciendo, sed celebrando, nec praeterita praeterire permittit." (*Sermo 210, In Vigiliis Paschae*, 2, PL 38, 1089). In line with this understanding, St. Thomas Aquinas teaches clearly that the eucharist is called a "sacrifice" because it is a "representative image" of the one sacrifice of Christ, which took place on the cross, and because it permits us to participate sacramentally in the effects of the passion (*S.T.*, 3, q. 83, art. 1). Moreover, he teaches that it is the glorified body of Christ that is present in the eucharist, and that it is not "locally" present (*S.T.*, 3, q. 76, especially art. 5). But we can probably presume that popular piety had a much more material and physical sense both of "presence" and of "sacrifice."

Index